ENGLISH COLOURED BOOKS

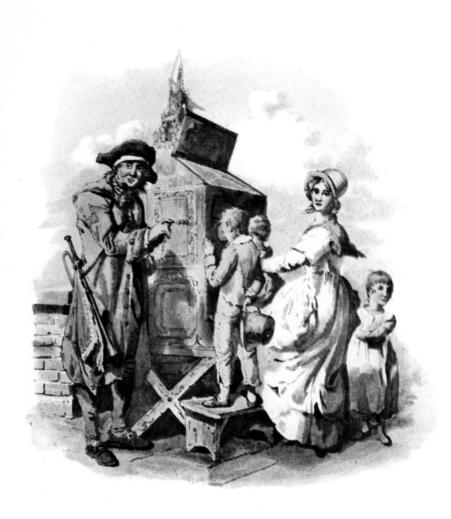

"THE HALFPENNY SHOWMAN"
FROM "THE COSTUME OF GREAT BRITAIN," BY W. H. PYNE, 1808

ENGLISH
COLOURED BOOKS

BY

MARTIN HARDIE

With an Introduction by
JAMES LAVER

KINGSMEAD REPRINTS
BATH

First published 1906
Reprinted 1973

© Kingsmead Reprints

SBN 901571 65 2

Kingsmead Reprints
Kingsmead Square
Bath

Printed by
Redwood Press Limited
Trowbridge, Wiltshire

INTRODUCTION

MARTIN HARDIE was a man of many parts and a variety of talents. Joseph Pennell, the biographer of Whistler, referred to him as "etcher and bureaucrat". The remark was not meant kindly, but it was true enough. Hardie was a most capable administrator, both as a Museum official and as officer of several bodies promoting the arts. He was also an etcher and water-colourist of great distinction.

There was a strong artistic tradition in his family. His great-uncle, Robert Frier, was a well-known Edinburgh drawing master, and two of his uncles, Charles Martin Hardie and John Pettie, were professional artists. His father, James Hardie, was the headmaster of a successful preparatory school, Linton House, and here Martin began his education, passing on, in due course, to St. Paul's School and Trinity College, Cambridge.

As he was born in 1875, he was twenty-three when in 1898 he obtained a post in the Art Library of the South Kensington Museum which, a few years later, was re-named the Victoria and Albert Museum, and here he remained until his retirement in 1935. He was a very competent and energetic librarian, with a particular interest in those art books concerned with water-colour painting and in all the various processes of print-making. It was a fortunate chance

that in the same building was housed the Royal College of Art, the graphic art section of which was in the capable hands of Frank (afterwards Sir Frank) Short. Short was a master of every kind of engraving technique and inspired whole generations of artists to emulate his own high standards of artistic integrity and technical competence. Hardie proved an apt pupil. He first exhibited at the Royal Academy in 1908, and exhibited also at the Royal Society of Painter-Etchers and the Royal Institute of Painters in Water Colour. He became an Associate R.E. in 1907 and R.E. in 1920.

He was an Officer in World War I and, when the conflict was over, returned to the Victoria and Albert Museum. By this time the authorities had realized that the growing collection of prints and drawings in the Art Library had become too cumbrous to handle. It was therefore decided to create a new department, to be known as Engraving, Illustration and Design, separate from the book collection, and Hardie was put in charge of it in 1921.

In one way it was fortunate that, for the first part of his career, he had been both a librarian and an expert on prints and drawings. This double function led him to take a special interest in illustrated books and to become an acknowledged authority on this subject. He had already written many articles, mainly on artistic subjects, but his first full-scale work was "English Coloured Books", issued by Messrs. Methuen as part of "The Connoisseur's Library" in 1906.

He had many advantages for the task he had undertaken. He enlisted the help of colleagues and other experts in this field: G. H. Palmer and E. F. Strange at South Kensington, Campbell Dodgson

at the British Museum, and of course Frank Short who revised the chapter on the technique of aquatint. Carl Hentschel showed him personally the full details of the three-colour process at his works at Norwood, and other professional colour-printers were equally helpful. He had also to hand the very large collections of books with coloured illustrations in his own Museum's Art Library and in the British Museum. Such a comprehensive work as "English Coloured Books" needed the great scholarship and immense industry which were among Hardie's characteristics; its composition was a considerable triumph.

It should be remembered that, until almost the end of the 18th century, nearly all coloured illustrations had to be printed in monochrome and coloured by hand afterwards. Curiously enough the very first book with coloured illustrations published in England, the anonymous Book of St. Albans (1486), contains coats-of-arms, the colours of which were added by means of wood blocks. But for nearly three hundred years afterwards, while there was no lack of illustrated books, the colours were added by hand. The 19th century phrase, "penny plain, twopence coloured", had its counterpart in much earlier times, for it is recorded that in the early 16th century the *Nuremberg Chronicle* was sold unbound and uncoloured for two Rhenish florins, bound and coloured for six.

It is obvious that coloured books were more attractive than those with monochrome illustrations. Hardie traces the development of all the processes of printing in colour which gradually came into being: the so-called chiaroscuro prints of John Baptist Jackson in the 18th century, William

Savage's colour-printing from wood blocks, George Baxter's curious blend of metal engraving and wood blocks charged with oil paint, mezzotints, stipple engravings and aquatints which could all be printed in colour by the laborious method of painting the copper plate itself, William Blake's method of colour etching which he said he had been taught "by an angel". And so on to the invention of chromolithography and the rise and development of the photo-mechanical three-colour process. It is a fascinating story and the student and collector of English coloured books could find no better guide than Martin Hardie.

English Coloured Books would certainly remain his *magnum opus* if, towards the end of his career, he had not embarked on an even more ambitious project, his truly monumental *Watercolour Painting in Britain*, published posthumously in three volumes between 1966 and 1968, Hardie himself having died in 1952.

If a personal tribute may be allowed, the present writer, who served under Hardie in the Print Room of the Victoria and Albert Museum for many years, can only say that he found in him the most considerate of chiefs, the most helpful of guides, and the most delightful of friends.

JAMES LAVER

PREFACE

THERE seems nowadays to be a tendency to abolish the preface, but for the writer of a book there is this in favour of its retention, that it enables him at the very outset of his work to acknowledge thanks where thanks are due. I have received much kind assistance from Mr. G. H. Palmer, Mr. E. F. Strange, and my other colleagues in the National Art Library at South Kensington; and from Mr. Campbell Dodgson, Mr. A. E. Tompson, and Mr. Whitman at the British Museum. Mr. Cyril Davenport, the editor of the present series, has also helped me considerably in researches at the British Museum, and has made many useful suggestions, of which I have been glad to avail myself. Mr. Frank Short, A.R.A., has most kindly revised the chapter on the process of aquatint, and at several points has given valuable advice on questions of technique. I am much indebted to Mr. Carl Hentschel for personally showing me the full details of his 'three-colour' process at Norwood; also to the Dangerfield Lithographic Company at St. Albans, and to Mr. A. Warner, of Messrs. Jeffrey's paper-printing works, for a similar courtesy in connection with their colour-printing. For other kind information and assistance I have to thank Mr. C. F. Bullock, Captain R. J. H. Douglas, Mr. Edwin J. Ellis, Mr. J. Grego, Mr. W. Griggs, Mr. A. D. Hardie, Mr. J. Henderson, Mr. John Leighton, and Mr. T. M'Lean. Last, but not least, my thanks are due to my wife, who, with infinite patience and care, has compiled for me a

complete bibliography of all the coloured books which have appeared for sale during the last five or six years. This bibliography, consisting of thousands of collated cuttings from booksellers' catalogues gathered from every part of the kingdom, has proved of invaluable service.

It is impossible to mention here the many books which have been consulted for biographical and bibliographical facts ; and I must frankly acknowledge that, in compressing the whole history of English colour illustration into a volume of the present size, I owe much to specialists who have devoted years of work to a man or a subject, where I have been able to give only a few pages. I have endeavoured to give specific references to such work at the points where I have found it of special value. I must, however, here express particular indebtedness to Messrs. Singer and Strang's *Etching, Engraving, and the other methods of Printing Pictures.* Their careful explanation of processes, and their bibliography of books on the history of engraving, have been an invaluable help.

At the risk of a certain amount of dulness I have endeavoured to give in detail the names of the artists and engravers who worked on each book mentioned. A study of coloured books, particularly of the aquatint books of the early nineteenth century, brings to light several engravers whose ample achievements have never received the recognition they deserve. Many of these coloured books contain the early and unrecognised work of men who have become famous in our British school of engraving and of water-colour painting. There is a saying of one of the Earls of Orford that 'the most useful of all historians is the maker of a good index,' and I trust that the appendices and index at the close of this book will supply a means of reference to much work for which artists and engravers have never received complete credit.

PREFACE

The colour-plates with which this volume is illustrated have been executed with great care and skill, and are admirable examples of successful three-colour work. It is only right, however, to emphasise the fact that, while they give a faithful rendering of pictorial qualities, they are simply a process translation, and naturally cannot reproduce the technique and texture of the originals.

The illustration representative of Kate Greenaway's work has been printed from the original wood-blocks by kind permission of Messrs. Warne, the printer being Edmund Evans, who printed the original edition.

I must also take the opportunity of explaining that I have adopted the term 'coloured books' as the only convenient way of avoiding the constant repetition of the phrase 'books with coloured illustrations.'

In a book of this type, covering a long period and dealing with a mass of dates and figures, it is almost inevitable that mistakes should occur ; and I shall be greatly obliged to any of my readers who are kind enough to inform me of errors which their knowledge enables them to correct.

MARTIN HARDIE

NATIONAL ART LIBRARY
 VICTORIA AND ALBERT MUSEUM, S.W.

CONTENTS

xiii

CONTENTS

xvi

CONTENTS

b xvii

xviii

CONTENTS

ENGLISH COLOURED BOOKS

LIST OF ILLUSTRATIONS

LIST OF ILLUSTRATIONS

xxiii

ENGLISH COLOURED BOOKS

CHAPTER I

THE BOOK OF ST. ALBANS

'Disserere incipiam et rerum primordia pandam.'—LUCRETIUS.

A DISTINGUISHED writer began a work that has since been the study of many willing and unwilling generations, with the straightforward remark—All Gaul is divided into three parts. With a like simplicity, and with an equal avoidance of unnecessary exordium, it may be said that all colour-illustration is divided into three parts. Its provinces are those of printing from wood, from stone, or from metal. The line of demarcation is, of course, exceedingly difficult to define, for the three provinces meet here, and overlap there, and all three possess a common *Hinterland*. As far as possible, however, each shall be treated separately, its features of interest noted, its limits defined; but at times it will be necessary, after the manner of Baedeker's guide-books, to call a halt and hark back on another route, or to cross a border at a place for convenient excursion in a new neighbourhood. And as the use of wood-blocks is the oldest of all methods of printing, and the use of coloured wood-blocks the *fons et origo* of all colour-printing, here lies our obvious starting-point.

The wealth of invention and the marvels of artistry and technique displayed in the colour-prints of Japan are apt to lead to the wrong idea that the art of colour-

printing, like so many other discoveries, owes its first origin to the gorgeous East. It was not, however, till the eighteenth century that Japan began to produce the brilliant colour-prints that have so charmed and influenced the Western world, and there is no evidence to show that the art of printing in colours, which rose in Germany in the fifteenth century, owes its origin to any foreign or Eastern influence. In his *Japanese Colour Prints*, Mr. E. F. Strange offers an interesting speculation as to the origin of colour-printing in the East. He points out that in the sixteenth century, under the auspices of St. Francis Xavier, Christianity was actively propagated in the island of Tanegashima, and in 1583 an embassy was sent by the native Christians to the Pope at Rome. The art of chiaroscuro engraving, in all essentials identical with Japanese colour-printing, was largely in vogue at the time in Italy, and nothing is more probable, as Mr. Strange suggests, than that prints of saints and similar religious subjects may have been among the objects taken home by the ambassadors, and at a later period may have suggested their colour process to the Japanese. The absolute truth of this remains to be proved, but it is certain that Italy and Germany owe nothing to Japan. The fact is that in every civilised society which possesses an established art of painting, colour-printing rises from the natural inclination to apply colours by hand to impressions from woodcuts printed in black and white, and from this to the application of colour to the block itself is a natural and easy step.

The earliest example in a book of printing in two or more colours by means of engraved wood-blocks is to be found in the *Psalter*, printed by Fust and Schoeffer at Mainz in 1457,[1] where the capital letters are in blue and red. Herzog's edition of Crispus de

[1] A perfect copy of this Psalter was sold at Sotheby's on December 11, 1904, for £4000.

Montibus's *Repetitio tit. Institutionum de Heredibus*, published at Venice in 1490, shows printing in red, brown, and green; and in 1493 Ratdolt's *Missale Brixinense*, published at Augsburg, gives examples of several colours printed from wood, with much additional colouring added by hand. Copies of all these books are in the King's Library at the British Museum, and in the Print Room may be seen a single page of Senfel's *Liber Selectarum Cantionum* (a complete copy is in the Berlin Library), printed at Augsburg by Grimm and Wirsung in 1520,[1] showing the use of seven or eight colours. The method of printing is the same as in the case of the chiaroscuros of this period, to which reference is made in Chapter III.

It is strange that one of the earliest books printed in England should contain an isolated example of colour-printing. This is the work known from the town in which it was compiled and printed as *The Book of St. Albans*. The earliest printed book-illustrations of any sort in England are two little woodcuts in the *Parvus et Magnus Cato*, printed by Caxton in 1481, and appearing again with some others in the *Mirrour of the World*, printed during the same year; so that the *Book of St. Albans*, published in 1486, contains not only the first colour illustration, but is within five years of the first English book-illustration of any sort, and within ten years of Caxton's *Dictes or Sayengis of the Philosophers*, the first book printed in our country.

The book itself bears no title, but as in many fifteenth century books, the subject of the work has to be learned from the text. It consists of four parts, the first of which is on hawking, the second on hunting, the third (the 'Liber Armorum') on the heraldic right

[1] The engraver working for Grimm and Wirsung has recently been identified by Dr. H. Röttinger and Mr. Campbell Dodgson as Hans Weiditz of Strassburg.

to bear arms, and the fourth on 'the blasyng of armys.' The colophon of the whole book states: 'Here in thys boke afore ar contenyt the bokys of haukyng and huntyng with other plesuris dyverse as in the boke apperis and also of Cootarmuris a nobull werke. And here now endyth the boke of blasyng of armys translatyt and compylyt togedyr at Seynt albons the yere from thincarnacion of owre lorde Jhu Crist. M.CCCC.LXXXVI.' There is a pleasing air of mystery about writer and about printer. Of the latter a little more information is supplied from an incidental notice by Wynkyn de Worde, who in his reprint of the *Chronicles*, originally issued from the St. Albans press, says in his colophon: 'Here endith this present Chronicle . . . compiled in a book and imprinted by our sometime Schoolmaster of St. Alban.' We have no time here for fanciful surmises as to the unknown schoolmaster, who set up his lonely printing-press beneath the shadow of the great cathedral, or as to Dame Juliana Berners, who from the statement at the end of the book of hunting— 'Explicit Dam. Julyans Barnes'—has been credited with the authorship of the whole work. The attempted biographies, from the time of Bale and Holinshed onwards, have been torn to shreds by Mr. William Blades in the introduction to his 1881 reprint of the *Book of St. Albans*. The sport-loving authoress and the studious schoolmaster-printer remain but a legend and a name.

Our present interest lies in the fourth part of the book, dealing with the 'blasyng of armys. Book III. had closed with: 'Here endeth the mooste speciall thyngys of the boke of the lynage of Coote armuris and how gentylmen shall be knowyn from ungentylmen, and now here foloyng begynnyth the boke of blasyng of all man armys: in latyn french and English.' This fourth book consists of sixty-six printed pages, embellished with woodcut initial letters, and with 117 coats-

¶ And then to tharmys of Galfrid lucy as here now apperis i this figure And ye most say ye he bare thus in latyn . ¶ Portauit tres lucios aureos in campo rubeo . Et gallice sic . ¶ Il port de goules et trois luces dor . Anglice sic . ¶ He berith goules and .iij. luces of golde . the which certan blasyng with owte declaracion here is enogh . for the sayd fisshes ar in thare propur placis as I sayd in the rule afore .

¶ Bot what shall be sayd of thys man then : the which beris .ij. barbellis turnyng theyr backys to geder as here apperis . Ye most say in latyn thus ¶ Portat duos barbillos aureos admutuam i ga vertentes in scuto asorio puluerisato cū crucibus cruciatis figituis de auro . Et gallice sic . ¶ Il port asor poudre dez crops crocelez fichez et duy barbulp dors an dors dor . Et anglice sic . ¶ He berith asure poldarit with crossis croslettys pycche and .ij. barbellis of golde backe to backe .

¶ Off armys the which ar calde frectis here now I wyll speke .

¶ A certan nobull baron that is to say the lorde awdeley of the Reame of Englonde baar in his armys a frecte . the which certan frectis i mony armys of dyuerse gentill men ar founde . other while rede other while golde . and other whyle blac oderwhile simple and oderwhile dowble other while tripull

A PAGE FROM "THE BOOK OF ST. ALBANS," 1486

of-arms. These initials and coats-of-arms are all colour-printed from wood blocks—blue, red, yellow, and an olive green being the principal colours—and the more unusual tints are added by hand.

The use of two printed colours for initials dates as far back as the Mainz *Psalter* of 1457, mentioned above, which has the magnificent B at the head of the first psalm, as well as some two hundred and eighty smaller initials, all printed from wood blocks, in blue and red. The method of the printing has always been a vexed question. In the editions of 1457 and 1459 the letter is in one colour and the surrounding ornament in another. In the edition of 1515, however, the same initials are used, but while the exterior ornament is printed, the letter and the interior ornament are omitted. This shows, at any rate, that two different blocks were used, and Mr. Weale is of opinion that they were not set up with the rest of the text, but 'printed, subsequently to the typography, not by a pull of the press, but by the blow of a mallet on the super-imposed block.' The same statement presumably applies to the first edition of the *Book of St. Albans*, which has the distinction of being not only the first, but for a period of almost three hundred years the only, colour-printed English book. The existing copies could be counted on the fingers of one hand, and were one to come into the market at the present day, its price would have to be reckoned in thousands. Fortunately there is a copy in the King's Library at the British Museum.

The fact that for nearly three hundred years after the publication of the *Book of St. Albans* there was no colour-printing does not imply that there were no books issued with coloured plates, for many were published with the plates coloured throughout by hand. Wynkyn de Worde's reprint in 1496 of the *Book of St. Albans*, to take an early instance, has new blocks rather rudely

hand-coloured. The battle royal between scribe and printer continued till well on in the fifteenth century, and it was no unusual thing for the printer to employ illuminators, not only because, while illuminators were still plentiful, hand-work was the least expensive method of decoration, but also because it was still necessary for him to vie with the excellence of illuminated manuscripts. As early as 1471 woodcut initials were used by Zainer at Augsburg, consisting of outlines only, intended to be filled in by hand. Also, owing to the introduction of the 'director,' a small letter indicating what initial the rubricator was to supply, hand-painted initials obtained a new lease of life.

The three principal people, apart from printer, binder, and so forth, who contributed to the making of an illustrated book in 1568, are perfectly portrayed by Jost Amman in his woodcuts illustrating Schopper's *Panoplia, omnium illiberalium mechanicarum aut sedentariarum artium genera continens*. One plate with the title 'Adumbrator: Der Reisser,' shows the artist making his drawing. In the next plate the engraver, 'Sculptor: Der Formschneider,' is at work on his block. The most interesting, however, is that of the colourer of prints, 'Illuminator Imaginum: Brieffmaler.' He is seated at a table, with what appears to be a good north light from a leaded window at his right hand. On an oak chest beside him are brushes and dishes of paints. In front on the table is a pile of prints, one of which he is illuminating. Schopper's elegiac verses tell how the colourer's painstaking brush clothes the engraver's outlines with the fitting colours, and how it revels in the glint of gold and silver, when opportunity offers for their display.

> 'Effigies variis distinguo coloribus omnes,
> Quas habitu pictor simpliciore dedit.
> Hic me peniculus juvat officiosus in omni
> Parte, meumque vagis vestibus ornat opus.

6

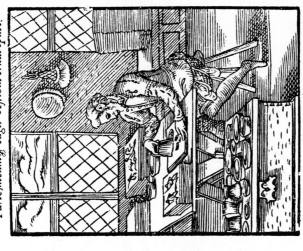

Effigies varijs distinguo coloribus omnes,
Quas habitu pictor simpliciore dedit.
Hic me peniculus iuuat officiosus in omni
Parte, meumq; vagis vestibus ornat opus.

Cuiq; suum tribuo quem debet habere colorem,
Materijs cultus omnibus addo suos.
Vtimur argenti,radiantis & vtimur auri
Munere,cum rerum postulat ordo vices.
Omnibus his furias pictoribus imprecor omnes,
Qui bene nec pingunt, nec vigilanter agunt.
Pictor.

Sculptor. Der Formschneider.

EXimias Regum species,hominumq; Deumq;
Omnia Phidiaca corpora sculpo manu.
Denique pictoris quicquid manus aemula ducit,
Id digiti possunt arte polire mei.

Effigies Regum ligno seruata vel aere,
Innumeros viuit post sua fata dies.
Diues & aeternis par illa deabus habetur,
Quae caelo fuerit nobilitata meo.
Nanq; senescentis videt omnia secula mundi,
Vt Dominam talem charta loquatur anus.
C 2 Typo-

Adumbrator. Der Reisser.

PHoebus imaginib. quod ad aucta volumina put-
Conspicit, egregios & tot vbiq; libros. (chris
Haec meruit nostris accepta laboribus olim,
Posterius calamo grata dabitq; meo.

Quicquid enim leui super assere pingimus,illud
Officio sculptor debet,opisq; mee.
Quicquid & effectu memorabile pace, vel armis
Phoebus in Oceano spectat vtroq; geri.
Dulcibus illustrat manus ingeniosa,figuris,
Blanda quibus cernens lumina pascat homo.
C Sculptor

THE DESIGNER, THE ENGRAVER, AND THE COLOURER
FROM SCHOPPER'S "PANOPLIA," 1568. ENGRAVED BY JOST AMMAN

PLAIN AND COLOURED

Cuique suum tribuo quem debet habere colorem,
 Materiis cultus omnibus addo suos.
Utimur argenti, radiantis et utimur auri
 Munere, cum rerum postulat ordo vices.
Omnibus his furias pictoribus imprecor omnes,
 Qui bene nec pingunt, nec vigilanter agunt.'

Throughout the sixteenth century in Germany it was quite usual for illustrations as well as initial letters to be coloured by hand, just as separate woodcuts had been before. The practice only gradually disappeared after Dürer's reforms in technique had caused the higher class of cuts to be accepted as complete in plain black-and-white. To Mr. Campbell Dodgson I am indebted for an amusing reference in the *Schatzbehalter* to the common practice, the author in the explanatory text to the tenth woodcut requesting that if the cut be coloured the cow may be painted red, since the animal he has in his mind is the red heifer of Numbers xix. It is recorded also that the *Nuremberg Chronicle* was sold, unbound and uncoloured, for two Rhenish florins; bound and coloured for six.

Colouring of heraldic devices and of engraved title-pages and maps is so common throughout the books of the sixteenth and seventeenth centuries as to make it a question of interest whether such colouring was contemporary, and if so whether it was executed in the workshop of the printer. The exact relation between printer and illuminator in the fifteenth and the early part of the sixteenth centuries still requires much investigation, but there is sufficient evidence that to a certain extent they worked side by side. Professor Middleton, in writing of illuminated manuscripts, draws a pleasing, though perhaps somewhat fanciful, picture of Gutenberg's shop, with its compositors and printers, cutters and founders of type, illuminators of borders and initials, and skilful binders, who could cover books with various qualities and kinds of bind-

7

ing. He suggests that a purchaser, for example, of Gutenberg's magnificent Bible, in loose sheets, would then have been asked what style of illumination he was prepared to pay for, and then what kind of binding, and how many brass bosses and clasps he wished to have. Actual evidences, however, are against this pleasing picture; for, if we take only the case of the Bible he mentions, Heinrich Cremer, who rubricated, illuminated, and bound the copy now in the Bibliothèque Nationale, and Johann Fogel, whose stamps are found on two or three of the extant copies, appear in no way to have been associated with the workshop of the printer.

If it is a doubtful supposition that the colouring was executed in the workshop, there is no reason to dispute the possibility of its having been done in many cases by an illuminator of the city where the book was produced. It is impossible to read a list of the members of any mediæval city guild without being struck by the infinite variety of the trades represented. In the records of the Guild of St. John the Evangelist, the patron saint of scribes, founded at Bruges in 1454, no less than fourteen branches of industry employed in the manufacture of books are represented, among the craftsmen being printers, painters of vignettes, painters (*Schilderer*), and illuminators (*Verlichter*). It may therefore be reasonably supposed that the same was the case in England at London, Oxford, St. Albans, and other publishing centres. Possibly also there were travelling limners, like those in Germany, whose trade was to illuminate *Stammbuch* and *Turnierbuch*. Heraldic books, as might be expected, are among those most constantly illuminated, and it must be remembered that in the sixteenth century heraldry was a popular science. Knowledge of it marked the gentleman, ignorance was the stamp of a churl. Knowledge of heraldry implied the knowledge of the correct

8

colouring of coats-of-arms, and there is no doubt that many illuminated heraldic books were coloured at the time of their issue by amateurs. That this is the case in England as well as abroad is shown by many books on the art of illumination, of which a good instance is that published by Richard Totill in 1573, 'in Flete-streete within Temple-barre, at the signe of the Hande and Starre,'—*A very proper Treatise, wherein is briefly sett forthe the Arte of Limming . . . with diverse other thinges very mete and necessary to be knowne to all such gentlemenne, and other persons as doe delite in limming, painting, or in tricking of armes in their right colors, and therefore a worke very mete to be adioned to the bookes of armes.*

CHAPTER II

HAND-COLOURED PLATES FROM 1500 TO 1800

FOR as nearly as possible a century after the *Book of St. Albans* the woodcut held undisputed sway in English illustration. From 1540 onwards a few line engravings on metal appear, and after 1590 engraved illustrations increase rapidly, ousting the woodcut from popular favour. For a hundred and fifty years or more, line engravings were the prevailing form of illustration in books of heraldry, of natural history, of furniture and ornament, in large county histories, or in series of reproductions of pictures, with or without letterpress. Line engraving does not naturally produce a successful result when printed in colour. Mezzotint, stipple, or aquatint plates, when printed in colour, give uniform tones, showing the tints in a mass; but if a line engraving is printed in colour, the colours seem to emphasise the streakiness of the separate lines, and the result is never wholly pleasing. Many of these early books, however, are illustrated with line engravings coloured by hand. The colouring, although contemporary, does not always imply a systematic issue by the printers, but is frequently the result of amateur amusement, often producing excellent results. That the colouring of prints by hand was a popular practice is shown by various treatises on the subject. *A Book of drawing, limning, washing, or colouring of maps and prints* was published in London in 1660. In 1723 there is a book by John Smith, entitled *The Art*

10

*of Painting in Oyl . . . to which is added the whole Art
and Mystery of Colouring Maps and other Prints with
Water-Colours.* The author states that he has 'as
yet seen nothing published upon this subject that is
Authentick.' A few years later appeared *The Art of
Drawing and Painting in Water-Colours. Whereby
a Stranger to those Arts may be immediately render'd
capable of Delineating any View or Prospect with the
utmost exactness; of Colouring any Print or Drawing
in the most Beautiful Manner.* This was printed 'for
J. Peele, at Locke's Head, in Amen-Corner, 1731.'
Chapter v. is headed, 'Of Colours for Illuminating of
Prints in the best Manner; or of Painting in Water-
Colours.'

The same writer repeats his advice in his *Method of
learning to draw in Perspective,* printed for J. Peele in
1735. He gives some interesting notes of technique in
colouring prints by hand, one of his main points being
the avoidance of white paint. 'If you leave the Lights
on this Occasion, the Whiteness of the Paper serves
instead of the Use of White Paint, which is an heavy
Colour, and would rather confound the edges of the
Colours, which I have prescribed to be laid on, than
do them any Service; but the Colours which I have
directed, where there is no White laid on, will agree-
ably shine into the White of the Paper. I am more
particular in this, because several, if they see a Flower
of a blue Colour, will lay it all over with one Colour,
though it is thick enough to hide both the Lights and
the Shades, and then it remains like a Penny Picture,
where there is nothing to be seen but a Jargon of Reds,
Blues, and Yellows. With a little Practice of what I
direct, you will soon see the good Effect of laying on
Colours for this Use; though the Dawbing of Prints
in the Common Manner may please the Ignorant, when
every one of Taste will soon discover the Impertinence.'
The employment of transparent water-colour as advised

11

in these treatises was soon extended from its original
use for tinting of prints to the tinting of outline
drawings; and when aquatint came to be used as a
means of producing coloured designs in facsimile, the
occupation of washer became a regular branch of
business. Turner and Girtin in their early days were
both thus employed by the publishers of prints. It
must not, however, be supposed that all books of the
sixteenth and seventeenth centuries, that now appear
with coloured plates, were hand-coloured by their
possessor for his own pleasure or edification. There
is, on the other hand, a large number of books,
illustrated with line engravings, which were issued by
the printer in a coloured state, the colouring being
frequently done by the author, or under his immediate
supervision.

All through the eighteenth century numerous books
were issued in this way, with engravings admirably
coloured by hand. Some of those dealing with natural
history are the most notable. *A Natural History of
English Insects*, published in 1720 by 'Eleazer Albin,
Painter,' contains one hundred engravings of moths
and butterflies, all carefully coloured by the author.
From 1731 to 1738 Albin also published a *Natural
History of Birds*, with two hundred and five coloured
plates.

Another noteworthy book of this period is *The
Natural History of Carolina, Florida and the Bahama
Islands*, by Mark Catesby, published from 1731-1748.
It forms two volumes, with two hundred and twenty
plates, hand-coloured by the author. In his preface he
writes : 'Of the Paints, particularly Greens, used in the
Illumination of Figures, I had principally a regard to
those most resembling Nature, that were durable and
would retain their Lustre, rejecting others very specious
and shining, but of an unnatural Colour and fading
Quality.' His care and skill are proved by the excellent

condition of many surviving copies. By the same author is the *Hortus Europae Americanus*, with sixty-three plates, published in 1767, 'price colour'd £2:2:6.'

Another early naturalist was George Edwards, who wrote with all the simplicity and piety of Isaac Walton. From 1743 to 1751 he issued his *Natural history of uncommon birds . . . to which is added a general idea of drawing and painting in water colours*; and from 1753 to 1764 his *Gleanings of Natural History*. The two together form seven volumes containing over three hundred plates, coloured by the author. Another interesting book was published in 1749 by Benjamin Wilkes: *The English Moths and Butterflies. Together with the Plants, Flowers, and Fruits whereon they Feed. All Drawn and Coloured in such a manner as to represent their several beautiful Appearances.* The book has one hundred and twenty copper-plates 'all drawn and etched in a quite new manner, whereby every Design, when coloured, appears like a regular Piece of Painting. . . . The Price of this Work colour'd is Nine Pounds; Uncoloured, Three Pounds Thirteen Shillings and Sixpence.' The *Flora Londinensis*, 1778-1798, by William Curtis, contains over four hundred hand-coloured plates of wild-flowers in the neighbourhood of London. A word, too, must be said of *The Botanical Magazine, or Flower Garden displayed*, started by William Curtis in 1787, and still in existence. From 1801 to 1826 it was continued by J. Sims as *Curtis's Botanical Magazine*. After 1826 it was conducted by S. Curtis, Sir W. J. Hooker, and Sir J. D. Hooker successively. In 1901 a complete set from the commencement was offered for sale for £150.

One of the last examples of the old style of colouring line engravings by hand is the work of William Fowler. Fowler was born at Winterton, Lancashire, on March

13, 1761. He was trained as an architect and builder, but his real interest lay in purely antiquarian and artistic pursuits. To his wonderful industry and patient pertinacity is due the series of plates, *Mosaic Pavements, Stained Glass, etc.*, of which a complete set is so extremely rare. The plates were issued separately, and without any definite order, from 1799 onwards. It was not till twenty-seven subjects had appeared that Fowler thought of gathering them into a volume, published on October 1, 1804. Emboldened by his success, he produced in 1809 an appendix with twenty-seven engravings, and in 1824 a second appendix with twenty-six plates. The principal subjects of the plates throughout are mosaics, stained glass, and monuments. All except the two plates of Roman tesselated pavements at Winterton and Horkston were engraved in line, with the occasional use of aquatint, by Fowler himself. Practically all were hand-coloured by Fowler; the few remaining ones were coloured under his supervision. The second appendix is almost unknown, and a perfect set of the three volumes seems never to have appeared in the sale-room. The most complete set offered for sale within recent years contained seventy-seven plates; and Lowndes's *Bibliographer's Manual* describes it as 'a magnificent work in two volumes of fifty-four plates,' stating that thirty or forty copies only were printed.

CHAPTER III

JOHN BAPTIST JACKSON

IN the last chapter the history of books with illustrations coloured by hand was sketched briefly as far as the year 1800. In regard to illustrations actually printed in colour, there is a long gap in England from the *Book of St. Albans* till the eighteenth century, when the revival of chiaroscuro by Kirkall, Jackson, and others brings a renewal of colour-printing from wood-blocks. As this revival of chiaroscuro is of no little importance in the history of illustration, it may not be out of place to trace briefly the earlier history of the art, its nature, methods, and aims, and to show its later development and influence.

However well the great masters of engraving succeeded in expressing texture, tone, and the gradations of light and shade by means of pure black and white, there was always the natural inclination to supply the want of those qualities that colour alone can bestow. And once the possibility of printing in two colours is grasped, you have the root idea that passes through the stages of chiaroscuro printing to develop into the finished product of coloured mezzotint, aquatint, and lithograph, and that finds its expression alike in the modest delicacy of a stipple-engraving by Ryland, and in the flaunting glare of some modern posters. One of the earliest manifestations of the natural instinct towards colour was the method of wood-engraving known as chiaroscuro, which, in rendering form as well

15

as colour, went a step further than the coloured orna-
ment of the early German printers. Just as their
coloured initials originated from the desire to imitate
cheaply the work of the illuminator, so in its initial
stages chiaroscuro was simply a method of copying
drawings or sketches by the masters of the sixteenth
century, executed in the prevalent fashion of two or
three tones on a tinted paper, with the lights put in
with white body-colour. The earliest work of this
style in Germany ('St. Christopher' and the 'Venus
and Cupid' by Lucas Cranach) is dated 1506, while the
first Italian chiaroscuros ('The Death of Ananias' and
'Æneas and Anchises,' both by Ugo da Carpi after
Raphael) bear the date of 1518. Though the former
country has therefore the actual priority, the Italian
masters, particularly Ugo da Carpi, developed the art
with more artistic feeling.

Of special interest in connection with the history of
book illustration is the title-page of the *Alexandri
Magni Regis Macedonum Vita*, by P. Gualterus, pub-
lished at Strassburg in 1513. The title-page is simple
and decorative, having a short title and the date printed
in red and black. Round this is a border design, at
the sides being twisted trees whose branches intertwine
across the top. Birds are seated among the branches,
and various animals are enclosed behind a fence at the
bottom. The whole bears a curious resemblance to
some of Blake's designs. The border has been over-
printed with a second block covering the whole design,
and conveying a red tint. It is in the chiaroscuro
manner, the square centre for the lettering and the
lights on the trees and animals having been cut away
from the block.

It is noticeable that in cases where the design to
be reproduced was unusually large and complicated,
as in Da Carpi's copies of Raphael, the chiaroscuro was
printed on several separate sheets. The reason lay in

the difficulty of finding large enough blocks and a sufficiently large press; and a division into sheets is still the case with all large picture-posters of to-day.

To reproduce such sketches as have been mentioned, the wood-engraver had to make one block for each tone. The ordinary method was to make a first block, which was printed in black, containing the outline and in some cases the deeper shadows. On this printed outline were superimposed the other blocks, with tints of sepia, bistre, or green, as the case might be. Care had to be taken that each block should register exactly, and if this was carefully managed the result was a good imitation of the gradations obtained by the painter from the use of flat tints of colour. This repetition of impression with coincidence of register, forming what is termed by French writers the *rentrée*, is of extreme importance in all colour-printing from successive blocks. Registration is obtained by means of fine points, placed at the four angles of the frame or on the tympan of the press, which may pierce the paper always at the same spot. These marks will be found on uncut proofs of any colour-printing done by successive impressions, such as that of Baxter, Janinet, Debucourt, and later men, as well as the early chiaroscurists. In Papillon's *Traité de la Gravure en Bois*, published at Paris in 1766, will be found an instructive example of the method, illustrated by prints from each of the four separate blocks composing a chiaroscuro, as well as by an impression of the completed whole, produced by combining the four. The German school rarely used more than three blocks, while the Italians not infrequently employed four or five. There seems no doubt also that in a few instances the early German engravers used for the outline a metal plate instead of wood, resorting to wood-blocks for their colour impressions. In one instance, the *Historia Imperatorum Cæsarum Romanorum*, with forty-six portraits by Hubert Goltzius and

B

Gietleughen (Bruges, 1563), it seems an accepted fact that not only the first impression but the two subsequent *rentrées* as well were from metal plates. This substitution of a metal plate for a wood-block must be borne in mind in considering the later work of Kirkall and Baxter. In printing chiaroscuros the paper was probably damped, and subjected to considerable pressure. Even when thick paper was employed, the back bears quite an embossed appearance.

The art of chiaroscuro never quite died out. Abraham Bloemaert (1564-1658) executed a number of masterly chiaroscuros, using an etched plate to convey the first outlines. About 1623 Louis Businck, a French engraver, produced prints after Bloemaert and Lalleman ; between 1630 and 1647 Bartolomeo Coriolano practised at Bologna ; and later came Vincent le Sueur in France, 1691 to 1764. In England there began a revival with E. Kirkall, who between 1721 and 1724 executed several chiaroscuros after Italian paintings, in which he attempted an improvement by printing his first impression from a metal plate worked in mezzotint, and adding his colours from wood. A fine collection of Kirkall's work is in the Print Room at the British Museum, of particular interest being the ' Æneas carrying his Father out of the Flames of Troy,' after Raphael, where there is a finished mezzotint plate of the subject as well as another print showing the colours from wood-blocks superimposed. Kirkall's prices were not particularly high, for there are in existence receipts, dated in 1722, in which the engraver acknowledges the sum of one guinea, and promises to deliver a dozen more prints on payment of a second. Between 1730 and 1740 Arthur Pond and George Knapton published imitations of sketches, the tinted grounds, landscapes, draperies, and so on being impressed from wood-blocks over an impression from an etched plate. Some of

18

Pond's best work reproduces the sepia drawings of Claude.

This somewhat lengthy preamble brings us to the first book published in England with chiaroscuro illustrations, for the work mentioned so far has entirely consisted of separate prints. In 1754 John Baptist Jackson published an *Essay on the Invention of Engraving and Printing in Chiaro Oscuro*, the first English book—with the exception of Le Blon's *Colorito*, to be mentioned later—with illustrations printed in colour since the *Book of St. Albans*, and of extreme value and importance. Jackson was born in 1701, and studied as a pupil under Kirkall in London and Papillon in Paris. From Paris he travelled to Venice, where he worked from 1738 to 1745. Encouraged by the Marquess of Hartington and Sir Roger Newdigate, who were travelling in Venice, as well as by Mr. Joseph Smith, the famous English consul and connoisseur, he published in 1745 a volume of chiaroscuros after Titian, Tintoretto, and Veronese.[1] Subsequently he returned to England, and opened at Battersea a manufactory of paper-hangings printed in colours in the chiaroscuro method. Jackson knew little of the history of the art, and it was really to push this enterprise that the *Essay* was published, a small quarto volume containing eight chiaroscuro prints, four in the old style, and four in 'proper colours.' These last four are an attempt to go beyond the three or four shades of one colour hitherto employed in chiaroscuro, and to use different natural colours in imitation of drawings. It is difficult to refrain from quoting the essay in its entirety, so pleasing is the old-world flavour of its rambling preface, with its unblushing laudation of Mr. Jackson, and its side-reference to the establishment by the Duke of

[1] Titiani Vecellii, Pauli Caliarii, Jacobi Robusti et Jacobi de Ponte Opera Selectiora a Joanne Baptista Jackson Anglo ligno coelata et coloribus adumbrata. Venetiis, MDCCXLV.

Cumberland of a tapestry manufactory at Fulham, a laudable encouragement that the writer seems to hint might well be extended to Mr. Jackson and his work. The writer refers briefly to the chiaroscuro work of Dürer, Ugo da Carpi, and others, and continues: 'After having said all this, it may seem highly improper to give to Mr. *Jackson* the Merit of inventing this Art; but let me be permitted to say that an Art recovered is little less than an Art invented. The Works of the former Artists remain indeed, but the Manner in which they were done, is entirely lost: the inventing then the Manner is really due to the latter Undertaker, since no Writings or other Remains are to be found by which the Method of former Artists can be discover'd, or in what Manner they executed their Works; nor, in Truth, has the *Italian* Method since the Beginning of the 16th Century been attempted by any one except Mr. *Jackson*.' The writer completely ignores the work done in England alone by Kirkall, Knapton, and Pond; and misses Jackson's real claim to originality in his attempt to reproduce landscapes in their natural colours—'proper colours,' as he calls them.

His first attempt to use, as it were, a fuller palette in colour-printing, and to discard the conventional for the realistic treatment of landscape, appeared in a series of six prints, published at Venice, and dedicated to the Earl of Holderness, the British ambassador. On coming to England he developed still further this method, which is described fully in the *Essay*. 'It is not improbable,' says the preface, 'that Gentlemen acquainted with Mr. *Le Blond's* Manner of Printing Engravings on Copper in Colours [1] may imagine it to be the same with this of Mr. *Jackson*, and that from the former he has borrowed his Design; but whoever will take the least Pains to enquire into the Difference,

[1] See Chapter VI.

will find it impossible that the cutting on Wood Blocks, and printing the Impressions in various Colours from them, can be done in the same Way that is done on the Copper Plates in the Mezzotinto or Fumo Manner. Every Man who knows any Thing of the Nature of Engraving must be convinced that those Mezzotinto Plates, of all others, are the most liable to wear out; that it is impossible for any Two Prints to be alike in their Colours when taken off in that Manner, and for this Reason, because the delicate and exquisite Finishings of the Flesh, and the tender Shadowings of all the Colours must be destroy'd; the very cleaning the Plates from one Colour to lay on another is sufficient to ruin all the fine Effect of the Workmanship, and render it impossible to take off ten Impressions without losing all the Elegance of the Graving. On the contrary, the Method discovered by Mr. *Jackson* is in no Degree subject to the like Inconveniency; almost an infinite Number of Impressions may be taken off so exactly alike, that the severest Eye can scarcely perceive the least Difference amongst them. Added to this, Mr. *Jackson* has invented ten positive Tints in *Chiaro Oscuro*; whereas *Hugo di Carpi* knew but four; all which Tints can be taken off by four Impressions only.'

The book has also a definite importance in the history of applied art and house decoration. To quote once more:—' Mr. *Jackson* has imagined a more extensive Way of applying this Invention than has hitherto been thought of by any of his Predecessors; which is the printing Paper for the Hanging of Rooms. By this Thought he has certainly obtained the most agreeable and most useful Ends for the Generality of Mankind, in fitting up Houses and Apartments, which are Elegance, Taste and Cheapness. By this way of printing Paper, the Inventor has contrived, that the Lights and Shade shall be broad and bold, and give

great Relief to the Figures ; the finest Prints of all the antique Statues which imitate Drawings are introduced into Niches of *Chiaro Oscuro* in the Pannels of their Paper ; these are surrounded with a *Mosaic* Work, in imitation of Frames, or with Festoons and Garlands of Flowers, with great Elegance and Taste. . . . In short, every Bird that flies, every Figure that moves upon the surface of the Earth from the Insect to the human ; and every Vegetable that springs from the Ground, whatever is of Art or Nature, may be introduced into this Design of fitting up and furnishing Rooms.'

The illustrations show suggested panels of wall-paper, four pictures of classical statues being in ordinary chiaroscuro, and four of ' Buildings and Vegetables ' in superimposed natural colours. The author claims that ' the Ruins of *Rome*, *Athens*, *Palmyra* or *Egypt* may be printed, and Landscapes of any Kind after the best Masters in any Size, and the Ground of the paper done of one Colour. This, as has been said, will make a lasting and genteel Furniture, as all the colouring is done in Oil, and not subject to fly off, as in Papers finish'd in Water Colours.' In the illustrations the colours are so badly compounded with oil that the paper is in consequence extremely stained, and those unacquainted with Jackson's previous work are not likely to form from the *Essay* a favourable impression of his ability, however much value they may attach for its own sake to the book itself, which is indeed one of the most notable in the history of colour-printing. His Venice publication, more in the old Italian style of three or more shades of one colour, shows far finer execution. In the British Museum are several loose prints, pictures in the classical style of ruined temples and wooded landscapes, executed with several natural-istic colours. A certain amount of convention was employed in these, for Jackson never dreamed of the twenty or more printings used later by Baxter, and in

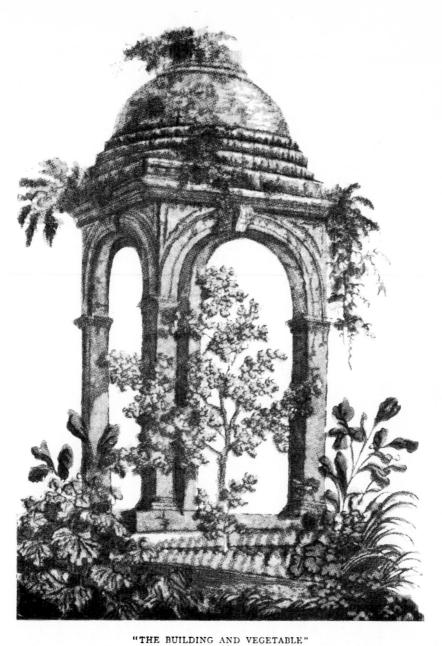

"THE BUILDING AND VEGETABLE"

FROM THE "ESSAY ON THE INVENTION OF ENGRAVING AND PRINTING IN CHIARO OSCURO,"
BY J. B. JACKSON, 1754

the limitation of their colouring many of the prints have a surface affinity to modern work, say by Rivière. Jackson's supreme achievement is a large battle scene, with wonderful masses of rich colour superbly blended, reminiscent of Velasquez in breadth, in dignity, and in glory of tone.

That Jackson's manufactory at Battersea enjoyed more than a measure of patronage and success, is shown in the *Letters of Horace Walpole*, those easy, polished chronicles of an eighteenth-century dilettante and connoisseur, wherein the modern collector finds so much of information, and so much that brings the water to his mouth. Who, for instance, can read unmoved that Walpole had been 'collecting for above thirty years, and originally never gave for a mezzotint above one or two shillings ; the lowest are now a crown ; most from half-a-guinea to a guinea ' ? The capricious Gothic villa at Strawberry Hill, of which its owner wrote that some 'might be disposed to condemn the fantastic fabric, and to think it a very proper habitation of, as it was the scene that inspired, the author of the *Castle of Otranto*,' was hung throughout with Jackson's papers. In a letter of 1753 Walpole writes :— ' Now you shall walk into the house. The bow-window below leads into a little parlour hung with a stone-colour Gothic paper and Jackson's Venetian prints, which I could never endure while they pretended, infamous as they are, to be after Titian, etc., but when I gave them this air of barbarous basreliefs they succeeded to a miracle : it is impossible at first sight not to conclude that they contain the history of Attila or Tottila, done about the very æra. . . . The room on the ground-floor nearest to you is a bedchamber, hung with yellow paper and prints, framed in a new manner, invented by Lord Cardigan : that is, with black and white borders printed.' Another bedchamber, he tells us, was hung with red in the same manner ; the room

that contained his water-colours was papered in green ; another has a ' blue and white paper in stripes adorned with festoons ' ; and ' under this room is a cool little hall, where we generally dine, hung with paper to imitate Dutch tiles.'

There is a certain charm in straying down these quaint, old-fashioned side alleys that attract one from the broad, main street of history, and we are tempted to turn aside once more to look at Papillon's *Traité de la Gravure en Bois*, published in 1766, when its author was seventy-eight years of age. Papillon's father and grandfather before him had been working engravers on wood, so that his book contains the accumulated gossip as well as the experience of three generations. As Christopher North remarked of sheep's head, it contains a deal of fine confused feeding. Its interest at the present moment lies in Papillon's connection with Jackson, and his repudiation of Jackson's claim to have invented wall-papers coloured in the chiaroscuro manner. According to Papillon, the first to invent coloured or ' tapestry ' papers, as he calls them, was his own father, who placed them on the market in Paris about 1688. He tells us that in his own early days his principal work, rather to his disgust, was the hanging of these tapestry papers, and relates how in 1719 or 1720 he was sent to paper a room for a Mons. de Greder, a Swiss officer, who had a charming house in the village of Bagneux, near Mont-Rouge. After hanging the room, he was asked to paste coloured papers, in imitation of mosaic, between the shelves of the library, and it was here that he found in an ancient book the curious history of the twin Cunios, those legendary engravers of the year 1284. Papillon has much to say of the Comte de Caylus, with whom Jackson had worked in Paris, of Le Blon, of Vincent and Nicolas Le Sueur, who printed in colours; and of Lefèvre, Blondel, Panseron, Langlois, and others, who before

24

1750 were selling coloured wall-papers in Paris—all going to show that Jackson, thinking himself safe in London, wilfully suppressed all mention of his indebtedness to other workers in his own sphere.

It is of interest to note that Thomas Bewick, the maker of modern wood-engraving, had in his possession some of Jackson's prints, and also a drawing of the press he used. Their owner, it must be confessed, did not think much of these prints, though he gave Jackson some credit as a maker of paper-hangings. It is to Bewick, however, that we owe the account of Jackson's last days, which, he tells us, were spent in an asylum under the protecting care of Sir Gilbert Elliot, at some place on the Scottish border near the Teviot, or on Tweedside.

The last to make a definite practice of chiaroscuro work was an amateur named John Skippe. He was a Gentleman-Commoner of Merton College, Oxford, and after leaving the University studied painting under Vernet. In 1781 he published in book-form two sets of chiaroscuros (these, however, are without text)— 'Part the First, containing Ten Prints engraved in Chiaroscuro,' and 'Part the Second, containing Ten Prints engraven in Chiaroscuro.' These are capital work in the old Italian manner, though Skippe does not hesitate to combine two distinct colours, as, for instance, sepia and green. With Skippe the art practically died out, though it has still to be referred to in connection with Savage's *Hints on Decorative Printing*, and the work of George Baxter.

25

CHAPTER IV

WILLIAM SAVAGE

AT the beginning of the nineteenth century the most popular process for book illustration was aquatint, printed in colour and finished by hand, to which reference will be made later. But while aquatint was the principal process employed, there was a notable revival of colour-printing from wood-blocks in continuation of the chiaroscuro work of Jackson and Skippe. This was due to William Savage, who was born in 1770 at Howden, Yorkshire, and in 1799 was appointed printer to the Royal Institution. The results of Savage's experiments in colour-printing appeared in his *Practical Hints on Decorative Printing*, published in 1822. The price of the book was five guineas for small-paper copies, and eleven for large; and for the satisfaction of subscribers it was decided that all the blocks used should be destroyed after the first and only edition was printed. To prove the sincerity of this decision, the blocks were gashed across, and prints from the damaged surface are given at the end of the book. Though the book is extremely interesting as a typographical curiosity, the plates on the whole are indifferent and not particularly 'decorative.' As an example, however, of straightforward printing in colour without any retouching by hand, one of the illustrations, the 'Cottage and Landscape,' after J. Varley, reaches a remarkable degree of excellence. All the

26

illustrations were printed by Savage himself or by members of his family, and the fact that the author was a practical working printer adds to the instructive value of his book. The illustrations, he tells us, so far as regards the printing and the inks, are the result of a long and protracted series of experiments, prosecuted for the purpose of overcoming practical difficulties that arose in almost every stage of his work, and which elicited new facts or gave hints for further improvements. Some idea of the scope and aim of these *Practical Hints* will be best given by an extract from the preface, where the author writes: ' Upon the whole, the art of printing has been contracted to the mere process of producing books, and impressions from engravings on wood ; and the imitation of drawings has been disused. From an examination of what had been done I long felt that the powers of it might be extended considerably ; and that the old practice of printing in chiaro oscuro might be restored, and the imitation of coloured drawings be attempted with success, so as to give fac similes of the productions of different masters, at a small expense, to serve as studies, or for the decoration of rooms, where, if framed and glazed, the eye should not be able to distinguish them from drawings. With these feelings the present work was projected, so far as relates to printing in colour.'

Savage in another place gives credit to Jackson for being the first to reproduce a water-colour drawing in proper or natural colours, but he makes the further statement that since Skippe's death nothing had been done in England in colours, with the exception of a few engravings in books printed with brown ink, and lottery bills printed in three colours. It may well be supposed that Savage was ignorant of the work done in France by Janinet and Debucourt, and that the coloured mezzotints of the late eighteenth century, notably the

27

superb examples by W. Ward after Morland, were dismissed by him as outside his province of decorating books, but there is absolutely no excuse for his entire omission of all reference to the work in coloured aquatint, where two and often three of the colours were printed. This may have been due to professional jealousy, or a more charitable reason may be found in his probable lack of sympathy with any work except that of the wood-engraver; yet Savage must have seen, and ought to have admired, some of the aquatint books published by Ackermann and Orme at the very period when he was writing.

The book deals with the whole art of printing, treating of materials, types, and presses, but the centre of the book is the chapter on 'Printing in Colours,' and it is to the art of colour-printing that most of the text and nearly all the illustrations bear reference. It should, however, be premised that all Savage's experiments were confined to the use of wood-blocks. His entire sympathy was with the art of wood-engraving, of which he seems to have been an ardent admirer. In reference to the use of a suite of blocks and the difficulty of registration he writes: 'I have invariably printed the whole impression from each block before I have proceeded with the continuation, without experiencing any particular variation in the paper; adopting only common precautions to prevent its drying; one of which was, to keep the edges from being too near the fire; and another, to keep the outside wrappers damp; and to continue to work the succeeding blocks in the same order that I had the first; so that, if there should be any variation in the dampness of the paper—provided it be kept in the same state as when the work was commenced—after register is once made accurately it will continue the same, even should some of the paper be wet and some dry. When wet paper is worked, I found the best method was to interleave it with damp

paper, in the same manner that set-off sheets are used in fine work ; for, where thirteen or fourteen blocks are used, working the paper so many times will make it drier, and that alters its dimensions ; but when a subject requires only three or four blocks, I should work three or four hundred impressions, without any other precaution than wetting the outside wrappers at night, and perhaps at the dinner hour, and should have no fear of their getting out of register. When a subject requires many blocks, or when it is large, four points will be necessary. They keep the paper steadier than two ; and serve to show any variations that may arise from its shrinking or expanding. Sometimes there are small parts in a drawing of a different colour from any other part. Where this happens it will save a block and time in the working, to introduce the small parts on some other block, where they may stand clear of its tint, and to beat them with their proper colour with a small ball.' In a similar way, as will be noted later, an extra stone is saved in the process of chromo-lithography, and Savage's remarks as to damping the paper and using pin-points for registration apply equally to the work of the lithographer, and indeed to all colour-printing. From time immemorial the system of registration by pin-points has been in use in India for printing coloured textiles. The only difference is that there the colour is applied from blocks stamped by hand, and the pins are on these blocks instead of the frame of a printing-press.

The illustrations of the book consist of a number of specimens treated in different ways for the purpose of explaining the process and of showing the effect that may be produced in a variety of subjects. They comprise wood-engravings printed first with black ink, then with various simple tints. In imitation of slight drawings in sepia or Indian ink three blocks are employed, their separate and combined effects being

shown, while more finished water-colour drawings are reproduced by a combination of seven or nine blocks. The value of these illustrations is much increased by the descriptive notes showing the method in which each was executed. Of the 'Cottage and Landscape,' drawn by J. Varley and engraved by J. Thompson, we are told that 'in this subject there is a suite of fourteen blocks. It commenced with printing the clouds, which are the Neutral Tint; then the blue sky, with Antwerpt blue, and advanced progressively to the darkest shades; the trees were glazed with green after the deepest parts were printed.' Of the 'Mercy,' painted by W. H. Brooke and engraved by G. W. Bonner, he writes that it 'consists of a suite of twenty-nine blocks, in one of which two colours were introduced, making thirty distinct tints in the working; this number, including the different tints produced by the blocks passing repeatedly over each other in a partial way, make it the most complete subject that was ever produced in the Type Press.' It should be added that the frontispiece is a fine chiaroscuro of four blocks, beautifully reproducing the British Museum bas-relief of a Bacchante. Savage obtained help in the illustrations from C. Nesbit, G. Thurston, R. Branston, W. Hughes, J. Lee, J. Martin, W. C. Walker, J. Byfield, J. Berryman, and H. White, in addition to the engravers already mentioned.

After the publication of this book Savage seems to have given no further practical expression to his ideas on colour-printing, though he still continued to prosecute his researches. In 1825 he was a candidate for a premium from the Society of Arts, and the *Transactions* state that 'the large silver medal and fifteen guineas were this session presented to Mr. Wm. Savage, Cowley-Street, Westminster, for his improvements in Block Printing in imitation of coloured drawings.' Savage's letter to the Society, dated 19th January

"COTTAGE AND LANDSCAPE." BY J. MARTIN AFTER J. VARLEY; PRINTED IN COLOURS
BY W. SAVAGE

FROM SAVAGE'S "PRACTICAL HINTS ON DECORATIVE PRINTING," 1822

1825, is practically a recapitulation of the contents of his book, indeed for the most part consists of extracts. The last paragraph in reference to his use of coloured inks should perhaps be quoted : 'In venturing before the Society of Arts as a candidate for a premium, I certainly advance no pretensions as an inventor ; but rest my expectations on having extended the application of the common printing press ; on having introduced additional colouring matters for printing ink ; and on having introduced a simple varnish (balsam of capivi), in its natural state, for the composition of these inks, that does not affect the colours and renders them perfectly easy in their management, nothing more being required than a stone and mullar. On my part this is a first attempt to open a path to raise printing to a higher scale than was before thought practicable—that of a closer imitation of works of art, and also of nature—which will, I trust, be carried to a far greater state of perfection, and thus enable the press to decorate its own productions with an elegance and splendour well suited to that art which bestows so many blessings on man.'

A subject to which Savage devoted special attention was the improvement of printing inks, which in his day were of a most inferior quality. His aim, in which he was ultimately successful, was to procure a printing ink without oil in its composition, and the result of his labours was embodied in a little book published in 1832 with the title, *Preparations in Printing Ink in Various Colours*. In 1841, two years before his death, he published a *Dictionary of the Art of Printing*, the compilation of which had occupied him for forty years.

The *Practical Hints on Decorative Printing* is now a rare book, and has the greater value in that it contains the only examples of Savage's work in colour-printing. Though the illustrations themselves in most cases compare unfavourably with later work executed on the

same lines, it must always be remembered that Savage was a pioneer, and that his experiments supplied the foundation on which Baxter, Edmund Evans, and other printers from wood-blocks have all built their work.

It is an additional recommendation of Savage's book that it has won a reference in the monumental work on wood-engraving by Mr. W. J. Linton, the greatest authority on the art of which he was so great a master. Mr. Linton does not as a rule concern himself at all with colour-printing, but at the close of a few remarks on chiaroscuro, he refers particularly to Savage's *Practical Hints on Decorative Printing*. He is not altogether satisfied with the colour-printing, which he is inclined to think too ambitious, but of the chiaroscuros he speaks with high praise. 'These are the finest, the most finished chiaroscuros from wood that I know ; admirable copies of the original drawings, tints efficiently arranged and most carefully printed, the engraver's part well done.'

CHAPTER V

GEORGE BAXTER

A NAME of no little importance in the history of colour illustration is that of George Baxter, whose process of colour-printing has been treated as somewhat of a mystery, and whose work has come to be honoured in booksellers' catalogues with the title of 'Baxter print' or 'Baxtertype.' Baxter's work possesses a certain rarity, which is the more extraordinary in that he is said to have published 300,000 copies of some of his prints. The importance attached to his name has been further enhanced by the cult of a Baxter Society at Birmingham, 'where his works, *cum notis variorum*, are talked about.' How far his work bears any claim to originality, or how far he has merited this distinction, is a matter for discussion. For many of my facts as to his life and work I am indebted to information kindly supplied by Mr. Charles F. Bullock, and to the excellent pamphlet on Baxter which he published in 1901.[1]

George Baxter was born in 1804 at Lewes, in Sussex, where his father was a well-known printer and publisher in the High Street. After leaving the High School of his native town, Baxter worked for a time under a wood-engraver in London. Returning to Lewes, he assisted in illustrating Horsfield's *History*

[1] *Life of George Baxter, Engraver, Artist, and Colour-Printer*, by C. F. Bullock. Birmingham, 1901.

C

33

of Lewes, published by his father, John Baxter. For the first volume, published in 1824, he executed several lithographs ; and the second volume, published in 1827, when he was twenty-three years old, was illustrated throughout with line engravings from his original drawings. In the same year he engraved the illustrations to *Select Sketches in Brighton*, another of his father's publications.

By this time ideas for colour-printing were floating in his mind, and returning to London he spent several years in wood-engraving and in maturing his schemes, but it was not until 1834 that his colour-prints were placed upon the market. The first notice in regard to his new process appears in Mudie's *Feathered Tribes of the British Isles* (1834), in the preface of which the publisher writes : ' I should mention that the vignettes on the title-pages are novelties, being the first successful specimens of what may be termed polychromatic printing, or printing in many colours from wooden blocks. By this method every shade of colour, every breadth of tint, every delicacy of hatching, and every degree of evanescence can be obtained. In these vignettes Mr. Baxter had no coloured copies but the birds, which are from nature. I made him work from mere scratches in outline, in order to test his metal, and I feel confident that the public will agree with me in thinking it sterling. In carrying this very beautiful branch of the Typographical Art successfully into effect Baxter has completed what was the last project of the great Bewick, but which that truly original and admirable genius did not live to accomplish.'

This book was followed by Mudie's *The Heavens*, *The Earth*, *The Air*, and *The Sea*, four duodecimo volumes, published in 1835. To 1835 also belongs Gandee's *The Artist*, the preface to which says : ' The frontispiece is a very successful specimen of a new Art. It is done by taking successive impressions from wood-

blocks, and when it is stated that no less than twelve are used in this instance, and consequently that each plate goes through the press twelve times, some idea may be formed of the ingenuity and skill required to consider so difficult a process.'

In 1835 Baxter applied for a patent, and in 1836 his productions, hitherto inscribed 'Printed in Oil Colours by Geo. Baxter, 29, King Square, London,' have the word 'Patentee' added. Before taking out this patent Baxter had worked solely by means of superimposed wood-blocks, entirely in the manner advocated by Savage, but now seems only to have used the wood-blocks for adding the colours to an impression from a steel or copper plate. It is interesting to note that just at this time Owen Jones was engaged in his first essays at producing a similar result by means of successive printings in chromo-lithography.

For Baxter's process it will be best to quote his own description, given in his specification for a patent, No. 6916 of 1835, entitled, 'Improvements in producing coloured steel plate, copper plate, and other impressions.' The specification begins with the usual formulary and rigmarole of 'To all to whom these presents shall come, I, George Baxter of Charterhouse Square, in the County of Middlesex, Engraver, send greeting'; and continues as follows :—

'My Invention consists in colouring impressions of steel and copper plate engravings, and lithographic and zincographic printing, by means of block printing, in place of colouring such impressions by hand, as heretofore practised, and which is an expensive process, and by such improvements producing coloured impressions of a high degree of perfection, and far superior in appearance to those which are coloured by hand, and such prints as are obtained by means of block printing in various colours uncombined with copper, steel, lithographic, or zincographic impressions. The process of printing landscapes, architectural, animal, and other decorative impressions,

35

by means of wooden blocks, being well known and in common use, it will not be necessary to enter very extensively into a description of that art, farther than to explain its application to the colouring of impressions of copper and steel plate and of lithographic and zincographic printing. In order to produce a number of ornamental prints resembling a highly coloured painting, whether in oil or water colours, according to my Invention, I proceed first to have the design engraved on a copper or steel plate, or on stone or zinc, as is well understood, observing, however, that I make several spots or points on the plate or stone from which the impressions are taken, in order to serve as register marks for the commencement of the register, which is most material in carrying out my Invention with correctness and effect. . . . Having possessed myself of an engraving of the subject which it is desired to have coloured to represent a highly finished oil or water colour painting, and having a copy of the painting before me which it is desired to produce an extensive series of imitations, and having determined on the number of colours and tints it will require, which is a matter of taste, at the same time depending on the nature of the painting which is to be copied; but this is the same as if the copies are to be produced merely by a succession of printings from a series of wooden blocks without having my improvement combined therewith—that of taking such printings on to impressions from steel or copper plates, or from stone or zinc, in order to colour the same, thereby producing coloured impressions having a high degree of finish. It will be found that by thus colouring such descriptions of impressions the result will be, that the prints produced will be more exquisite in their finish, more correct in their outline, and more soft and mellow in their appearance, for it will be found that successive colourings and tints of a series of blocks being received on copper or steel plate, or lithographic or zincographic impressions, more body and character will be given to the finished print than when the coloured print is the result of the same series of blocks taken on plain paper, which has been the practice heretofore. Having determined on the number of blocks which are to be used, I take an equal number of impressions on paper off the engraved plate, and successively place one face downwards on each block, and subject them respectively to the pressure of the press. By this means the blocks

will each have an impression of the engraving. I then proceed to mark out carefully the particular parts which are to be left in relief of each block, by colouring them in those parts, having the painting before me, by which I readily observe to what extent each colour is laid on the original picture, and the various shades to be produced, and by this means, when the blocks have been properly cut, I thus obtain a series of blocks suitable for the particular print which is to be produced ; but I would remark that such designing and cutting of the blocks form no part of my Invention, but are in common use. Having taken the number of impressions, whether of steel or copper plate, or of lithography or zincography, and having the necessary block in the press for the first colour, on the tympan there are four or other number of fine points to receive the impression which is to be coloured by a series of blocks, the fine points receiving each engraving, and on each tympan there are a number of points which are caused to strike through the paper in pulling the first printing of colour, and the point holes thus produced are those which are used for the purpose of securing a correct register in all the future impressions from the wooden blocks.' (Here follows a detailed reference to his annexed illustrations, which show one of his plates printed with seventeen colour blocks on a steel plate impression, another printed by the old plan of block-printing alone, and another with the colour-printing on a lithographic impression.) ' I would observe, that throughout the description I have spoken of the blocks for printing the colours as being of wood ; but it will be evident that metal blocks, being engraved in relief, in like manner to wood, would answer a similar purpose. Having thus described the nature of my invention, and the manner of carrying the same into effect, I would remark that I am aware that many years ago some attempts were made to tint copper-plate impressions, called claro obscuro, which consisted in giving additional tints of the same or nearly the same colour. I do not therefore lay any claim to such tinting. But what I claim as my improvement consists in colouring the impressions from steel or copper plates, or from lithographic stones or from zinc, by means of block printing as described.'

In 1849 (Pat. No. 12,753, Aug. 30) an extension of five years of Letters Patent was granted to Baxter. It

is interesting to note that on the occasion of this extension, the Committee of the Privy Council called on David Roberts, R.A., to give evidence as to the actual value of one of Baxter's shilling prints. The artist replied that he considered it 'worth half a guinea,' and that there was 'nothing known that equalled the Patentee's invention in Colour Printing.' In delivering judgment on the same occasion, the Right Hon. Lord Brougham, Chairman of the Judicial Committee, laid considerable stress on the public utility of Baxter's invention. 'Their Lordships,' he stated, 'are also of opinion that the invention is of public utility, because whatever makes good prints almost pictures, prints almost of the merits of paintings or drawings, is of great utility to the public in every respect.'[1]

A careful examination of the detailed specification above shows that Baxter had no genuine claim to a patent for any invention. In the use of a succession of colour impressions from wood-blocks he had been anticipated by Jackson and Savage. What he claims as the original part of his process, namely the use of a metal plate for the first impression, followed by a succession of wood-blocks, had been invented by German engravers of the sixteenth century, as shown in the work of Goltzius. Kirkall also had employed a mezzotint plate before applying colours from wood, and though Baxter's first plate was aquatint as a rule, the principle is not affected. Besides this, the work of Pond and Knapton, in its application of wooden blocks carrying tints to an impression from a metal plate, was essentially the same. The very first sentence of his patent proves that he was absolutely ignorant of the colour-printing of Janinet and Debucourt. It will be noticed that he makes no claim of invention for his use of oil colours, though there is no doubt that in this respect he made notable improvements. There is no

[1] See Baxter's preface to his *Pictorial Key to the Great Exhibition*, 1851.

38

doubt also that in his regular use of twenty or thirty blocks for each print he carried the art of colour-printing to an elaboration it had never before reached. The fact remains that his work is not really unique, that he was not an inventor or pioneer, though he did important work in widening and improving the tracks laid down by his predecessors.

Those who are interested in Baxter's prints will find a large collection of proofs of his work in the Print Room at the British Museum. These illustrate clearly his method as he describes it in the *Pictorial Album, or Cabinet of Painting.*—'The first faint impression forming a ground is from a steel plate ; and above this ground, which is usually a neutral tint, the positive colours are impressed from as many wood-blocks as there are distinct tints in the picture. Some idea of the difficulty of Picture-Printing may be conceived when the reader is informed that, as each tint has to be communicated by a separate impression, some of the subjects have required not less than *twenty* blocks ; and that even the most simple in point of colour have required not less than *ten*. The very tint of the paper upon which each imitative painting appears to be mounted, is communicated from a smooth plate of copper, which receives the colour and is printed in the same manner as a wood-block.' This first metal plate will be found to be usually aquatint, with occasionally some stipple engraving, and frequently some roulette work. In the British Museum is a print from wood-blocks, 'Butterflies,' said by his daughter to have been his first print in oil colours. Other proofs show instances of the same plate being treated with different colours, and many bear rows of pin-pricks in the margin, showing the method of registration. The print of 'Me Warm Now' shows the first printing from the metal, entirely in red, which may be presumed to be the prevalent tone that Baxter wanted to obtain

before imposing his wood-blocks ; and in the same way the 'Belle of the Village' has a first printed state, entirely in blue, from an aquatint plate. It should be said that Baxter's book illustrations, with a few exceptions, are by no means equal to his separately published prints.

After taking out his patent, Baxter published in 1836, together with his father at Lewes, the *Horticultural Gleaner*, which has a frontispiece and title-page in colours. Coming to London, he had an office for two years at 3 Charterhouse Square, and then moved to larger premises at 11 Northampton Square, where, in 1837, he issued *The Pictorial Album, or Cabinet of Paintings*, with eleven prints, one of his best illustrated works. The volume is also noteworthy for its interesting, though inadequate, history of colour-printing, containing the special reference to Baxter's own work, quoted above. A second edition was issued, in which the substitution of a few extra figures in the plate entitled 'Boa Ghaut' forms the only difference. Becoming interested in mission work about 1840, he illustrated several of the missionary publications of the Religious Tract Society. In 1842 he executed the illustrations for Sir N. H. Nicolas's *History of the Orders of Knighthood*, a book now in considerable demand. The illustrations are said to be by 'G. Baxter, Patentee,' but some are lithographic plates by Madeley, showing the full robes of various orders, in which it seems extremely doubtful whether any colour at all is actually printed. In fact, practically all of the plates, besides being printed in colour, are much painted over by hand, which is unusual in the case of Baxter's prints.

In 1849 Baxter commenced granting licences to other printers, at a fee of two hundred guineas, for the use of his patent. Among the many who availed themselves of this privilege the principal was Abraham Le

Blond, who engaged Baxter's manager and produced some excellent work. Another firm which paid the fee for using the Baxter process was Messrs. Bradshaw and Blacklock. A curious link between past and present is formed by the fact that Mr. Frederick Shields—whose noble work, particularly the frescoes in the Chapel of the Resurrection (near the Marble Arch), has hardly yet won the full recognition it deserves—worked as apprentice to this firm at designs to be printed in the Baxter manner. In a scrap of autobiography, written many years ago,[1] he refers to his early struggles as an artist at Newton-le-Willows, where he had been drawing portraits at seven shillings each. 'The mine of the little town,' he says, 'grew exhausted, and at this juncture old Bradshaw, the Quaker partner in the Railway Guide printing firm, sent for me, and said, "Dost thou think thyself able to design for Baxter's Patent Oil Printing Process?" Modestly, but confidently, I replied, "Yes." "What wages wilt thou require?" Seven shillings a week I had received at bobbin tickets, and I dared to ask ten shillings for the elevated post of designer, and returned to my old shop in honour. The despised became a head, with a little room to himself where no defilement of bobbin tickets ever entered; and I revelled in gleaners and milk-maids and rustic lovers, and a box of colours for the first time.'

To return to Baxter: he seems to have contributed no illustrations to books after 1849, with the exception of a portrait in Waterhouse's *Vah-ta-ah, the Feejeean Princess* (1857). In 1851, however, he produced a little book, which is now of considerable rarity—*Baxter's Pictorial Key to the Great Exhibition, and Visitor's Guide to London.* In this there are two coloured plates, one showing the Crystal Palace and grounds,

[1] See *The Atlantic Monthly*, October 1882—'An English Interpreter,' by H. E. Scudder.

the other a really fine view of the Houses of Parliament from the river, obviously done under the influence of Turner. It may be added that in the Fine Arts Court of the Crystal Palace more than sixty specimens of Baxter's work were exhibited, consisting of historical and architectural subjects, landscapes, portraits, and flowers. 'Such was the demand,' we are told, 'for some of these gems, that it has been requisite to reproduce them, the sale of some having exceeded four hundred thousand'!

During all this period, however, Baxter's main work was not book-illustration, but the production of a series of separate plates. These won the notice of the Royal Family, and attained considerable popularity, as indeed is shown by Baxter's account of the quantity sold. They are of no little merit, though many of them—the pictures of the Great Exhibition, for instance, showing the statuary and exhibits in general—smack somewhat in sentiment and execution of the 'early Victorian' period to which they belong. These plates hardly concern our present purpose, but among the most important may be mentioned 'The Coronation,' 'The Opening of the First Parliament,' and 'The Wreck.' The last is a remarkable piece of colour-printing.

Baxter, who was now at the end of a busy and useful career, decided, in 1860, to retire from business. A sale was advertised in May 1860 to dispose of his stock of prints. The invitation card says that 'upwards of 100,000 of these beautiful productions will be Sold by Auction . . . in consequence of the Inventor and Patentee retiring from his Artistic Labours.' The sale, however, did not take place, and the whole stock, blocks as well as prints, passed by private arrangement into the hands of Mr. Vincent Brooks, who only issued a few plates. Baxter, after assisting Brooks for a time, seems to have led a secluded life at Sydenham, where he died on January 11, 1867. The plant, which had

been bought by Brooks, then passed into the possession of Abraham Le Blond, a fine colour-printer. Le Blond issued a large number of prints, many of them difficult to distinguish from Baxter's originals, but without any commercial success. On his death in 1896, the whole of Baxter's remaining plates were sold at Birmingham, and dispersed throughout the country.[1]

[1] A bibliography of books with colour-illustrations by Baxter is given in Appendix I.

CHAPTER VI

JACOB CHRISTOPH LE BLON

S O far our attention has been confined to books
illustrated by means of printing from wood-
blocks, following a definite line of development
from the two or three blocks used by the early German
chiaroscurists to the thirty employed by George Baxter.
In certain instances it has been pointed out that a
metal plate was employed in conjunction with the
wood, but that its purpose was entirely subservient.
It must not, however, be forgotten that during all this
period colour-printing from metal plates enjoyed a
separate existence, and the time has now come to
retrace our steps and consider printing from metal as
a separate and distinct development. The main differ-
ence is that the design on a wood-block is in relief, that
on a metal plate in intaglio. On the wood-block the
lines or spaces that constitute the design, and are
intended to hold the ink or colour, are left standing in
relief, while all the spaces that are to appear white in
the picture are cut away, as is the case with the type in
a printed book. In the metal plate the lines and spaces
that hold the ink or colour are normally sunk below
the surface. The ink is wiped away from the surface
of the plate, and allowed to remain only in the incised,
sunk, or roughened parts. The print from the actual
surface remains white, and is therefore diametrically
opposite in principle to an impression from a wood-
block. The fact that a mezzotint plate begins by print-

44

ing a dead black makes it an apparent exception, but the gradual removal of the burr in the working reveals it as an intaglio print with the ink coming not from the surface, as with the wood-block, but from the incised dots and lines. A real exception is Blake's method of etching metal in relief, a unique process which has been described above. In modern times confusion has been caused by the substitution of metal for wood, and *vice versa*, particularly in the printing of wall-papers and posters; but for all older work the fact holds good that, for the purposes of printing, the engraved wood-block is in relief, the metal plate in intaglio.

There are two methods of printing in colours from a copper plate. The one is to ink the plate all over at once with the required colours. This practically amounts to painting the plate, remembering that the colour has to be forced into the lines and bitings. It stands to reason that this method is laborious as well as difficult, for the printer has to see that in colouring one part of the plate he does not encroach on lines that should contain a different colour. It is therefore extremely difficult to obtain entirely satisfactory results from the printing alone, and almost all colour-prints produced in this manner require to be finished with colour applied by hand. The natural result is that no two prints executed in this manner from a single plate are ever exactly alike. Except in the inking, colour-prints of this kind involve no new process, the plate being etched, stippled, or mezzotinted in the ordinary manner. Of almost every one-plate colour-print proofs have been printed in black before the issue of the coloured impressions; indeed, as in the case of mezzotints, a better colour result is obtained when the plate is somewhat worn. Besides its use with mezzotint, for examples of which one may point to the prints of J. R. Smith and W. Ward, now so justly appreciated, colour-printing with one plate has been most

45

successful when applied to stipple engraving—witness the charming plates after Bartolozzi, Ryland, and others. In the following chapter some books containing mezzo-tint and stipple illustrations executed in this manner will be described; and of colour-printing from a single aquatint plate something will be said later, when we come to the aquatint books of the early nineteenth century.

The second method of colour-printing from metal is to employ a separate plate for each distinct colour, and to print such plates consecutively one upon the other, as is the case with all colour-printing from wood-blocks. The registering and damping of the sheets of paper are again important matters, and the methods used to obtain exactness are the same as those employed by Savage and Baxter for their wood-blocks. This second method is far easier in that it is more mechanical than the other, for each plate requires the application of one colour only, which any intelligent printer can undertake; whereas by the first method the colouring of the plate requires the hand of an artist. The use of several copper plates for the transmission of colour to a single print finds almost its sole use for book-illustration in Le Blon's *Colorito*, an important work of which mention will shortly be made. Though not coming within the sphere of book-illustration, the splendid colour work done in aquatint by Alix, Janinet, and Debucourt is remarkable for the use of seven, eight, or even more plates, employed one after the other to convey the required colouring. In the Print Room at the British Museum are several proofs of the work of these three engravers, admirably showing the system of registration by means of pin-pricks all round the paper. In addition to this interest of technique these particular prints have a wonderful fascination in their subjects, especially those chosen from the *beau monde* of Paris of about 1800, the gay throng of fashionable ladies and

46

gentlemen who jostled one another in the arcades and gardens of the Palais Royal.

The earliest attempt to print in colour after the work of the sixteenth century chiaroscurists seems to have been made by Hercules Seghers, a Dutch etcher of the first half of the seventeenth century. His method is said to have consisted in the application of colour without shadows to paper or canvas, on the top of which he printed from an etched plate. He is also credited with the invention of aquatint, but his work is so tentative and experimental that it can hardly be classed as true colour-printing. Another early experimentalist was Johannes Teyler, who worked in the first method described, by painting or inking his copper plate all over at once. Somewhere about 1670 he published at Amsterdam a book, of which only one copy seems to be known, with prints of birds, animals, flowers, landscapes, and architectural subjects, all delicately printed in colours;[1] and while Mathematical Professor of the Military College at Nymegen, his native town, he established on the premises a factory for producing prints in colours, not only engravings, but wall-hangings of linen or fabric as well.

Round these earlier colour-printers from metal there lies a mist of uncertainty and romance, but with Le Blon daylight begins, facts take shape, and colour-printing from metal assumes a clear reality. Jacob Christoph Le Blon, son of a bookseller, was baptized on the 23rd of May 1667 at Frankfort-on-the-Main.[2] After studying art under Konrad Meyer at Zurich, he travelled in 1686 in the suite of the Comte de Martinitz

[1] *Teilleri J. Batavi, Chalcographi ingeniosissimi, opus Typochromaticum, i.e. Typi aenei omni colorum genere impressi, et ab eo ipso primum inventi.* See Graesse, J. G. T., *Trésor de livres rares et précieux.* Supplement, 1869.

[2] For Le Blon's biography see Laborde, L. de, *Histoire de la gravure en manière noire,* 1839; Gwinner, F., *Kunst und Künstler in Frankfurt am Main,* 1862; and Singer, Dr. Hans W., *Jacob Christoffel Le Blon and his Three-Colour Prints,* in *The Studio,* May 1903.

to Rome, where he worked in the studio of Carlo Maratti, and also developed a talent for the painting of miniatures. Le Blon's reckless, Bohemian nature, his unsettled principles, and his lack of perseverance, promised to bring him to little good, but at this juncture he was persuaded by his friend Overbeck, who was eager for his reform and anxious that his genuine talents should not be wasted, to accompany him to Holland. Under Overbeck's guidance he practised for a time with some success as a miniature painter, and when his eyesight began to fail took to painting cabinet portraits in oil.

To his want of perseverance, that led him always to seek some new thing, and to his idleness, that made him persistent in the search for some cheap and easy way of multiplying pictures, we owe his invention of colour-printing from metal. While living in Amsterdam he was much impressed by Newton's theory of light, which reduced all colours to three, counting black as the absence of all colours and white as the combination of all. Dealing on this basis with pigment colours, yellow, blue, and red, Le Blon tried to apply the theory to colour-printing. His theory and the valuable results of its practice appeal the more to our interest as being the anticipation, two centuries ago, of the latest developments of science in regard to the 'three-colour' process of photo-mechanical printing.

Le Blon's first experiments were made at Amsterdam and at the Hague. At both of these places and in Paris, though his portrait of General Salisch and his pictures of a nymph won much admiration, he was unsuccessful in obtaining the monetary support that he needed—his idea being always to form a company for the production and sale of his picture prints. In 1719 he came to London, and, thanks to his persuasive powers, managed to win the interest of several art-lovers, notably Colonel Sir John Guise and Lord

Perceval. Under their advice he took out a patent (No. 423 of 1719), but as it seems to have been unnecessary in those days to put in any specification of the details of an invention, the sole interest of the document lies in the preamble, incorporating what appears to be the broken English of Le Blon's original title.

'George by the grace of God, etc., to all to whom these Presents shall come, greeting.

'Whereas James Christopher Le Blon hath by his petition humbly represented unto us that he hath by his great labour and expence found out and invented "A New Method of Multiplying of Pictures and Draughts by a Natural Colleris with Impression," which hath never yet been used or invented by any person, and as this is entirely new and meets a general approbation, as well for its ingenuity as the great benefit and advantage that will accrew to the publick; thereby the petitioner hath humbly prayed us as a reward and encouragement for his great labour and expence in finding out and bringing the same to pfecõn, to grant him our Royal Letters Patent for the term of fourteen yeares, for the sole carrying on his said Invencõn as the law allows in such cases; wee being willing to give encouragement to all arts and Inventions that may be of publick use and benefit, are gratiously pleased to gratifie him his request.'

So it runs for more than two pages of legal verbiage, with vain repetition of 'executors, administrators, and assignes,' having 'the sole use and exercise of the aforesaid Invention.' Not of much value, but still there it stands, recorded in the chronicles of the Great Seal Patent Office, and it makes Le Blon real.

Armed with this patent, and fortified by the assistance of his influential friends, Le Blon promoted a company with considerable capital. Portraits of George I. and Prince Frederick were published, followed by life-sized reproductions of paintings by the old masters at Kensington Palace and elsewhere, and shares rose

D

from £10 to £25. The returns, however, were by no means sufficient to meet the necessary outlay, and general mismanagement, coupled with Le Blon's personal extravagance, soon involved the 'Picture Office,' as it was called, in bankruptcy. It was about this time, in 1722 to wit, that Le Blon, perhaps as a last despairing effort, published the book that brings him into our notice, the book in which, for the first time, he reveals the secret of his process. The title is *Colorito. L'harmonie du coloris dans la peinture, reduite en pratique mecanique et à des régles sures et faciles: avec des figures en couleur, pour en faciliter l'intelligence, non seulement aux peintres, mais à tous ceux qui aiment la peinture. Par J. C. Le Blon.*[1]

The book, published in London in 1722, is undated and is written in English and French; but as the English is obviously a laboured translation by Le Blon of the French, which came more naturally to his pen, quotation shall be made, where needed, from the latter language—slipshod and lacking in accents, but better than the doggerel English. In his dedication to Robert Walpole, Chancellor of the Exchequer, he writes :—

'C'est en cherchant cet Art (*i.e.* l'Harmonie des Couleurs) que par occasion j'ai trouvé l'Invention d'imprimer les objects avec leurs Couleurs naturelles, pour laquelle Sa Majesté a bien voulu m' accorder ses Lettres Patentes : les pieces faites sou ma direction (car je ne suis pas responsable des autres ;) & imprimés en presence & sous les Yeux des plusieurs Persones de Qualité et de bon gout se recommendent elles mêmes. Cette Invention est approuvée des Nations les plus eclairées en Europe, d'autant plus qu'on l'avoit regardée comme impossible ; & les Representations Anatomiques, auxquelles je travaille actuellement sous la direction de Mons.

[1] Reprinted at Paris in 1756, edited by G. de Mont d'Orge, Le Blon's pupil, with the title *L'art d'imprimer les tableaux. Traité d'après les Ecrits, les Opérations, et les Instructions verbales, de J. C. Le Blon.*

A PLATE FROM THE "COLORITO." BY J. C. LE BLON, 1722
ILLUSTRATING THE FINAL PRINTING IN LE BLON'S PROCESS

THE THREE-COLOUR THEORY

St. André, Anatomiste and Chirurgien du Roy, confirmeront l'utilite de cette sorte d'imprimerie. C'est cette meme Invention qui dans la suite m'a tracé la route des Sciences Theoretiques, sans lesquelles je n'aurois pas pu reduire l'Harmonie du Coloris en Practique mecanique et à des Regles ; Je Soumets aujourdhui mon Systeme au Jugement des savans.'

His theory, fully developed in his book, is summed up in the following paragraph :—

'La Peinture peut representer tous les Objets visibles avec trois Couleurs, savoir le *Jaune*, le *Rouge*, & le *Bleu* ; car toutes les autres Couleurs se peuvent composer de ces trois, que je nomme *Couleurs primitives*. Par exemple, le Jaune et le Rouge font l'Orangé. Le Rouge et le Bleu font le Pourpre & le Violet. Le Bleu & le Jaune font le Verd. Et le mélange de ces trois Couleurs primitives ensemble produit le Noir et toutes les autres Couleurs ; comme je l'ai fait voir dans le Pratique de mon Invention d'imprimer tous les Objets avec leurs Couleurs naturelles. Je ne parle ici que des *Couleurs materielles*, c'est à dire, des Couleurs dont se servent les Peintres ; car le mélange de toutes les Couleurs primitives impalpables, ne produit pas le *Noir*, mais precisément le contraire, c'est à dire, le *Blanc* ; comme l'a démontré l'incomparable Mons. le Chevalier Newton dans son Optique.'

Working on this principle, Le Blon resolved each portion of the picture he intended to reproduce into its component parts of red, yellow, and blue, making a mezzotint plate for each colour. White was produced by leaving the paper untouched by colour ; black by the super-printing of all three plates. It must be noted, therefore, that Le Blon's prints are entirely different from the coloured mezzotint of our English engravers, where the colours were all applied to a single plate before printing. Le Blon's three plates were superimposed with careful registration, and the colours blended to produce the complex result attained by the 'three-colour' prints of to-day. This book, con-

51

taining the theory, is important because it is illustrated by five colour plates, one of them representing a palette (the colours on which, being painted by hand, have oxidised in existing copies), the others showing the gradual colouring of a girl's head and bust, starting from the plain mezzotint plate.

Though this is the only illustrated book with which Le Blon is connected, the life and work of its author are of the highest importance in connection with the history of colour-printing. By no means disheartened by the failure of the Picture Office, Le Blon found a new field for his versatile genius in the promotion of another company to work a tapestry factory at Mulberry Ground, Chelsea. In 1727 he took out another patent for 'The Art of Weaving Tapestry in the Loom,' and in 1731 his inventions, both of printing and weaving, were brought to the notice of the Royal Society, whose secretary, Cromwell Mortimer, reported on them at length.[1] He summarises clearly the salient points of Le Blon's process of colour-printing :—

'This Art of Printing consists in Six Articles, viz. :—
 I. To produce any Object with three Colours, and three Plates.
 II. To make the *Drawings* on each of the three Plates, so that they may exactly tally.
 III. To engrave the three Plates, so that they cannot fail to agree.
 IV. To engrave the three Plates in an uncommon way, so that they may produce 3000 and more good Prints.
 V. To find the three true *primitive material Colours*, and to prepare them, so that they may be imprimable, durable, and beautiful.
 VI. To print the three Plates, so as that they may agree perfectly in the Impression.
The *first* of which is the most considerable, comprehending

[1] See *Philosophical Transactions*, vol. xxxvii., 1731-32.

the *Theoretical* Part of the Invention ; and the other five are subservient, to bring it into *mechanical* Practice, and of such Importance, that if any one of them be wanting, nothing can be executed with Success or Exactness. Sometimes more than the *three Plates* may be employ'd ; viz. when Beauty, Cheapness, and Expedition require it.'

The new company came also to grief, and Le Blon fled to Holland in 1732. At the Hague and at Paris, where he was again granted letters patent (12th November 1737), he enjoyed a measure of success and tranquillity, but is said to have been in poverty when he died on 16th May 1741. His character was well summed up by Horace Walpole : ' He was . . . very far from young when I knew him, but of surprising vivacity and volubility, and with a head admirably mechanic, but an universal projector, and . . . either a dupe or a cheat. I think the former ; though, as most of his projects ended in the air, the sufferers believed the latter. As he was much of an enthusiast, perhaps, like most enthusiasts, he was both one and the other.'

As is the case with Baxter, it is unfair to estimate the work of Le Blon by a study of these book-illustrations only. Besides them he produced some fifty large prints, valuable not only on account of their exceeding scarcity, but for their intrinsic merit. In them he renders his subject in broad masses of harmonious colour, and there is no doubt that, setting aside his theory, he worked with an additional plate, and also added touches with a brush. However produced, they are among the wonders of colour-printing.

CHAPTER VII

THE GOLDEN AGE OF MEZZOTINT AND STIPPLE

THE history of colour-printing from metal after the time of Le Blon becomes rich in interest, for the last half of the eighteenth century is the golden age of coloured mezzotint and stipple. It was a remarkable period in English art, both of portraiture and landscape. Reynolds and Gainsborough, Romney and Hoppner, were painting portraits that have made our English school the envy of the world. Gainsborough and Morland were throwing off the fetters of the classical convention, and showing the pure beauty of natural landscape and simple rural life. In landscape and in portraiture alike, genius was being substituted for tradition. These great painters, however, owe no little of their immortality to the great mezzotint engravers—J. R. Smith, Earlom, Val. Green, the Wards, and others—who followed in their train. Along with these were working the stipple engravers of the Bartolozzi school—Ryland, Burke, Caroline Watson and the rest. To them are due the fascinating miniature-like portraits and figure subjects that illustrate the history of the Georgian era, with its subtle Court intrigues and political imbroglios. Mrs. Clarke, the impudent mistress of princes; Mrs. Robinson, the famous 'Perdita,' who ensnared 'Florizel'; the Duchess of Devonshire, Miss Farren, the Linleys—a whole galaxy of beauties, some frail, some fickle, but all fair—still

54

smile for us from the colour-prints of more than a century ago. It is no wonder that the mellowed glories of coloured mezzotints and the dainty charms of coloured stipple are so strong a lure to the collector of to-day.

It was the common practice among publishers of this period to issue mezzotint and stipple engravings in colour as well as plain. It makes one's mouth water to read a contemporary list of two hundred engravings after Morland 'to be had on applying to James Cundee, Ivy-Lane, Paternoster Row.' Their prices range from half a crown to a guinea, though the latter price is rare, fifteen shillings being a fair average ; 'proofs and coloured prints always charged double.' Imagine coloured proofs of the whole *Letitia* series for £4, 10s., of *Delia in Town* and *Delia in the Country* for thirty shillings, of the *Ale-House Door* for fifteen ! The history, however, of these prints, fascinating though it be, is somewhat alien to our present subject, for coloured mezzotint and stipple, probably owing to their expense, were only sparingly employed in the illustration of books.

A few facts, however, that bear directly or indirectly on colour - illustration, should perhaps be placed on record. First of all, it is of interest to note the further progress of Le Blon's process. Among his pupils in Paris was Gautier Dagoty, who shortly after Le Blon's death represented to the State that he was prepared to carry the principles of Le Blon's process to a still higher degree of perfection, and was granted a patent for a term of three years by order of the Council at Versailles, September 5, 1741. In 1745 and 1748 he was illustrating anatomical subjects, and in 1749 issued a pamphlet entitled *Lettre concernant le nouvel art d'imprimer les tableaux avec quatre couleurs*. Gautier is eager to disprove the idea that he had learned his methods from Le Blon, and in his

55

Observations sur la Peinture, published in 1753, boldly claims the invention as his own—'L'Art d'imprimer les Tableaux sous Presse, dont je suis l'Inventeur, n'est point un jeu Machinal, où les Peintres ne peuvent rien comprendre; c'est au contraire une nouvelle façon de peindre sans Pinceau et sans Couleurs, avec le Burin seulement, et sur quatre Cuivres.' Gautier seems to protest too much, and when all is said and done, his laboured explanation shows little difference between his four-plate system and that of Le Blon. That his process roused interest in England is shown by a notice in *The Public Advertiser* of November 21, 1767.—'Yesterday arrived a Mail from France. At Versailles on the 17th of this Month, a coloured Print of the King, engraved on Copper, was worked off in his Majesty's Presence, by M. Gautier Dagoty, assisted by one of his Sons. The Work was compleated in six Minutes, and the Picture came out finished with all its Colours.'

So little has been written of colour-printing, that three more points, a little off the beaten track, may well be noted. One is that one of the early experimentalists was Captain William Baillie, well known for his etched imitations of Rembrandt. In the catalogue of the tenth exhibition of the Royal Incorporated Society of Artists, in 1769, No. 319 is 'A print in imitation of a drawing, printed in colours, from different plates, after Rembrandt.' This is interesting, because 1769 is an early date for coloured stipple. Captain Baillie's existing works in this method, such as his portrait of the Duke of Buckingham, after Van Dyck, and his 'Woman's Head,' after G. Dow, belong to a later date. The second point is that in 1776 Robert Laurie, of Johnson's Court, Fleet Street, received from the Society of Arts a premium of thirty guineas for his proposed method of printing in colours. After mezzotinting his plate, he warmed it, and applied

56

colours by means of stump camel-hair pencils. The plate was then wiped with a coarse gauze canvas, or with the hand, and passed through the press. The process appears from his description to be identical with that employed by Smith, Ward, and the later masters of colour-printing in mezzotint. Laurie's main idea at the time of his appearance before the Society of Arts seems to have been to illustrate books of natural history with pictures of animals, plants, and so on. A third point of interest is to be found in a trade-card in the British Museum collection, dated 1784, to which Mr. Whitman has kindly drawn my attention. On it is a stipple engraving in colour, picturing two cherubs, who support a plaque bearing the inscription—'Gamble, Print-Seller and Inventor of Printing in Colours, Pall Mall, London.' Though all three men must have had considerable influence in their day, remarkably little is known of their colour-work.

To go back now for a few years, one of the first after Le Blon to practise intaglio printing in colours was a Dutch amateur named Ploos van Amstel, born at Amsterdam in 1726. Originally he was a merchant, but having a strong inclination towards art retired from business and devoted himself to engraving, while his ample means enabled him to form a large and important collection of prints and drawings, which, after his death, fetched by auction at Amsterdam 109,406 florins. His engraving was of an experimental nature, and the mixed methods of his complicated process have always been a puzzle to the student of prints.[1] Even in his own day their originality caused some doubt and perplexity, and to silence suspicions Ploos van Amstel invited to his studio on 8th October 1768 a commission, which included the Mayor of Amsterdam, to initiate them into the mysteries of his process. Their testimony was 'that his figures were neither engraved

[1] See Singer and Strang, *Etching, Engraving*, etc., p. 120.

by means of the burin, nor etched with a point, nor hammered with a puncheon on to the copper, but that they were rather produced by means of certain "ground"-varnishes, powders, and liquids ; that he by no means coloured the prints by hand, but printed them entirely, and not with water-colours but with oil-colours.' This testimony is interesting as a historical document, but the fact remains that either the members of the commission were somehow hoodwinked by the engraver, or else the veracity of those days was not so rigid as might have been, for in existing prints by Ploos van Amstel there is sufficient evidence that all the colours were not printed, and in many of them hand-work is undoubtedly plain to see.

Now Ploos van Amstel forms an important link in our chain of events, for he is indirectly the author of a valuable work with coloured illustrations, published in London in 1821. In 1765 he had issued forty-six facsimile engravings of drawings by the Dutch masters. These had met with deserved success, and his design was to continue the series in conjunction with his young relation, Christian Josi, who had come to London with a travelling studentship from the Art institute of Utrecht, and worked under John Raphael Smith from 1791 to 1796. Owing to the death of Ploos in 1798 the scheme was never put into execution, but his stock, nevertheless, passed into Josi's hands. The latter worked for a time as an engraver, but owing to failing health ceased all active practice, and being a great traveller and collector, devoted himself to a kind of aristocratic art dealing, of a type not unfamiliar at the present day. Being a connoisseur of considerable honour in his own country, he was one of the commissioners appointed by the King of Holland to reclaim from Paris the objects of art removed by Napoleon in 1810. He had long conceived the project of continuing Ploos van Amstel's work, but was hindered for many

years by the unsettled state of his country, and again by this journey to Paris. In 1819, however, he removed with his family to London, and there devoted himself to the publication of his *Collection d'Imitations de Dessins d'après les principaux Maîtres Hollandais et Flamands, commencée par C. Ploos van Amstel, continuée et portée au nombre de Cent Morceaux . . . par C. Josi. A Amsterdam et à Londres, chez C. Josi, 42, Gerrard Street, Soho Square.* The book contains biographical notices of all the artists whose work is represented, both these and the preface being written in French, as the language most generally understood. The preface itself, instinct with all the enthusiasm of a connoisseur, is none the worse for its frank egotism. Interesting, too, at the present day, are the personal reminiscences of a keen and cultured collector of a hundred years since, his gossip of sale-room and studio, his notes and comments on prints and prices, his tales of his own triumphs, his story of how, amid the disasters that afflicted their native land of Holland, a little band of collectors met night by night to forget their national sorrow in the joy of turning over and discussing their portfolios of drawings. Notable, as showing the popularity of prints by J. R. Smith and his school, on the Continent as well as at home, is the anecdote Josi relates of the wholesale forgery of English colour-prints in Holland, and of his inability to sell his own work till he added a title and inscription in English! 'Rien n'était comparable aux estampes anglaises. Tel mérite que pouvaient avoir d'autres, il suffisait, pour leur disgrâce, qu'elles ne portassent pas des titres et des inscriptions en anglais, avec le nom du marchand éditeur à Londres.'

The number of plates amounts to one hundred and fifty, most of them being in imitation of chalk or wash drawings in monotone, but many are coloured facsimiles of crayon or water-colour drawings. Aquatint

is the prevalent process, though other methods are freely employed, and much of the colouring is conveyed by hand with the brush. The reproductions in stipple of drawings executed in two or three crayons are remarkable, particularly fine being the 'Portrait of Rembrandt.' This was engraved by C. Josi himself, who says he was unable to trust the execution of the two or three necessary plates to any engraver he knew ; and though he had long relinquished the practice of engraving, his cunning seems by no means to have deserted him. Among the other engravers employed on the work were Cootwyck—a goldsmith by profession and a personal friend of Ploos—Kornlein, Schroeder, J. de Bruyn, and Ditrich, with one print after a Rembrandt landscape by an Englishman, C. C. (? F. C.) Lewis. The edition was limited to a hundred copies for France and a hundred for England, the price being forty guineas to subscribers, fifty to non-subscribers, so that the high prices of *éditions de luxe* of some modern art publications are by no means without a precedent. Though he had the utmost difficulty in disposing even of these two hundred copies, Josi had a firm belief in the ultimate success of his work—a belief that should shortly find fulfilment, for the book is extremely rare. 'Je me plais donc à espérer,' he writes, 'et c'est dans la nature des choses, que cet ouvrage, devenant de plus en plus rare, doit devenir plus recherché, et qu' alors le prix de quarante guinées doit progressivement augmenter.' It may be added that Josi died in 1828, and his collection of prints and drawings—many of them the originals of these illustrations [1]—was dispersed in 1829 at Christie's in a ten days' sale, bringing over £2400; while the surplus was sold at Christie's in 1830 for £617.

[1] One of these, a canal scene by Van der Neer, bearing the collectors' marks of Baron de Leyde, Josi, and W. Esdaile, is in the National Art Library.

A PROTESTANT CHURCH IN THE LOW COUNTRIES. AFTER PIETER SAENREDAM

FROM THE "COLLECTION D'IMITATIONS DE DESSINS" BY C. JOSI, 1819

REPRODUCTIONS OF DRAWINGS

Josi's book has been mentioned first, because in its origin it dates back to Ploos van Amstel, but it stands by no means alone. The latter part of the eighteenth and the beginning of the nineteenth century was a great period for private collections of prints and drawings— it will be sufficient to mention those of Sir Joshua Reynolds, Benjamin West, Richardson, Esdaile, Ottley, Udny, and Sir Thomas Lawrence. The interest taken in the prints and drawings of the old masters had caused a demand for several handsome volumes of reproductions before Josi published his *Collection d'Imitations de Dessins.* Foremost among these is *A Collection of Prints in Imitation of Drawings . . . with explanatory and critical notes by C. Rogers*, printed by J. Nichols and published by Boydell and others in 1778. It is in two volumes, and contains one hundred and fifteen engravings on one hundred and seven plates, including two frontispieces, and a charming mezzotint portrait of Rogers by Ryland, printed in a rich brown. The plates are etched, stippled, or mezzotinted, and are printed in inks of widely different colours, as a rule only one colour to each plate. They show that metal plates can reproduce the chiaroscuro drawings of the old masters no less than wood-blocks. The two frontispieces are in stipple by Bartolozzi, printed in red, and other plates are by J. Deacon, W. Hebert, S. Watts, and J. Basire. The rest, however, are all by Ryland, in etching or in red stipple, with the exception of a few plates, printed in more than one colour, by Simeon Watts. Among these are the 'Elizabeth' and 'Earl of Leicester' after Zuccaro, and 'Helen Forman' after Rubens—all executed in stipple, the figures printed in black or brown, the hands and faces in red. In a 'Crucifixion' the ground-work is printed in a vivid grass green, while the etched outlines and the shaded figures are in a brown tint. This, of course, is a case where these different colours are printed from a single metal

plate. Warning must be given that there is a later issue of the plates alone, without date, 'printed by Joseph Kay,' in which the impressions are much inferior.

In 1789 Boydell and Co. published *A Collection of Prints after the Sketches and Drawings of the late celebrated Giovanni Battista Cipriani, Esqr., R.A., Engraved by Mr. Richard Earlom.* The plates are in aquatint and stipple, a few of them in two colours, exquisitely engraved, and making a wonderful imitation of ink and chalk drawings. Of the fifty plates all are by Earlom except one by C. Prestel, one by Kirk, and three by Bartolozzi in a single tint of brown.

To 1792 belongs *Imitations of Original Drawings by Hans Holbein . . . Published by John Chamberlaine.* The eighty-four plates are all by Bartolozzi with the exception of three by C. Metz—one of them the pleasing portrait of 'The Lady Eliot'—and one by C. Knight. All are beautiful examples of stipple printed in colours. They gain added value from the interest attached to the originals, which are now at Windsor Castle. After Holbein's death the drawings were sold into France, but returned to England on being presented to Charles I. by Mons. de Liancourt. Charles exchanged them with the Earl of Pembroke for a St. George, by Raphael, now in the Louvre. By the Earl of Pembroke the drawings were presented to Thomas, Earl of Arundel. In a manuscript in the Bodleian Library by Edward Norgate, entitled 'Miniatura, or the Art of Limning,' there is an interesting reference to this work by Holbein. In speaking of crayons, Norgate writes that 'the better way was used by Holbein, by pinning a large paper with a carnation or complexion of flesh colour, whereby he made pictures by the life of many great lords and ladies of his time, with black and red chalke, with other flesh colours, made up hard and dry, like small pencill sticks. Of this kind was an excellent

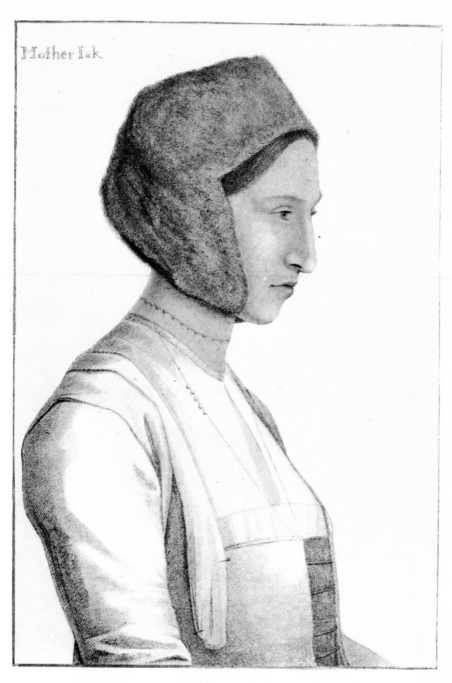

Mother Iak

"MOTHER JAK." BY BARTOLOZZI, AFTER HANS HOLBEIN

FM FROM "IMITATIONS OF ORIGINAL DRAWINGS BY HANS HOLBEIN," 1792

booke, while it remained in the hands of the most noble
Earl of Arundel and Surrey. But I heare it has been
a great traveller, and wherever now, he hath got his
Errata, or (which is as good) hath met with an Index
Expurgatorius, and is made worse with mending.' On
the death of Thomas, Earl of Arundel, the drawings
disappeared altogether, though in 1686 the editor of
the *London Gazette* says he has reason to believe they
were purchased for the Crown at the sale of Henry,
Duke of Norfolk. They were finally discovered by
Queen Caroline in a bureau of her closet at Kensington
Palace. Under Chamberlaine's auspices their beauties
were made public, and, as his preface says, 'the world
need not be told what to expect from Bartolozzi's
engravings after Holbein's drawings.' Holbein's
originals were drawn in his bold and free style, being
little more than outlines in chalk, usually on paper of
a flesh colour. The slight transparent tints that the
artist added have been wonderfully rendered in Barto-
lozzi's coloured stipple. The book was an expensive
one, being published in fourteen numbers, at thirty-six
guineas for the complete set. The same series of
portraits was issued again in 1812 by Chamberlaine,
who was keeper of the royal drawings and medals, with
a fresh title, *Portraits of Illustrious Personages of the
Court of Henry VIII.* This edition is in quarto instead
of large folio, and the engravings, again in coloured
stipple, are by various engravers. The two volumes
contain the eighty-four plates plain, with a duplicate
set printed in colour. Of the engravings seventeen
are by R. Cooper, thirteen by G. S. Facius, nine
by T. Cheesman, eight by A. Cardon, seven each by
E. Bocquet and J. Minasi, six by C. Knight, five by
Meyer, four each by M. A. Bourlier and Freeman, and
two each by Bartolozzi and W. Nicholls. The list is
given in detail because it contains representative names
of the large school of stipple engravers who followed

Bartolozzi. Their work is a marvel of delicate engraving and colouring, the one fault being, as with the corresponding Bartolozzi set, a tendency to make the shadows round eye and nose of too bright a blue. Colour-printing, as a rule, has failed from attempting what is beyond its possibilities. In these two editions Holbein's slight tints lend themselves to simple and direct reproduction, and in the history of the art there are few, if any, results more successfully and adequately achieved than these stippled illustrations. The rarity of the two series in the form of their original issue is due, of course, to their having been ruthlessly broken up for the sake of single prints.

Another book of drawings, edited with biographical and historical notes by Chamberlaine, is *Original Designs of the most Celebrated Masters of the Bolognese, Roman, Florentine and Venetian Schools*. The work was originally prepared for publication in 1796, and the original title-page, dated 1797, *Engravings from the Original Designs by Annibale, Agostino and Ludovico Caracci*, is retained as a sub-title in Chamberlaine's edition of 1812. One or two of the plates have a coloured border printed in a second ink, but the pictures themselves, etched or aquatinted, are printed in a single tint of sepia, brown, indigo, or Bartolozzi red. The book is a striking example of the use of diversified inks, and illustrates the power possessed by Bartolozzi and his school of reproducing with the utmost faithfulness all the spirit and the actual technique of a chalk or sepia drawing. Of the forty-five pictures, twenty-two are engraved by Bartolozzi, nine by F. C. Lewis, four by P. W. Tomkins, three by G. Lewis, three by Pastorini, two by Schiavonetti, with one by Facius, and one by Stephanoff.

Another book illustrating the use of different inks is *Imitations of ancient and modern Drawings from the restoration of the arts in Italy to the present time.*

This was printed for the author, C. M. Metz, in 1798, but the title-page is undated. A few of the hundred and fifteen plates are signed C. M., and it may be assumed that Metz, who was a capable engraver and a pupil of Bartolozzi, executed all himself. They represent all methods—stipple, etching, aquatint, etc.—particularly fine being a reproduction in aquatint, printed in at least three colours, of a drawing of a woman by Albert Dürer, dated 1500, and of a hunting scene by Titian, printed in two colours.

In 1808 appeared a large volume in a similar style, entitled *The British Gallery of Pictures, selected from the most admired productions of the Old Masters in Great Britain*. The text was by H. Tresham, R.A., and W. Y. Ottley, the executive part being under the management of P. W. Tomkins. There are twenty-five coloured plates in stipple, exquisitely finished, but with much additional hand-work. With each plate is a biography of the artist and a note as to the picture represented. The interpretation of an oil painting by Raphael, say, or Giorgione, is beyond the province of stipple, which finds its true office in rendering the delicate fancies of Angelica Kauffmann or Cipriani, and in reproducing chalk drawings with slight tints, like those of Holbein. Yet these plates, executed when the art of stipple was in its decadence, are triumphs of colour-printing. The list of engravers contains some distinguished names, five plates being by Tomkins, three by A. Cardon, three by J. Scott, two each by R. Cooper and E. Scriven, while others are by Cheesman, Bourlier, Freeman, Woodman, Wright, Agar, Schiavonetti, and Medland. The copy at South Kensington is one bought by Charles Landseer within two years after his election as an Academician, and on the fly-leaf is a note: 'I bought this handsome Volume of Mr. Bohn, for £50. I consider it cheap at that sum. Charles Landseer, 1847.' There must

be very few copies intact now; certainly none has come into the market for some years.

A final volume of the same class, showing the occasional use of two tints to reproduce drawings of old masters, is *The Italian School of Design*, by W. Y. Ottley, published in 1823. The original issue was in twelve monthly parts at one guinea, and on large vellum paper, two guineas. Among the engravers are Ottley himself, G. and F. C. Lewis, Schiavonetti, and Gaetano Bartolozzi.

In most of the books just mentioned the prevalent method is that of stipple. While combinations of aquatint and etching, elaborated with delicate and intricate tool-work, were engaging the attention of foreign engravers such as Janinet and Debucourt, Alix and Descourtis, stipple engraving was firmly planted in England by William Wynne Ryland. Like mezzotint, it became an English art; indeed, contemporary French writers allude to it always as *la manière anglaise*, a name that it still retains in art circles abroad. The method was expensive and not easy, and though a fair number of book illustrations in stipple were printed in the single 'Bartolozzi red,' the instances where two or three colours were used on the one plate are comparatively rare. In addition to the examples already noted, may be cited the *Book of Common Prayer*, published in 1794, with engravings in colour by Schiavonetti, Bartolozzi, Nutter and others. *Paul Hentzner's Travels in England, translated by Horace, late Earl of Orford*, republished by Jeffery in 1797, is remarkable for three or four stipple engravings in red and black, among them the well-known portrait of Sir Philip Sidney, 'from a Curious Limning by Oliver.' Another example is a pretty edition, published in 1817, of Hayley's *Triumphs of Temper*, where the frontispiece, stippled by T. B. Brown and printed in colours, is a reproduction of Romney's 'Serena.' The lines,

which it is chosen to illustrate, are appropriate enough :—

> 'Possesst by sympathy's enchanting sway
> She reads, unconscious of the dawning day.'

If the use of coloured stipple in book illustration is rare, that of coloured mezzotint is rarer still, though there are one or two notable instances of its use to be chronicled. Of peculiar interest is Dr. R. J. Thornton's *Temple of Flora, or Garden of Nature, being Picturesque Botanical Plates of the New Illustration of the Sexual System of Linnæus.* Though this appeared in 1807, the date 1799 is given on the title-page, contained in two leaves, and also on some of the plates. The book belongs to a class of works containing elaborate botanical specimens of great value to the student, but which, from the very exactitude of their detail and colouring, can hardly please the artistic sense. But in many cases Dr. Thornton's illustrators rise above the ordinary conventional treatment, and a glance at their names shows that in this instance the plates are of more than usual interest. The book opens with an engraved title-page, 'The Temple of Flora, or Garden of Nature,' followed by a second page with the sub-title, 'Picturesque Botanical Plates of the New Illustration of the Sexual System of Linnæus,' MDCCXCIX. Then follow three engraved plates, 'Æsculapius, Flora, Ceres and Cupid honouring the Bust of Linnæus,' 'Cupid inspiring plants with Love,' 'Sexual System of Linnæus,' in place of the first of which, in the South Kensington copy, is a coloured mezzotint representing Linnæus in Lapland costume. Of the original drawings for the thirty illustrations which follow, fifteen are by Henderson, ten by P. Reinagle, two by Pether, and one each by Hoffmann, S. Edwards, and R. J. Thornton himself. Reinagle's originals were exhibited at the Royal Academy, between the years 1797 and 1800. Among

the engravers' names appear those of W. Ward, Earlom, and Dunkarton, enough in themselves to ensure the collector's interest. The engraver who contributed most work is Caldwall, with seven plates. The work of Earlom and Ward is of course mere pot-boiling, if compared with such fine examples of their power as Earlom's Fruitpiece after Van Huysum, or Ward's Farmyard after Morland. It is strange to find the same men who produced these masterpieces filling up their foregrounds in Thornton's book with an enormous life-size snowdrop or tulip in full bloom, and adding a background of miles of distant landscape. The plates, however, are extremely valuable from the technical point of view. They are of a most experimental character, a plate with aquatint ground being frequently finished off with stipple or mezzotint work ; and in several cases at least three colours were employed in the printing. The saving grace of the work is that, though the botanical specimens are faultless, the plates are hybrid in the extreme. Earlom's work, however, is almost entirely in pure mezzotint, having three or four colours printed, and then being finished with the brush.

The 1807 edition of the *Temple of Flora* was a large quarto, and in 1812 a smaller edition appeared with the title *The Temple of Flora, or Garden of the Botanist, Poet, Painter and Philosopher*. The illustrations of the earlier edition appear again, but for some of them new engravers have been found. The plates are smaller in size, but there is the same confusion of methods, and it is interesting to compare the work of the new engravers with that of the earlier ones. The names of Ward and Earlom have disappeared ; and Roffe, Stadler, Quilley, and Maddox engrave five plates each.

Another interesting set of illustrations in coloured mezzotint occurs in *A Series of Portraits of the*

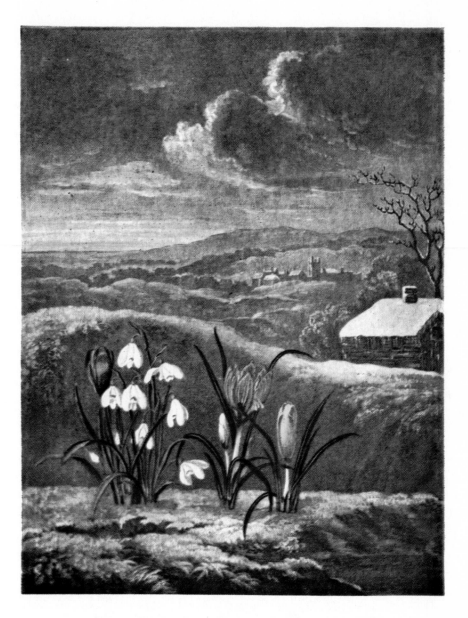

"THE SNOWDROP AND CROCUS." BY W. WARD, AFTER PETHER

FROM "THE TEMPLE OF FLORA," BY R. J. THORNTON, 1799-1807

Emperors of Turkey, engraved by John Young, and published by the engraver and R. Ackermann, in 1815. The originals were a series of cabinet pictures at Constantinople, executed by a Greek artist from materials at the Turkish Court. The commission for engraving these was intrusted originally in 1806 by Selim the Third, one of the more enlightened emperors of Turkey, to the Turkish ambassador in England. Young, who was well to the front as a mezzotint engraver, was selected to execute the work, which was to be absolutely secret. The death of Selim and his advisers, coming with Oriental unexpectedness, closed the original commission; but Young was encouraged to complete the work on his own account. In his preface Young writes: 'It will scarcely be necessary for me to point out how materially these Portraits differ from plates engraved in the line manner, which when finished, will produce an impression of several thousand copies; whereas of the mezzotintos which constitute the present volume, I can avail myself but of a very limited impression; as the process of colour-printing tends so materially to injure the plates. The impressions have all been printed in colours from the Pictures, and each Portrait has been attentively revised by myself.' The plates, thirty-one in all, are fine, though not very interesting, specimens of coloured mezzotint, with more than a suspicion of added hand-colouring on all.

A remarkable work, in which mezzotint, stipple, and aquatint were all employed, is the *Ceremonial of the Coronation of King George the Fourth*, published by John Whittaker in 1823. As a contemporary notice of the book states, it was 'designed for a specimen of typographical elegance not to be surpassed, and will be printed in gold letters, accompanied with portraits of the distinguished persons who composed the splendid procession, in their respective dresses, richly coloured

as drawings.' The frontispiece represents George IV. on his throne, holding his sceptre. The picture is finished in oils like a miniature, highly varnished, so that one can only guess that it is on a mezzotint basis. This is followed by thirty-nine plates showing the various distinguished personages who took part in the ceremony, and also a plate picturing the regalia. Each plate has a full description above it in stamped gold lettering on a cream ground. There are three additional sheets in this gold lettering, one with the full titles of the Duke of York, the other two giving lists of names of those present. The plates of costume show the use of mezzotint, stipple, and aquatint, employed singly or in combination. The plates are all finished most carefully by hand-colouring, but in most cases two or more tints were printed. At the end of the series is a mezzotint, printed in colour and finished by hand, of the coronation ceremony, and another of the banquet scene. This last, like the frontispiece, is painted over with oils, but one can clearly see marks of roulette and rocker in places. The British Museum Library possesses the King of Holland's copy of this book, and a more magnificent show-book could scarcely be found. It contains an additional frontispiece showing the coronation chair beneath a canopy. Round the top of this, on pillars at the sides, and elsewhere, are coats-of-arms on highly embossed gesso work, with the minutest details most elaborately painted. The title-page and the dedication page are similarly ornamented; and both book and binding represent the most lavish expenditure.

Another book on the *Coronation of George IV.* was also commenced by Sir George Nayler, Garter King of Arms, and was announced to consist of five parts. The first part was issued in 1825, and the second part appeared two years later. Several thousands of pounds were lost in the venture, and owing to the death of its

promoter in 1831, the work was stopped. In 1835 the remaining unsold copies of these parts, together with the copyright and copper-plates, were submitted for public sale. These and the plates for Whittaker's work were acquired together by Henry Bohn, who amalgamated the two issues and published them in one volume with text in 1837, omitting the stamped gold lettering of the Whittaker edition. In Bohn's edition thirty-three of the costume plates are reprinted from the Whittaker edition, and we now find from the inscriptions that, with the exception of one by Uwins, the drawings are all by Francis and James Stephanoff; while the engravers are S. W. Reynolds, H. Meyer, W. Bond, W. Bennett, E. Scriven, and P. W. Tomkins. Reynolds's work, as might be expected, is mainly in mezzotint. Besides the costume plates there are eight others in aquatint of the Ceremony of the Homage, the Banquet, etc., printed in colour and finished by hand, by Bennett, R. Havell, and M. Dubourg after C. Wild, J. Stephanoff, and Augustus Pugin, the two last working together on architectural views. Some of the original water-colours by them for this work are in the Victoria and Albert Museum. Another coloured plate, making forty-two in all, is a mezzotint in colour, by S. W. Reynolds after Stephanoff, of the Court of Claims. Another edition of the book was published by Bohn in 1839.

Some coloured stipple and mezzotint engravings form part of the illustrations to Blagdon's *Authentic Memoirs of George Morland*, published by Orme, of which more will be said in connection with Orme's other publications. Finally, as an example of a somewhat unusual colour process, may be mentioned two or three soft-ground etchings, printed in red and black, that occur in Pennant's *Account of London, Westminster and Southwark*, 1795.

CHAPTER VIII

WILLIAM BLAKE

'I am inspired. I know it is Truth! for I sing
According to the Inspiration of the Poetic Genius,
Who is the Eternal, all-protecting, Divine Humanity,
To whom be Glory and Power and Dominion evermore.'

W. Blake.

LIKE every man, from Socrates downwards, who by
some of his fellows has been esteemed a seer,
by others a madman, William Blake remains
isolated and remote. He is like a rugged fir-tree,
standing solitary on a hillside, buffeted by storm-
blasts, scorched by the summer sun, frozen by winter's
ice and snow, yet in sunshine and in storm living a
free, open, unhampered life, with God's heaven always
above. It were a Procrustean task to crush into the
narrow limits of a page or two of print a history and
criticism of the life and work of this great poet, mystic
philosopher, painter, engraver, and book illustrator.
Yet his books with coloured illustrations are so far
unique that some account must be given of the method
of their production. Fortunately for those who wish
to pursue this study, there are three admirable works
on Blake—Swinburne's *William Blake, A Critical
Essay*, 1868; *Life of William Blake*, by A. Gilchrist,
new edition, 1880; and *The Works of William Blake*,
by E. J. Ellis and W. B. Yeats, 1893.

Blake was born on November 28, 1757, at 28
Broad Street, Golden Square, where his father had a

72

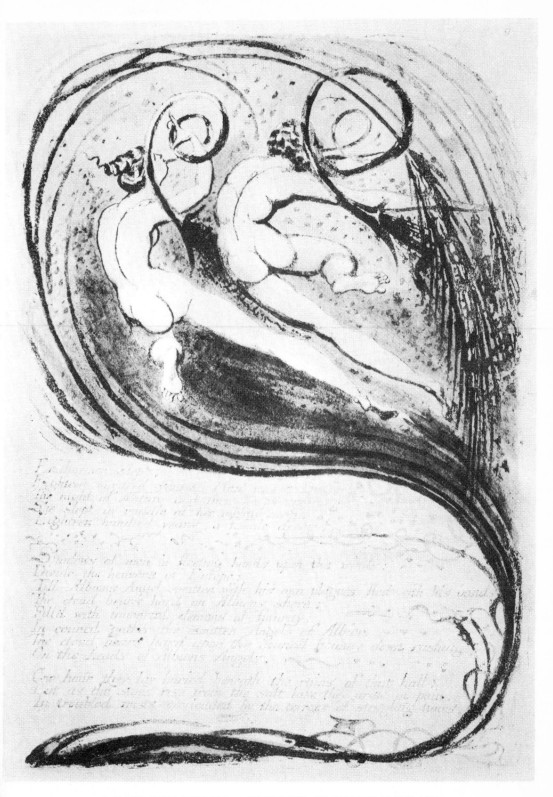

A PLATE FROM "EUROPE: A PROPHECY." BY WILLIAM BLAKE, 1794

moderately prosperous hosiery business. As a boy he was quiet and dreamy, with a strong liking for art, and a keen love of solitary rambles in the country. During one of these he saw his first vision, 'a tree filled with angels, bright angelic wings bespangling every bough like stars.' In 1767, at the age of ten, he was sent to Mr. Pars's drawing-school in the Strand, which subsequently became Ackermann's showroom. At this early age he was a constant frequenter of sale-rooms, and at a time when auctioneers took *threepenny* bids, became a collector in a limited way. Langford, the auctioneer, 'called Blake his little connoisseur, and often knocked down a cheap lot with friendly precipitation.' This reminds one of the similar episodes in the life of Geddes, who as a boy used to haunt the salerooms of Edinburgh. Martin, the well-known auctioneer, would prelude the sale of a print, which he thought might suit his youthful bidder's purse, with, ' Now, my bonny man, now's your time,' and when he knew a high price was imminent, 'Ye need na fash, wee creetur.'

At the age of fourteen Blake exchanged the drawing-school of Pars for the shop of Basire the engraver, in Great Queen Street, Lincoln's Inn Fields. His main work during his apprenticeship was making drawings of monuments in Westminster Abbey and other London churches, to be engraved by Basire for Gough the anti-quary. The task fed his romantic imagination and kindled a love of Gothic art. Apart from this he had little else for which to thank Basire, except a careful grounding in the mechanical side of the engraver's art. It was while an apprentice to Basire that he wrote the poems, published in 1783 with the title *Poetical Sketches*, in which he struck a note to be repeated later in the work of Wordsworth, of Shelley, and of Keats. They were days of courtship also, for in 1782 he married Catherine Boucher, who was to become so loving and

73

practical a helpmate. Leaving Basire, he commenced a course of study in the Academy School under its first keeper, Moser, and also earned his livelihood by the journey-work of an engraver, doing some capital work after Stothard for the *Novelists' Magazine* and the *Wits' Magazine*.

On the death of his father in 1784, he entered partnership with James Parker, a fellow-apprentice at Basire's, and started a business as printseller and engraver at 27 Broad Street, next door to his birthplace, where his father's business was continued by his brother Robert. Blake's union with Parker proved unsatisfactory, and when his brother Robert died in 1787 he dissolved the partnership and moved to 28 Poland Street, Mrs. Blake being now his sole pupil and assistant.

By 1788 Blake had in readiness a new volume of poems with the proposed title, *Songs of Innocence*. He had even completed the illustrative designs in colour to accompany the poems, but lacked both ways and means of publishing them. For days and nights the question of publication formed the subject of anxious thoughts and dreams, until in a vision during the night his brother Robert appeared before him and revealed a means of producing with his own hands a facsimile of song and design. On rising in the morning our artist sent out Mrs. Blake with half a crown—the only money they possessed in the world—to spend one and tenpence on the necessary material for the fulfilment of the dream. Thus began the series of poems and writings illustrated by coloured plates which form the principal revelation of Blake's genius. It is the irony of fate that Blake lived and died in poverty, while a single copy of this little book, to make which he changed his last halfcrown, should now be worth many times its weight in gold.

The method employed for the *Songs of Innocence*,

74

and consistently adhered to in the later books, was absolutely original. It was a system of 'etching in relief' both words and designs. The artist wrote his verses and drew his designs and marginal ornaments on a copper plate, using for this purpose probably the ordinary stopping-out varnish employed by etchers. He then applied acid, which bit away all the remainder of the plate. The text and designs now stood in relief, and could be printed in black or in any colour, while the bitten parts would remain white. As a rule the written part of the plate was printed in red, and to the rest the colour was given which was to be dominant in the final effect. The print thus produced was finished with colour applied by hand in every variety of tint. Mr. Gilchrist tells us that Blake ground and mixed his water-colours himself on a piece of statuary marble, adding a mixture of diluted carpenter's glue, after the method of the early Italians, a secret revealed to him in a vision by Joseph, the sacred carpenter. Mrs. Blake was his constant helper, soon learning to take off the impressions, to tint them with great artistic feeling, and finally to bind them in boards. From the making of the colours to the issue of the prospectus announcing the sale of the work, it was in every essential a home industry.

It will be seen that there is a strong similarity between the plate thus produced and a wood-block; in fact, Blake himself attached a memorandum to his *Public Address*, with the direction :—'To *wood-cut on copper*. Lay a ground as for etching; trace, etc., and, instead of etching the blacks, etch the whites, and bite it in.' His method, indeed, of merging the outlines into the shadows and of balancing broad masses of pure black and pure white is essentially that of the early chiaroscurists and of all good engravers on wood. The description of the method employed is perfectly correct so far as the majority of Blake's coloured plates

are concerned, but in one or two books, notably the *Song of Los*, *Ahania*, and *Urizen*, the method of colouring becomes more complicated. In these the underlying engraving is entirely hidden by an impasto of solid colour. The print has a curiously mottled or granulated appearance, obviously caused by the pressure of a flat surface covered with oil paint, which has adhered slightly and then been withdrawn. The effect is well known to the unhappy artist who has returned from a day's sketching with two of his boards accidentally stuck together. Blake's method was apparently to draw his design upon mill-board, and apply oil-colour to this just as Le Blon did to his mezzotint plate. The impression on the paper was then coloured with water-colours, and the mill-board was used again for a second print. The appearance of the plates is exactly that of some of Le Blon's experimental work in oil-colours, and in a similar way the oil has penetrated the paper employed for printing, however thick it may be. Of course every design was most carefully finished by hand, and at first this seems impracticable owing to the apparent difficulty of painting in water-colour over oil. But if the oil were allowed to dry into the paper, the artist could easily proceed in the method he pursued in his ' frescoes ' of adding a thin transparent wash of glue, and working over this in water-colour.

It is impossible to express adequately the imagination and the compass of Blake's actual colouring. There can be no terms of comparison, for his work is unique, and those who have attempted to describe it have invariably risen to a height of poetical eloquence. In the words of one perfervid chronicler : ' They are marvels of colouring ; such tender harmonies of delicate greens, and blues, and rosy pinks ; such brilliancy of strong golden and silver lights ; such gorgeous depths of purples and reds ; such pictures of the dark chasms

of the nethermost pit, lit up and made lurid by un-
earthly glare of flame tongues—it has been in the
power of no mortal brain to fancy, and no mortal hand
to depict.' Fire, indeed, seems to be the underlying
motif of all Blake's work. Page after page is a furnace
glowing and glittering with bursts of flame that leap
and quiver in prismatic iridescence. You lay down
one of Blake's books tenderly, says Gilchrist, 'as if
you had been handling something sentient.'

The *Songs of Innocence* was printed in the first
method described, and finished with delicately laid
tints of water-colour. The poems, with their melody
of rhythm and their tender simplicity, bring recollec-
tions of the heaven that lay about us in our infancy.
They belong to a period before Blake, visionary though
he already was, had adopted a mystical clothing for his
thoughts. The drawings are plain illustrations of the
poems, decoratively expressed, but without any alle-
gorical or cryptic symbolism. They show simple,
domestic, and rural scenes, but have a grandeur of
style and conception, presaging the larger and fuller
development of his decorative schemes. Text and
designs, as in the later books, mingle and interweave,
showing a grasp of ornamental treatment as strange to
the times in which the artist lived as the poems them-
selves. The little book had no general circulation, and
was not in a proper sense published. From time to
time some friendly person would order a copy, but it is
doubtful whether fifty copies in all were ever printed
and coloured. In the same year Blake used his new
discovery for another illustrated poem, *The Book of
Thel*, a strange mystical allegory. The book com-
prises seven engraved pages, including the title, some
six inches by four in size. The text, enigmatic and
vague, but simple in comparison with the later
prophetic books, is accompanied and interwoven by
pictured shapes of flying angels, birds, serpents, and

trailing plants, and a few copies were coloured by the artist with extraordinary elaboration.

Following the mystical *Book of Thel* came in 1790 the more mystical *Marriage of Heaven and Hell*, which Gilchrist describes as 'perhaps the most curious and significant, while it is certainly the most daring in conception and gorgeous in illustration, of all Blake's works.' It is an octavo volume, consisting of twenty-seven illuminated pages, about six inches by four in size, the letter text in some copies being red, and in others brown. In the best copies the artist seems to have sought inspiration for his colour scheme in the hues of the rainbow and the glow of the fire. The student who wishes to probe and dissect the hidden mysticism of this and the later prophetic books will find in Mr. Swinburne's *Critical Essay*, and in the work of Messrs. Ellis and Yeats, interpretations of Blake's symbolism that are full of poetic insight and vivid imagination.

In 1793 Blake moved to 13 Hercules Buildings, Lambeth, and there published *The Gates of Paradise*, printed in his usual way, but not coloured, and also two of his visionary books, printed in colour. The first of these was *Visions of the Daughters of Albion*, a folio volume of eleven engraved pages of designs and rhymeless verse, coloured with flat, even tints. The other volume bears the title *America: a Prophecy*, and is a folio of eighteen pages of text and designs. The theme is the American War of Independence, and the verse is dithyrambic, and unfathomable in meaning. The book sometimes occurs in a coloured form, but more often plain black, and occasionally blue and white, though it is doubtful whether Blake ever meant to send forth to the world any uncoloured copy. For sheer power and beauty the designs in this book rank with the finest of Blake's work. The colouring, particularly in the copy of the Crewe collection, is almost dazzling in its brilliance.

78

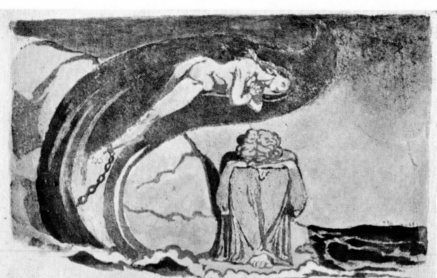

Have shadows of discontent! and in what houses dwell the wretched
Drunken with woe forgotten, and shut up from cold despair.

Tell me where dwell the thoughts forgotten till thou call them forth
Tell me where dwell the joys of old! & where the ancient loves?
And when will they renew again & the night of oblivion past?
That I might traverse times & spaces far remote and bring
Comforts into a present sorrow and a night of pain
Where goest thou O thought! to what remote land is thy flight?
If thou returnest to the present moment of affliction
Wilt thou bring comforts on thy wings and dews and honey and balm;
Or poison from the desart wilds, from the eyes of the envier.

Then Bromion said: and shook the cavern with his lamentation

Thou knowest that the ancient trees seen by thine eyes have fruit:
But knowest thou that trees and fruits flourish upon the earth
To gratify senses unknown? trees beasts and birds unknown:
Unknown, not unpercievd, spread in the infinite microscope,
In places yet unvisited by the voyager, and in worlds
Over another kind of seas, and in atmospheres unknown:
Ah! are there other wars, beside the wars of sword and fire!
And are there other sorrows, beside the sorrows of poverty!
And are there other joys, beside the joys of riches and ease?
And is there not one law for both the lion and the ox?
And is there not eternal fire, and eternal chains!
To bind the phantoms of existence from eternal life?

Then Oothoon waited silent all the day, and all the night,

A PLATE FROM "VISIONS OF THE DAUGHTERS OF ALBION," BY WILLIAM BLAKE, 1793

BLAKE'S ILLUSTRATIONS

By the end of 1793 the *Songs of Experience* was added as a complement to the *Songs of Innocence*, and the two sets were issued in one volume in 1794 with the general title *Songs of Innocence and Experience, showing the Two Contrary States of the Human Soul.* Some copies are in existence bearing the water-mark of 1825, having been printed by Blake shortly before his death. The volume was composed of fifty-four engraved pages, and was sold at a modest price rising from thirty shillings or two guineas, though later copies were elaborately coloured by the artist for Sir Thomas Lawrence, Sir Francis Chantrey, and others, at from twelve to twenty guineas each. The illustrations of the additional *Songs of Experience* are of the same simple character as the first set, and among them is that of the 'Tyger, tyger burning bright, In the forests of the night,' a poem which Charles Lamb pronounced 'glorious.' Some one has remarked that the verses of this volume in their framework of birds and flowers and plumes, all softly and magically tinted, seem like some book out of King Oberon's library in fairyland, rather than the productions of a mortal press.

To 1794 also belongs a sequel to the *America*, entitled *Europe: a Prophecy*, and consisting of seventeen engraved quarto pages. The frontispiece is a majestic design representing the Almighty 'when He set a compass upon the face of the earth,' a picture composed with childlike fidelity, and one in the colouring of which the artist always took especial pleasure. The eighth plate of this book, representing a male and a female figure, carried in rapid motion through the air, and from a twisted horn scattering mildew upon ears of wheat, is one of the sublimest of Blake's conceptions; text and figures combine to form a superb piece of decorative design.

In spite of the laborious processes that the style of work involved, the *Europe* was rapidly followed in the

same year by the *Book of Urizen*, which consists of twenty-six engraved pages, but text and designs alike are shapeless and incoherent. To the following year, 1795, belong *The Song of Los*, *The Book of Los*, and *The Book of Ahania*. The first of these contains eight engraved pages, two being full-page pictures without text. In this work Blake began his first use of oil-colours for printing, with the result that the illustrations have a heavy and opaque appearance. *The Book of Los*, not mentioned by Gilchrist, consists of an engraved frontispiece and title, and three pages of finely etched script, with a vignette at the beginning and end. The colouring is again in oil, as is also the case with *Ahania*, which contains six engraved pages, three of them being text only, as though Blake was weary of his pictorial elaborations.

In 1797 Young's *Night Thoughts* was published by R. Edwards, with forty-three engraved illustrations by Blake. It was not issued in colours, and the copy, coloured by the artist for Mr. Butts, and sold recently from the collection of the Earl of Crewe for £170, appears to be unique. After 1797 comes a gap of three years, so far as coloured books are concerned. In 1800 Flaxman introduced Blake to the poet Hayley, a country gentleman, at whose invitation Blake went to reside at Felpham. Here, except for a curious charge brought against him by a soldier, resulting in his trial for high treason, Blake resided in peace and obscurity, working quietly at engravings to illustrate various publications by Hayley. 'Felpham,' he writes, 'is a sweet place for study, because it is more spiritual than London. Heaven opens here on all sides her golden gates; her windows are not obstructed by vapours; voices of celestial inhabitants are more distinctly heard, and their forms more distinctly seen.' The result of this sojourn in Sussex was a long poem descriptive of the 'spiritual acts of his three years'

slumber on the banks of Ocean'—so Blake himself described it. This poem, published in 1804, bears the title *Jerusalem: the Emanation of the Giant Albion,* and is a quarto volume with a hundred pages of engraved text and design, a few copies being published in colours at twenty guineas. In connection with the pictorial part of this book, attention may be drawn to the extreme largeness and decorative character of the drawings, made up of massive forms thrown together on a grand, equal scale—a fact characteristic of all Blake's later work. The copy of this book in the Crewe collection, printed in a warm, reddish brown, was particularly remarkable for the breadth and grandeur of its colouring.

The other book of 1804 was *Milton : a Poem in Two Books.* In this there are forty-five pages engraved and coloured in the usual manner, but more than half of these pages have slight marginal ornament only. The actual drawings are not particularly striking, and have little affinity with the text, and one—the picture of 'Blake's Cottage at Felpham'—has as little connection with the actual cottage as with Milton. After the publication of the *Milton* came dark years of poverty and neglect, lighted only by the artist's friendship with John Linnell and Varley, and in 1822 Blake was on the verge of want. But work was soon to come to him. A year or two before this, he had made for his patron Mr. Butts a set of water-colour illustrations to the Book of Job, which afterwards passed into the possession of Lord Houghton. In 1823 Linnell, impressed with the power of these drawings, commissioned the artist to make a duplicate set and engrave them. For designs and copyright Blake received £150—the largest sum he ever obtained for any one series—but no profits were realised by the engravings, their sale barely covering expenses. The engravings, esteemed by some as Blake's best work, were published in 1825 with the

title *Illustrations of the Book of Job*. They were not coloured, but are worthy of mention, because the two sets of original coloured designs are still in existence.

Another book, not mentioned by Gilchrist, is *There is no Natural Religion*. The plates, twelve in number including the title, are small in size, being about two inches by one and a half, but wonderfully decorative. The ideas in the poem belong to almost the whole of Blake's life, but there is much to justify the opinion, kindly offered to me by Mr. Ellis, that the book belongs to the Felpham period.

Blake's death took place on Sunday, the 12th of May 1827, nearly three months before the completion of his seventieth year, and he was buried on the following Friday in Bunhill Fields Cemetery. At first sight it appears strange that the *Milton* and *Jerusalem*, both dated 1804, should have been Blake's last coloured publications. Mr. Ellis, however, has shown me that although both were begun on metal in 1804, they occupied Blake in reality for several years. In the *London Magazine* for September 1820 the *Jerusalem* is reviewed by Wainewright as a new book. The *Milton* Blake left off regretfully because he could not make it twelve books instead of two. He meant practically to work under these two titles for an indefinite number of years. One more proof of this is that there are extra pages in various copies of the *Milton*, while the copy of the *Jerusalem*, facsimiled in the Quaritch edition of Blake's works by Messrs. Ellis and Yeats, is not the same as that in the British Museum Print Room, and even the numbering of the pages differs.

There are two interesting documents that throw light on the original issue of Blake's books and their prices. The first is extracted from a characteristic prospectus, egotistic indeed, but with the egotism of genius. The original is in engraved writing, printed in blue on a single sheet.

BLAKE'S PROSPECTUS

'TO THE PUBLIC

'*October* 10, 1793.

'The Labours of the Artist, the Poet, the Musician, have been proverbially attended by poverty and obscurity; this was never the fault of the Public, but was owing to a neglect of means to propagate such works as have wholly absorbed the Man of Genius. Even Milton and Shakespeare could not publish their own works.

'This difficulty has been obviated by the Author of the following productions now presented to the Public; who has invented a method of Printing both Letter-press and Engraving in a style more ornamental, uniform, and grand, than any before discovered, while it produces works at less than one-fourth of the expense.

'If a method of Printing which combines the Painter and the Poet is a phenomenon worthy of public attention, provided that it exceeds in elegance all former methods, the Author is sure of his reward.

'The following are the Subjects of the several Works now published and on Sale at Mr. Blake's, No. 13, Hercules Buildings, Lambeth.

3. America, a Prophecy, in Illuminated Printing. Folio, with 18 designs, price 10s. 6d.
4. Visions of the Daughters of Albion, in Illuminated Printing. Folio, with 8 designs, price 7s. 6d.
5. The Book of Thel, a Poem in Illuminated Printing. Quarto, with 6 designs, price 3s.
6. The Marriage of Heaven and Hell, in Illuminated Printing. Quarto, with 14 designs, price 7s. 6d.
7. Songs of Innocence, in Illuminated Printing. Octavo, with 25 designs, price 5s.
8. Songs of Experience, in Illuminated Printing. Octavo, with 25 designs, price 5s.

'The Illuminated Books are Printed in Colours, and on the most beautiful wove paper that could be procured.

'No Subscriptions for the numerous great works now in hand are asked, for none are wanted; but the Author will produce his works, and offer them to sale at a fair price.'

Another interesting reference to the original prices occurs in a letter written by Blake on April 12, 1827, to Mr. Cumberland, quoted in *Blake's Works*, by Ellis and Yeats.

'You are desirous, I know, to dispose of some of my works, but having none remaining of all I have printed, I cannot print more except at a great loss. I am now painting a set of the "Songs of Innocence and Experience" for a friend at ten guineas. The last work I produced is a poem entitled "Jerusalem, the Emanation of the Giant Albion," but find that to print it will cost my time to the amount of twenty guineas. One I have finished, but it is not likely I shall find a customer for it. As you wish me to send you a list with the prices, they are as follows :—

America	£6	6	o
Europe	6	6	o
Visions, &c.	5	5	o
Thel	3	3	o
Songs of Innocence and Experience				.	10	10	o
Urizen	6	6	o'

Blake's coloured books are naturally rare, and their appearance in the book market is extremely infrequent. Fortunately there is a good and representative collection in the Library and Print Room of the British Museum. The finest collection, however, was that acquired by Mr. Monckton Milnes, afterwards Lord Houghton. From him they passed into the possession of his son, the Earl of Crewe, who sold a selection at Sotheby's on March 30, 1903.

I append a note of the prices at this and some other sales during the last twenty years. It must be borne in mind that the colouring varies with each separate copy, and also that Mrs. Blake coloured and sold some of the books after her husband's death.

			Crewe Sale, 1903
Songs of Innocence and Experience, .	1882	£146	£300
	1890	£48 and £87	
	1903	£216 and £700 [1]	
The Book of Thel, .	1890	£29	£77
	1891	£14, 10s.	
	1895	£14	
	1901	£46	
	1905	£67	
America, a Prophecy, .	1888	£23	£295
	1890	£61	
	1904	£207	
Visions of the Daughters of Albion, .	1890 and 1895	£26, 10s.	£122
	1905	£105	
Europe, a Prophecy, .	1901	£225	£203
The Book of Urizen, .	1890	£66	£307
The Book of Ahania,	£103
The Song of Los, Europe, and Visions of the Daughters of Albion, together, .	1901	£225	
The Song of Los, .	1904	£144 (copy incomplete)	£174
The Marriage of Heaven and Hell, .	1892	£50	£260 (The same copy, June 1905, £150)
Young's Night Thoughts,	£170 (Unique, in colours)
Jerusalem, . .	1887	£166	£83
The Book of Job; proofs of the engravings and the 21 original coloured designs	£5600

[1] An exceptional copy, with an ornamental border round each design.

The Crewe sale gave a unique opportunity for collectors. A year or two often elapses between the appearance even of single copies, which are as expensive as they are rare. The ordinary collector must be patiently content with Mr. W. Muir's reprints, which, except from the sentimental standpoint, are quite worthy of being placed beside the originals, and are of a satisfactory degree of scarcity withal. These reprints appeared from 1884 to 1886. The photographic transcripts give Blake's outlines with exactness, and the tints, laboriously studied, were patiently added by hand in careful facsimile of the originals. The workers at this task of colouring, Messrs. W. and J. B. Muir, Miss Muir, Miss E. J. Druitt, and Mr. J. D. Watts, well deserve that their names should be placed on record.

Finally, it is perhaps only fair, in view of the flattering criticisms quoted above, to append an adverse note. Ruskin speaks of Blake 'producing, with only one majestic series of designs from the Book of Job, nothing for his life's work but coarsely iridescent sketches of enigmatic dream.'

CHAPTER IX

THE PROCESS OF COLOURED AQUATINT

'It is not unlikely that the day may arrive when the connoisseur of a future age shall turn over the pages of a book, and pause upon an aquatinta print, with the same solemn delight, as those of our day are wont to do upon a woodcut of Albert Dürer, an etching of Hollar, or a production of any ancient engraver.'— SAMUEL PROUT, in 1813.

IT is to be feared that there is a large class of educated and intelligent people in this country, collectors of books among them, who know nothing, or have that little knowledge that is dangerous, of the various processes by which book illustrations are produced. There are still many who cling to the comfortable old belief that a pen-and-ink drawing is an etching, people to whom a coloured plate in one of Ackermann's books a colour-plate is and nothing more. Seeing, therefore, that a large proportion of all colour-plates in books consists of coloured aquatints, it seems opportune to give a short explanation of the process.

From about the year 1790 to 1830 the principal process employed in book-illustration is aquatint engraving. The original aim of aquatint was to produce an imitation of drawing in sepia or Indian ink. The art appears to have been invented, or at least perfected, by Jean Baptiste Le Prince (1733-1781), a French painter and engraver—something too of a scapegrace, who at eighteen married a woman of forty. His secret was purchased by the Hon. Charles Greville, and by him communicated to Paul Sandby, who at once recognised the possibilities of the process, and in 1775

87

published a set of quarto plates described as *Twelve Views in Aquatinta, from Drawings taken on the Spot in South Wales.* From this time the art has a steadily growing popularity, till in the works of Malton, W. Daniell, and the Havells, it reaches its highest perfection in this country.

As its name shows, aquatint is a means of producing a tint from a copper plate by means of biting with strong water. If an aquatint is examined with a magnifying glass, it will be seen that the 'ground' consists of innumerable little rings, larger or smaller in size, and more or less broken and irregular, but all joining one another. There have been various methods of producing this ground. The most common is to place some finely powdered resin in a box containing a circular fan working with a cord from outside. When this is set in rapid motion, the dust is raised in a cloud, and if a copper plate be then inserted, the fine dust of the resin will settle evenly on its surface. If the plate be then removed and heated to just the melting-point of the resin employed, atoms of dust will adhere to the copper, giving a ground of innumerable particles, almost touching one another, though there must always be minute spaces between them. If acid be now applied to the plate, it will fill these spaces, and bite the copper wherever it is unprotected. If the plate be then cleaned and printing ink applied, the ink, when the plate is wiped, will remain only in the bitten spaces, which will print with that granulated 'ground' that appears in all aquatints.

Another method, which appears to have been first employed by Sandby, is to use a fluid ground, consisting of resin dissolved in rectified spirits of wine. When drying upon the plate this breaks up into a granulation, which is coarser in proportion to the amount of resin used in the solution. In either case, when the ground has been obtained and the outline

88

etched, the finished aquatint is produced by successive bitings, any portion that is not intended to receive a tone being stopped out by covering it with Brunswick black. It will be seen that by this method any exact gradation of tone is extremely difficult to obtain, but while the perfection of gradation that is characteristic of fine mezzotint cannot easily be produced, the effect of an aquatint is extremely liquid and translucid, enabling it fairly to reproduce a sepia or water-colour drawing worked in simple washes.

It remains now to consider the method of making the coloured aquatints, which for a period of more than thirty years at the beginning of last century held the field as the principal means of colour-illustration. It is a method with which must always be specially associated the great names of Rowlandson and Alken, as well as that of Ackermann the publisher. A careful examination of the coloured aquatints of the period shows that two or three coloured inks of neutral tints were employed in the printing of the plate. The usual process was to use a brown tint for the foreground and blue for the sky and distance. The prints thus made were afterwards finished by hand, the method of printing in two or three inks being adapted so as to save the colourist as much trouble as possible. From the latter half of the eighteenth century the colouring of prints was a regular industry. Turner and Girtin both passed a boyhood apprenticeship in tinting prints for Dayes, Malton, and John Raphael Smith. The laying of even washes in correct tone was an excellent training for the development of sureness and precision of colouring. Girtin, however, rebelled against the monotonous task of colouring prints for week upon week and month after month. He expostulated with his master Dayes, telling him that his apprenticeship was meant to teach him drawing, but the tyrant Dayes committed him to prison as a refractory apprentice, and there he remained till he

was rescued by his future patron, the Earl of Essex. It is of interest to note that in 1836 F. W. Fairholt, the well-known author, artist, and antiquary, was glad to earn ten shillings a week at the same mechanical task.

For the colouring of aquatints a publisher had to keep a number of workmen occupied in this particular task. Rudolph Ackermann, for instance, had a large staff of engravers and colourists working continually at his ' Repository of Arts.' The magnitude of the work will be best realised by considering what the issue of a single book meant. The *Microcosm of London*, for instance, contains one hundred and four plates, and one thousand copies of the book were published. This means that for this one book alone at least 104,000 plates were separately coloured by hand ; and any one who has studied Ackermann's books knows with what uniform excellence this colouring was done, and to what a high degree of finish it frequently attained. Let us consider for a moment how one of Rowlandson's coloured plates for this work would be produced. The artist was summoned to the Repository from his lodgings in James Street, in the Adelphi, and supplied with paper, reed-pen, Indian ink, and some china saucers of water-colour. Thus equipped, he could dash off two caricatures for publication within the day ; but in the case of the coloured books he worked with greater care. With his rare certainty of style, he made a sketch, rapid but inimitable. This he etched in outline on a copper plate, and a print was immediately prepared for him on a piece of drawing-paper. Taking his Indian ink, he added to this outline the delicate tints that expressed the modelling of the figures, and the shadowing of interiors, architecture, or landscape. The copper plate was then handed to one of Ackermann's numerous staff of engravers—Bluck, Stadler, Havell, and the rest. When Rowlandson returned in the afternoon he

would find the shadows all dexterously transferred to the plate by means of aquatint. Taking a proof of this or his own shaded drawing, the artist completed it in those light washes of colour that are so peculiarly his own ; and this tinted impression was handed as a copy to the trained staff of colourists, who, with years of practice under Ackermann's personal supervision, had attained superlative skill.

In the actual printing from the plate the ordinary method, as has been said, was to use two or three inks. A soft paper was employed, as a rule the best Whatman, which was then sized to prevent the colour blotting through. The print was finished by hand-colouring, as a water-colour drawing, in many cases the high lights being systematically scraped out with a knife. Some of the elaborate botanical plates of Thornton's *Flora* will serve best as an example of the use of three colours in printing, while in Pyne's *Royal Residences*, and in most of Ackermann's books, two inks have been employed. This is shown well by an uncoloured copy of the *Royal Residences* in the National Art Library, where the landscape views of Windsor, Hampton Court, etc., have the sky printed in a blue ink, and the buildings, trees, and foreground in brown. It will often be found—in the *Temple of Flora* or in Cox's *Treatise on Landscape Painting*, for instance—that the ink used in the imprint for the title and artists' names varies from plate to plate, showing the particular ink, blue, green, or brown, which is predominant in each. Occasionally also, where two colours have been used, the artist's name below is printed in the one colour, and the title in the other.

With this method of printing in two or three colours on one plate it is extremely difficult to accomplish any delicate work, because of the necessity, in wiping off the superfluous ink, of not encroaching on the adjacent lines of another colour. Much, therefore, is necessarily

left to the final touching with water-colour. In printing from a copper plate, however, it is easy to leave—indeed often difficult to avoid leaving—a trace of the ink on the surface of the plate besides that retained in the sunk parts; and this appearance of surface tint can be further helped by a process called by printers *retroussage*, which consists in dragging some of the ink evenly over the surface of the plate by means of a piece of soft rag or the palm of the hand. Apart from where this *retroussage* occurs, the usual test of what is hand-coloured work can be applied, namely, that where the paper between the dots and lines appears white when viewed through a magnifying glass, it can be assumed that the colour is printed. Where colour has been applied in a wash by means of a brush, it will cover the whole surface, dots, lines, and space between as well.

The process employed by Janinet and Debucourt, and in later times by Marie Jacounchikoff, Delâtre and others, of superimposing seven or eight aquatint plates, each being inked with a separate colour, seems never to have been applied to book illustration, probably because it would involve too much work and expense. The printing of coloured aquatint from one plate differs also in its result from the printing of coloured mezzotint. With mezzotint the softer, richer ground readily holds the colours, which are laid on with a stump on one plate, and gives a full, 'fat' impression. With aquatint the finer and more open ground hardly holds the colour, and gives a thin and weak result, making hand-colouring essential as a finish. Of course the method of hand-colouring made the coloured plates much more expensive, and many books, such as those of Malton, were published in a 'plain' state as well. One cannot but think that many of these, like the eighteenth century books mentioned in an earlier chapter, were bought at 'one penny plain' for the joy of amateur illumination.

HAND-COLOURING

The fascination of colouring is the same that drew Stevenson when he purchased Skelt's ' Juvenile Drama.' ' Nor can I quite forgive the child,' he writes, ' who wilfully foregoing pleasure stoops to " twopence coloured." With crimson lake (hark to the sound of it—crimson lake!—the horns of elf-land are not richer to the ear)—with crimson lake and Prussian blue a certain purple is to be compounded, which for cloaks especially, Titian could not equal. The latter colour with gamboge, a hated name, although an exquisite pigment, supplied a green of such a savoury greenness that to-day my heart regrets it.' [1] Stevenson mentions Skelt's successors, but with what joy would he have known of his forerunners, Messrs. Hodgson and Company, of 10 Newgate Street, who in 1822 and 1823 published three volumes of theatrical characters, the plates ranging from ' 1d. to 4d. plain,' and rising to as much as ' 9d. coloured,' the luscious crimson lake and Prussian blue being cheap indeed at the price. Thackeray, too, knew the joy of colouring prints. In his essay on Cruikshank he writes :—' Did we not forego tarts in order to buy his *Breaking-up*, or his *Fashionable Monstrosities* of the year eighteen hundred and something? Have we not before us at this very moment a print—one of the admirable *Illustrations of Phrenology*—which entire work was purchased by a joint-stock company of boys, each drawing lots afterwards for the separate prints, and taking his choice in rotation? The writer of this, too, had the honour of drawing the first lot, and seized immediately upon *Philoprogenitiveness*—a marvellous print (our copy is not at all improved by being coloured, which operation we performed on it ourselves)—a marvellous print indeed.' Constable also spent a pleasant afternoon in colouring the plates of a book. He writes from Charlotte Street, on March 27, 1833, to his boy Charles

[1] *Memories and Portraits*, xiii., ' A Penny Plain and Twopence Coloured.'

at school:—' I have coloured all the little pictures in Dr. Watts's Hymn-book for dear Emily, to be sent to her on her birthday. It looks very pretty.' This coloured copy of the *Songs Divine and Moral for the use of Children* is now in the National Art Library. It is a dainty little book, published in 1832 by Charles Whittingham at the Chiswick Press, with woodcuts after Stothard. A strange contrast it is, as you turn from the simple letter and the book with its simple colouring, to the rugged, massive strength and the Titanic grandeur of the large sketches for the Leaping Horse and the Hay-Wain in the gallery near by.

Where a book is a genuine coloured copy, issued under the direction of the artist and the publisher, the collector must not grudge a little extra expense, for to colour a whole edition, following a given model for each plate, is no mean task. In many cases the engraver of the aquatint is the colourist as well, or at least, as in Ackermann's case, colourist and engraver worked side by side. There are only very few cases where the colourist's name is mentioned separately, as in the series of views of Northumberland, where the imprint says, ' Drawn and etched by T. M. Richardson. Coloured by B. Hunter. Engraved by D. Havell'; or in Ackermann's *Scenery, Costumes and Architecture . . . of India*, where J. B. Hogarth is mentioned as the colourist, distinct from the engraver.

One of the best of these books, with the plates in perfect condition, is a real treasure, for, as any one who possesses a collection will know, there is a frequent tendency for the plates to become ' foxy,' and often the entire print will be reprinted in yellow over the text of the opposite page. In many other cases it happens that, where the text on the opposite page is of lesser extent than the engraving, the engraving loses its colour round the margin outside the text where it is touched by the plain paper. In a copy I have seen of

94

COLOURED AQUATINT

Ackermann's *Picturesque Tour of the Seine*, the frontispiece facing the title has lost its colour wherever it touched the bare paper, with the result that the reversed title appears as though printed in bright blue across a dead-coloured sky. It is a common fault, and Mr. Frank Short has suggested to me that it is due to the oil in the printer's ink having preserved the colours that touched it, whereas some chemical used in bleaching the paper has tended to destroy the colour. It is not a case of rubbing off, for the colour vanishes without leaving a trace on the opposite page. A coloured aquatint without any of these imperfections reproduces better than any other method the elusive beauties of a water-colour drawing. It has a delicacy, refinement, and purity that its successor the lithograph has never attained.

Before passing to the chapters on books illustrated by this method, I must state clearly that wherever I have used the term 'coloured aquatint' throughout these chapters, I mean by it an aquatint either partly or wholly coloured by hand. As explained above, it frequently has two (or three) tints printed in coloured inks as a preliminary assistance to the colourist, but it is invariably finished with water-colour applied by hand. In very many cases, in view of this hand-colouring, it is impossible to say definitely whether there are any underlying printed tints.

CHAPTER X

RUDOLPH ACKERMANN

AT the opening of the nineteenth century the great presiding genius, before whose magic wand so many pictorial books sprang into existence, was Rudolph Ackermann. Yet Ackermann was no romantic figure, but a shrewd, hard-headed German man of business, many-sided and resourceful, full of energy and enterprise, yet withal overflowing with kindness and charity. His influence and his personality count for much in the story of coloured books in England. Though there was much to discourage his early efforts, yet by strenuous perseverance, backed by clear judgment of artistic merit, he fostered what at first was a weakling plant in a strange soil till it reached a glorious maturity. As the first to gain real popularity for colour-illustration in books, Ackermann has considerable claim on our attention. The only early accounts of his life seem to be the short biographical notice in the *Gentleman's Magazine* (1834), a somewhat fuller notice in *Didaskalia* (1864), and a biography adapted from this, with corrections by ' W. P.' (Wyatt Papworth), in *Notes and Queries* (1869).

Ackermann was born on April 20, 1764, at Stolberg, in the Saxon Harz. Educated in his native town, he became apprentice to his father, a coach-builder and harness-maker, who in 1775 moved his business to Schneeberg. After receiving a thorough training in the designing branch of the trade, young Ackermann

96

visited Dresden and other German towns, and settled for a time in Paris, where he was the pupil and friend of Carossi, then of wide fame as a designer of equipages. Proceeding to London, he worked there for eight or ten years, furnishing all the principal coachmakers with new designs, among examples of his skill and success being the state coach built for the Lord-Lieutenant of Ireland in 1790 at a cost of £7000, and that for the Lord Mayor of Dublin in 1791. In 1795 he married an English-woman, who is chronicled as having no other dowry than all the domestic virtues, and in order to provide a settled home for his expected family, he set up a print-shop at 96 Strand, moving in the following year to No. 101. Here he had already revived a drawing-school established by William Shipley, the founder of the Society of Arts. Though he soon had eighty pupils, working under three masters, Ackermann saw fit to close the school in 1806, finding that his business as publisher, printseller, and dealer in fancy articles and artists' materials was so prospering that the room would be more profitable if used as a warehouse.

His ingenuity and enterprise were not confined to art matters alone, for at the opening of last century he was one of the first who arrived at a method of water-proofing leather, paper, cloth, etc., and for this purpose he erected a factory at Chelsea. In 1805 he was in-trusted with the preparation of the hearse for Lord Nelson's funeral. In 1807 he made experiments in aerostation, inventing a balloon that distributed thirty printed notices a minute from a packet of three thousand. He was almost the first in London to adopt the use of gas to illuminate his business premises, and in 1818 he patented a movable axle for carriages. But amid all this business activity—and as yet nothing has been said of his enterprise as a pub-lisher—he found time for an equally active philanthropy. During the period when the French *émigrés* were so

G

numerous in this country, he was one of the first to relieve their distress by liberal employment. He had seldom less than fifty nobles, priests, and ladies engaged in manufacturing screens, card-racks, flower-stands, and other ornaments. Again, when the sad affair of Leipzig, in 1813, and the consequent distress in Germany, gave rise to a movement for the relief of the sufferers, for over two years Ackermann devoted all his energies to raising and distributing a sum of over £200,000. In 1815 he was again active in the collection and distribution of a large sum for the relief of wounded Prussian soldiers and their relatives, and about the same time was enabled to aid the Spanish exiles, as he had those of France. To assist this branch of his charity he spent large sums in publishing Spanish translations of English books and in forming branch dépôts for their sale in many of the South American cities.

In 1827 Ackermann returned to 96 Strand, his old premises having been rebuilt by J. B. Papworth, architect by profession, and author of several architectural works which Ackermann published. He married for a second time, and in 1830 experienced an attack of paralysis, from which he never recovered sufficiently to take any personal interest in his business. He removed in consequence from his residence at Ivy Lodge, in the Fulham Road, to Finchley, but a second stroke brought a gradual decline of strength. On March 30, 1834, his useful life drew to its close, and a few days later he was buried in the family grave at St. Clement Danes.

Such is a brief outline of Ackermann's life, to show something of his largeness of heart and of the versatility of his genius. It remains to speak now of his connection with art, and of the publishing business, the foundation of which was his principal work. From the first his interest lay in illustrated books. Finding that

INTERIOR VIEW OF ACKERMANN'S REPOSITORY OF ARTS

FROM "THE REPOSITORY OF ARTS," VOL. I, 1809

among all the libraries of the metropolis there was none exclusively appropriated to books on the fine arts, he made up his mind to supply the want, and fitted up as a public library, from designs by Papworth, the large room at 101 Strand, once used as a studio. This he now furnished 'with a copious collection of such books as relate to the arts, or are adorned with graphic illustrations, among which may be found the most splendid works, both ancient and modern.' A coloured aquatint of this library is included in vol. ix. of the *Repository*. Always ready to welcome any discovery in art, Ackermann was one of the first to encourage the new art of lithography, for which Senefelder had taken out an English patent in 1800. The inventor himself had taken no advantage of this, but a M. Andrée of Offenbach, acting perhaps as Senefelder's agent, published in 1803 his *Specimens of Polyautography*. Though from this time the art began to take root, it was not till Ackermann showed a practical interest in it that real progress began. 'The admirable productions which have of late appeared in Munich,' says the *Repository* of 1817, 'have excited a spirit of emulation in Mr. Ackermann, who is determined to use his best endeavours to rival this art of the Continent.' The article, from which this quotation is drawn, deals with the technique of the process, and is illustrated with a lithograph by Prout. The most important outcome of Ackermann's interest in this art was the publication in 1819 of Senefelder's *Complete Course of Lithography*, an English translation of the original German edition, published a year before at Munich. The book, it should be remarked, contains as frontispiece an ornamental initial, printed in red and black— the first example of colour lithography in an English book. All these essays are noteworthy as the incunabula of the colour lithographs which were later to form so important a branch of book illustration.

Ackermann's highest achievement, however, was the great series of books with coloured illustrations, published from 1808 onwards, which have given him a high place in the roll of publishers, from the Sosii downwards, who have won a place in history. To accomplish this work he had to train a large band of artists to act under his instructions and carry out his ideas. The result was a wonderful output of excellent work; but just as the writers for a large newspaper, under the strong personality of an editor, produce work of singular similarity in style, so among Ackermann's staff there was a trend towards uniformity and mediocrity. But the mediocrity was golden, and if the casual observer cannot say, without a glance at the inscription below, 'There's a Stadler,' or 'That's by Bluck,' with the triumph of the lady who points out a Peter Graham or a MacWhirter without the aid of her catalogue, yet this want of ready distinction is of little consequence where all is so excellent. Ackermann no doubt knew the men he dealt with, and when he 'discovered' Rowlandson, gave him unhampered scope for his genius. The very nature of coloured aquatint, when applied continually to architectural and topographical views, caused a uniformity; but when so high a standard was maintained, the publisher might well be content.

In 1808 began the sumptuous series of books in elephant quarto.[1] Printed on hot-pressed, handmade paper, these books were illustrated with coloured aquatints, which in the history of book illustration have scarcely been surpassed. All were published at Ackermann's Repository of Arts, No. 101 Strand, and were issued originally in monthly parts with paper covers. The first to appear was *The Microcosm of London: or London in Miniature*. The original idea was to publish this book in twenty-four numbers, at 7s. 6d. a number, but Ackermann soon found himself obliged to raise the

[1] Elephant quarto measures 14 by 11½ inches, atlas quarto 16½ by 13.

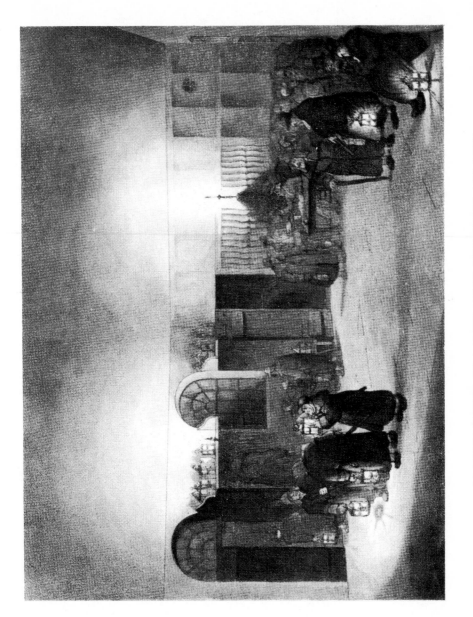

"A WATCH HOUSE." BY J. BLUCK, AFTER ROWLANDSON AND PUGIN

FROM "THE MICROCOSM OF LONDON," 1810

price to 10s. 6d. and the number of parts to twenty-six, saying in the preface to the third volume that 'when the price is compared with the work itself, the publisher flatters himself that it will appear that he has been influenced by other motives besides those of gain in the prosecution of it.' In its final form in three volumes, published in 1810, the book was sold at thirteen guineas. The striking feature, as in all this series, is not so much the text (though the third volume is notable as the work of W. Combe) but the coloured illustrations, in this case the combined work of Pugin and Rowlandson. To quote from the preface: 'The great objection that men fond of the fine arts have hitherto made to engravings on architectural subjects has been that the buildings and figures have almost invariably been designed by the same artists. In consequence of this, the figures have been generally neglected, or are of a very inferior cast, and totally unconnected with the other part of the print. . . . The architectural part of the subjects that are contained in this work, will be delineated, with the utmost precision and care, by Mr. Pugin, whose uncommon accuracy and elegant taste have been displayed in his former productions. With respect to the figures, they are from the pencil of Mr. Rowlandson, with whose professional talents the public are already so well acquainted, that it is not necessary to expatiate on them here.'

The pictures in this book cover all the well-known public buildings of London—churches, banks, prisons, theatres, etc.,—capitally portrayed by Pugin. Pugin had exhibited first in the Royal Academy ten years before, and during the intervening period had been employed in the office of Nash, the architect of Waterloo Place and Pall Mall. His work for Ackermann seems to have been his first essay in book illustration, but his architectural training enabled him to add great care and accuracy of detail to a bold and expressive

style. Of Rowlandson and his connection with Acker-
mann we shall have more to say in a separate chapter.
The great metropolis, with its high life and low, its
light and its shade, could have had no one better fitted
to portray its inmates. The spirited figures that he
adds to Pugin's backgrounds show that his talents
were not limited to the ludicrous and grotesque. With
the happiest faculty for expressing character, he is
equally at home amid a serious discussion of naval
policy at the Admiralty Board-Room, or among the
excited, gambling crowd of the Royal Cockpit. At
Westminster Abbey or Bridewell, the College of Physi-
cians or Billingsgate, everywhere he has seized on the
essential features and the typical frequenters of the
place. Like every great satirist, he has stamped upon
his work the *humani nihil a me alienum puto*. The
book is a living and delightful record of the old metro-
polis of a hundred years ago, the London of Lamb,
Jane Austen, Dickens, and Thackeray, of places and
incidents that are now mere memories. You will find
here the old playhouses—Covent Garden, Drury Lane,
Astley's, and Sadler's Wells. You will find a picture
of Doctors Commons, that recalls David Copperfield
and Mr. Twemlow. You will find the Fleet Prison,
with its memories of Mr. Pickwick, Sam Weller, and
Mr. Jingle. Here, too, is Vauxhall Gardens, where
Becky Sharp so enjoyed herself.

Of the hundred and four coloured aquatints after
these two artists, fifty-four are engraved by J. Bluck,
twenty-nine by J. C. Stadler, ten by T. Sutherland, ten
by J. Hill, and one by Harraden. In addition there
are three titles, one to each volume, engraved in line
by R. Ashby after T. Tomkins, and at the head of
each of these a small allegorical stipple by T. William-
son after E. F. Burney. In each volume also is the
mark of the printer, a very indifferent woodcut, looking
as though Ackermann had deliberately left it to show

the difference between a stock trade device and his own artistic productions. The Print Room at the British Museum possesses two of Rowlandson's original sketches for this volume, which are mounted along with a copy of the published aquatint. The first, a sketch for 'Christie's Auction Room,' differs considerably from the aquatint, where the architectural details have been added by Pugin, and the crowd of figures altered and re-arranged. The original sketch for 'Mounting Guard, St. James's Park,' also shows much variation, and with all due deference to Pugin, the grouping of the buildings, and the architectural effect given by Rowlandson's slight wash of colour, are much preferable to Pugin's laboured perspective.

Ackermann's next publication was *The History of the Abbey Church of St. Peter's, Westminster*, which was intended as a 'companion and continuation of *The Microcosm of London*.' Published in sixteen monthly numbers, it appeared finally in two volumes in 1812 at £15. The text was by Combe, and the book is an interesting one to the student of history and architecture, but after the life and variety of the *Microcosm* there is a certain dulness about the storied urns and monumental busts that form a great part of the illustrations. The artists seem somehow to have failed in producing the majesty of long-drawn aisle and fretted vault, the atmosphere that would be found in a line engraving is missing, and the blues and greens used in translating the colours of the stones are monotonous and not altogether convincing. Yet the work was one of which its publisher might be justly proud. When it was completed, he had all the original drawings bound up with the letterpress and mounted on vellum, making a unique copy. A special design with Gothic details was prepared by J. B. Papworth for the brass mountings and clasps of the two volumes, which cost £120. This copy Ackermann valued so highly that

he used to provide a pair of white kid gloves for the use of the happy individual who was granted the honour of inspecting it.[1] Eight engravers are represented, the principal one again being J. Bluck, who executed forty-nine of the aquatints (seven in conjunction with other engravers), and T. Sutherland, who worked on fourteen. The other engravers are J. Hamble, Hopwood, W. J. White, Williamson, G. Lewis, and F. C. Lewis, who, in 1803, at the age of twenty-four, had aquatinted Girtin's 'Views of Paris,' and who afterwards became a prolific engraver of stipple portraits after Lawrence and others. The artists are seven in number, thirty-four of the drawings being by F. Mackenzie and eighteen by Pugin, while others are by W. J. White, H. Villiers, T. Uwins, Thompson, and G. Shepherd. Besides the eighty aquatints the book includes a plan, a title-page engraved in line by S. Mitan, and a portrait in stipple by H. Meyer after W. Owen.

In *The Historical Sketch of Moscow*, published in 1813 at '£1, 11s. 6d. plain, £2, 2s. coloured,' the twelve coloured aquatints are views of a panoramic nature, picturesque, but of no striking artistic value, the best being a view of Moscow from the balcony of the Imperial Palace. No artist's or engraver's name is mentioned, though the text is quite subservient to the pictures. The introduction states that the text 'is intended by the publisher merely to convey some historical recollections to the mind of the reader at the time of viewing the prints.'

During 1813 and 1814 *The History of the University of Oxford* and *The History of the University of Cambridge* were being issued in monthly parts, a thousand copies being published, the first five hundred at 12s., and the remaining five hundred at 16s. a part. To these was added a supplementary series of portraits

[1] See *Life of J. B. Papworth*, by W. Papworth. Privately printed, 1879.

of founders of the colleges, and the two noble volumes thus completed were published in 1814 and 1815 respectively, their price being £16 in elephant and £27 in atlas quarto. The fine aquatints, with their somewhat old-world flavour, are well suited to reproduce the spirit and to recall the antique associations of the old quads and courts. Apart, too, from their fitness and beauty, the plates are of value as a historical record. To take St. John's, Cambridge, as a single instance, one view shows the old chapel, pulled down in 1863, in its place now being an erection by Sir Gilbert Scott; and in the view from Fisher Lane several buildings are shown on both sides of the river, which have since disappeared. The principal artists employed by Ackermann to make the drawings for these two books were Pugin, Mackenzie, W. Westall, and F. Nash, and in interiors and exteriors alike their work is full of strength, sympathy, and charm. To prove the care spent on the originals one has only to examine Pugin's drawing, now in the Victoria and Albert Museum, for the 'High Street, Oxford, looking west.' In the *Oxford* volume twenty-three of the sixty-eight[1] coloured aquatints are engraved by J. Bluck, twelve by J. Hill, eleven by J. C. Stadler, and the rest are divided among F. C. Lewis, W. Bennett, D. Havell, G. Lewis, J. and R. Reeve, and T. Sutherland. Of the sixty-four *Cambridge* illustrations thirty-five are by Stadler, fourteen by Bluck, twelve by Havell, and the other three by R. Reeve and J. Hill. In each volume there is a series of hand-coloured plates of costume, in line and stipple, by J. Agar after T. Uwins, fifteen in the *Cambridge*, and seventeen in the *Oxford*.[2] Mr. Uwins seems to have been inspired with the belief that all university

[1] In the index of plates these count as sixty-four, as four sheets contain two plates each.
[2] These seventeen were all portraits. For a list of the originals, see the note by the Rev. J. Pickford in *Notes and Queries*, July 6, 1878.

dons are divinely tall and slender, with the exception of doctors of divinity, who alone in both volumes are depicted in possession of a comfortable portliness. In the *Oxford* volume there are thirty-two portraits of founders, in the *Cambridge* fifteen, in line and stipple, hand-coloured, but no engraver's name is mentioned. Each volume also has as frontispiece an engraved portrait of the chancellor of the university by H. Meyer. The collector need not bemoan his fate if the plates of founders be missing, for they were purely a supplement, and Ackermann's index of plates provides for binding 'with or without the founders,' and the value of the book lies in the aquatints. It may be noted that the exterior landscape views in these two volumes occasionally illustrate the use of a blue printed tint for the sky, and of a brown for buildings, trees, and ground. In the National Art Library there is what appears to be a rare copy of the *Oxford* with the plates on India paper, uncoloured.

The *Oxford* and *Cambridge* were fittingly followed by a *History of the Colleges*, which embraces the principal public schools—Winchester, Eton, Westminster, Charterhouse, St. Paul's, Merchant Taylors, Harrow, Rugby, and Christ's Hospital. Of this also a thousand copies were issued in monthly parts, the first appearing on January 1, 1816. The price for each part was again the same, but the whole, forming only one volume, was sold for seven guineas. The text, with the exception of the parts dealing with Winchester, Eton, and Harrow[1] (the work of W. H. Pyne), was entirely written by Combe, and the same artists were employed in its decoration, the highest praise for which is that it equals, if not surpasses, that of the *Oxford* and *Cambridge*.

The original drawings for the forty-eight coloured

[1] Camden Hotten, in his memoir of Combe, says 'Winchester, Harrow, and Rugby,' but the above statement bears Ackermann's own authority.

"PEMBROKE HALL, ETC. FROM A WINDOW AT PETERHOUSE." BY J. C. STADLER,
AFTER F. MACKENZIE
FROM ACKERMANN'S "HISTORY OF THE UNIVERSITY OF CAMBRIDGE," 1815

plates were distributed among Westall, who executed fifteen, and Pugin and Mackenzie, who did fourteen each, while one is by J. Gendall, who besides illustrating Ackermann's publications was employed for some years in managing his business, particularly in developing the new art of lithography. The actual engraving was done by Havell and Stadler, with a few plates by Bluck and Bennett, and four line engravings of costume by Agar after Uwins. Here again it may be noticed that many of the aquatints are printed in two colours before being finished by hand. This and the two University volumes, published in three successive years, with the kindred nature of their subject and the splendour of their illustrations, form a magnificent trilogy. The happy owner of all three books, with aquatints complete and clean, and the ample margin of the text uncut, has a possession both rich and rare.

In 1820 began a series of books dealing with travel and scenery. The first was *Picturesque Illustrations of Buenos Ayres and Monte Video*, with descriptions of scenery, customs, and manners by E. E. Vidal. The book was issued in six monthly parts, seven hundred and fifty copies on elephant paper, and fifty on atlas, the final price being £3, 13s. 6d. and £6, 6s. The twenty-four aquatints, all after drawings by Vidal, four of them being large folded plates, are engraved by G. Maile, J. Bluck, T. Sutherland, and D. Havell. These are not of any striking merit, and are not to be compared with those of the *Oxford* trilogy or the *Microcosm*, but, like all coloured aquatints, they possess a subtle charm of their own apart from their historical and geographical value. The same year saw the publication of a *Picturesque Tour of the Rhine from Metz to Cologne*, by Baron von Gerning. The book is illustrated with twenty-four highly finished and coloured aquatints from the drawings of M. Schuetz, and it is impossible not to feel that in his selection of the artist

Ackermann was overcome by the exuberance of his own patriotism. Though finely produced, the volume fails to rise above the ordinary type of show-book for a drawing-room. The engravings are by Havell and Sutherland, but the subjects are too German in character, too pretty, and too lacking in breadth and atmosphere. The best, perhaps, is the view of Thurnberg, where the square turreted castle standing high above the Rhine lends its own dignity to the drawing.

A companion volume, a *Picturesque Tour of the Seine*, by M. Sauvan, was published in the following year, 1821, being first issued, like all the others, in monthly parts. The paper covers have a design in lithography by J. Gendall. Though the title-page states that the twenty-four coloured aquatints are from drawings by A. Pugin and J. Gendall, only one original is directly ascribed to the former, but two of the engravings are from drawings by Gendall after Pugin. The rest are all after Gendall, but it is possible, especially considering the number of architectural subjects, that Gendall may have worked from Pugin's drawings in other than the two cases mentioned. Sixteen of the engravings are by Sutherland and six by Havell, with two vignettes at beginning and end unascribed. Coloured aquatint, unless it be executed with consummate skill and care, fails most easily in the case of open landscape. Many of the engravings in this book are poor in composition and colouring, but the ' Pont de l'Arche,' ' Rouen,' and ' Havre,' by Sutherland after Gendall, give a charming effect.

The same year saw the publication of a *Picturesque Tour of the English Lakes*, in the preface to which Ackermann pays fitting tribute to the beauty of English scenery. The prefaces to this and to the book on the public schools seem to have been the only ones written, or at any rate signed, by the publisher himself. The book came out in twelve monthly parts, seven hundred

and fifty copies in demy quarto, and one hundred on elephant paper, the final price being £3, 13s. 6d. and £6, 6s. Of the forty-eight coloured aquatints, thirty-five are after T. H. Fielding, twelve after J. Walton, and one after Westall. No engraver's name is mentioned, but an announcement in the *Repository* shows the engraving to have been done entirely by Fielding. The book shows the frequent use of two preliminary tints in the printing of the aquatints. In most cases the hand-colouring is rather harsh and crude, deep browns being prevalent, with none of the transparency that is one of the beauties of aquatint. The engraver seems to have relied more on added water-colour than on the aquatint ground, and to have forsaken broad washes of colour for the sake of details. As has been said before, the colouring of an aquatint landscape has to be extremely good, or else is worse than useless. An indifferent architectural subject is invariably superior to an indifferent landscape. The test one naturally applies is to ask how far these pictures in frames would add to the adornment of a room or to its owner's delectation, and herein the *Tour of the English Lakes* is found wanting, but this is only when compared with the best of its kind.

The next of this large series was a *Picturesque Tour along the Rivers Ganges and Jumna*, with views by Lieut.-Col. Forrest, published in six monthly parts in 1824. Of the twenty-six coloured aquatints, nineteen are by T. Sutherland and five by G. Hunt, and in addition to these there are two vignettes not attributed. The illustrations are clear and bright, finely engraved, frequently printed in two colours, and well finished by hand; yet they are too cool and shadowless to be expressive of simmering, tropical heat. For all that, they are a brave attempt to express what the author in the glittering and oriental peroration to his preface describes as 'the enchanting features of India, eternally glowing

in the brilliant glory of the resplendent Asiatic sun.'
Ackermann's *Repository* in 1824 announces that Lieut.-
Col. Forrest 'is engaged on a *Picturesque Tour through
the Provinces of Lower and Upper Canada,*' to be
illustrated by coloured lithographic drawings. Of this
book, if it were published, I fear I cannot speak from
personal experience.

In 1828, shortly after returning to his old premises,
Ackermann produced another of the series, a *Picturesque
Tour of the River Thames*, again in six monthly parts,
with coloured aquatint illustrations. Two vignettes
and five plates, showing the open part of the Thames
from Southwark to Sheerness, are after S. Owen, whose
views of Thames scenery had recently been produced
in a brilliant series of line engravings by W. B. Cooke.
The other nineteen plates are after W. Westall. Fifteen
of the engravings are by R. G. Reeve, the rest being
by C. Bentley, J. Bailey, and J. Fielding. The use of
two tints in printing is particularly noticeable, as the
blue used for the sky is unusually bright. The plates
suffer from the fact that the engravers have laid very
little, or else a very fine ground, leaving clear spaces,
and evidently trusting to the hand-colouring for the
final effect, which as a result is thin and without depth.
Where the aquatint work is more careful, as in the
'View of Richmond Hill' by Reeve after Westall, the
result is more satisfactory, but one cannot but feel that
here subject and drawing made a special appeal to the
engraver's taste.

Such were Ackermann's larger and more important
single publications. It must not be supposed that
these books repaid the risk, and in some cases the
actual cost, of publication, but the losses were partly
compensated by the wonderful success of smaller works,
particularly the *Repository of Arts* and the *Poetical
Magazine*, both of them monthly periodicals. The
Repository was an attempt to cut out the old-established

Gentleman's Magazine and *European Magazine*, which dealt with life and politics in a fashion somewhat lofty and severe, with only an occasional illustration. Published at 4s. a month (the first number appeared on January 2, 1809), it aimed throughout at popularity. Its full title, *The Repository of Arts, Literature, Commerce, Manufactures, Fashions and Politics*, was no exaggeration, for its wares were as universal as those of Autolycus. The value and nature of the magazine are best shown by the success which attended the re-issue of its more important contents in separate volumes. Besides the continued articles, which were of sufficient length and importance to be deemed worthy of separate publication, there were criticisms of art exhibitions, reviews and announcements of books, reports on the public health, market prices, the weather, bankruptcies, etc. There were articles, too, on 'London Fashions,' and a monthly letter, treating of the latest confections of millinery, written in the most modern style by 'Eudocia' to 'My dear Sophia,' under the general heading of 'French Female Fashions.' Correspondence was encouraged; the latest discoveries and inventions were explained in simple terms; the current topics were discussed. If 'the whole fashionable world was attracted to Pall Mall' by some Indian jugglers, the country cousin would find in the next *Repository* a coloured picture and their complete history. In 1819 you are told of the wonderful invention of a 'Pedestrian's hobby-horse,' and hear that 'the swiftness with which a person well-practised can travel, is almost beyond belief; eight, nine, or even ten miles can be passed over within an hour. The price is from £8 to £10.' The 'embellishments' are numerous, consisting of woodcuts, line and stipple engravings, after 1817 a gradual introduction of lithography, and throughout a large series of coloured aquatints. The *Repository* became a universal provider, and before the end of a year

could boast of three thousand subscribers—a large number for those early days of journalism. Under the management of F. Shoberl as general editor, it continued till December 1828, consisting of a first series of fourteen volumes, a second of fourteen, and a third of twelve. The coloured plates comprise about eight hundred of London streets, squares, palaces, etc.; about four hundred and fifty of costumes and fashions; numerous plates by Rowlandson; about one hundred and eighty of noblemen's and gentlemen's seats, others of furniture, and so on.

The character of the *Repository*, however, is best shown by the series of reprints, which were issued in book form. *Letters from Italy*, by Lewis Engelbach (1809-15), with eighteen plates by Rowlandson, was reprinted as *Naples and the Campagna Felice* in 1815. *Select Views of London*, seventy-six plates, with text by J. B. Papworth (1810-15), was republished in 1816, followed in 1818 by Papworth's *Rural Residences* (1816-17). *Sentimental Travels in the Southern Provinces of France*, with eighteen plates by Rowlandson (1817-20), reappeared in 1821. *A Picturesque Tour from Geneva to Milan* (1818-20), with text by Shoberl and thirty-six plates, was republished in 1820; *Pictorial Cards* (1818-19) in 1819; *Hints on Ornamental Gardening*, thirty-four plates by J. B. Papworth, in 1823; and a *Picturesque Tour through the Oberland*, with seventeen plates (1821-22), in 1823.

The prospectus of the *Poetical Magazine* appeared with the fourth number of the *Repository*, April 1809. The editor had evidently become tired of acknowledging among his answers to correspondents the receipt of 'Angelica's beautiful lines on the faded Pensée,' and other 'very elegant trifles,' and decided to give scope to the growing talents of these poetical contributors. In the May number he notes the appearance of the new magazine. 'To the lovers of Poetry we have also to

apologize for the disappointment they will experience from our present number. We shall endeavour in future to prevent its recurrence; but, in the mean time, beg leave to recommend to their notice the first number of the *Poetical Magazine*, published on the 1st May by the Proprietor of the *Repository*.' This first number in its introductory address remarks how many flights of fancy have been lost, how many odes, elegies, songs, ballads, and madrigals have been destroyed and forgotten because no immediate vehicle could be found to give them a chance of celebrity. The *Poetical Magazine* was established 'that no future offspring of the Muses may be born but to die, and that no poetic flower may blush unseen.' The magazine continued for three years, and amid pages replete with indifferent and amateurish work it contained the first *Tour of Dr. Syntax* with its famous illustrations by Rowlandson, which was published later in book form, to be followed by the two other Tours, running through edition after edition.[1] The illustrations to the magazine, all in coloured aquatint, are those of the *Tour*, with occasional views of Italian and English scenery.

Among other works was a *History of Madeira*, in imperial quarto, published (at £2, 2s.) in 1821 with a series of twenty-seven coloured aquatints. No engraver's name is mentioned, but the designs are stated to have been 'communicated by a resident of the island.' They are intended to display character as well as costume, and show priest, friar, peasant, and fisherman at their daily occupations, not without a touch of humour. The entire text, most of it in verse, was from the pen of W. Combe, then in his seventy-ninth year. In 1822 appeared *Illustrations of Japan*, translated from the French of I. Titsingh by F. Shoberl. The book consists of private memoirs and anecdotes of the sovereigns of Japan, descriptions of feasts and

[1] See pp. 167-170.

ceremonies, and remarks on language and literature. Its eleven coloured plates in aquatint or line, one being signed by J. C. Stadler, are of little value in themselves, but are of interest as illustrating one of the first books, dealing with things Japanese, introduced into this country. Isaac Titsingh, who for fourteen years served the Dutch East India Company as chief of their settlement at Nagasaki, is claimed by Mr. E. F. Strange in his *Japanese Illustration* as the earliest European collector of Japanese prints, the modern appreciation of which may be said to date from the Paris Exhibition of 1867.

From 1821 onwards the *World in Miniature* was published in monthly parts, forming at its close in 1827 a series of forty-two volumes. The motto on each title-page was ' The proper study of mankind is man,' and the idea was to produce a series, as the preface states, ' descriptive of the peculiar manners, customs, and characters of the different nations of the globe. Agreeably to this plan the reader will obtain, within a moderate compass, and at a very cheap rate, considering the number and elegance of the embellishments, such circumstantial details respecting the various branches of the great family of Man, as are not to be found in any of our systems of geography.' The text was edited by Frederick Shoberl, the volumes are duodecimo, and the plates, none of which are signed, are in line and stipple coloured by hand. These form a valuable and dainty series of costume plates, and the publisher may well claim ' spirit, fidelity, and elegance of execution ' for his ' numerous graphic illustrations.' The first to appear was *Illyria and Dalmatia* in two parts at 12s., with thirty-two coloured engravings, and this was followed by *Africa* in four volumes at 21s., with forty-five engravings, and *Turkey* in six volumes. In 1822 came *Hindoostan* (six volumes), *Persia* (three), and two volumes of *Russia*. The third and fourth volumes of

Russia appeared in 1823, and were followed by *Austria* (two), *China* (two), *Japan* and the *Netherlands* (one). In 1824 were issued *The South Sea Islands* (two), *The Asiatic Islands* (two), and *Tibet* (one). In 1825 came *Spain and Portugal* (two), and in 1827 the series ended with *England, Scotland, and Ireland* in four volumes, edited by W. H. Pyne.

In June 1826 the *Repository* noted that ' Mr. Ackermann has ready for publication a work intended for the present to consist of two parts in atlas 4°, each containing six coloured plates in aquatint, illustrative of *Scenery, Costumes, and Architecture, chiefly on the western side of India* . . . by Capt. R. M. Grindlay.' The two parts here referred to were published in 1826, but after this the plates have the imprint of Smith, Elder, and the title-page of the book, published finally in 1830, is endorsed 'London, Smith, Elder & Co., Cornhill.' Of the thirty-six original drawings for the book, fifteen were by Westall, ten by Grindlay, while other artists were W. Daniell, Clarkson Stanfield, D. Roberts, and Copley Fielding. The principal engravers were R. G. Reeve with fourteen plates, T. Fielding with six, C. Bentley with seven, and G. Hunt with three. It may be added as somewhat exceptional that on many of the plates the name of J. B. Hogarth, the colourist, is given besides that of the engraver. In good condition this is an exceedingly fine book, and in Christopher North's *Noctes Ambrosianæ* we read :—

> '*Shepherd.* What thin Folio's yon sprawling on the side-table ?
>
> *North.* Scenery, costume, and architecture, chiefly on the western side of India, by Captain R. M. Grindlay—a beautiful and a splendid work. Pen, pencil, or sword, come alike to the hand of an accomplished British officer.
>
> *Shepherd.* There maun be thousan's o' leebraries in Britain, private and public, that ought to hae sic a wark.'

To the year 1828 belongs the *Characters in the Grand Fancy Ball given by the British Ambassador, Sir Henry Wellesley, at Vienna*, 1826. The book appeals to many by its thirteen plates (line engravings, tinted by hand) and descriptive text of the dresses worn by the many people of rank and distinction, who formed quadrilles composed of characters from the novels of Sir Walter Scott and La Motte Fouqué. 'The profusion of jewels and precious stones displayed on this occasion was almost incredible. The grandeur of the whole, the high rank of the co-operating persons, the assemblage of the flower of the highest nobility, of female beauty, and of noble manly forms, the brilliant armour and weapons, the succession of characters of the East and of the West, of history and of romance—all served to heighten the impression of this extraordinary fête, which can never be erased from the memory of those who had the good fortune to be present.'

One of Ackermann's last publications is the *History and Doctrine of Buddhism*, by Edward Upham, in 1829. The illustrations are forty-three lithographs, coloured by hand, from original Singalese designs. These designs, consisting of friezes that slowly unroll some Eastern tale, pictures of gods and devils, signs of the zodiac, etc., are decorative in treatment and colouring. This seems to have been Ackermann's first venture with coloured lithographs, but no engraver's name is given.

Some Drawing-Books published by Ackermann are referred to in the following chapter; and in Appendix II. will be found an attempt to give a complete chronological list of Ackermann's coloured books.

CHAPTER XI

DRAWING-BOOKS

OF special interest among books with coloured plates are some of the early drawing-books. They are of very distinct value in that they treat of the different ways of handling the water-colour medium at a time when the art was in its transitional stage. The painters in water-colour worked over a monochrome ground; perfection of tone, by means of greyish blues and timid browns and yellows, was the final aim and object; the brilliancy of colour produced by laying natural colours on white paper was considered a daring innovation. The contemporary drawing-books are therefore of the utmost importance in considering the evolution of the essentially English art of water-colour, and for our present purpose it is noteworthy that many are written by well-known artists, whose theories are illustrated by the reproduction in colour of their own sketches.

Some of the earliest of these treatises were published by Ackermann. One of the first was *Bryant's treatise on the use of Indian Inks and Colours*, which appeared in 1808, with six plates in coloured aquatint, two being engraved by Harraden, and four by J. Bluck. The plate by Bluck after W. H. Pyne is a perfect example of printing in two tints from one plate, the ruins and rocks in the foreground being in a rich brown colour, the water and distant hills in blue. It is to be noted that the publication line is printed in the brown ink used

117

for the foreground. In 1812 W. H. Pyne, already mentioned in connection with Ackermann, wrote his *Rudiments of Landscape Drawing*, illustrated by several aquatints somewhat roughly coloured by hand. But among many books of this kind issued by Ackermann, the best and most important was the *Rudiments of Landscape*, by Samuel Prout, published in 1813. It contains many engravings and sixteen really fine aquatints, so coloured by hand as to be almost original water-colour drawings. I have known four of these plates to be offered for sale as water-colours, marked as a genuine bargain at £20! In 1813, it may be added, eleven soft-ground etchings by Prout were published by T. Palser, but the hand-colouring is weaker than that of the Ackermann book, and the lines of the etching are always obtrusive. In a late work by Prout, *A Series of Easy Lessons in Landscape Drawing*, published by Ackermann in 1820 at £1, 11s. 6d., there are again eight coloured aquatints. In 1821 *The Cabinet of the Arts, being a New and Universal Drawing-Book*, contains a few coloured aquatints after Prout and others.

The best and most important of all the early drawing-books, in view of the position that their author now holds in public esteem, are those by David Cox. The first and best, *A Treatise on Landscape Painting and Effect in Water Colours*, was published in large oblong quarto by S. and J. Fuller in 1814. Cox was then only thirty years of age, and it was not till 1840 that he reached the fulness of his power, but the book is the more interesting in that it shows the man and his art in the making. Besides soft-ground etchings it contains fifteen aquatints in colour, engraved by R. Reeve, and so highly finished as to give almost the effect of an original water-colour. 'Afternoon' and 'A Heath, Windy Effect,' may be mentioned as exceptionally brilliant in execution, and as typical examples of

118

"AFTERNOON: A VIEW IN SURREY." BY H. REEVE, AFTER DAVID COX
FROM "A TREATISE ON LANDSCAPE PAINTING AND EFFECT IN WATER COLOURS", 1814

Cox's work. In the possession of Mr. Frank Short are proofs of two of the plates for this book, coloured by Cox for the hand-colourist to copy. Several editions of the book were issued, the latest in 1841. This treatise was followed by a smaller oblong quarto, *A Series of Progressive Lessons in Water Colours*. The first edition was published by T. Clay in 1816, and by 1823 the book had reached a fifth edition, having larger and improved aquatint illustrations, many in colour, engraved by G. Hunt. In this book Cox pursued, though to a lesser extent, the method adopted by Hassell in 1813, of giving in the text small squares of the required colour as a specimen. Of this book also there were several editions, the last in 1845. Its early success caused its author to follow it by another 'drawing-book of studies and landscape embellishments,' entitled the *Young Artist's Companion*, and published by S. and J. Fuller in 1825. In this, in addition to other plates, there is a coloured frontispiece, and at the end twelve coloured aquatints of still life and landscape engraved by T. Sutherland and R. Reeve, and again highly finished in water-colour.

A Practical Essay on the Art of Colouring and Painting Landscapes in Water Colours, an earlier book than Cox's, was published in 1807 by E. Orme. Six of the ten aquatint plates are in colours, and all are engraved by J. Hamble after Clark. A second edition appeared in 1812. In 1824 Clark produced *A Practical Illustration of Gilpin's Day . . . with instructions in . . . painting in Water Colours*. Intended primarily as a drawing-book, it contains thirty aquatints coloured entirely by hand, some of them the nearest approach to actual water-colour paintings that I have met with in a book. Mr. Clark has tried to obtain the washy effect of water-colour by disregarding and softening the edges of the aquatint work, letting his colour, particularly in the case of foliage, run into blots. The subjects of the

plates range from early dawn and the stages of the sunrise, to dewy eve and the various phases of the moon. Some of the pictures, particularly where there is a predominant tone of cool blue or grey, have strength and dignity. Although the colouring in others is naturally somewhat crude and startling, especially in the treatment of the sky at sunrise and sunset, or of rainbow or lightning effects, yet all are suggestive. One notices how skilfully the burnisher has been used in getting the effect of the rising mist in No. 23, 'Evening closing in,' and of the flecky white clouds in No. 28, 'Cloudy Moonlight.' It is noticeable also that in the effort to obtain the full effect of a water-colour drawing the sparkling reflections of the moon in the water have been systematically scraped out by the colourist with a knife.

A word should perhaps be said here as to the Rev. W. Gilpin, to whose writings on the picturesque and beautiful we owe Clark's book. Gilpin began Ruskin's work before Ruskin's time, and 'built up a storehouse of images and illustrations of external nature, remarkable for their fidelity and beauty.' Born in 1724, he became a schoolmaster, and in his summer vacations visited parts of England on sketching tours, by the publication of which he became so well known. His *Observations on the River Wye*, published in 1782, was the first of a series of five works with similar titles, creating a new class of travels which exposed the author to the satire of Combe's 'Dr. Syntax.' The illustrations to all these books are in aquatint, over which is washed with the brush a tint of warm yellow or brown to give tone to the picture, as in Hassell's *Isle of Wight*. The description, from which Clark takes his title of 'Gilpin's Day,' occurs in a poem in Gilpin's *Essays on Pictorial Beauty*, which tells of the 'arch ethereal . . . pregnant with change perpetual, from the morning's purple dawn, till the last glimm'ring ray of russet eve.'

Two or three drawing-books are by John Hassell, an engraver and drawing-master, and the friend of George Morland, whose life he wrote in 1806. The date of his birth is unknown, but he exhibited first at the Royal Academy in 1789. He was one of the earliest to apply colour to aquatints, and in his *Tour of the Isle of Wight*, published in 1790, he has experimented by washing a single tint of a blue, green, or reddish colour by hand over the finished aquatint. This is the method employed by Gilpin, except that Hassell varies his colours. In 1808 he produced his *Speculum, or Art of Drawing in Water Colours*, which by 1818 had reached a third edition. On the front page is the advertisement: 'Drawing taught, and Schools attended by the Author. Letters addressed to J. Hassell, No. 5 Newgate-Street, will be duly attended to.' Both this and his *Camera: or Art of Drawing in Water Colours*, of 1823, have as frontispiece a brightly coloured aquatint. His largest and most interesting book is his *Aqua Pictura*, published in parts in 1813. The idea was, as the preface states, to take a drawing by one of the most celebrated draughtsmen of the age, and to publish four prints showing progressive stages of the work. These appeared on the first of each month. The drawings selected are by Payne, Varley, Girtin, Prout, Cox, and others. For the text the curious method was adopted of explaining in detail the progress of the accompanying drawing, analysing its methods, and illustrating by a dash of actual colour each colour mentioned as being employed in the picture, with the natural result that the text looks exceedingly like an advertisement of Aspinall's enamel. There are four plates to illustrate each picture selected—an etched outline to give the drawing, an aquatint to represent the drawing finished with Indian ink or sepia, the same washed over with a yellow colour to give it warmth and tone, and an aquatint finished in

colours to represent the completed water-colour. The same method is followed with each of the nineteen artists whose work is represented.

In 1810 was published *Practical Directions for learning Flower Drawing*, by Patrick Syme, Flower-Painter, Edinburgh. Syme, who was at this time a teacher of drawing, afterwards became a Royal Scottish Academician. He writes that 'in this work it is intended to illustrate the art of Drawing and Painting Flowers, by progressive delineations consisting of Eighteen Drawings, accurately copied from Nature. Six of these are finished drawings, intended as examples of Yellow, Orange, Red, Purple, Blue, and White Flowers; other six represent the successive stages of the colouring of these flowers; and the remaining six are simple outlines of the same plants.' Though Syme was a distinguished scientific botanist, he knew as an artist the necessity of selection and the value of restraint. These plates are simple, direct, and wholly charming, differing widely from the pretentious examples of many botanical books of the period. It is worthy of remark also that among the books of the day the title-page of this stands out as a model of simplicity and taste. Another book by a water-colour painter of repute is Francia's *Progressive Lessons tending to elucidate the character of Trees: with the process of sketching and painting them in Water Colours*, published by T. Clay in 1813. This contains twelve soft-ground etchings by Francia, eleven of them nicely coloured by hand, and well mounted on greyish paper. As a drawing-book also may be counted *Studies of Landscapes, by T. Gainsborough, J. Hoppner, T. Girtin, etc., Imitated from the originals by L. Francia*, 1810. The sixty plates are admirable examples of soft-ground etching by one of its best exponents. They are executed on paper of various tints, and many of them are delightfully coloured,

though unfortunately in many cases the white used for the high lights has oxidised. The book is rather a rarity, and a copy in good condition (and the condition varies exceedingly) should give unfailing pleasure to its possessor. Very inferior to these, though not without instructive value, are some books by George Brookshaw. *A New Treatise on Flower Painting, or every Lady her own Drawing Master*, was published by Longman, Hurst, Rees, Orme, and Brown in 1818. The plates are in stippled outlines, to show the method of drawing the outline in pencil. Several of these are coloured, but the examples are stiff and unnatural. Of a similar nature are *Six Birds, Groups of Fruit*, and *Groups of Flowers*, 'drawn and accurately coloured after nature' by the same artist, all three volumes being published by T. M'Lean in 1819. All Brookshaw's books are typical of a period when painting in water-colours was a necessary accomplishment of every young lady who aspired to elegance and taste. A few sentences from a single preface will show how these books were produced to meet popular requirement. 'The following Drawings are submitted to Young Ladies with the view of promoting the taste for drawing Birds, many of which, from their elegant forms and beautiful plumage, are interesting and appropriate subjects for the pencil. . . . They progressively unfold the delicate touches of the art, and tend to awaken a taste for the chastened and elegant beauties of nature. The next attempt will be on Fruit Painting, in the course of which will be introduced instructions and designs for Painting on Velvet.'

The Amateur's Assistant, by J. Clark—different, I think, from J. H. Clark—was published by S. Leigh in 1826, and is of technical value in that it represents the different stages of water-colour by an aquatint printed in blue, and bitten in successive stages, showing how much can be produced by a print in even one

colour. The *Lessons on Landscape*, by F. Calvert (1815), has six coloured aquatints, which may be dismissed as of no consequence. *The Practice of Drawing and Painting Landscape from Nature*, by Francis Nicholson, one of the prominent members of the early British school of water-colour painters, was published by J. Booth and T. Clay in 1820. There is an interesting folding plate in coloured aquatint by T. Fielding after Nicholson, with four sketches showing the method of laying successive washes in water-colours. A second edition was published by John Murray in 1823, and the same four sketches are reproduced by lithography. Nothing could be more instructive than to place the two side by side, and the merest glance will show the utter weakness of the lithograph when finished with colour in the aquatint method. Where the ground in an aquatint seems to give a tone, 'pulling together' the whole picture, the coarse blackness of the lithograph seems irrepressible, and quite unsuitable for reproducing the effect of a water-colour drawing.

T. H. A. Fielding's *Index of Colours and Mixed Tints*, published in 1830, is interesting for its eighteen plates, which are not pictorial, but contain squares of colour (twenty-eight on each plate) actually applied by hand to illustrate different varieties of tint. The labour and care involved in producing an edition of a book, each copy of which contains five hundred and four distinct colours, applied one at a time by hand, is truly extraordinary. A later book, with some pleasing illustrations in coloured aquatint, is the *Principles of Effect and Colour*, by G. F. Phillips, published in 1838 by Darton and Clark. The same artist's *Theory and Practice of Painting in Water Colours*, and his *Practical Treatise on Drawing and Painting in Water Colours*, both appeared in 1839 with a few coloured plates.

DRAWING-BOOKS

From 1819 to 1821 Ackermann was publishing *The Cabinet of Arts, being a new and Universal Drawing Book*. It appeared in thirty-two monthly numbers, in dark blue paper wrappers ; each part, published at three shillings, containing four engravings, three plain and one coloured, with twelve pages of letterpress. The original intention was to have thirty numbers, but two more were added, the last being a valuable one, giving an interesting account, with illustrations, of Ackermann's lithographic experiments. The coloured plates illustrate shells, flowers, and landscape. It should be added that this drawing-book is really a second edition, considerably enlarged, of that published by T. Ostell in 1805, with only one coloured plate. To about the same date belong Ackermann's five *Books of Shipping*, by Atkins, published ' plain ' and ' coloured '; *The Seasons* and *Pomona*, by Henderson, published at two guineas and one guinea respectively ; and *A Series of Lessons on the Drawing of Fruit and Flowers*, by Madame Vincent, at the price of five guineas.

CHAPTER XII

COLOURED AQUATINTS, 1790-1830

THE years 1790 to about 1830 form the great period of coloured aquatint illustration—the 'golden age,' it may be called, of coloured books in England. Ackermann has been placed by himself, for he occupies by far the leading position in this branch of the publishing trade. Other publishers, however, issued during this period hundreds of books, which have a claim to record and remembrance for the beauty of their coloured plates. This and the following chapter, therefore, will contain some account of the chief of these miscellaneous volumes, roughly classified, where possible, according to publisher or subject.

Foremost among Ackermann's contemporaries in the publishing world were Messrs. John and Josiah Boydell. As printseller, publisher, founder of the Shakespeare Gallery, and Lord Mayor of London, John Boydell has gained a lasting name in the history of English printing and engraving. At the close of the eighteenth century he and Josiah Boydell, his nephew and partner, had won a unique reputation as publishers of line engravings, issued separately or as book illustrations. They seem to have published only a few books with coloured aquatint plates. The most important is their *History of the River Thames*, with text by W. Combe, published in 1794 at £10, 10s. The seventy-six hand-coloured aquatints are all by J. C. Stadler after J. Farington, R.A., the treatment of

126

landscape being very similar to that employed so effectively by Rowlandson. The pictures themselves are excellent, some of them, the 'Windsor Bridge,' for example, delightful compositions; but the colouring is sunk and dead, and lacks variety and sparkle. The same applies to *Boydell's Picturesque Scenery of Norway* (1820), containing eighty hand-coloured aquatints, drawn and engraved by J. W. Edy. These exhibited some of the wildest and most romantic scenery in the world; the drawings, however, are weak in execution and colouring, and fail to do justice to the magnificent scenery of fiord and mountain. It must be remembered that these were the days when water-colour paintings were still 'tinted drawings,' not yet emancipated from a monotony of grey. The early colourists of aquatints were among the pioneers of the movement to heighten the key, and give bold contrasts of bright tints, making water-colour doff its grey, Puritan sobriety for the gay colours of a Cavalier costume. *Views in the South Seas*, published by Boydell in 1808, has sixteen plates drawn and engraved by J. Webber, R.A. Webber was draughtsman to Captain James Cook's expedition on the *Resolution*, and the splendid original drawings for the plates are preserved at the Admiralty.

Another book published by J. and J. Boydell was the *Sketches and Hints of Landscape Gardening* in 1794, by H. Repton. This contains details and descriptions of different gardens and parks laid out by Repton, and only two hundred and fifty copies were printed. Repton, whose first work in landscape gardening was done at Cobham in 1790, was employed afterwards by the chief noblemen of the day. He laid out Russell Square in London, and altered Kensington Gardens. The phrase 'Landscape Gardening' was invented by Repton, and its first use is in the title of this book. The author explains that he has adopted the term 'because the art can only be advanced and perfected by

the united powers of the landscape painter and the practical gardener.' The fourteen plates in hand-coloured aquatint are ingenious contrivances. Each plate shows the park or garden in its original condition before Repton's improvements; but, on examination, it will be found that a portion lifts back on the principle of some Christmas cards, disclosing to view the alterations, suggested or executed. Plate I., for example, presents 'a scene in the garden at Brandsbury, where a sunk fence is used instead of a pale, which had been so injudiciously placed as to exclude a very rich and distant prospect.' The sliding panel, on being removed, shows this prospect opened up by the removal of the fence.

This was the only work by Repton published by Boydell, but his other books are worthy of notice. His *Observations on the Theory and Practice of Landscape Gardening*, printed for J. Taylor in 1803, has a large number of aquatints, among them twelve coloured by hand, working on the same sliding system. In 1804 he published a curious little medley of plays, poetry, and essays, in two small volumes, with ten hand-coloured aquatints by J. C. Stadler, after drawings by the author.

To 1808 belongs his *Designs for the Pavilion at Brighton*, printed for J. C. Stadler, No. 15 Villiers Street, Strand. Repton had been commissioned by George IV., then Prince of Wales, to draw up designs for altering the buildings and gardens of the Royal Pavilion at Brighton, which, like Carlton House in London, was the scene of many a gay meeting in the days of the Prince Regent. Repton, who had recently been much impressed by the Indian drawings of his friend T. Daniell, determined to adopt the Indian style of architecture. His plans are illustrated with aquatints by J. C. Stadler, many of them coloured by hand, with ingenious slips, like those of the *Landscape Gar-*

dening, that fold back to show the proposed alterations. These ideas of Repton won the approval of the Prince, but through want of funds were never carried out. When Joseph Nash, however, was appointed architect, Repton's ideas were largely followed, as may be seen in *Illustrations of Her Majesty's Palace at Brighton, formerly the Pavilion*, published by Nash in 1838 with highly finished aquatint views of exterior and interior.

The twenty-four coloured plates of Repton's *Fragments of the Theory and Practice of Landscape Gardening* (1816) follow the same system. A collected edition of his works, edited by J. C. Loudoun, was published in 1840, illustrated by cheap woodcuts, coloured by hand, showing the sad decline in book-illustration that took place in less than thirty years.

Repton's works are representative of the keen interest displayed in country estates at this period. Within ten years or so, works on rural architecture were written by Atkinson, Cordier, Dearn, Gandy, Low, Pocock, and many others. *An Essay on British Cottage Architecture*, with plates drawn and engraved by J. Malton, appeared in 1798; and in 1804 a second edition was issued with twenty-three aquatint illustrations, £1, 15s. plain and £2, 2s. coloured. Malton's *Designs for Rural Retreats* appeared in 1802, with thirty-four plates, 'principally in the Gothic and Castle styles,' showing the Gothic survival in its most debased aspects. *Architectural Sketches for Cottages, Rural Dwellings, and Villas*, by R. Lugar (1805), has thirty-eight plates, twenty-one of them pleasingly coloured. In 1816 R. Elsam produced his *Hints for Improving the Condition of the Peasantry*, published by Ackermann, with ten picturesque coloured aquatints of country cottages. Papworth's *Rural Residences* (1818) and *Hints on Ornamental Gardening* (1823) have already been mentioned as published by Ackermann.

Towards the beginning of the nineteenth century

there seems to have risen a love of travel, coupled with a keen interest in foreign countries and the manners and customs of their inhabitants. This is sufficiently shown by the demand for the large and expensive works on continental scenery and travel, issued by Ackermann. But the interest was not confined to the Continent, for Englishmen were beginning to give their attention to India and its government, its sport, and its possibilities. Proof enough of this is that a book of pure satire and caricature like *Qui Hi in Hindostan* should have had its vogue. 'Science has had her adventurers,' wrote Daniell in his *Picturesque Voyage to India*, 'and philanthropy her achievements; the shores of Asia have been invaded by a race of students with no rapacity but for lettered relics; by naturalists whose cruelty extends not to one human inhabitant; by philosophers ambitious only for the extirpation of error, and the diffusion of truth. It remains for the artist to claim his part in these guilt-less spoliations, and to transport to Europe the pictur-esque beauties of these favoured regions.' One of the earliest books dealing with India from the artistic point of view was *Select Views in India, drawn on the Spot in* 1780, 1781, 1782 *and* 1783 *by William Hodges, R.A.* This was printed for the author in 1786, and contains forty-eight plates engraved by him-self. His sketches are bold, and coloured by hand with a freedom that makes them practically original water-colours. The colouring, indeed, tends to sup-press, rather than employ and accentuate, the aquatint ground.

The principal promoters, however, by means of book and picture, of this interest in India, were Edward Orme, and Thomas and William Daniell. Possibly Orme, who was publisher to His Majesty and the Prince Regent, was a kinsman of Robert Orme, author of that forgotten classic, *The History of the British*

Nation in Indostan, of which the first volume appeared in 1763, and in that case his love of India may have been inherited. Orme opens his Indian campaign with *Twelve Views of Places in the Kingdom of Mysore,* by R. H. Colebrooke. The first edition seems to have appeared in 1794, the second in 1805. The twelve coloured aquatints by J. W. Edy after Colebrooke are large rather than fine, but give a good notion of Indian scenery. In 1803 the field is still in the Far East, but changes to the Holy Land, with *Picturesque Scenery in the Holy Land and Syria,* the text being by F. B. Spilsbury, who was surgeon on H.M.S. *Le Tigre* during the campaigns of 1799 and 1800. The book, published originally in five parts at £1, 1s. each, has nineteen coloured plates; nine are coloured aquatints by J. C. Stadler, three by H. Merke and two by Jeakes, while two are soft-ground etchings by Vivares. The drawings from which they are executed were by Daniel Orme after sketches by Spilsbury. A second edition appeared in 1819. In 1803 appeared *Twenty-four Views in Hindostan, drawn by W. Orme from the Original Pictures, Painted by Mr. Daniell and Colonel Ward.* Of the coloured aquatint engravings nine are by Stadler, five by Merke, four by Harraden, two by Fellows, while four are unascribed. This fine set is particularly valuable, because in the National Art Library it is possible to compare with the prints W. Orme's original drawings for the engravers, and to note with what wonderful success coloured aquatint produces the effect of water-colour. It is possible also to recognise its limitations. Here, for instance, where the landscape is a bright green, the aquatint fails through the printer having used a brown ink for his ground. *Picturesque Scenery in the Kingdom of Mysore* was Orme's next work, in 1805. It contains a portrait in stipple of Tippoo Sahib, and forty coloured aquatints after James Hunter, twenty being engraved by H.

Merke, fourteen by R. B. Harraden, and six by J. C. Stadler—forming an interesting series of Indian views. In 1805 Orme added to the series *A brief History of Ancient and Modern India*, by F. W. Blagdon, containing a stippled title-page, and one plate of portraits of Indian judges in coloured stipple. This last was issued with the intention of its being bound by subscribers along with the volume of *Views in Hindostan* or the *Picturesque Scenery in Mysore*. All three are frequently found bound in one volume.

A book that has a somewhat interesting history is Orme's *The Costume of Hindostan*, a series of sixty plates published with descriptive text at £8, 8s. in 1805. The title-page is undated, and the purchaser must be wary; for a later edition, with the imprint of 1805 still on the plates, was printed on Whatman paper with the water-mark date of 1823. The genesis of the book is a series of *Two hundred and Fifty Drawings descriptive of the manners, customs, and dresses of the Hindoos*, by B. Solvyns, the originals of which are in the National Art Library. These were published at Calcutta with the above title in 1799, the plates being etched, and coloured by hand, and a separate catalogue being issued with descriptive text. From Solvyns' drawings W. Orme, as he had done with the *Twenty-four views in Hindostan*, made a set of sixty water-colour copies (also in the National Art Library), infinitely better drawn than the originals; and Orme's drawings are the originals of the plates in *The Costume of Hindostan*, in which Solvyns appears as the artist without any acknowledgment being made of the Calcutta publications. The plates are in stipple, and seem to be all by Scott with the exception of four very poor ones by T. Vivares, son of the more famous Francis Vivares.

Another book of Orme's was *The European in India*, by Captain Thomas Williamson, published in

1813. Incorporated with this is Blagdon's *History of Ancient and Modern India*, mentioned above. The book contains twenty coloured aquatints, of no special merit, by J. H. Clark and C. Dubourg after C. Doyley. These plates without Blagdon's history seem to have been published separately in the same year as *The Costume and Customs of Modern India*, with the descriptions by Williamson. An Indian book in which Orme had an interest was *A Picturesque Voyage to India, by the way of China* (1810), by Thomas and William Daniell. Thomas Daniell had two nephews —William, born in 1769, and Samuel, born in 1775— both of whom followed in his steps as painters of landscape, and who were also engravers of remarkable proficiency. In 1784 Thomas Daniell went to India, taking with him his nephew William, then aged fourteen. They stayed for ten years, gathering material for several important works from regions then almost entirely unvisited by artists. Their *Picturesque Voyage to India* has fifty plates, valuable as a series of world views, but rather small and of indifferent quality, lacking the distinction of those in W. Daniell's later work, *The Voyage round Great Britain*. Thomas Daniell's other nephew, Samuel, seems also to have acquired the family taste for travel, and spent several years in Africa, returning to England in 1804. About a year later he went to Ceylon, but his constitution suffered by his residence in forests and swamps in pursuit of his art, and he died there in 1811. Before his death he published two volumes. The first was *African Scenery and Animals*, published in 1804-5. There is no title-page, the title here given being taken from the dedication plate with which the book opens. There are thirty plates in the volume, drawn and engraved by S. Daniell. He was a skilled draughtsman, and some of the plates in this interesting series show him at his best. The other book was *A Picturesque*

Illustration of the Scenery, Animals, and Native Inhabitants of the Island of Ceylon, which appeared in 1808 with twelve coloured aquatints after his drawings. The best plates in the book are those of landscape, and one notes specially an excellent view of Trincomalee and another of the ferry at Cultura. His *Views in Bootan* contains six plates, which after his death were engraved and published by his brother William, but hardly bear comparison with his other works.

Another Indian book that should be mentioned is *Oriental Drawings: sketched between the years* 1791 *and* 1798, by Captain Charles Gold, published by G. and W. Nicoll in 1806. Gold's drawings are somewhat weak, but the subjects they portray are attractive and valuable, particularly the uniforms of the early native regiments, and the costume of various religious sects and enthusiasts. Specially peculiar are the pictures of the Gentoo zealot who *rolled* from Trichinopoli to Pylney, a distance of over a hundred miles, and of the Pandoram, who walked about wearing an iron grating riveted on his neck to prevent his ever lying down. The fifty plates in hand-coloured aquatint are engraved by T. Medland, Hassell, Ellis, and others. *An Historical Account of the Rise and Progress of the Bengal Native Infantry*, by Captain Williams, published by J. Murray in 1817, is also illustrated by four aquatints of native regimental uniforms.

So much for India as an inspiration for coloured plates. We have now to consider Orme's other publications. In 1806 he had issued a unique book of quite a different type, namely, the *Authentic Memoirs of the late George Morland*. This contains twenty-one plates, among them four soft-ground etchings by T. Vivares, two mezzotints by E. Bell, an aquatint by R. Dodd, and several stipple engravings. The sketches by Morland are bold and boldly reproduced, while the colour-printing, unless one compares it with the

134

masterpieces of W. Ward after Morland, is more than satisfactory. One mezzotint, signed Malgo (Mango?), is particularly striking. In the text the most is made of Morland's somewhat chequered career, anecdotes of his life are freely introduced, and his habits as a toper are by no means whitewashed. The interest of the text, and probably also the fact that the book has frequently been broken up for the sake of selling the prints singly, have made the *Authentic Memoirs* both rare and valuable. Its interest is further enhanced by its standing alone in the method of its illustration (I refer particularly to the colour-printed mezzotints) among a host of books with coloured aquatints. On December 7, 1903, a copy was sold at Sotheby's for £54. In 1806, Orme's *Graphic History of the Life, Exploits, and Death of Horatio Nelson* contains a memoir by F. W. Blagdon, and sixteen plates. Of these, four only are in colours; one, anonymous, represents 'Youthful Intrepidity'—Nelson as a middy attacking a Polar bear; and the other three, on which J. Clark, J. Hamble, H. Merke, and J. Godby all worked, illustrate the funeral procession and the ceremony in St. Paul's Cathedral.

In 1812 Orme published *The British Sportsman*, by Samuel Howitt. This contains seventy of Howitt's capital etchings illustrative of every manner of sport on field and river, all tinted by hand. The plates seem to have been first issued in 1800, but were republished in this collected form by Orme. This heralds a series of books, which were bound to appeal to the sporting instincts of the British race. Orme's *Collection of British Field Sports*, in 1807, without text, has a series of twenty coloured aquatints by Clark, Merke, Godby, and Vivares after Howitt. To the same year belongs the *Oriental Field Sports*, issued originally in twenty monthly parts at £1, 1s. each. The text is by Captain Thomas Williamson, and the

forty plates, which, as a bookseller's catalogue insidi-
ously remarks, would make a fascinating series in
frames to adorn a smoking-room, are from William-
son's designs, re-drawn by Howitt. The preface, in
the florid language of the period, claims that in this
book 'the British Nimrod may view with no small
satisfaction a new and arduous species of the Chase.
The Artist may reap a rich harvest of information ;
. . . the Philosopher and the Historian may either
confirm or correct their conceptions of former details.'
The book is not only a mine of information as to the
manners, customs, scenery, and costume of India, but
contains one of the finest series of sporting plates ever
published. All are coloured aquatints engraved by
H. Merke, with the exception of two by J. Hamble,
and a soft-ground etching by Vivares. Another similar
book is the *Foreign Field Sports, Fisheries, Sporting
Anecdotes, etc.*, published in 1814, which attracts the
grown sportsman and appeals to the healthy schoolboy
as well. The text is possibly a little pedantic ; the
typical anecdote of the American boy shut up with the
wolves in a log-hut brings recollections of early child-
hood, with a remembrance of Blackie's School Reader,
No. v. The plates illustrate every kind of hunting,
trapping, and adventure. Some are so theatrical as to
be almost comic—witness the picture of the Indian
bobbing up in the waves beside the turtle. Among
the plates are a valuable set of thirteen in gay colours,
illustrating a bull-fight. The artists employed were
J. H. Clark, S. Howitt, and F. J. Manskirch, a German
painter who resided for some ten years at this period
in England. The engravings are almost entirely by
Dubourg, whose name appears alone or in conjunction
with another on over seventy of the hundred plates.
His principal helpers were Howitt and Merke. To quote
the enticing words of another bookseller's catalogue,
'every plate is worthy of framing.' There is a supple-

mentary series of ten plates dealing with *Field Sports
. . . of New South Wales*, dated 1813, with ten plates
by J. H. Clark. A second edition of the whole
appeared in 1819, 'published and sold by H. R. Young,
56 Paternoster Row.'

Orme's *Life of Nelson* found a successor in 1814 in
*The Historical Memento representing the . . . scenes
of public rejoicing which took place the first of August
. . . in Celebration of the Peace of* 1814, *etc.* ' In
the course of the war,' writes Blagdon in his text,
' Mr. Edward Orme has not been inactive in the good
cause; he has omitted no opportunity of bringing for-
ward to public admiration, by the graphic art, the
principal events in which our arms have triumphed
both by sea and land; publishing at various periods,
engravings of those great exploits most calculated to
impress the mind with correct ideas of the arduous
struggles which have immortalised the British name.'
The Historical Memento describes the different scenes
of public rejoicing which took place on August 1st in
St. James's Park and Hyde Park, in celebration of the
glorious peace of 1814. The six coloured aquatints by
M. Dubourg after J. H. Clark show the pavilions and
pagodas that adorned the parks, the balloon ascents,
displays of fireworks and of allegorical transparencies,
and the wonderful *Naumachia* that took place on the
Serpentine to show the action between the French and
English fleets.

Another book of the same class is the *Historic,
Military, and Naval Anecdotes of personal valour, etc.,
which occurred to the armies of Great Britain and her
allies in the last long contested war, terminating with
the Battle of Waterloo.* ' The many important vicissi-
tudes and national anecdotes,' says the preface, ' which
occurred during the late disastrous war, have occasioned
too general an interest to be overlooked. The object
of the present work is to consolidate those transac-

137

tions, and to concentrate their brilliancy in one focus.'
The forty coloured aquatints, vividly depicting all the
horrors and incidents of warfare, are from drawings
by J. A. Atkinson, F. J. Manskirch, W. Heath,
J. H. Clark, etc.; one being by George Scharf, a
German who was attached to the British army through
the Waterloo campaign, and who later became the
father of Sir George Scharf. Of the engravings, thirty-
one are by M. Dubourg, seven by Clark and Dubourg
together, and two by Fry and Sutherland together.
Among the plates are ' Nelson in the Cock-Pit,' ' Board-
ing of the Chesapeake,' ' Horse Guards at Waterloo,'
etc. The book is remarkable for its brilliant colouring,
and makes a capital companion for the two series of
Martial and Naval Achievements, which will be men-
tioned later.

Orme's *Picture of St. Petersburgh represented in
a collection of twenty interesting views of the city,
the sledges, and the people*, appeared in 1815. The
plates by Clark and Dubourg after Mornay are lurid
in colouring, very much in the style of toy theatre
scenery.

The same publisher also had an interest in *A Voyage
round Great Britain . . . by Richard Ayrton, with a
series of views . . . drawn and engraved by William
Daniell, A.R.A.*, which for its wonderful series of
coloured aquatints could scarcely be surpassed. It
appeared in eight volumes, from 1814 to 1825, and con-
tains no less than three hundred and eight plates, drawn
and engraved by William Daniell. The work was
published in the days before railways turned remote
fishing villages into fashionable watering-places, be-
fore even Southend—witness the plate thereof—was
known to trippers. The writer's idea was that ' many
who would not venture in pursuit of amusement out
of the latitude of good inns and level roads, to make
paths for themselves over rocks and crags, may still be

"DUNBAR, HADDINGTONSHIRE." BY W. DANIELL.

FROM " A VOYAGE ROUND GREAT BRITAIN," BY W. DANIELL, A.R.A., 1814-25

pleased to become acquainted, at a cheaper rate, with the character of their own shores, where they are most conspicuous for boldness and picturesque beauty.' Author and artist began their task in 1813, sparing no pains and shirking no task to make complete their survey of the coast in all its rugged wildness as well as peaceful beauty. Though they apologise for 'frequently sailing on horseback,' their voyage was a literal one, whenever they were unhindered by the 'rapid tides, ground-swells, unsurmountable surfs, strong winds and foul winds, which were frequently all raging at the same time, and no one of which could be encountered with safety in a small and open boat.' Vol. iii. (1818) contains Daniell's dedication to Mr. Walter, not yet Sir Walter, Scott, and refers to 'the vivid pictures which your last great poem presents of the magnificent scenery of the Isles.' Where all the plates are so excellent, it seems unfair to make distinctions, but where Daniell specially excels is in suggesting the warm haze that hangs over a summer sea, or sunlight playing on the roofs of a fishing village and the walls of its harbour—note, for instance, his 'Tenby, Pembrokeshire,' or his 'Dunbar.' Among other particularly fine plates are 'Solva, near St. David's,' and 'Clovelly' (vol. i.), 'Gribune Head' and 'Ayr' (vol. iii.), 'Gairloch' (vol. iv.), 'Dunbeath Castle' (vol. v.), 'Freshwater Bay' (vol. vii.), and 'St. Michael's Mount' (vol. viii.)—but the list might be indefinitely extended. Daniell's original sketch for his 'View of Lancaster Castle,' corresponding almost exactly with the coloured plate, is in the National Art Library.

CHAPTER XIII

COLOURED AQUATINTS, 1790-1830—(*Continued*)

OUR list of miscellaneous books illustrated with coloured aquatints, and dealing with scenery and travel, is by no means yet exhausted. John Hassell has been mentioned as the author of drawing-books, but he also produced several glorified guide-books, illustrated with coloured aquatints. In 1793 his *Picturesque Guide to Bath* takes us all the way to the west country, starting from London by 'that beautiful and elegant outlet, Piccadilly.' The book contains sixteen hand-coloured aquatints of much merit, all engraved by Hassell, fourteen from his own drawings, with one after J. Laporte and one after J. C. Ibbetson. In eight of Hassell's drawings the figures are inserted by Ibbetson. In 1817 was published his *Picturesque Rides and Walks . . . round the British Metropolis*, two dumpy volumes in small octavo. These are copiously illustrated by a hundred and twenty views, which, though small, are charmingly composed and tinted, and make an interesting record of the topography of London and its suburbs in the early part of last century, when Paddington and Kensington were still rural villages. The sixty plates of the first volume are all drawn and engraved by Hassell; in the second volume the majority are by D. Havell after Hassell. The *Tour of the Grand Junction*, an octavo volume with twenty-four aquatints drawn, and probably

engraved, by Hassell, appeared in 1819. The colouring of the views shows a lack of care and refinement, but none the less they are of great topographical interest. Canals at this period were the great highways of commerce, and the shares of the Grand Junction, opened as far as Uxbridge in 1801, had risen in 1818 from their original price of £100 to £250. Shortly before the publication of this book it had been the vogue for London Society to visit Uxbridge on barges drawn by horses gaily decked with ribbons. This was a favourite excursion with Nollekens, the miserly sculptor, and the pleasures of the trip induced Benjamin West, when President of the Academy, to paint a picture of the barge he travelled by, introducing his own portrait among the passengers on the crowded deck. Hassell's last engraved work appears in the aquatints for *Excursions of pleasure and sports on the Thames*, published in 1823.

A Picturesque and Descriptive View of the City of Dublin, by J. Malton, published in parts from 1792 to 1797, is one of the earliest and best of books with coloured aquatints. It should, however, be added that it appeared in a plain state as well. Malton as a topographical draughtsman had few equals, and the plates, of which there are twenty-five in colour, besides map and title-page, have a distinction of their own in addition to their value as an architectural record.

Views in Egypt, printed for R. Bowyer in 1801, is illustrated by forty-eight drawings by Luigi Mayer, engraved by and under the direction of Thomas Milton. It is still early days for coloured aquatint, and those in this book are a little crude, but are interesting from the nature of the subjects, among them being some capital views of the interior of the Pyramids. Another book with rather unsatisfactory coloured aquatints is *Travels through part of the Russian Empire and the Country of Poland*, by

Robert Johnston, printed for J. J. Stockdale, No. 41 Pall Mall, in 1815. The nineteen illustrations look as though Mr. R. Johnston was one of those gifted amateurs whose work must have taxed the engraver's utmost powers to translate into respectability. It is interesting to note that five of the engravings are by H. Dawe, then only twenty-five years of age, and not yet known to fame as a mezzotinter. Four are by F. C. Lewis, and the rest are by J. Hill, C. J. Canton, J. Gleadah, C. Williams, and T. Cartwright. Better than either of these books is Landmann's *Historical, Military, and Picturesque Observations on Portugal*, printed for T. Cadell and W. Davies in 1818. The seventy-five coloured aquatints are after Landmann's drawings, and the book was published in fourteen monthly parts at a guinea each. Among the plates are four by J. C. Stadler, representing the four degrees of torture employed by the Inquisition, which possess a considerable amount of the vigour and gruesomeness that characterise the work of Goya. Besides these there are numerous views of Portuguese scenery of great, though not transcendent, merit by J. Jeakes, J. Hill, D. Havell, J. Baily, and J. Ogborne.

An important book of this period is Pyne's *History of the Royal Residences*, published by A. Dry of 36 Charlotte Street, Fitzroy Square, in 1819. Pyne, though a water-colour painter of some repute (he was one of the original members of the Water Colour Society), in his later life devoted himself entirely to literature. The only books that he illustrated himself were his *Microcosm*, a series of above a thousand small groups of rustic figures 'for the embellishment of landscapes,' and his *Costume of Great Britain*. He wrote part of Ackermann's book on the Colleges, edited the later part of the *World in Miniature*, and was the author of *Wine and Walnuts*. The *Royal Residences*, edited by him, contains one hundred

NORTH FRONT OF WINDSOR CASTLE. BY T. SUTHERLAND, AFTER G. SAMUEL

FROM THE "HISTORY OF THE ROYAL RESIDENCES," BY W. H. PYNE, 1819

coloured aquatint views of Windsor Castle, St. James's Palace, Carlton House, Kensington Palace, Hampton Court, Buckingham Palace, and Frogmore. Of the original drawings fifty-nine were by C. Wild, twenty-five by J. Stephanoff, nine by R. Cattermole, six by W. Westall, and one by G. Samuel. Of these, thirty-six are engraved by T. Sutherland, twenty-three by W. J. Bennett, twenty-eight by R. Reeve, eleven by D. Havell, and two by J. Baily. An uncoloured copy of this book in the National Art Library is important, for it shows that for all the interior views in this book the aquatint was printed in a single tint, whereas for all the exteriors a blue tint was used for the sky, and a brown for buildings and playground. Artists and engravers have combined in making this a production that ranks with the best of Ackermann's publications. The colouring of some of the landscapes, notably the view of Windsor Castle, is delightfully soft and delicate, but the garish magnificence of the royal interiors, gleaming with purple and gold, is rather monotonous. You will find here the gilded grandeur of Carlton House, with its Gothic conservatory and dining-room, its Golden Drawing-Room, and its vestibule with pillars of green marble crowned with capitals of gold. Royal residences are not always notable for perfect taste in decoration and furniture, so that it is almost a relief to come on a picture of the stone staircase of the Round Tower, pleasing in its unadorned solidity. The view of St. George's Chapel proves again how inadequately a coloured aquatint interprets the atmosphere and majesty of a lofty building. Personal predilection may cause criticism of the architectural features and the furniture represented, but this need not prevent the frank statement that as an artistic production the book is deserving of unqualified praise.

Another book of a similar nature, smaller in size

but almost as fine, is Havell's *Series of Picturesque Views of Noblemen's and Gentlemen's Seats*, published in 1823. Here most of the landscapes show a single tint for the printing, but in many towards the end of the book a blue for the sky and brown for the rest are quite apparent beneath the hand-colouring. He has a wonderful knack of expressing the play of sunlight, and the effect of atmosphere on distant hills. The twenty coloured engravings in the *Noblemen's and Gentlemen's Seats*, including the title-page, are all attributed to ' Robert Havell and Son.' Six are after W. Havell, six after C. V. Fielding, and the rest from drawings by Turner, F. Nicholson, and others. Havell's highest achievement, however, was his *Views of the River Thames*, coloured aquatints published without text in 1812. Another book dealing with English scenery is *Picturesque Views of the Architectural Antiquities of Northumberland* (1820?), the engravings being coloured aquatints after drawings by Thomas Miles Richardson, a water-colour painter of considerable repute. The engravers are D. Havell and T. Sutherland, while the imprint has the somewhat unusual addition of the name of the hand-colourist—B. Hunter. The best are the frontispiece,—' The Barbican or Utter Ward of Alnwick Castle,' engraved by Havell, and the ' Remains of Dunstanborough Castle ' and ' Bamborough Castle,' engraved by Sutherland. The latter is a good example, at least in the case of the copy that has come under my notice, of the paper being scraped away to give the high lights on the water. To 1820 also belongs *The Northern Cambrian Mountains; or a Tour through North Wales*, published by Thomas Clay. Of the forty plates, twenty-seven are after T. Compton, with one each after Turner, De Wint, Prout, and others. Twenty-three of these are engraved by D. Havell, nine by T. H. Fielding, with others by J. Baily and T. Cartwright. Three are unascribed, and there is an

144

isolated lithograph by H. Walter, with colour applied by hand, giving a very soft and pleasing effect. The quality of the aquatints is extremely varied, but some of Havell's work is particularly delicate. *Views of the Lake and of the Vale of Keswick*, published in 1820 at three guineas, contains twelve coloured aquatints, drawn and engraved by William Westall, in which he interprets well his water-colour treatment of distant hills and cloud effects. A *Selection of Fac-Similes of Water Colour Drawings*, published by R. Bowyer in 1825, contains twelve aquatints, beautifully executed and coloured. No engraver's name is mentioned, but the plates are after S. Prout, R. Hills, F. Nicholson, W. Collins, and J. Smith. 'The dripping fountain,' after Nicholson, will appeal to many as a *tour de force* of engraving and colouring, and some of Prout's characteristic Normandy sketches are reproduced with sympathy and skill.

Sketches of Portuguese Life, Manners, Costume, and Character, by A.P.D.G., published in 1826, is illustrated with twenty coloured aquatints unsigned. Plates and text describe with vivacity, and often in a most outspoken way, the peculiarities of the country and its people, priest and peasant in particular. The writer is annoyed with 'the fair authoress [Marianne Baillie] of some late letters from Portugal,' who declared in her preface that 'the *whole* truth should not be told,' and prides himself that 'he can without impropriety enter into details of habits and circumstances, to which modesty will not even permit her to allude.' The author professes to have lived for many years in Portugal, and disclaims all prejudice against the country; yet if the truth is in his mouth, Portugal can have been no pleasant place in the early part of last century.

Two other books of travel, both published in 1822, may be added, but their coloured aquatints are a little

coarse in execution. The first is *A Selection of Views in Egypt, Palestine, etc.*, by the Rev. C. Willyams, printed for John Hearne. Of the thirty-eight illustrations thirty-two are engraved by J. C. Stadler, after drawings by Willyams. The second is *Travels in South Africa*, by the Rev. John Campbell, published by the London Missionary Society, with plates by Clark after Campbell's drawings.

In our last chapter mention was made of the books published by Orme as a record of the Waterloo campaign, but several books of a similar nature issued by other publishers are no less noteworthy. *An Illustrated Record of Important Events in the Annals of Europe during the years* 1812-1815, published by R. Bowyer, comprises a series of nineteen coloured aquatints, giving excellent views of the Kremlin, Berlin, Dresden, etc., and depicts the 'Entrance of the Allied Sovereigns into Paris,' 'Ceremony of the Te Deum at Paris,' 'Flight of the French through Leipsic,' and other scenes. *The Martial Achievements of Great Britain and her Allies from* 1799 *to* 1815 was published by J. Jenkins in 1815. Besides the dedication and title pages there are fifty coloured aquatints after W. Heath, thirty-eight engraved by T. Sutherland, seven by M. Dubourg, four by D. Havell, and one by D. Hill. This was followed in 1817 by a companion volume, *The Naval Achievements of Great Britain from the year* 1793 *to* 1817, containing fifty-four coloured aquatints after T. Whitcombe, forty-five engraved by Sutherland, six by J. Bailey, and three by J. Jeakes. The two volumes depict battle-scenes, and make a glorious record of acts of heroism and valour performed by our soldiers and sailors in bygone days. Among the military scenes depicted are the battles of Maida, Vimiera, Talavera, Salamanca, The Burning of Moscow, Wellington's Entrance into Salamanca, Entry of the Allies into Paris, Sortie

146

from Bayonne, etc.; and among the naval engagements are the Defeat of the Spanish Fleet off Cape St. Vincent, Bombardment of Algiers, Destruction of the Danish Fleet off Copenhagen, Capture of the *Chesapeake* by the *Shannon*, Defeat of the French fleet off the Nile by Admiral Nelson, etc. The two volumes form a brilliant and worthy record of a brilliant period in our country's history. To 1817 also belongs *An Historical Account of the Campaign in the Netherlands in* 1815, by W. Mudford, published by Henry Colburn. It has a frontispiece, 'Portraits of the General Officers,' a second frontispiece, 'The Battle of Waterloo,' and an illustrated title-page, all 'drawn and etched by G. Cruikshank.' The imprint adds, 'Rouse sculp.,' which must imply that Rouse added the aquatint work to Cruikshank's etching. There are twenty-five other aquatint plates, and also two engraved maps. These twenty-five are engraved by James Rouse, three from drawings by C. C. Hamilton, one after Cruikshank, and the rest from his own originals. These, with the frontispieces and title-page, are all in aquatint coloured by hand. Some of the plates are technically interesting in that they show a curious combination of softground etching and aquatint, both badly bitten, giving quite a lithographic appearance.

The Victories of the Duke of Wellington, published by Rodwell and Martin in 1819, is another book of the same class, but smaller and of less importance. It owes its chief interest to the fact that its twelve plates are from drawings by R. Westall, R.A. Westall as a book illustrator, like Thomas Stothard, will always be remembered by his innumerable vignettes, so daintily engraved for editions of Pope, Dryden, Crabbe, Gray, Moore, the Arabian Nights, etc.; and some day the 'little masters' of this class of engraving (Heath, Robinson, Greatbach, the Findens, Kernot, and the rest) will surely come into their own again. Here

Westall is not at his best, and his classical treatment of military subjects, as though he had a large canvas before him, is unsuited to the size of the book and the manner of reproduction. The coloured aquatints, with the exception of one by C. Heath, are all by T. Fielding. Another book of this class is *An Impartial Historical Narrative of those Momentous Events which have taken place in this country during the period from the year* 1816-1823, published by R. Bowyer in 1823. The main events treated in the book are the Napoleonic campaigns and the trial of Queen Caroline. A series of nineteen unsigned coloured aquatints shows views of Moscow, Leipzig, Dresden, and other towns through which Napoleon passed, ending with two plates showing the grand entry of the Allied Sovereigns into Paris. Two interesting coloured aquatints by Dubourg show the procession of watermen in 1820 to present an address to Queen Caroline, and the Queen returning from her trial before the House of Lords. An engraving by Stothard gives a page of medallion portraits, and another by J. G. Murray after Pugin and Stephanoff shows the interior of the House of Lords during the trial. Another coloured aquatint by Dubourg after Pugin and Stephanoff displays the interior of Westminster Abbey on the occasion of the Coronation of George IV.

George IV.'s coronation gave rise to two magnificent works by Whittaker and Sir George Nayler, published in 1823 and 1825, and amalgamated later in 1837. They contain a quantity of coloured aquatint work, but were mentioned above in chapter vii. on account of their more uncommon display of mezzotint and stipple.

One remarkable feature of this period is the enormous output of books whose sole object was the illustration of costume of our own and foreign lands. Orme's *Costume of Hindostan* is a typical volume

already mentioned, while in other books like Grindlay's *Costume and Architecture of India*, costume, if not the main subject, forms an integral and important part of the book. The interest in English costume is easy to understand, for the period was one of rapid change and development, and the fashion-plate was coming into vogue, forming the prominent feature of Ackermann's *Repository*, *La Belle Assemblée*, and other popular magazines of the day. Frills and furbelows, fashions new and old, make a perennial appeal to feminine fancy. It is interesting to look back upon this particular period, and note the progression, or retrogression, from the patches and powder, the hoops and elaborate high-piled head-dresses of 1770, through the eccentricities of the classical revival, with its high-waisted, scant decency of clinging silk, inaugurated by the *incroyables* and *merveilleuses* of empire times in Paris, to the monstrosities of early Victorian bonnets and crinolines. You can note each step in turning over the prints of Hogarth, Rowlandson, Gillray, and John Leech, and it is one of the everlasting wonders of Leech's genius, that even to the early Victorian bonnet and crinoline his pencil could lend unfailing grace and charm.

Why there should have been sufficient interest in the costume of foreign countries, particularly of Russia, Turkey, and the Far East, to cause a demand for large and expensive volumes of costume pure and simple, is harder to understand. It seems clear, however, that the time of the Napoleonic campaigns was one of expansion, when travel became easier and more popular, and the interest in other lands consequently greater. In painting there was a demand for accuracy and appropriateness of costume and surroundings. The days when a Roman toga was the accepted clothing for a British general were happily coming to a close. Sculpture clung longer to old conventions, the utter

folly and bathos of which are revealed in the statue by John Bacon of Dr. Johnson—Dr. Johnson of all people, semi-nude and clad in toga—erected in St. Paul's Cathedral in 1795. The stage, too, was becoming modernised, the 'wretched pair of flats' that formed the scenic decoration in the days of Garrick were considered insufficient, and though it was not till the Shakespearean revivals of Charles Kean at the Haymarket in the 'fifties that absolute accuracy of costume and accessories was obtained by painstaking research, still there was a growing tendency to the production of topical subjects and their proper placing upon the stage. In proof of this it may be mentioned that in 1812 a realistic representation of the burning of the Kremlin at Moscow was a popular attraction in theatres all over the country. All these influences no doubt contributed their share in promoting the demand for books of costume.

It is impossible to mention all the ephemeral collections of fashion-plates that appeared from 1790 onwards, but one of the first of these has more permanent value and is worthy of special attention. This is the *Gallery of Fashion*, published by N. Heideloff, of which the first number appeared in April 1794. The price to subscribers was three guineas for the twelve numbers that formed a volume, or to non-subscribers 7s. 6d. each number. The whole series, completed in 1802, forms nine volumes, and is illustrated by two hundred and fifty-one engravings and aquatints, delicately tinted by hand, and heightened with gold. It claims to be 'a collection of all the most fashionable and elegant Dresses in vogue . . . in short it forms a Repository of Dress.' There is no attribution of the plates to any engraver, but it may be assumed that they are by Heideloff himself, who executed the engravings for Ackermann's *Costume of the Swedish Army*. These prints, at any rate, are full of life and spirit, and the

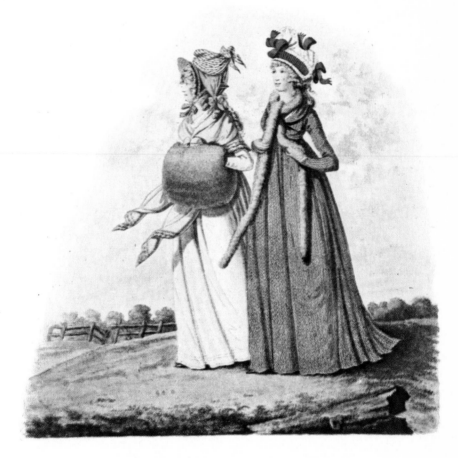

"MORNING DRESSES," MONTH OF NOVEMBER, 1795

FROM "THE GALLERY OF FASHION," BY N. HEIDELOFF,1795

graceful figures illustrated are quite unlike the conventions of the stereotyped fashion-plate. A complete copy is rare, and now fetches from thirty pounds upwards.

A most important series of books on costume was that issued by W. Miller from 1800 to 1808, the volumes being sold at a price of six to eight guineas, all of them, except the *Costume of Great Britain*, having text in French as well as English. The first to appear was the *Costume of China* by Lieutenant-Colonel Mason. The sixty plates were engraved by J. Dadley in stipple and coloured by hand, from drawings by Peu Qua of Canton. This was followed in 1801 by the *Punishments of China*, with twenty-two engravings, again in stipple by Dadley. In the *Costume of Turkey* (1802), the plates are by Dadley and Poole after O. Dalvimart. The *Costume of Russia* (1803) contains seventy-three plates engraved by Dadley, and was followed in 1804 by the *Costume of Austria*. In 1805 came the *Costume of China* with forty-eight plates after W. Alexander, who was draughtsman to the Embassy of Earl Macartney. Being executed by a British artist, the work forms a contrast to that from the pencil of Peu Qua, and also contains a different selection of subjects. The series was completed in 1808 by a seventh volume of the *Costume of Great Britain*, by W. H. Pyne, the whole set consisting of three hundred and seventy-three engravings, and being sold for £48, 16s. 6d. The last volume is by far the best, for Pyne's work reaches a high standard, and instead of giving single figures, as in the other volumes, he illustrates all types and classes of the people, singly or in groups, engaged in their several occupations. To judge the scope of the work one has only to glance at such titles of the plates as ' Leather Dressing,' ' Woman selling Salop,' ' Halfpenny Showman,' ' Lord Mayor,' ' Lamplighter,' ' Lottery Wheel,' and so on in indiscriminate sequence.

These are only a few selected at random from sixty coloured plates, intensely pictorial, full of human interest, and illustrating many quaint English customs and occupations. The engravings are all in aquatint coloured by hand, and as no engraver's name is mentioned, they are presumably by Pyne himself.

The years 1803 and 1804 brought forward a new illustrator of costume in J. A. Atkinson. *A Picturesque Representation of the Manners, Customs and Amusements of the Russians* forms three folio volumes printed for its authors, J. A. Atkinson and J. Walker, in 1803-4, and published at £15, 15s. The illustrations consist of one hundred soft-ground etchings by Atkinson, coloured by hand. Walker and Atkinson in 1807 began a *Picturesque Representation of the Naval, Military and Miscellaneous Costumes of Great Britain*. This was to have been published by W. Miller and J. Walker in three volumes, but one volume only seems to have appeared, containing thirty-three soft-ground etchings coloured by hand. These two books reveal Atkinson as a vigorous and capable, and at times a brilliant, draughtsman. He has the power of selection and suppression that make for greatness in drawing, and his work seems never to have received the recognition it deserves. The colouring in both books is delicately applied in the Rowlandson manner, the flat tints being extremely like the method of some modern posters. There is nothing stiff or stereotyped in Atkinson's treatment of scenes and figures, and these two books are among the most charming of books on costume.

The Army of Russia, Containing the Uniforms in Portrait of the Russian soldiery, was published in 1807 by E. Orme at £1, 1s. The frontispiece by J. Godby after Pinchon is a good example of stipple printed in colours. The eight other plates adequately represent various uniforms, but are not of particular

merit. *Russian Cries . . . from drawings done on the spot by G. Orlowski*, was published by Orme in 1809, and contains eight interesting plates in stipple, coloured by hand, by J. Godby, and a hand-coloured line engraving by J. Swaine. *Costume of the Russian Empire*, published by E. Harding in 1811, with text in French and English, contains a fine series of seventy-one plates, engraved in line and stipple, and coloured by hand. *The Military Costume of India*, by Captain James, published by T. Goddard in 1813, has thirty-five plates of etched outlines coloured by hand. They are somewhat grotesque, but form faithful representations of the uniform and the manual and platoon exercises of native troops of the period.

Among books of 1814 is the *Costume of Yorkshire*, published by Longman, Hurst, Rees, Orme, and Brown, with text in French and English. The forty-one coloured aquatints, by R. and D. Havell after George Walker, are faithful presentments of British peasantry in their various occupations, and also depict Yorkshire military uniforms, sea-bathing from machines at Bridlington, hawking on the moors, the Doncaster races, and other popular subjects. In 1814 also John Murray takes his place among the publishers of coloured books of costume, with a series of volumes in small quarto. In 1813 he had published *Picturesque Representations of the Dress and Manners of the Austrians*, by W. Alexander, with fifty plates. *Picturesque Representations of the Dress and Manners of the Chinese* by the same author, was issued in 1814 with fifty plates. Both of these books bear on the title-page, 'Printed for Thomas McLean,' though the imprint on the plates gives Murray as the publisher. These and the three others of the series published in 1814 are all illustrated by aquatints, but no engraver's name is mentioned. The others are *Picturesque Representations of the Dress and Manners of the Turks*, with

153

sixty plates ; *Picturesque Representations of the Dress and Manners of the Russians*, with sixty-four plates ; and *Picturesque Representations of the Dress and Manners of the English.* In the last volume the strange juxtaposition of characters reminds one of the old rhyme of 'tinker, tailor, soldier, sailor,' etc. The titles of some of the illustrations may be quoted in the amusing order in which they stand without respect to persons—'Yeomen of the Guard, Shrimper, Peer in his Robes, Dustman, . . . Dairy Maid, Drayman, Speaker of the House of Commons, Butcher's Boy, Admiral,' and so on. There are fifty plates in all, admirably drawn and hand-coloured in a style so like that of Atkinson that they may well be accepted as his work. In 1814 also Colnaghi and Company added to the books of costume *Selections of the Ancient Costume of Great Britain and Ireland from the seventh to the sixteenth century*, by Colonel Hamilton Smith. The sixty-one plates are all inscribed as 'etched by J. A. Atkinson,' who infused much of his own spirit into the original drawings. They are finished in coloured aquatint by J. Hill, J. Merigot, and R. and D. Havell. The costumes represented are those of the seventh to the sixteenth century, and the figures wearing them are placed in appropriate surroundings. *The Costume of the Original Inhabitants of the British Isles from the earliest periods to the sixth century*, published by R. Havell in the following year, is by Hamilton Smith and S. R. Meyrick. This is a handsome folio volume, but the twenty-five plates in coloured aquatint by R. Havell after Hamilton Smith are very inferior to Atkinson's work in the previous volume, and though they embody much antiquarian research and information, are dull and of little general interest.

After a study of Colonel Hamilton Smith's drawings, it is apparent that much of the liveliness that appears in the first set of engravings was imparted to them by

Atkinson. Hamilton Smith was a keen traveller, and in the intervals of his active military career he accumulated materials for numerous subjects of historical, zoological, and antiquarian research. These two books on the costume of Great Britain have ever since been one of the principal sources from which illustrators of ancient costume have derived their material, and it is scarcely possible to open any pictorial English history, or any work bearing on the dress and manners of our ancestors, without recognising some group of figures appropriated or adapted from Smith's drawings.

An even greater work, on the title-page of which Colonel Smith's name does not appear, but which is in reality hardly less indebted to him, is Sir Samuel Meyrick's *Critical Enquiry into the History of Ancient Armour*. This appeared first in three volumes in 1824 with eighty plates, and was reissued in 1842, again in three volumes, with a hundred plates. The greater part of the coloured plates, with which the three volumes are profusely decorated, were copied from Colonel Hamilton Smith's drawings. Eight volumes of his drawings for these and other books are in the National Art Library. The ancient costume and manners, not only of Europe but of every part of the world, architectural remains, monumental effigies, arms and armour, heraldry, military antiquities, topography, and natural history, are all delineated with an exact and unwearied pencil. Colonel Hamilton Smith was a personal friend of Benjamin West, and there is no doubt that his arguments and his exact research were of considerable weight in making West abandon the old and careless ideas as to costume in pictures. Hamilton Smith might well laugh at a President of the Royal Academy for representing the Conqueror and Edward III. both habited like Charles I.

The preface to the *Military Costume of Turkey*, published in 1818, states that 'T. McLean respectfully

begs to inform the Public that the Costumes of the Various Countries published by Mr. Miller are become his Property.' This additional volume on Turkey is of interest at the present time, and a paragraph in the preface, attempting to explain the decline of Turkish power, goes to the root of the matter. 'The rays of despotic power which can vivify every energy and command every resource in the immediate vicinity of the Ottoman throne, diminish their influence as they diverge, until they are lost in the extent of empire; and the monarch whose frown is death at Constantinople, not unfrequently finds his power derided, and his majesty insulted, by the murder of the Capidigi, who bears his imperial mandate, by the Pachas and Beys of the more distant provinces.' The book is a large volume, containing thirty coloured aquatints by J. H. Clark.

J. A. Atkinson has been so frequently mentioned in the last few paragraphs, that one may add here another work by him on entirely different lines. This is his *Sixteen Scenes taken from the miseries of Human Life, by one of the Wretched.* It was published by W. Miller in 1807, and is illustrated by etchings, mostly in soft-ground, coloured by hand. His spirited and clever drawings are full of character, surpassing those of Alken. No. II., 'Seeing the boy who is next above you flogged for a repetition which you know you cannot say,' should appeal to most Britons. The angry schoolmaster, laying on the birch with a will, the pathetic countenance of the horsed victim, and the anguished stare of the miserable onlooker, waiting his turn with book in hand, are all most happily and naturally expressed. Another excellent drawing, well worthy of Rowlandson, is No. IX.—'Miseries of Watering-Places.' A noteworthy point about the book is that the title and the idea of the illustrations seem to have inspired Rowlandson, whose *Miseries of Human Life* appeared, a year later, in 1808.

156

CARICATURES

This book by Atkinson brings us to a large number of works whose only purpose was comedy and caricature. Rowlandson, Alken, and Cruikshank stand apart among the early caricaturists who illustrated books, and their work must be treated separately, as it deserves. Here, however, may be added a note of one or two odd volumes belonging to this class. Of the same nature as some of Rowlandson's works are *Here and There over the water: being Cullings in a trip to the Netherlands*, and *Airy Nothings, or Scraps and Naughts, and Odd-cum-Shorts, etc.*, both drawn and written by 'M. E., Esq.,' and engraved and published by George Hunt in 1825. Both volumes are illustrated by spirited aquatints in colour, which are valuable as a record of topography and costume. The first gives interesting views of Antwerp, Brussels, Ostend, and Waterloo, with wayside pictures of curious barges, coaches, and costumes. The second deals in the same way with our own country, the author travelling from a *Street Breakfast* in London to a *Trip up Loch Lomond* by steamer, and a *Ride up the Phœnix Park in Dublin*, and showing on the way the manners and customs of the inhabitants. Lovers of the 'Kailyard School' and of Winsome Charteris will enjoy the picture of Scotch lasses washing clothes in tubs beneath the Calton Hill.

Among other books of a caricature nature should be ranked some by William Heath—'poor Heath, the ex-Captain of Dragoons, facile and profuse, unscrupulous and clever,' so Dr. John Brown sums up his character. It will be remembered that he drew the originals of the plates to the *Martial Achievements*, and many of those to the *Historic, Military and Naval Anecdotes*. *The Life of a Soldier, a Narrative and Descriptive Poem*, with Heath's illustrations, was published by W. Sams in 1823. The book is obviously imitated from the *Military Adventures of Johnny*

Newcome, illustrated by Rowlandson in 1815; and though the eighteen coloured etchings are of little merit, with the figures stiff and ungainly like wooden dolls, it has always commanded a good price. Among Heath's other works are *Studies from the Stage, or the Vicissitudes of Life*, in 1823; *Parish Characters, Household Servants*, and *Theatrical Characters*, all between 1823 and 1829; and *Omnium Gatherum* and *Old Ways and New Ways*, about 1830. All of these are sets of plates without text.

Another book owing its origin to *Johnny Newcome* is the *Post Captain, or Adventures of a True British Tar: by a Naval Officer*. This was published in 1817, and has twenty-five plates in coloured aquatint (including the title-page), by C. Williams. The drawings are spirited, and much superior to those in Heath's similar work.

M'Lean at this period issued several sets of plates by R. Seymour, among them the *March of Intellect*, the *Trip to Margate, Humorous Illustrations of Heraldry*, and *A Search after the Comfortable*, all with six plates in hand-coloured etching, published at twelve shillings or fifteen shillings.

CHAPTER XIV

THOMAS ROWLANDSON

'All the real masters of caricature deserve honour in this respect, that their gift is peculiarly their own—innate and incommunicable.'
RUSKIN'S *Modern Painters*, iv. 377.

TO all who seek information as to Rowlandson and his work, Mr. Grego's *Rowlandson the Caricaturist* is invaluable. Here we have to consider Rowlandson and his career only in their limited connection with illustrated books. For though he published hundreds of separate caricatures for each of his book illustrations, one is tempted to believe that it is by the books that all the world shall know him. His caricature sheets are for the most part hasty cartoons, dealing only with the passing, and often petty, questions of the hour. His claim on posterity lies in his creation of Dr. Syntax, and in his more serious work for the *Dance of Death*, the *Microcosm of London*, or the *Vicar of Wakefield*.

There is a world of difference between the careful plates executed for Ackermann's coloured books and the lurid caricatures that were issued by Tegg in Cheapside, bespattered with garish daubs of red, blue, and yellow. Yet these last pass current in the print-shops of to-day, and many who are ignorant of Rowlandson as an illustrator of books condemn him on their account as a vulgar caricaturist. His caricature work, without doubt, frequently displays a coarseness of sentiment that occasionally verges on absolute vulgarity. The broad humour, associated with an age that still

called a spade a spade, and that we may pardon and even enjoy in Smollett and Fielding and Sterne, is carried so far as to be indefensible. Too many of Rowlandson's drawings and caricatures, like those of his contemporaries, Bunbury and Gillray, are marred by an ill-odoured taint of coarseness that makes them repulsive. In the books, however, owing perhaps to Ackermann's guiding hand, the limits of decency are never outstepped.

Rowlandson was born in the Old Jewry in July 1756, the same year as Isaac Cruikshank, six years after Bunbury, and a year before Gillray. Attending 'a scholastic symposium of celebrity,' presided over by Dr. Barrow in Soho Square, he had as his schoolfellows Jack Bannister, the celebrated actor, and Henry Angelo, son of the Angelo who was fencing-master to the Royal family. Even in his schooldays his genius for humorous drawing began to assert itself, and the margins of his books were filled with grotesque sketches. For a short time Rowlandson attended the schools of the Royal Academy, but in 1771 was invited to Paris by his widowed aunt, who paid the expenses of his education at a Parisian art school. His two years in Paris were spent to good advantage, and he learned there the dash and brilliance that characterised French art of the day. On his return he resumed his studies at the Academy schools, and in 1775 exhibited in the Academy his first picture, 'Delilah paying Samson a visit while in prison at Gaza.' From 1777 we find him settled at Wardour Street, and devoting himself to the painting of portraits, several of which appeared at the Academy. In 1778 he travelled on the Continent, passing through Flanders, Holland, and Germany. The notes made during this journey of travellers and coaches, ordinaries and innyards, foreigners and their habits, with all the incidents of the road, show their influence in much of his later work.

160

About this time Rowlandson appears to have plunged into a career of dissipation, aggravated by the receipt of a legacy left to him on the decease of his aunt in Paris. He became a familiar figure in the gaming-houses of London, but though he squandered his aunt's fortune and other moneys as well, it is chronicled that he played as a gentleman, and that his word passed current even when his purse was empty. A friend of forty years' standing, who wrote the obituary notice in the *Gentleman's Magazine* in 1827, says that on Rowlandson's own word he had 'frequently played through a night and the next day; and that once, such was his infatuation for the dice, he continued at the gaming-table nearly thirty-six hours, with the intervention only of the time for refreshment.' All this is related partly to account for Rowlandson's insight into the seamy side of London life, partly because it no doubt contributed to his abandonment of 'the legitimate' in art. Rowlandson was not one 'to scorn delights and live laborious days.' When his means were exhausted he is said to have sat down to produce a series of new designs, saying, 'I have played the fool, but'—holding up his reed pen—'here is my resource.' The success, too, of his picture 'Vauxhall Gardens' at the Academy in 1784, and of his series of caricatures, published during the excitement of the celebrated Westminster election in the same year, doubtless was a factor in his adoption of a career which offered ease and a ready supply of money. So facile was his dexterity, and so fertile his imagination, that he could produce a finished picture in a few hours; and at the time of the 'inquiry into the corrupt practices of the Commander-in-Chief in the administration of the army,' involving the scandal of the notorious Mrs. Clarke, fresh caricatures by the artist were issued from Ackermann's Repository, hot, as it were, from the oven, twice daily.

Ackermann remained the artist's best friend, cer-

tainly his best adviser. At a time in his career when indolence and dissipation were doing their worst, Ackermann stepped to his help, and thenceforth supplied him with ideas, published and paid liberally for his work, and finally with Bannister and Angelo, the two friends of his youth, followed him to the grave. It was Ackermann who introduced the artist to Combe, inaugurating a union that was fruitful of results as that of Gilbert and Sullivan in later days and another sphere, and the similarity goes further, for Combe, like Gilbert, did far more than write up a libretto to go with a master's work. To judge by the varied vicissitudes of Combe's career, nature seems to have made him the fitting companion and collaborator for Rowlandson. Born in 1741, he went to Eton and Oxford, and in 1763 started for three *Wanderjahre*, passing his time in France and in Italy, where he fell in with Sterne, naturally a kindred spirit and welcome comrade. In 1766 he returned to England, and came into a fortune left by an uncle, quickly to be squandered in the gaming-houses of London, and amid the fashionable attractions of Bath and Tunbridge Wells. He lived in a most princely style, and though a bachelor, kept his carriages, several horses, and a large retinue of servants, being known in town by the nickname of ' Count Combe.' Over head and ears in debt, he disappeared from London, and is said to have become soldier, teacher of elocution, under-waiter in a tavern at Swansea, and to have spent a year in the French army—all contributing to that larger insight into men and things, into the highest life and the lowest, that enabled him to write equally well, whether his subject was a sermon, or the text for *Dr. Syntax* and the *Dance of Death*. By 1772 his worst wild oats were sown, and he set himself to a life of toil in the journalistic world of London. Though tales are told of his continued gaming, thieving, intriguing, and discredit-

able marriage—'the infamous Combe' he was dubbed by Walpole—much of this may be regarded as exaggerated gossip. His worst fault seems to have been a wild extravagance, and to his credit he was a 'teetotaller' in a day when drunkenness was a fashionable virtue. True it is that he spent the greater part of his life as a prisoner for debt in the precincts of King's Bench Prison ; and a dozen different *aliases* perplexed his brother authors, for Combe was rarely in a position to sign his own name. A most voluminous author, he wrote and edited, between 1773 and 1823, upwards of a hundred books, and contributed to a score of journals. Satire, history, theology, politics, topography, humour, were all graced by his versatile pen. For some years he was in receipt of £200 a year from the Pitt party, and for several years was on the staff of the *Times*.

In 1809 Combe had reached the age of sixty-eight, and was earning a bare living by literary hack-work— he had just been writing seventy-three sermons—when Ackermann summoned him to the Strand. Rowlandson had offered the publisher a number of drawings representing an old clergyman and schoolmaster travelling during his holidays in search of the picturesque. The idea had been suggested partly by his friend Bannister. The artist had requested an idea for embodying his Cornwall and Devon sketches, with adventures at inns and comic incidents on the road. 'I have it !' said Bannister : 'You must fancy a skin-and-bone hero, a pedantic old prig in a shovel hat, with a pony, sketching-stools and rattletraps, and place him in such scrapes as travellers frequently meet with—hedge ale-houses, second and third rate inns, thieves, gibbets, mad bulls, and the like.' The result was Dr. Syntax, and Ackermann at once saw that the specimen sketches submitted would make the success of his new *Poetical Magazine*, if a narrative in verse could be found to accompany them. The proposal was made to Combe,

who at once accepted it, and writes that 'an etching or drawing was sent me every month, and I composed a certain proportion of pages in verse, in which, of course, the subject of the design was included : the rest depended on what my imagination could furnish. When the first print was sent to me I did not know what would be the subject of the second; and in this manner, in a great measure, the artist continued designing, and I continued writing every month for two years, till a work containing near ten thousand lines was completed.' A writer in the *London Cyclopædia*,[1] who knew Combe, describes how he used regularly to pin up the sketch against a screen of his apartment in the King's Bench, and write off his verses as the printer wanted them.

We shall return later to the *Tours of Dr. Syntax*, for these, and the other books for which Combe supplied the text, were not Rowlandson's first appearance on our stage of coloured books. With foreign invasion threatening our shores, martial ardour was the keynote of the year 1799, and subscribers were readily found for the *Hungarian and Highland Broadsword Exercise*, with twenty-four plates designed and etched by Rowlandson for Messrs. Angelo and Son, Fencing-Masters to the Light Horse Volunteers of London and Westminster, and published by H. Angelo, Curzon Street, Mayfair. 'At a period,' writes Rowlandson in his dedication, 'when the spirit of the Nation is so eminently manifested, and when all that is loyal and honourable in this Empire is ranged in Arms to support its Government and Constitution, I may safely indulge the hope that my Countrymen will readily acknowledge the utility of the Work which I herewith offer to them.' The twenty-four plates in coloured aquatint show military exercises and movements of cavalry, but the single figures in the foreground, illus-

[1] Vol. vi. p. 427, 1829.

trating sword exercises, are relieved and animated by the introduction in the background of various skirmishes, assaults, and battle-scenes, so that the plates lose all sense of formality. In the general liveliness of the picture you forget that the two central figures illustrate 'Cut two, and horse's off side protect, new guard,' and other formulæ of broadsword exercise, just as for the nonce in a stage duel you forget that cut, thrust, and parry are planned, rehearsed, and mechanical.

The martial spirit of the day was further encouraged by the *Loyal Volunteers of London and Environs*, the first of the handsome publications with Rowlandson's plates inaugurated by Ackermann. The eighty-seven illustrations represent the infantry and cavalry of the various corps in their respective uniforms, and show the whole of the manual, platoon, and funeral exercises. Ackermann himself, in a preface full of sincere patriotism, though sometimes smacking of Baboo Chunder Mookerjee's more modern style in the cheerful mixture of its metaphors, writes: 'The high fermented state of Politics at Home, in conjunction with the crooked policy of our enemies Abroad, was truly alarming: for the perturbed spirits of France were hastening the progress of disorder, while internal disaffection made all the way it could for its extension. At this moment, the enemy had advanced their best regulated legions to the shore of the British Channel; and for the determined purpose of spreading through our land such miseries as have already rendered wretched their own. . . . As a detester of Gallic atrocities, and from a sincere attachment to the best of Sovereigns, the Proprietor of this Work cheerfully contributes his Mite towards the general welfare of a Country, that has from early time, like a sturdy rock, amidst the buffetings of the storm and insolence of the billows, raised fearless its gorgeous head to Heaven, yielding matchless fruits

beneath a blaze of sunshine and unremitted salubrity.' On June 21, 1799, the king came in procession through London, inspecting the loyal volunteers, to the number of 12,208, who lined the royal route; so that Ackermann's book, issued in parts from June 1, met the wave of popular enthusiasm at its height. The plates are in aquatint, finely coloured by hand and liberally heightened with gold. The single figures, undergoing various military exercises, though they give little play for Rowlandson's real genius, show his skilful draughtsmanship and form a valuable record of costume.

In 1799 also he supplied a frontispiece in colours to the *Musical Bouquet* by E. Jones; in 1802 he contributed another to the same author's *Bardic Museum of Primitive British Literature*; in 1804 to the companion volume of *Lyric Airs*; and in 1806 to his *Selection of the most Admired and Original German Waltzes*. The last book is interesting, for waltzing at the time was a new invention 'made in Germany,' and recently introduced into our country. Crabb Robinson, in his *Diary* for 1800, speaking of Frankfort society, writes: 'The dancing is unlike anything you ever saw. You must have heard of it under the name of waltzing—that is, rolling or turning, though the rolling is not horizontal but perpendicular. Yet Werther, after describing his first waltz with Charlotte, says—and I say so too—" I felt that if I were married, my wife should waltz with no one but myself." Judge— the man places the palms of his hands gently against the sides of his partner, not far from the arm-pits. His partner does the same, and instantly with as much velocity as possible they turn round and at the same time gradually glide round the room.' It may be added that in 1806 Rowlandson illustrated the *Sorrows of Werther* with a picture of a 'German Waltz,' not, however, in colours.

The Chesterfield Travestie, or School for Modern
166

Manners, published by T. Tegg of Cheapside in 1808, has a fine hand-coloured frontispiece and other full-page illustrations by Rowlandson; and to the same year belongs the *Beauties of Tom Brown*, by C. H. Wilson, published by Tegg, with a hand-coloured frontispiece representing a gaming-house. This year also saw the publication of *The Miseries of Human Life*, a collected edition in a reduced size of fifty etched plates coloured by hand, which had been issued separately during the previous years. Rowlandson's principal work, however, of 1808, was for Ackermann's *Microcosm of London*, with its hundred and five plates, of which a more extended notice was given in chapter x.

In 1809 *An Essay on the Art of Ingeniously Tormenting*, again published by Tegg, has five plates, etched by Rowlandson after G. M. Woodward, and coloured by hand. To the same year belong the two similarly coloured plates for Sterne's *Sentimental Journey* and two for the *Beauties of Sterne*, both published by Tegg at 4s. 6d. The year, however, is most remarkable for the issue by Ackermann of the *Poetical Magazine*, which, under the title of the 'Schoolmaster's Tour,' contained the original impressions of the plates for the *Tour of Dr. Syntax in search of the Picturesque*. The *Repository* for January 1812 announces that Ackermann 'is preparing for the press the Adventures of Dr. Syntax, so highly admired on their first appearance in the *Poetical Magazine*, revised and augmented by the humorous author. They will form an octavo volume embellished with a considerable quantity of engravings.' A new set of plates, with very slight variations, was expressly prepared to take the place of the originals, rather worn by their use for the *Poetical Magazine*. The illustrations were now thirty-one, three new subjects being added: a frontispiece showing the Doctor meditating at his desk over

the idea of the Tour; a title-page with a vignette of architectural ruins; and plate 27, introducing the Doctor's dream of the Battle of Books. The good-natured moralising schoolmaster became a public character and a general favourite. Syntax was the popular title of the day, and shop windows displayed Syntax hats, Syntax wigs, and Syntax coats. A racehorse, too, was called by the name of Dr. Syntax, and was honoured by having his portrait painted by James Ward, R.A. By 1822 his winnings in cups, plates, and money exceeded those of any other racer known.

The *Repository* for October 1812 announces that owing to the rapid and extensive demand for the book, a very large impression has been completely exhausted, and that a second edition will be ready in a few days. The book reached a fifth edition in 1813, a sixth in 1815, a seventh in 1817, and an eighth in 1819. Its success produced a host of parodies and spurious imitations. Among them the best perhaps is the *Tour of Dr. Syntax through London*, with twenty plates, published in 1820. Others were *Dr. Comicus, or the Frolics of Fortune*, in 1815, with fifteen plates; and the *Adventures of Dr. Comicus*, by a modern Syntax, with fifteen plates. It looks as if *Com*-icus were a pun on Combe's name, to add insult to injury. Other imitations were *Syntax in Paris*, which appeared in 1820, with seventeen plates; and the *Tour of Dr. Prosody in Search of the Antique, etc.*, in 1821, with twenty plates by W. Read. A French edition with twenty-six lithograph renderings by Malapeau of Rowlandson's originals appeared in 1821 with the title *Le Don Quichotte Romantique, ou Voyage du Docteur Syntaxe à la Recherche du Pittoresque*; and a German edition of the original work was published at Berlin in 1822 under the title *Die Reise des Doktors Syntax um das Malerische aufzusuchen*, with lithographs by F. E. Rademacher.

The success which attended the first Tour led the publisher to project a second series with the help of Rowlandson and Combe. Dr. Syntax's termagant spouse has died, and an excuse is found for further eccentric travels—*Dr. Syntax in Search of Consolation.* The dame of good Squire Worthy tells Dr. Syntax that she has a certain cure for his sorrows :—

> ' Make another Tour,
> And when you 've made it you shall write it ;
> The world, I 'll wager, will not slight it ;
> For where 's the city, where 's the town,
> Which is not full of your renown ?
> Nay, such is your establish'd name,
> So universal is your fame,
> That Dunces, though to dulness doom'd,
> Have with a Dunce's art presum'd
> To pass their silly tales and tours,
> And other idle Trash, for Yours.'

The volume, issued in monthly parts, with twenty-four plates by Rowlandson, was completed in 1820, and published in octavo, uniform with the first volume. This was quickly followed by a third and final tour, *Dr. Syntax in Search of a Wife*, which, after being issued in monthly parts, appeared in a collected form in 1821, uniform with the others, and containing twenty-five plates. So great was the popularity of the complete work that Ackermann issued a pocket edition in 1823. Its three volumes were in 16mo instead of 8vo, fresh plates were engraved, and the price was 7s. a volume, the earlier volumes having cost a guinea each. It may be noted that the original drawings for the aquatints in the early editions, ' Dr. Syntax pursued by a Bull' (vol. i. p. 40), 'Dr. Syntax Drawing from Nature' (vol. i. p. 121), and ' Dr. Syntax at a Card Party' (vol. iii. p. 163), are in the Dyce Collection at South Kensington. Placed beside the aquatints, these show very slight variations, and illustrate excellently both the style of Rowlandson's original water-colours, and the

manner of their reproduction under Ackermann's auspices. Besides these three, there are fourteen other drawings of incidents in the life of Dr. Syntax, which were submitted to Combe, but never used, though it is apparent from his verse that in some cases he accepted the suggestions they conveyed.

In 1813 Ackermann published the *Poetical Sketches of Scarborough*, with twenty-one plates in aquatint, etched by Rowlandson after J. Green, and coloured by hand. The 'advertisement' states that 'the originals of the plates introduced in this volume were sketches made as souvenirs of the place during a visit to Scarborough in the season of 1812. They were not intended for publication, but being found to interest many persons of taste, several of whom expressed a desire to possess engravings of them ; and, some gentlemen having offered to add metrical illustrations to each, the present form of publication has been adopted.' The illustrations show comically all the delights and amusements of a fashionable watering-place. They might serve as illustrations to Humphrey Clinker's notable misadventures at the same place some forty years earlier. Though etched by Rowlandson, the plates are signed by J. Bluck and J. C. Stadler after J. Green, so that it may be presumed that they passed through the hands of these artists to receive the aquatint and colour. Both Combe and J. B. Papworth contributed to the text.

In 1815 appeared the *Military Adventures of Johnny Newcome, with an account of his Campaign on the Peninsula and in Pall Mall*, printed for P. Martin, 198 Oxford Street. The fifteen plates are comic and interesting, but not in Rowlandson's best style, and not executed with the finish they would have received from Ackermann's assistants. *Naples and the Campagna Felice*, with eighteen plates, reprinted by Ackermann in June of this year from the *Repository*, reaches a

higher standard. Later in the year Tegg published *The Grand Master, or Adventures of Qui Hi in Hindostan*, by Quiz, with twenty-eight hand-coloured aquatints by Rowlandson. Entitled a 'Hudibrastic poem,' this is a lampoon on the Marquis of Hastings' governorship of India, and shows the public estimation of the East India Company, with its toleration of suttee for revenue purposes, and its total disregard otherwise of Hindu prejudices. The British mission-ary comes in for many cynical sneers both in text and in illustration.

In 1816, after being issued in twenty-four monthly parts, the *English Dance of Death* was published by Ackermann in two volumes, royal octavo, at three guineas, with seventy-two illustrations, besides frontis-piece and title-page. The subject of the book lies in the often quoted saying of Horace—'Pallida Mors aequo pulsat pede pauperum tabernas Regumque turres.' The idea of Death as the universal depredator, stretch-ing out his bony hand to seize his prey at moments inopportune and unexpected, showing the vanity of human life and the futility of human pleasures and pursuits, had been pictured by many artists before Rowlandson, notably in the famous series by Hol-bein. In 1794 an edition of Hollar's engravings after Holbein had been published by Francis Douce, and in 1804 this was reissued by J. Harding. In 1816 J. Coxhead had the same plates retouched, and pub-lished a somewhat garish hand-coloured edition. This may have inspired Rowlandson with the idea, but in his *Dance of Death* he takes his characters from the world around him, sees them in his own original way, and imparts to the subject his own satirical humour, with its curious combination of the sublime and the ludicrous. It is obvious at a glance that the artist bestowed exceptional care on the illustrations for this book. The union of the gruesome and the grotesque

appealed strongly to his imagination, and in completeness of detail and carefulness of grouping the illustrations excel nearly all his other work. The hand-colouring also has been delicately and judiciously applied. Combe's versification is full of wit, and shows a force and vigour surprising in a man who had passed his allotted threescore years and ten—a fact that adds a certain grimness to the humour of the work.

The *Dance of Death* was followed in 1817 by the *Dance of Life*, published first in eight monthly parts, and then as a companion volume to the other at £1, 1s. Its twenty-six plates are full of cheerful and humorous satire of life and its follies. To 1817 also belongs an illustrated edition of Goldsmith's *Vicar of Wakefield*, with twenty-four designs by Rowlandson, published by Ackermann. The tale itself is one of perpetual charm, and Rowlandson's plates show his full sympathy with the text. Nothing could be better than the spirited way in which he has realised Goldsmith's idea of the 'Family Picture.'—'My wife desired to be represented as Venus, and the painter was desired not to be too frugal of his diamonds in her stomacher and hair. Her two little ones were to be as Cupids by her side; while I, in my gown and band, was to present her with my books on the Whistonian controversy. Olivia would be drawn as an Amazon, sitting upon a bank of flowers, dressed in a green joseph, richly laced with gold, and a whip in her hand. Sophia was to be a shepherdess, with as many sheep as the painter could put in for nothing; and Moses was to be dressed out with a hat and white feather. Our taste so much pleased the Squire, that he insisted on being put in as one of the family, in the character of Alexander the Great, at Olivia's feet.' In this connection it may be recalled that the *Vicar of Wakefield* was written in 1766, five years before Benjamin West caused a sensation by his 'Death of Wolfe,' with its startling innovation in sub-

"THE FAMILY PICTURE," BY T. ROWLANDSON
FROM "THE VICAR OF WAKEFIELD," 1817

stituting a regulation military coat, cocked hat, and musket, in place of the classical paludamentum, with helmet, spear, and shield. Rowlandson's *Vicar of Wakefield* has frequently of late fetched over £20 in the saleroom. The collector, however, should note that another edition was published in 1823, with the plates dated 1817.

In 1818 the *Adventures of Johnny Newcome in the Navy*, by Alfred Burton, published by W. Simpkin and R. Marshall, has sixteen plates by Rowlandson. This was followed in 1819 by an open imitation by J. Mitford bearing the same title, and illustrated with twenty plates. Mitford, at one time an officer in the navy, was a constant inmate of the Fleet, and wrote his *Adventures of Johnny Newcome* in the gravel pits at Bayswater, where he lay in hiding, receiving from his publisher a shilling daily in return for his copy, wherewith to purchase gin and cheese. He was the editor of the *Scourge*, which helped to make Cruikshank famous, and after a very chequered career died in St. Giles's workhouse.

The Characteristic Sketches of the Lower Orders was published by S. Leigh in 1820 at 7s. as a supplement to his *New Picture of London* (1819), the two being sold separately, or in one volume at 15s. No subjects could be better adapted to Rowlandson's pencil than these fifty-four sketches. Etched in outline, and tinted by hand, they show many phases of London street life that have now disappeared. The coal-heaver, and other characters always with us, are interesting in their bygone guise; while the night-watchman, the raree-showman, the sellers of poodles, bandboxes, saloop, and other commodities, are quaintly representative of London life in olden days. As says the 'advertisement' (for publishers' puffs are by no means a modern invention), 'There is so much truth and genuine feeling in his delineations of human char-

173

acter, that no one can inspect the present collection without admiring his masterly style of drawing, and admitting his just claim to originality.'

In 1821 the *Journal of Sentimental Travels in the Southern Provinces of France* was republished by Ackermann from the *Repository*, with seventeen plates. This, as the title suggests, is a close imitation—*longo sed proximus intervallo*—of the inimitable *Sentimental Journey* by Sterne.

In 1822 Ackermann produced *The History of Johnny Quae Genus, the little Foundling of the late Dr. Syntax*. The text by Combe was illustrated with twenty-four coloured aquatints by Rowlandson. The introduction gives the best clue to the nature of the contents: 'The favour which has been bestowed on the different tours of Dr. Syntax has encouraged the writer of them to give a "History of the Foundling," who has been thought an interesting object in the latter of these volumes, and it is written in the same style and manner with a view to connect it with them. This child of chance, it is presumed, is led through a track of life not unsuited to the peculiarity of his condition and character, while its varieties, as in the former works, are represented by the pencil of Mr. Rowlandson with its accustomed characteristic felicity. The idea of an English *Gil Blas* predominated through the whole of this volume, which must be considered as fortunate in no common degree, if its readers, in the course of their perusal, should be disposed to acknowledge even a remote similitude to the incomparable works of Le Sage.' The eccentricity of the title is explained in the opening stanzas :—

'But whether 'twas in hum'rous mood,
 Or by some classic whim pursued,
 Or as, in Eton's Grammar known,
 It bore relation to his own,
 Syntax—it was at Whitsuntide,
 And a short time before he died—

THOMAS ROWLANDSON

In pleasant humour, after dinner,
Surnam'd, in wine, the little sinner.
And thus amid the table's roar
Gave him, from good old Lilly's store,
A name which none e'er had before.'

The death of Combe in the following year put an
end to their brilliant collaboration. It says much for
his buoyant nature that between the ages of seventy
and eighty-two he should have produced such vigorous
work as *The Tours of Dr. Syntax*, *The Dance of
Death*, *The Dance of Life*, and *Johnny Quae Genus*.
It is a curious fact also that he never made the
personal acquaintance of Rowlandson till the first
Tour of Dr. Syntax and the *Dance of Death* had been
published. From 1822 till his death in 1827 Row-
landson produced very little work, certainly no coloured
illustrations, with the exception of two plates in West-
macott's *English Spy*, in 1825. No. 32 is 'R.-A.'s of
Genius Reflecting on the True Line of Beauty at the
Life Academy, Somerset House.' No. 36, 'Jemmy
Gordon's Frolic, or Cambridge Gambols at Peter
House,' is in Rowlandson's coarser style.[1] The rest
are by Robert Cruikshank.

Apart from the intrinsic merit of their illustrations,
these books all form a valuable record of contemporary
costume and manners. One likes to remember that
Stevenson found in them suggestions for two of his
books. 'I have written to Charles,' says one of his
letters from Vailima in 1893, 'asking for Rowlandson's
Syntax and *Dance of Death* out of our house, and
begging for anything about fashions and manners
(fashions particularly) for 1814. Can you help? Both
the Justice Clerk[2] and St. Ives fall in that fated
year.'

In conclusion, I would fain append a quaint passage
from the chit-chat of *Wine and Walnuts* (1823), by

[1] See also p. 192. [2] Afterwards published as *Weir of Hermiston*.

Ephraim Hardcastle (W. H. Pyne), which supplies a contemporary frame to our picture of the caricaturist :—

' Master Caleb was on his way up the Hill in the Adelphi to his post at the Society of Arts, and who should he stumble upon at the corner of James Street, just turning round from Rowlandson's, but Master Mitchell, the quondam banker. He had, as usual, been foraging among the multitudinous sketches of that original artist, and held a portfolio under his arm ; and as he was preparing to step into his chariot, Caleb accosted him.—" Well, worthy sir, what more choice bits, more graphic whimsies, to add to the collection at Enfield, hey ? Well, how fares it with our old friend Rolly ? "

' " Why, yes, Mister Caleb Whiteford, I go collecting on, though I begin to think I have enough already, for I have some hundreds of his spirited works ; but somehow there is a sort of fascination in these matters, and—heigh—ha—ho—hoo " (gaping), " I will never go up—up—bless the man ! why will he live so high ? it kills me to climb his stairs," holding his ponderous sides. " I never go up, Mister Caleb, but I find something new, and am tempted to pull my purse-strings. His invention, his humour, his oddity is exhaustless."

' " Yes," said Whiteford, " Master Rolly is never at a loss for a subject ; and I should not be surprised if he is taking a bird's-eye view of you and I at this moment, and marking us down for game. But it is not his drawings alone ; why, he says he has etchèd as much copper as would sheathe a first-rate man-of-war."

' " Yes," replied the banker, " he ought to be rich, for his genius is certainly the most exhaustless, the most—the most— No, Mister Caleb, there is no end to him ; he manufactures his humorous ware with such unceasing vigour, that I know not what to compare his prolific fancy to. . . . Come, then, my old friend, none can be more welcome. You shall have a bottle of the best, and we will gossip of old times. Rolly has promised to come down—I would have taken the rogue with me, only that he is about some new scheme for his old friend Ackermann there, and says he must complete it within an hour. You know Rolly's expedition, and so he will come down by the stage." '

CHAPTER XV

HENRY ALKEN

''Orses and dorgs is some men's fancy. They're wittles and drink—
lodging, wife, and children—reading, writing, and 'rithmetic—snuff, tobacker,
and sleep.'—*David Copperfield.*

DURING the last few years of Rowlandson's career two other caricaturists—George Cruikshank and Henry Alken—were rising into fame as illustrators of coloured books. The greater of the two is George Cruikshank, but his work is reserved to the following chapter, because he forms a link between the old school of Rowlandson and Alken and the newer school of Leech and Thackeray. Here we may consider the work of Henry Alken, which stands more by itself.

As Montaigne hoped that all the world should know him by his books, so till recently one had to be content to know Henry Alken by his drawings and prints. Any biography was of necessity a thing of shreds and tatters; for where the *Dictionary of National Biography* failed, who should hope to succeed? Sir Walter Gilbey, however, while writing his *Animal Painters* (1900), was fortunate in obtaining many personal details of the Alken family from a grandson and a granddaughter of Henry Alken, and to his book I am indebted for some dates which were first published owing to his research. Henry Alken, it appears, was born in Suffolk in 1784. His uncle, Samuel Alken, who died in 1825, was an engraver, and also draughtsman of sporting subjects. From 1822 to

M

1824 he supplied the originals for a series of coloured plates in the *Annals of Sporting*, published in thirteen volumes from 1822 to 1828. It may be remarked in passing that, while odd volumes of this frequently appear, the complete set is hard to obtain, and has been sold for £80 and upwards. It was probably the influence of Samuel Alken that determined the career of Henry Alken and the character of his work.

There seems to be no authenticity for the commonly accepted statement that Henry Alken was huntsman, stud-groom, or trainer to the Duke of Beaufort. The first real fact about him is that he exhibited at the Royal Academy a miniature portrait of Miss Gubbins and a portrait of Miss Jackson, sending them from the address, 'at Mr. Barber's, Southampton Street.' His earliest sporting prints appeared anonymously under the signature of 'Ben Tallyho,' but in 1816 he published in his own name *The Beauties and Defects in the Figure of the Horse comparatively delineated*. He seems at this time to have been occupied as a teacher of drawing and etching. In his *Art and Practice of Etching*, published in 1849, he writes : ' Forty years of practice in the various methods of engraving, with some natural mechanical genius, may be considered as some qualification for this task. Nor will my endeavours prove less successful from the fact that during a great portion of that time I have been in the habit of giving lessons in the library, parlour, and drawing-room, by which I must naturally have acquired a method of mitigating, and, where practicable, avoiding the unpleasant processes of the Art.'

From 1816 to 1824, besides the *Beauties and Defects*, which has hand-coloured plates, he published several drawing-books, illustrated by uncoloured soft-ground etchings or lithographs. Among these are *Illustrations for Landscape Scenery, Sporting Sketches, Sketches of Cattle*, and *Rudiments for Drawing the Horse* (1822).

178

Scraps from the Sketch Book (1821), *A Sporting Scrap Book* (1824), and *Sketches* (1824)—all with uncoloured soft-ground etchings—are in reality drawing-books, but aim at a wider popularity by giving groups and scenes that have a certain life and interest apart from their value for the copyist.

Alken's principal publisher was M'Lean, of No. 26 Haymarket, and Mr. T. M'Lean, the present representative of the firm, tells me that in his father's days Alken occupied a room in the upper part of the house in the Haymarket, and received thirty shillings a day. Mr. M'Lean, in turning over some old stock that had not been disturbed for years, came on treasure trove of over a hundred of Alken's drawings. From 1821 onwards a large number of Alken's coloured plates appeared from this publisher's 'Repository of Wit and Humour,' evidently a rival to Ackermann's 'Repository of Art.' The distinction, however, of these names has a subtle reality, for Alken's work contains a quantity of wit and humour to the sacrifice of art. It is doubtful even whether he can lay claim to humour, for there has always been a happy distinction, well understood though not easy of definition, between wit that is shallow, with sparkling surface, and humour, whose still waters run deep. His wit, as in the *Symptoms of being Amused*, or the *Specimens of Riding*, is rather of the nature that one associates with the cheap comic papers of to-day. It is a forced wit that Rowlandson only occasionally descended to, and that is very different from the easy, genuine humour of Leech or Caldecott. His work differs from that of these two men, just as among French caricaturists the work of Vernier and 'Cham' differs from that of Daumier. Leech and Caldecott and Daumier are not caricaturists in the first sense of the word. By their power of observation, backed by sheer force of brilliant draughtsmanship, they transferred to paper the humour that faced them in

real life. Alken, Vernier, and 'Cham' produced their ludicrous effects by an obvious effort, by exaggeration, in a word, by caricature.

Even in his more serious work Alken lacks genuineness. His appeal is to the sportsman who wishes every horse that meets his eye in book or print to be a creature of blood and mettle, a potential winner of the Derby or the Oaks. The sportsman pure and simple is rarely capable of appreciating the refinements of art, and this no doubt accounts for the popularity of sporting prints that depict horses standing with elongated legs and a diminutive jockey insecurely perched on the top; or else galloping round Tattenham Corner with all four legs wide outstretched—a sheer contradiction of nature, but long accepted by convention, and stereotyped in the nursery rocking-horse. Ruskin complained bitterly that he could 'get at the price of lumber any quantity of British squires flourishing whips and falling over hurdles.' It may be rank heresy to say it, but it is to this class that Alken's work belongs. His drawings are frigid and academical; his horses are uniform, exaggerated, ideal. His figures lack individuality and variety of character. He gives you mere puppets on horseback, very different from the 'British bone and beef and beer' that form the honest sportsmen of Leech or Keene or Caldecott. His work leaves you cold and unmoved, whereas, enthusiast for hunting or not, you are carried off by Caldecott's 'Tallyho!' along with his jovial squires in pink, in all the joy, excitement, and reality of the chase.

For all this, Alken represents a phase and a period, and no sporting squire or yeoman of credit and renown has his library complete without *The Life of a Sportsman* and the *National Sports of Great Britain*. These are the best of Alken's coloured books, but by no means all, for he was a most prolific worker. Booksellers are fully aware that the name of Alken is one to conjure

with where sporting prints are concerned, and so he has come to resemble the 'poor Pagan Poets,' of whom Byron wrote that—

> 'Time, and transcribing and critical note
> Have fathered much on them which they never wrote.'

The idea, moreover, of his fertility may be fictitiously enhanced, if it is not remembered that he left two sons, George and Henry Gordon, both of them artists, and both sporting artists, who worked in aquatint, lithography, and etching. Henry Gordon, who died recently at a great age, spent his whole life in the deliberate imitation of his father's pictures. Many of these copies, particularly as they were signed 'Henry Alken,' or 'H.A.,' have been sold as originals. Henry Alken, junior, was enough of an artist for George Augustus Sala to write of him in 1878 as 'the well-known painter of racing and coaching scenes'; and it is interesting to note that Sala, in his early days an illustrator and engraver, worked along with him in etching a panoramic view (over five feet in length) of the funeral of the Duke of Wellington.[1]

It remains to give more detailed consideration to some of Alken's principal works. His *Beauties and Defects of the Horse, comparatively delineated*, published by S. and J. Fuller in 1816, contains eighteen soft-ground etchings coloured by hand. This is really a drawing-book, and the plates contain studies of portions of the horse, and illustrations of the horse in motion, galloping, jumping, etc. *Specimens of Riding near London*, published by T. M'Lean in 1821, has fourteen plates, again soft-ground etchings coloured by hand. The humour of the pictures, 'One of the comforts of riding in company,' 'Symptoms of things going down hill,' etc., is forced and exaggerated, but it must

[1] See *Notes and Queries*, August 1867; and *The Gentleman's Magazine*, May 1878.

be admitted that Alken displays a keen knowledge of the horse, and the book is one that the British admirer of horseflesh may, an it please him, bow down and worship to his heart's content. In 1821, also, M'Lean published the *National Sports of Great Britain*. The temptation to separate the plates has caused the book to become extremely rare in a complete state, with the result that a good copy fetches anything between forty and seventy pounds. It is a folio volume, published originally at ten guineas, with descriptive text in English and French, and fifty hand-coloured aquatints by J. H. Clark after Alken. These have large margins, and as the booksellers' catalogues are cruel enough to suggest, 'form a unique set for framing purposes.' They are full of sheer delight for the sportsman, and are of historic interest, for they not only include plates of all sorts and conditions of hunting, shooting, angling, and racing, but also of many obsolete, so-called ' sports,' such as bull-baiting, badger-baiting, bear-baiting, cock-fighting, and so on. Readers of *Evelyn's Diary* will recall how, in 1699, a bill of great consequence was lost in the House of Commons by ten votes, owing to so many supporters of the measure having preferred the counter-attraction of a tiger baited by dogs. In Alken's day press and pulpit were uniting their influence to put a stop to these inhuman amusements, and as the writer of the *National Sports* says, 'their exertions have not been altogether useless ; for although bull-baiting and the baiting of other animals still prevail to a degree to be lamented, yet the extent of such barbarous follies is, in no degree of comparison, equal to that of former times.' A quarto volume with the same title and preface, containing fifty hand-coloured soft-ground etchings by Alken, was issued by M'Lean in 1825. The plates cover the same subjects, but vary considerably from those of the 1821 edition, and the collector must not be misled by the similarity of title.

182

"BULL-BAITING." BY J. CLARK, AFTER HENRY ALKEN

FROM "THE NATIONAL SPORTS OF GREAT BRITAIN," 1821

HENRY ALKEN

Symptoms of being Amused and *Illustrations to Popular Songs*, published by T. M'Lean in 1822 and 1823, are oblong quartos, containing forty-two plates each. These are soft-ground etchings, coloured by hand, and were originally issued in seven monthly parts, at 12s. a part. Each page is packed tight with random, haphazard sketches, with titles laboriously fitted, of a strained and very tiresome wittiness. They form a kind of rough-and-tumble, knock-about entertainment, with little taste or refinement, that seems to have had some topical interest at the time of publication, for we are told of the *Symptoms* that 'an unprecedented Sale of 30,000 bespeaks the Public estimation of the unrivalled spirit and fertility of design, evinced throughout this Novel and Elegant Work.'

A Touch at the Fine Arts, published by M'Lean at one guinea in 1824, is, says the preface, 'an attempt to elucidate, by graphic delineations, a variety of terms generally and perhaps exclusively made use of by artists, amateurs, connoisseurs, virtuosos, and the like. Long, indeed, has a generous public been, doubtless, puzzled in the endeavour to discover some ray of meaning in those *glowing*, *brilliant* and *forcible* phrases, which the critical catalogues, *Catalogues Raisonnées*, etc., of the day are woefully burthened with.' It is a cheap kind of humour at the best. To take two of the most deserving subjects—'A Moving Effect; the Execution rapid,' is represented by a runaway coach, with expressions of the utmost horror in the faces and attitudes of the occupants; 'A Striking Effect, the handling by no means good or pleasant to the eye,' is illustrated by a fracas between two returning roisterers and some night-watchmen. In these and in plate 2, a prison-scene depicting 'An unpleasant effect, but the Keeping is Good,' Alken shows genuine power as a draughtsman, and infuses his work with a character lacking elsewhere. The last plate, indeed, might almost be a

coloured lithograph from the hand of Daumier. All twelve plates, it should be said, are soft-ground etchings, with colour applied by hand.

In his *Sporting Scrap Book*, published by M'Lean in 1824, Alken returns to his combination of drawing copies and sporting scenes. The fifty plates are in soft-ground etching, one plate often containing several studies of dogs, horses, cattle, etc. There are, however, several full plates of shooting, hunting, racing, coursing, and sporting incidents in general. This book is not so often found in coloured state as some of the others.

Of the many attempts to represent *Shakespeare's Seven Ages of Man* in pictures, Alken's is one of the poorest. His seven plates with this title, published in oblong quarto by M'Lean in 1824, are 'counterfeit presentments' of the weakest type. Alken has no business *dans cette galère* ; he should have stuck to his horses and his cockfights. The only plate of the seven that is really good is 'The Schoolboy,' 'with his satchel and shining morning face, creeping like snail unwillingly to school.' Here the artist succeeds, because he has chosen surroundings where he is thoroughly at home. The schoolboy loiters on a wooden bridge that spans a brook, stopping to watch two other boys with dogs, all hot in the excitement of a rat-hunt. Their eager energy serves to emphasise the schoolboy's slow and idle progress, while the background suggests a charming piece of flat landscape, with red-roofed buildings on the left, on one of which the mystic letters —EMY (every school was an Academy in Alken's day) show through an angle of the bridge. All the other plates are tawdry and ineffective, but about this one there is a feeling of truth to nature and of restrained power that makes one wish Alken had always gone and done likewise. Two plates further on we come to its very antithesis, 'The Soldier,' a picture that in con-

ception and execution might well have been accomplished an hour later by the aforesaid schoolboy, to console his feelings after the necessarily uncomfortable interview with his pedagogue.

In his illustrations to the *Memoirs of the Life of John Mytton*, published by Ackermann in 1837, Alken is again in his proper element. The author and the hero of the book are alike calculated to win his sympathy. Its author, C. J. Apperley, better known by his pseudonym of 'Nimrod,' after being educated at Rugby, was gazetted a cornet in Sir Watkin Wynn's ancient light British Dragoons. After serving in the suppression of the Irish rebellion he returned to England to settle as a yeoman farmer, hunting with the Quorn, the Pytchley, and the Warwickshire hounds. He was a good, all-round sportsman, and when experiments in farming ran away with his capital, turned his hand to the writing of sporting reminiscences. He wrote at first with reluctance, having the conviction that no 'gentleman' ever wrote for a sporting paper; but his scruples were soon overcome, and he contributed largely to the success of the *Sporting Magazine* and the *Sporting Review*; nor must it be forgotten that he helped to win popular appreciation for the work of Surtees. But his greatest success was in his books illustrated by Henry Alken. The first of these was *The Chace, the Turf, and the Road*, which appeared in 1837, with thirteen plates, uncoloured. The *Memoirs of the Life of John Mytton, Esq.*, was issued in the same year with twelve coloured plates, but owing to its popularity it appeared within a few months in a second and better edition with eighteen plates. This is not a work of fiction, for John Mytton, a rather inglorious character for a biography, was a hard-living, hard-drinking country squire of Halston, Shropshire, capable of the utmost physical endurance, and ready to accept any wager to walk, shoot, or ride

against any man. Many of his feats are recorded and graphically delineated, including the climax of his folly in setting his nightshirt on fire to cure a hiccough. Of the eighteen plates, all engraved by E. Duncan, nine are after originals by Alken, eight after Alken working with T. J. Rawlins, and one after Rawlins alone. There have been many reprints of the book, the best being the third edition of 1851, which contains a memoir by Surtees of 'Nimrod,' who died in 1843.

The Life of a Sportsman, by 'Nimrod,' published by Ackermann in 1842, again gave Alken the opportunity he wanted. 'In his character as a sportsman,' says the author, 'I make my hero commence with the *lowest* branches of the art, of which rat-catching is, I believe, the type. He thence proceeds to the rabbit and the badger, progressing gradually to the higher sports of the field, and finishes as a Leicestershire fox-hunter, and a horseman of the first class. I have also made him a coachman—that is to say, an ardent amateur of the coach-box, characteristic of the era in which I place him, which is, as nearly as may be, my own.' Here was full scope for Alken, who produced thirty-six plates, coloured by hand, drawn and etched by himself, many containing aquatint, showing sporting scenes of every variety of interest. The book was published at two guineas. Copies are often found with the plates cut close and mounted; and it is just possible that R. Ackermann, junior, who published it, may have directed this process. The earliest copies were issued in blue cloth, and the colour was afterwards changed. In May 1904 a copy realised £35, 10s. in the saleroom. There was an edition by Routledge in 1869, another in 1874, and a two volume edition in 1901. The sporting novels of R. Surtees will be referred to later, but here it must be stated that the famous *Jorrocks' Jaunts and Jollities, or the Hunting, Shooting, Racing, Driving, Sailing,*

HENRY ALKEN

Eccentric and Extravagant Exploits of that re-
nowned Sporting Citizen, Mr. John Jorrocks of St.
Botolph Lane and Great Coram Street, after being
published in 1838 with twelve illustrations by 'Phiz,'
was reissued in 1843 with sixteen plates after Alken.

With the *Analysis of the Hunting Field*, a series
of six hand-coloured plates engraved by Harris after
Alken in 1846, and the *Art and Practice of Etching*
in 1849—a curious finale for a sporting artist—Alken's
work draws to a close. He died in 1851, and was
buried in Highgate Cemetery. Since his death he has
become so much the object of a sort of fetish-worship
that booksellers have still further complicated the
natural confusion between father and son by attaching
the name of Henry Alken to book or print on the
slightest pretext or opportunity. Many books of later
days have also been illustrated with reproductions of
his work, among them *Down the Road, or Remini-*
scences of a Gentleman Coachman, by C. T. S. Birch
Reynardson (1875-6), and some books by W. C. A.
Blew, among them *The Quorn Hunt and its Masters*
(1899) and *A History of Steeplechasing* (1891).

CHAPTER XVI

GEORGE AND ROBERT CRUIKSHANK

'And yet it is no trifle to be a good caricaturist.'
PROF. WILSON on G. Cruikshank,
in *Blackwood's Magazine*, 1823.

ROBERT CRUIKSHANK died in 1856, and though George Cruikshank lived till the year 1878, it must be remembered that, born in 1792, he was the contemporary of Rowlandson, and that his best work was all done before 1850. Isaac Cruikshank, their father, who hailed from north of the Tweed, was an engraver, etcher, and painter in water-colours. Coming to London about 1788, he became one of the most prominent of the many caricaturists at the opening of the nineteenth century, and one of the first steps towards art made by his two sons was to work, together with their mother, at colouring their father's prints. The work of the father and the two sons has been considerably confounded, for George Cruikshank in his boyhood used to work on his father's plates, and also assisted his brother, Isaac Robert (or Robert, as he was generally known), when the latter forsook miniature painting for drawing on wood and etching. The varying signatures—I. CK., I. R. CK., R. CK., and G. CK.—have caused natural confusion among dealers, printsellers, and collectors. Some reference to this confusion by an English author has no doubt led to the amusing entry in Nagler's great *Künstler-*

188

Lexicon:—'PURE, Simon, der eigentliche Name des berühmten Caricaturzeichners Georg Cruikshank.'[1]

Robert, the elder of the two sons, was born on 27th September 1789, three years to a day before George. The two brothers were educated at an elementary school at Edgeware, and then Robert, inspired by the 'moving accidents by flood and field' related by his mother's lodger, Mungo Park, went to sea as a midshipman in the East India Company's service. During a storm at St. Helena he was left on shore and reported as lost, so that his return three years later caused no little astonishment to his mourning family. During his brother's absence George had made considerable progress in his art, producing headings for songs, comic valentines, lottery prints, and so forth. The two brothers now worked in partnership, and on their father's death kept on the family home at Dorset Street. Now that Gillray, Bunbury, and Dighton were dead, and Rowlandson growing old and careless, they commanded a ready market for their caricatures. For a time, of course, they may be called Rowlandson's rivals, for they assailed the same abuses, censured the same crimes. The Regent, Napoleon, the 'delicate investigation,' and Queen Caroline, attracted these humourists together. George Cruikshank, in particular, levelled endless manifestoes against Buonaparte, and 'did his very prettiest for the Princess,' believing that she was 'the most spotless, pure-mannered darling of a Princess that ever married a heartless debauchee of a Prince Royal.' Ackermann, Fores, and Fairburn came with plentiful commissions, but the leading prize-fighters of the day were made equally at home in their studio, and the two brothers formed an extensive and peculiar acquaintance with the 'Tom and Jerry' life that they so admirably depicted. George in particular,

[1] 'PURE, Simon, the proper name of the famous caricaturist, George Cruikshank.'

as his friend Mr. G. A. Sala contended, knew London and London life 'better than the majority of Sunday-school children know their Catechism.' Robert, how-ever, finding some success as a portrait painter, married and moved to a more fashionable quarter at St. James's Place, but still continued his work as a caricaturist and illustrator.

Robert, when the spirit moved him, could produce brilliant work, but was often apt to be hasty and slovenly, and cannot be compared with his more gifted brother. The latter, long before he reached middle age, entirely abandoned caricature for book illustration, beginning humbly with illustrations for chap-books, one of the earliest of his coloured frontispieces bearing the attractive title of 'Horrid Murder of Elizabeth Beasmore.' Publishers soon found that George Cruik-shank could be relied on to treat any subject under the sun with resource and sympathy, and his remarkable fecundity is shown by the five pages of cross-references under his name in the British Museum Catalogue, and by the 5265 entries in Reid's Catalogue of his work. What interests us now is that 669 of these entries refer, not to separately published prints, but to books or tracts illustrated by the artist—not, of course, all published with coloured plates—some having merely a frontispiece, but others with forty or more of his illustrations. Many of these, it is true, were ephemeral and minor publications, that even Cruikshank's genius could not raise above mediocrity, and in many cases he took the stage in a character to which he was utterly unsuited, as when he supplied some forty etchings to Byron's Poems. With this enormous output it is no wonder that in 1865, on being shown the *Life in Paris*, he 'at first professed his utter ignorance of the entire performance.'

The work of Robert Cruikshank as a maker of coloured illustrations may be briefly summed up before

190

we describe that of his more distinguished brother. Besides contributing frontispieces to several books, he illustrated *Lessons of Thrift* with twelve coloured aquatint plates in 1820; *The Commercial or Gentleman Traveller* with five plates, and *The British Dance of Death* with eighteen plates, in 1822; and Pierce Egan's *Sporting Anecdotes* in 1825. His illustrations for *Life in London*, done conjointly with George, and the *Finish to the Adventures of Tom, Jerry, and Logic*, to which this gave rise, must be referred to in connection with George's work. Apart from these, Robert Cruikshank's most important work was the illustration of *The English Spy: an Original Work, characteristic, satirical, and humorous . . . being Portraits of the Illustrious, Eminent, Eccentric, and Notorious. Drawn from the life by Bernard Blackmantle*, published in 1825. 'Bernard Blackmantle' is the pseudonym of Charles Molloy Westmacott, who died in 1868, and who was long famous, or rather infamous, as the proprietor and editor of *The Age*, a paper which levied blackmail without mercy. For the suppression of certain information he had acquired as to a scandalous intrigue involving some members of the court, he obtained on one occasion not less than £5000. *The English Spy* is a veritable *chronique scandaleuse* of the time. In the pages of this extraordinary work figure all the notabilities of the day, either openly or under slight disguise; and Tom Best, White-headed Bob, 'Pea-green' Hayne, Colonel Berkeley, the 'Golden' Ball, Dr. Kett, Charles Mathews, Jemmy Gordon, and a host of others of equal notoriety, mingle, cheek by jowl, in the vivid and moving panorama.[1] The first volume is occupied mainly with life at Eton and Oxford, and in the second volume life in London of all sorts and conditions is even more vividly depicted

[1] *See* Maclise, D., *A Gallery of Illustrious Literary Characters.* Edited by W. Bates, 1873.

than in Pierce Egan's famous book. The *English Spy*, says the preface, 'contains copper-plates, etched, aquatinted, and coloured, by and under the direction of the respective artists whose names appear to the different subjects.' Of the seventy-two hand-coloured aquatint plates, all are by Robert Cruikshank with the exception of four. One of these is by G. M. Brightly, and one by J. Wageman. The other two are by Rowlandson, one illustrating 'Jemmy Gordon's Frolic, or Cambridge Gambols at Peter House,' the other 'R.-A.'s of Genius reflecting on the True Line of Beauty.' This last represents West, Shee, Haydon, Lawrence, Westmacott, Flaxman, and others—the identity indicated by the initials on their drawing-boards, even if the portraits were not recognisable—gloating over the nude charms of a model who might have sat for Rubens. Besides the coloured plates there are numerous woodcuts, and it is noteworthy that the last in the book, by Robert Cruikshank, under the title of 'Bernard Blackmantle and Bob Transit,' presents portraits of the author and the artist.

George Cruikshank was not a great draughtsman; he showed no refinement in his handling of line or composition, and had no notion of how to draw a horse or a tree. Yet he was a keen observer of character, possessing the high qualities of imagination, wit, fancy, and tragic power; and his work is always alive and expressive, vivid and spontaneous. With these qualities was combined an exuberance of invention that made him never content with his main idea, but drove him to crowd humorous details into every corner of his picture. His drawings were often full to overflowing with episodes and incidents, to each of which he devoted an equal concentration, often neglecting artistic unity, and sacrificing art for mere popular interest.

The coloured plates by Robert and George consist of etched outlines, with occasionally some aquatint,

tinted by hand. Etching was adopted by all the caricaturists of the period as a cheap and convenient method of reproducing their work. George Cruikshank's etchings are marked by a certain crispness of execution that made Ruskin write of their 'pure unaffected rightness of method, utterly disdaining all accident, scrawl, or tricks of biting.' Cruikshank's published work conveys no idea of the painstaking study and the endless elaboration by which it was produced. For every illustration he would make several sketches in pencil or ink, and it was his habit to add in the margin, as he worked, numerous little studies of figures, suggesting an alteration in position or in features, often expressed in a few lines, yet always full of animation. Whether his illustration was intended to be published in colours or not, he often finished his pencil drawing in water-colour, perhaps because he obtained by this means a better feeling of light, shade, and atmosphere, and could enter better into the spirit of the scene. His colouring, it should be said, was of the simplest, consisting of slight washes of yellow, green, and blue, in pure tints, with here and there a suggestion of red. From the drawing thus completed he made a pencil tracing to be transferred to the copper for etching. If the illustration were to be published in a coloured state, a proof of the etching was tinted by the artist. With this as a model, hundreds of similarly tinted copies were produced by the colourists working for the publisher, precisely as was the case with Rowlandson and his coloured plates published by Ackermann. 'Coloured etching' in reference to Cruikshank's illustrations invariably means an etching coloured by hand, not printed in colour.

These methods of procedure were amply illustrated in the 'George Cruikshank Collection' of etchings and drawings, selected by the artist himself, and exhibited in 1863 at Exeter Hall. This collection subsequently

passed into the possession of the Westminster Aquarium, whose managers bought it from the artist in 1876 for £2500, with a life annuity for himself or his wife of £35. When the Aquarium premises were disposed of in 1903, the Cruikshank collection was sold on May 22nd and 23rd of that year at Sotheby's. Among a large number of water-colour and pencil sketches for book-illustrations, were the twenty water-colour drawings made for Harrison Ainsworth's *The Miser's Daughter*. These were sold for £190, while the twenty original water-colours for the *Irish Rebellion* fetched £180. Both of these sets are remarkable for the clever marginal sketches, so characteristic of the artist's style. The collection also contained Cruikshank's own coloured versions of twelve etchings for *Greenwich Hospital*.

The collection in the National Art Library, given by the late Mrs. Cruikshank, is also thoroughly representative of the artist's methods. There are dozens of trial studies to show the pains he bestowed on the smallest designs for woodcuts; and his liking for water-colours is proved by his existing coloured sketches for *The Greatest Plague of Life*, *Ben Brace*, *The Bottle*, and other works not issued in colours. Though only four numbers of the *Comic Almanack* appeared with hand-coloured illustrations, the original sketches at South Kensington include several in water-colour, notably the famous one of 'Lord Cornwallis' being soused under the fountain. In the same collection are Cruikshank's own hand-coloured copies of the etchings for *George Cruikshank's Magazine*, the *Comic Alphabet*, *Punch and Judy*, and *Greenwich Hospital*. Of the latter there are trial proofs of the etchings as well as the finished copy in colours. On one trial proof returned to the publisher with pencil corrections, the artist writes: 'This is an unfinished proof. You will not be able to judge what

194

it will look like until coloured.' In the Print Room at the British Museum there is a superb collection of Cruikshank's original drawings. Full details of these will be found in the valuable *Catalogue of Drawings by British Artists*, compiled by Mr. Laurence Binyon.

The two sets of water-colour drawings for *The Miser's Daughter* and the *Irish Rebellion*, referred to above, were admirably reproduced by the three-colour process in a volume entitled *Cruikshank's Water-Colours*, published in 1903 by Messrs. A. and C. Black, with an introduction by Mr. Joseph Grego. Along with them was included a set of *Oliver Twist* drawings. To avoid misapprehension, it should be stated that though Cruikshank made these coloured drawings for *The Miser's Daughter*, the book was never issued with coloured plates. Nor was the original issue of *Oliver Twist* in colours, and the set of drawings reproduced in *Cruikshank's Water-Colours* was prepared in 1866 by the artist as a special commission for Mr. F. W. Cosens. They are to some extent replicas of the published etchings, but were carefully and conscientiously finished by Cruikshank, showing his full powers as a colourist. He enjoyed his task, for he supplemented the set with thirteen smaller drawings and a humorous title-page. These drawings passed into the possession of Mr. Grego, under whose direction they were expensively reproduced in photogravure by Messrs. Chapman and Hall in an *édition de luxe* of *Oliver Twist* in 1894.

It is noticeable that Cruikshank moved with the times, and that his work forms a link between the old style of caricaturists and the new, between Rowlandson, Gillray, Bunbury on the one hand, Leech and 'Phiz' on the other. In his early days he rejoiced in the exaggerated ugliness and broad grossness of Rowlandson's coarser work, but after his 'Tom and Jerry' phase he passed by a gradual transition into the school

of modern caricaturists, who without sacrifice of humour could produce serious work full of observation and of truth to nature.

The books containing coloured illustrations by George Cruikshank are so numerous that comment must be confined to a 'short leet,' as the Scots phrase has it, representing only the most important. It is in the *Scourge, or Monthly Expositor of Imposture and Folly*, that Cruikshank's best work, coloured by hand, begins. By Cruikshank it must be understood that George is now meant. In the pungent caricatures of this magazine, often severe to the extreme, and not infrequently coarse and indelicate, the political and social history of the time is vividly portrayed. The Regent and his mistress, the 'sainted' Queen Caroline, Buonaparte, Tom Cribb, Mrs. Jordan, Mrs. Siddons, Kean, Vaccination ('The Cow-Pox Tragedy') are all among the subjects of his satire. The magazine was published in sixty-six monthly numbers, in yellow pictorial wrappers, from 1st January 1811 to June 1816. Of a similar nature are *Town Talk, or Living Manners* (1811-14), and the *Meteor, or Monthly Censor* (1813-15). A complete copy of the latter is excessively rare, and one sold at Sotheby's on 7th December 1903 for £85.

In 1815 the *Life of Napoleon, a Hudibrastic Poem in Fifteen Cantos*, by Dr. Syntax, appeared in parts, with fifteen illustrations by Cruikshank, and was re-issued with the date 1817 on the title. The plates are coarse in sentiment and execution, and the verse mere doggerel, but the book is rare, illustrating events from the youthful Napoleon dreaming in the military college to the landing in Elba. This is not to be confounded with W. H. Ireland's *Life of Napoleon*, with twenty-seven plates by Cruikshank, etchings coloured by hand, from his own designs or those of Isabey, Denon, Vernet, and others. This was issued in sixty-four parts, the

first forty-eight, forming the first three volumes, being published by Fairburn. The publication was then taken over by Cumberland, and finished in sixteen more parts, the whole being published in four volumes in 1828. To the same year as the Syntax *Life of Napoleon* belongs another book of the same class, *An Historical Account of the Campaign in the Netherlands in* 1815, by William Mudford. This contains twenty-eight etchings by Cruikshank, coloured by hand (four only are signed), and was issued first in four parts.

Perhaps the most important, certainly one of the rarest, of the books with coloured plates by Cruikshank is *The Humourist, a Collection of Entertaining Tales, Repartees, Witty Sayings, Epigrams, Bon Mots, Jeu d'Esprits.* This was issued in numbers from 1st January 1819, and formed four volumes when complete in 1820. The forty hand-coloured etchings show Cruikshank at his best, and are full of variety, as the contents of any one volume will show. Pick up volume ii., for instance, and note the list of contents: —The Bashful Man; An Awkward Mistake; The Whiskers; The Witty Porter in the Stocks; Cooke the Actor, the Dirty Beau, and Big Ben; John Audley; Daniel Lambert and the Dancing Bears; The Biter Bitten; Monsieur Tonson. If you knew Cruikshank without knowing this book, you could imagine the wit and relish with which he treats these subjects.

In the following year, 1821, Robert and George Cruikshank won a huge success by their illustrations to Pierce Egan's *Life in London; or the Day and Night Scenes of Jerry Hawthorn, Esq., and his elegant friend Corinthian Tom, accompanied by Bob Logic the Oxonian, in their Rambles and Sprees through the Metropolis.* Containing thirty-six aquatint plates, coloured by hand, as well as numerous wood-engravings by the two brothers, it appeared in shilling numbers from August 1820 to July 1821, and took

town and country by storm. So great, indeed, was the demand for copies that the colourists found themselves unable to keep pace with the printers.

Twenty years later, Thackeray still remembered the leather gaiters of Jerry Hawthorn, the green spectacles of Logic, and the hooked nose of Corinthian Tom, and in a charming essay recalled his schoolboy's delight in the book. 'In the days when the work appeared,' he writes, 'we firmly believed the three heroes to be types of the most elegant, fashionable young fellows the town afforded, and thought their occupations and amusements were those of all high-bred English gentlemen. Tom knocking down the watchman at Temple Bar; Tom and Jerry dancing at Almack's, or flirting in the saloon at the theatre; at the night-houses after the play; at Tom Cribb's, examining the silver cup then in the possession of the champion; at Bob Logic's chambers, where, if we mistake not, "Corinthian Kate" was at a cabinet piano, singing a song; ambling gallantly in Rotten Row, or examining the poor fellow at Newgate who was having his chains knocked off before hanging; all these scenes remain indelibly engraved upon the mind. As to the literary contents of the book, they have passed sheer away. It was, most likely, not particularly refined; nay, the chances are that it was absolutely vulgar. But it must have had some merit of its own, that is clear; it must have given striking descriptions of life in some part or other of London, for all London read it, and went to see it in its dramatic shape.'

Like Rowlandson's *Tours of Dr. Syntax*, the *Life in London* was followed by a host of imitations and pirated copies. *Real Life in London, or Rambles and Adventures of Bob Tallyho, Esq., and the Hon. Tom Dashall in High and Low Life*, issued in sixpenny parts from 1821 to 1822 with thirty-four aquatint plates, coloured by hand, by Alken, Rowlandson, Heath,

"ART OF SELF DEFENCE. TOM AND JERRY RECEIVING INSTRUCTIONS FROM MR. JACKSON AT HIS ROOMS IN BOND STREET."

BY I. R. AND G. CRUIKSHANK

FROM "LIFE IN LONDON," BY PIERCE EGAN, 1821

Dighton, etc., is perhaps as good as the original. In 1821, *Real Life in Ireland, or the Day and Night Scenes, Rovings, Ramblings, and Sprees, &c., of Brian Boru and Sir Shawn O'Dogherty*, has nineteen aquatint plates by Alken, Heath, Marks, and others, coloured by hand. The imitation that most deserves special record is David Carey's *Life in Paris: comprising the Rambles, Sprees, and Amours of Dick Wildfire, of Corinthian celebrity, and his Bang-up Companions, Squire Jenkins and Captain O'Shuffleton, etc.* This was published by Fairburn in 1822, and has twenty-one coloured aquatints by George Cruikshank, 'representing scenes from real life.' The pictures are extremely spirited and true, and are all the more wonderful in view of the fact that the artist's continental experiences were limited to one day spent at Boulogne.

A French translation of the *Life in London* was published at Paris in 1823 with the title *Diorama Anglais ou Promenades Pittoresques à Londres*, and reproduces twenty-four of the original plates with wonderful exactness. Dramatic versions at the playhouses increased the notoriety of the book. W. Barrymore's play at the Royal Amphitheatre was produced on September 17, 1821. At the Olympic an extravaganza called 'Life in London' appeared on November 12, 1821. For the dramatic version at the Adelphi, entitled 'Tom and Jerry, or Life in London,' the scenery was arranged by Robert Cruikshank. This last version travelled all through the country and the United States, with crowded houses wherever it went. At Sadler's Wells a dramatic version by Egan himself ran for one hundred and ninety-one nights. The songs, duets, choruses, etc., in the Adelphi Burletta were published in 1821 with a frontispiece, a handcoloured etching by Robert Cruikshank, representing Mr. Wrench as Corinthian Tom, and replaced in a

second issue by Mr. Wilkinson as Bob Logic. By Robert also is the frontispiece in 1821, coloured by hand, to *Tom and Jerry in France, or Vive la Bagatelle, a Musical Entertainment in three Acts, as performed at the Royal Coburg Theatre.* Of the Sadler's Wells version the *Songs, Parodies, etc., introduced into the new Pedestrian Equestrian Extravaganza and Operatic Burletta . . . called Tom and Jerry,* were published with a frontispiece by George Cruikshank.

In 1829 Pierce Egan published a *Finish to the Adventures of Tom, Jerry, and Logic,* of the same size as its predecessor, and again with thirty-six plates, but this time all by Robert Cruikshank. In this volume the author rounds off his story; Corinthian Kate, Tom, and Bob Logic all come to a melancholy end; and the book ends with 'all happiness at Hawthorn Hall, and the Nuptials of Jerry and Mary Rosebud.' The plates are excellent, but compare them with the first series, and the absence of George Cruikshank's vitality is apparent.

In 1823 came the *Points of Humour,* published by C. Baldwyn, at eight shillings plain, twelve shillings coloured, with ten etchings by George Cruikshank, and this was followed in 1824 by a second part at the same price, with ten more plates. 'The collector,' says Thackeray, 'cannot fail to have them in his portfolio, for they contain some of the best efforts of Mr. Cruikshank's genius, and though not quite so highly laboured as some of his later productions, are none the worse, in our opinion, for their comparative want of finish. All the effects are perfectly given, and the expression is as good as it could be in the most delicate engraving upon steel. The artist's style, too, was then completely formed; and, for our part, we should say that we preferred his manner of 1825 to any other which he has adopted since.' The points of humour consist largely of scenes

200

from Smollett, but the book is also notable as containing an early reprint, certainly the first illustrated version, of the ' Jolly Beggars ' of Burns. The poet's muse had been too high kilted ' as she gaed owre the lea' for the earlier editors of Burns to include in their collections what Sir Walter Scott calls 'a cantata for humorous description and nice discrimination of character, inferior to no poem of the same length in the whole range of English poetry.'

Greenwich Hospital: A Series of Naval Sketches, descriptive of the Life of a Man of War's Man, was published in 1826 with twelve hand-coloured etchings by Cruikshank, besides numerous woodcuts. It was issued originally in four parts at five shillings each, or one guinea when complete. The plates are in a more free and open style than the artist usually adopted, with less crowding of detail and incident. ' *Greenwich Hospital*,' to quote Thackeray once more, ' is a hearty, good-natured book, in the Tom Dibdin school, treating of the virtues of British tars, in approved nautical language. They maul Frenchmen and Spaniards, they go out in brigs and take frigates, they relieve women in distress, and are yard-arm and yard-arming, athwart-hawsing, marlinspiking, binnacling and helm's-a-leeing, as honest seamen invariably do, in novels, on the stage, and doubtless on board ship. This we cannot take upon us to say, but the artist, like a true Englishman, as he is, loves dearly these brave guardians of Old England, and chronicles their rare or fanciful exploits with the greatest good-will.'

In 1826 Cruikshank started to publish on his own account, at 22 Myddelton Terrace, Pentonville, a series of books in small oblong folio, after the type of those by Alken and Seymour, consisting of sets of etchings without text, each plate containing a number of small sketches. All were published originally, in paper wrappers, at eight shillings plain, twelve shillings coloured, and on India

paper at fifteen shillings. *Phrenological Illustrations*, published on August 1, 1826, contains six plates, among them the 'Philoprogenitiveness,' which appealed so strongly to the youthful Thackeray. *Illustrations of Time*, published on May 1, 1827, has six similar plates. *Scraps and Sketches* was issued with six plates on May 20, 1828, and bears on the title-page the remark, 'To be continued occasionally.' Part 2 appeared in 1830, Part 3 in 1831, and Part 4 in 1832, each containing six plates. In 1834 was issued 'Plate 1, for Part 5 of *Scraps and Sketches*, Anticipated Effect of the Tailors' Strike, or Gentlemen's Fashions for 1834.' This was, however, all of the 5th Part that appeared, and collectors should bind the odd plate at the end of the four published parts. *My Sketch Book* began in 1834, consisting of nine numbers, each with four plates containing several subjects. They were issued at 2s. 6d. plain, 3s. 6d. coloured. 'The reader,' says Thackeray, 'will examine the work called *My Sketch Book* with not a little amusement, and may gather from it, as we fancy, a good deal of information regarding the character of the individual man George Cruikshank. What points strike his eye as a painter; what move his anger or admiration as a moralist; what classes he seems most especially disposed to observe, and what to ridicule.' There is, finally, one book that must be mentioned, because it shows Cruikshank's power of depicting scenes of pathos and tragedy as well as those of humour. This is Maxwell's *History of the Irish Rebellion in* 1798, published with Cruikshank's illustrations in 1845. The twenty hand-coloured etchings —the original drawings have been already mentioned— show a wonderful comprehension of Irish character, and illustrate with dramatic intensity wild scenes of savagery and lust for blood.

Such are the contributions of George Cruikshank to coloured illustration, and they are but a small

"THE BATTLE OF THE NILE." BY G. CRUIKSHANK

FROM "GREENWICH HOSPITAL," 1826

fraction of his life's work—work that Ruskin thought was wasted. 'Among the reckless losses of the right services of intellectual power with which this century must be charged, very few are, to my mind, more to be regretted than that which is involved in its having turned to no higher purpose than the illustration of the career of Jack Sheppard and the Irish Rebellion, the great, grave (I use the words deliberately and with large meaning), and singular genius of George Cruikshank.' We prefer to accept the saner and more human judgment expressed by Thackeray: 'Week by week, for thirty years, to produce something new; some smiling offspring of painful labour, quite independent and distinct from its ten thousand jovial brethren. . . . He has told a thousand truths in as many strange and fascinating ways; he has given a thousand new and pleasant thoughts to millions of people; he has never used his wit dishonestly. How little do we think of the extraordinary power of this man, and how ungrateful we are to him!' It is, indeed, no trifle to be a good caricaturist.

CHAPTER XVII

LEECH, THACKERAY, AND 'PHIZ'

IF Cruikshank, representing in his own person both the old school and the new, is typical of the transition, with Leech, Thackeray, 'Phiz,' and Doyle we are among the moderns—so much so, indeed, that only a slight recapitulation of biographical facts should be necessary. To some extent, however, these must be given, where they throw light on the artists in relation to their work, and give to their book illustrations added interest and importance.

John Leech was born on August 19, 1817. His father, a man of fine culture and a thorough gentleman, was landlord of the London Coffee House, once a famous hostelry on Ludgate Hill. Leech was sent to the Charterhouse at the age of seven, and began there a friendship with Thackeray that grew daily in warmth, and was severed only by Thackeray's death. On leaving school he went as a medical student to St. Bartholomew's Hospital, but his heart already was in his drawing, and his lecture notes consisted of caricatures of his medical professors and his fellow-students. At the age of eighteen he launched, timidly and obscurely, his first artistic venture, entitled *Etchings and Sketchings, by A. Pen, Esq.* This consisted of four quarto sheets, without text, containing numerous sketches of cabmen, policemen, broken-down hacks, and all the oddities of London life. The book is now extremely rare, and is of interest to us because it was published

204

at ' 2s. plain, 3s. coloured.' The first real success that brought his name into public notice was his clever caricature of the Mulready envelope, and he soon became well known by his constant contributions to *Bell's Life in London*. In August 1841 Leech's services were secured for *Punch*, the first number of which had appeared three weeks before. From this time till his death, more than twenty years later, he was the leading spirit of the paper, contributing over three thousand drawings, and earning by his contributions from first to last the sum of £40,000. 'Fancy a number of *Punch*,' wrote Thackeray, 'without Leech's pictures! What would you give for it?'[1]

But during all the time Leech was engaged in working for *Punch*, he was also producing book-illustrations, many of them issued in colours. Looking at his career as a whole, it may be said that Leech was the first of our English caricaturists whose work throughout was pure and wholesome. There is no Tom-and-Jerry stage in his career, as in that of Cruikshank. As some one has remarked, the most scrupulous mammas can find no intimation in his work that there is a Seventh Commandment sometimes broken. The coarseness of the old school of caricaturists disappears. In its place is a humour invariably fresh and innocent. With Leech, as with Izaak Walton, you feel a spirit of honest mirth, a sense of simplicity and sweetness, of clear skies and caller breezes. To make the truth of this the more apparent, you have but to glance at the work of his contemporaries in France, of Gavarni in particular. Leech infused into his work his own honest, cheerful, and wholesome nature. A note in *Punch* on the day of his funeral

[1] Anthony Trollope relates that for a week the writers and artists at the *Punch* office felt very sore about this awkward question. Then the author invited the confraternity to dine—*more Thackerayano*—and the confraternity came, and all was forgiven.

said well that 'he illustrated every phase of society with a truth, a grace, and a tenderness heretofore unknown to satiric art.'

The work of Leech marks not only the change to a purer atmosphere, but yet another difference between the old and new schools of caricature. The new men relied less and less on actual caricature in its proper sense of exaggeration and grotesqueness, and more on the inherent humour of the life that surrounded them. They worked straight from nature with a keen and accurate observation, and their humour in consequence is less forced and boisterous, and far nearer to truth and ordinary experience. The term 'caricaturist,' indeed, though useful in its generic sense, is wrongly applied to men like Leech and Keene and Phil May. They belong to the school to which the Japanese give the quaint yet beautiful title *Ukiyoye*—'mirror of the passing world.' In Leech's work there is a constant freshness, an ever-changing variety of scenes and characters. A Scotch gillie, an Irish driver of a jaunting-car, a Frenchman bathing at Boulogne, a fine lady or a crossing-sweeper are all touched with equal excellence. 'John Leech,' wrote Ruskin, 'was an absolute master of the elements of character.'

Leech's extraordinary versatility was shown not only in his grasp of character, which won Ruskin's praise, but in his keen observation of horses and landscape. That he was himself a zealous sportsman, angler as well as huntsman, is apparent in all his work, most of all, perhaps, in his pictures of *Mr. Briggs and his Doings*. He constantly rode with the Pytchley hounds, and it is stated that though he would follow a single huntsman for hours, noting his every movement, every button and wrinkle on his coat, yet in his own dress he invariably presented an utterly incongruous appearance. That he rode with his eyes wide open not only as to gate, hedge, ditch, and surrounding landscape,

but to every droll and comic aspect of sporting life, is shown by his illustrations to *Mr. Sponge's Sporting Tour, Handley Cross*, and the rest of Surtees's novels.

A few of Leech's illustrations in books are lithographs tinted by hand. The rest are etchings, and it may be supposed that he himself, like Rowlandson and Cruikshank, furnished the first coloured copy. The tints consist of simple washes of colour, requiring little skill in their manipulation, but Leech must have revelled in putting in the touches of 'pink' on the huntsmen's coats. He was not naturally a colourist, and the story of his exhibition of 'Sketches in Oil' at the Egyptian Hall in 1862, as related by Dr. John Brown,[1] is somewhat curious. The idea originated with his friend and colleague Mark Lemon, who saw that by a new invention—a beautiful piece of machinery —the impression of a block in *Punch*, being first taken on a piece of indiarubber, could readily be enlarged by stretching the rubber, when, by a lithographic process, the copy obtained could be transferred to the stone, and impressions printed on a large sheet of canvas. Having thus obtained an outline consisting of his own lines enlarged to some eight times the size of the original block, Leech proceeded to colour these. His knowledge of the technique of oil painting was very slight, and it was under the guidance of his friend Sir John Millais that his first attempts were made. He used a kind of transparent colour which allowed the coarse lines of the enlargement to show through, so that the production presented the appearance of an indifferent lithograph, slightly tinted. In a short time, however, he obtained great mastery over oil-colour, and instead of allowing the thick, fatty lines of printer's ink to remain on the canvas, he removed the ink with turpentine, particularly from the lines of the face and figure. These he re-drew, using a considerable skill in

[1] See *John Leech and other Papers*, by Dr. John Brown, 1882.

flesh-colouring, which greatly enhanced the value and beauty of his later works. This exhibition took London captive, was enthusiastically noticed by Thackeray in the *Times*, and brought in £5000 to the artist. Dr. John Brown relates how one day a sporting nobleman visited the gallery with his huntsman, whose naïve and knowing criticisms greatly amused his master. At last, coming to one of Leech's favourite hunting pictures, he said, 'Ah! my lord, nothin' but a party as knows 'osses cud have draw'd them 'ere 'unters.' Ten of these oil sketches were reproduced in chromo-lithography by Messrs. Agnew and Sons in 1865, and published under the title *Hunting: Incidents of the Noble Science*. Among them is a large edition of the illustration to *Handley Cross*—'Mr. Jorrocks (loq.)—"Come hup! I say—You ugly Beast!"'

The importance of these oil sketches lay in the opportunity they gave to the public of seeing Leech's actual work face to face. 'The greater part of my life,' said Leech in his preface to the illustrated catalogue,[1] 'was passed in drawing upon wood, and the engravers cut my work away as fast as I produced it.' His drawings on the surface of the wood-block were extremely beautiful, and perhaps no one has suffered more at the hands of the engraver. He was working in the days before photography, when any large drawing was executed on a wood-block composed of a number of small squares screwed together, the squares being handed to different engravers, none of whom had any idea of the proportion of light and shade his particular piece bore to the whole. When Leech had finished a block he would show it to his friends and say, 'Look at this, and watch for its appearance in *Punch*.' 'How I wish that the world could have seen those blocks!' says Canon Hole—'They were committed, no doubt, to

[1] *The Originals (from 'Punch') of Mr. John Leech's Sketches in Oil, exhibited at the Egyptian Hall, Piccadilly*. Bradbury and Evans, 1862.

the most skilful gravers of the day, but the exquisite fineness, clearness, the faultless grace and harmony of the drawing, could not be reproduced. The perfection of the original was gone. . . . Again and again I have heard him sigh, as he looked over the new number of *Punch*.' Now, whereas all the wood-engravings after Leech in *Punch* and elsewhere give a careful, but often very inferior, interpretation of his work, in all his coloured plates you get a ground-work of etching—that is to say, the work of Leech's own hand, put as directly on to the plate as if it were an original drawing. The immense superiority of the coloured etchings over the woodcuts is shown by a glance at the Surtees novels where both methods stand side by side. The thick lines and the ruled skies of the wood-engraving will bear no comparison with the etching. Leech's humour is inherent in all his work, however reproduced, but to find Leech the draughtsman you must go to his original drawings or to his coloured plates, etched by the artist himself, and coloured by hand in facsimile of his own tinted proof.

There is a long gap between Leech's first publication with plates coloured by hand, the *Etchings and Sketchings* of 1836, and his next venture in 1843, though in the meantime he had become the most successful artist-humourist of the day. In 1843 his services were secured by Charles Dickens to illustrate the *Christmas Carol*, the first and best of Dickens's Christmas books, and the only one illustrated exclusively by Leech. The original issue was in brown cloth with gilt devices and edges, and bears as the heading to the first chapter, 'Stave 1.,' afterwards altered to 'Stave One' to harmonise with the other headings, which were always 'Stave Two,' 'Three,' 'Four,' and 'Five.' Moreover, in the first issue the end-papers are green, in the second they are yellow. In it there are four full-page etchings, beautifully tinted, and four wood-engrav-

ings drawn by the artist in his best manner. The first edition of the book (it reached a tenth edition by 1846) is valuable for the sake of both artist and author as well as for its rarity. It was followed by *The Chimes* in 1845, *The Cricket on the Hearth* and *The Battle of Life* in 1846, and *The Haunted Man* in 1848, all of them partly illustrated by Leech, but without any plates in colour.

In 1845 appeared *Young Troublesome, or Master Jacky's Holidays*, published at 5s. plain, 7s. 6d. coloured, with twelve plates by Leech, comprising twenty-five etchings. The *Illuminated Magazine*, edited by Douglas Jerrold, was issued from 1843 to 1845, and besides numerous woodcuts by Leech, 'Phiz,' and others, contains two large coloured plates by Leech. These have so frequently been removed for framing that a perfect set of the magazine is rather rare.

Leech's next coloured work was for *The Comic History of England*, with text by Gilbert à Beckett, one of the *Punch* staff. This was published by Bradbury, Agnew and Co. in 1847, in two volumes, at a guinea, but the title-page is undated. The venture was warmly opposed at its inception by Douglas Jerrold, whose wrath at the idea of burlesquing historical personages was expressed with vehemence. The text is often tiresomely brilliant, an indigestible pudding of puns. It proved, however, ample food for Leech's rich and abundant humour, and his twenty plates coloured by hand, and two hundred and forty wood-engravings, though sometimes slight and hurried, are full of rollicking fun and ready satire. In 1852, again with no date on the title-page, appeared the companion volume, *The Comic History of Rome*, by Gilbert à Beckett, published at 11s. Leech's ten hand-coloured etchings and ninety-eight wood-engravings again exemplify his exuberance of fancy and irresistible humour. His drawings are as anachronistic in regard to costume

as the text is in the treatment of facts. While he preserves the idea of a toga, the nether extremities of his characters often exhibit an incongruous mixture of modern apparel, and the umbrella appears to be an equipment as essential to the ancient Roman as to Ally Sloper. Both volumes were reissued from the *Punch* office in 1864, and in 1897 there was a reprint in fourteen parts of the *Comic History of England*.

A year after the issue of the *Comic History of England*, Leech combined with Richard Doyle in illustrating *Punch's Almanack for* 1848, published at 'Two shillings and sixpence, plain ; Five shillings, coloured.' This was a reprint of the usual Almanac on large paper, with illustrations coloured by hand. The book consists of twelve plates, each containing numerous sketches, those in the border being by Doyle, the two principal ones in the centre by Leech. The drawings are characteristic of the seasons—a typical one, that for December, showing an old gentleman with influenza, who welcomes his guest with, 'This is really very kind of you to call. Can I offer you anything—a basin of gruel, or a glass of cough mixture? Don't say No.'

In 1848 was also published *The Rising Generation*, a series of twelve lithographs, coloured by hand, from the original designs in *Punch*, issued from the *Punch* office at 10s. 6d. Like the etchings, these may be said to come straight from the artist's hands, and it is interesting to compare them with the originals in *Punch*. Some of Leech's early work, notably the parody of the Mulready envelope, was executed in lithography, but in later days he almost entirely discarded this method. In the book before us he has been wonderfully successful in his use of his old method. The drawing has been kept light, and is therefore well adapted to receive the hand-colouring for which it was intended.

Among Leech's most important work, with illustra-

211

tions coloured by hand, is the series of plates for the sporting novels by R. S. Surtees. This exemplary sporting J.P. and High Sheriff for Durham died just forty years ago, and his work must be well within the memory of many people now alive. His novels are in their way inimitable, and the author could have found no better illustrator than Leech. *Jorrocks' Jaunts and Jollities*, with its illustrations by Alken, has already been noticed, but Alken's work, compared with that of Leech in the later volumes, seems laboured and ineffective. Leech had the real genius for character, and his drawings for the series have subtle qualities that will repay careful study. After the *Jaunts and Jollities* came *Hillingdon Hall*, without illustrations, in 1845; then *Hawbuck Grange* in 1847, with eight illustrations by 'Phiz,' not coloured. Leech's first illustrations to a novel by Surtees were those for *Mr. Sponge's Sporting Tour*, in 1853. This and the other novels by Surtees, illustrated by Leech, appeared originally in monthly parts, with paper covers of a terra-cotta colour, published at a shilling each, each part having numerous woodcuts in addition to one etching coloured by hand. In the two earlier volumes there is an occasional tendency on the part of the artist to make too much of his limited space, and to crowd his picture with figures and incidents after the manner of Cruikshank. In the later books there is a largeness and freedom of style, a breezy freshness of execution, the expression of an individuality that has shaken off all convention. In these illustrations, almost as well as in the pages of *Punch*, you can trace the development of the artist's power. *Mr. Sponge's Sporting Tour*, originally in thirteen monthly parts, has thirteen etchings, coloured by hand. It was followed in 1854 by *Handley Cross, or Mr. Jorrocks' Hunt*, with seventeen similar coloured plates, one in each of the original parts. ' Mr. Jorrocks,' says the Preface, ' having for many years main-

MR. JORROCKS (*LOQ.*): "COME HUP! I SAY—YOU UGLY BEAST." BY JOHN LEECH
FROM "HANDLEY CROSS, OR MR. JORROCKS' HUNT," BY R. S. SURTEES, 1854

tained his popularity, it is believed that, with the aid of the illustrious LEECH, he is now destined for longevity.' Leech's model for Jorrocks was a coachman, of whom the artist made a surreptitious sketch as he sat in a neighbouring pew during a church service.

The next volume was *Ask Mama, or the Richest Commoner in England*, with thirteen hand-coloured etchings. The preface to this gives a good description of the nature of the Surtees style of novel—' It may be a recommendation to the lover of light literature to be told that the following story does not involve the complication of a plot. It is a mere continuous narrative of an almost everyday exaggeration, interspersed with sporting scenes and excellent illustrations by Leech.' In 1860 came *Plain or Ringlets*, with thirteen hand-coloured etchings, and in 1865 *Mr. Facey Romford's Hounds*. This was Surtees's last work, and at the time of his death, in March 1864, he had just prepared it for its appearance in serial parts. During the issue of the parts Leech himself died, having completed only fourteen plates. The remaining ten were entrusted to ' Phiz,' and it is curious to note how strongly his style has been influenced by that of Leech. Possibly he deliberately imitated Leech's work, as Quiller-Couch imitated Stevenson in his similarly forced completion of *St. Ives*. *Mr. Facey Romford's Hounds* brings the Surtees series of sporting novels to a close. The rarity of *Jorrocks' Jaunts* and *Hawbuck Grange* makes it difficult to obtain a complete set, which is worth from £50 upwards.

One or two other books illustrated by Leech during the period of his work for Surtees must be added. One of the best is *A Little Tour in Ireland, being a Visit to Dublin, Limerick, Killarney, Cork, etc. By an Oxonian*. This was published in 1859, the Oxonian being Canon Hole, who accompanied Leech on a tour to Ireland in 1858, and at the artist's own suggestion

wrote his impressions, while Leech contributed folding plates (etchings coloured by hand) and woodcuts. The whole story of the tour and his general reminiscences of Leech were communicated by Canon Hole to Dr. John Brown, who published them in his volume, *John Leech and other Papers* (1882).

Nor must *Mr. Briggs and his Doings*, published in 1860, be forgotten. It was issued from the *Punch* office, and contains twelve plates coloured by hand. Briggs is a kind of Mr. Jorrocks—a peppery, generous, plucky British citizen, smitten with the craze for sport and hunting in general. As he shot, fished, rode, raced, and hunted, Mr. Briggs got into a thousand predicaments, but, undismayed by a thousand failures, pursued his sport with undaunted enterprise. Leech's pictures had made him a friend to the readers of *Punch* for a year or two before the publication of these coloured plates. Besides *Mr. Facey Romford's Hounds*, one of Leech's last publications with coloured plates was *Follies of the Year*, issued from the *Punch* office in 1864. It contains twenty-one hand-coloured etchings from *Punch's* Pocket Books of 1844 to 1864, and enables one to judge comprehensively the growth of the artist's individuality, and his advance from the cramped method of Cruikshank to a larger and bolder simplicity. The notes to accompany the plates were written by Shirley Brooks, and contain a slight, gossiping chronology of the years in which the drawings respectively appeared. The work itself, as he remarks, is 'quite out of the jurisdiction of criticism.'

One of the warmest admirers of the work of Cruikshank and Leech was W. M. Thackeray, who himself supplied illustrations to books, some of them coloured. That he started life with the intention of becoming an artist, and was draughtsman and illustrator before he was a writer of books, is a fact realised by few readers of his novels. At Charterhouse, as a

'rather pretty timid boy,' he formed a friendship with his schoolfellow Leech, which no doubt encouraged and developed his love of humorous drawing. In all his boyish work the element of caricature predominates, and it was always in caricature that his ability as an artist was shown. On leaving Cambridge in 1830 he studied for the Bar, and after some timid ventures in journalism, made up his mind that he could draw better than anything else, and accordingly in 1834, at the age of twenty-three, started to study art in a Paris studio. He possessed the specific gift of creative satire, and had he been endowed with the native cunning of Cruikshank or of Leech might have equalled or surpassed either as a caricaturist. Fortunately, however, for literature, his powers of draughtsmanship failed to develop in proportion to his aspirations, and his art studies became dilatory and desultory, the more so as his subtle grasp of character and power of invention began to find a richer and more genial soil. It was decreed that Thackeray 'should paint in colours which will never crack and never need restoration.'

It was doubtless to his art studies in Paris that Thackeray owed the sympathetic insight and nicety of judgment that made him capable of writing such excellent art criticism as the Essays on Leech and Cruikshank. Throughout his whole life his sympathy with art continued, and he executed a large number of illustrations, which though immeasurably inferior to his written work, are well worth consideration. 'The illustrations he produced,' says Sir Leslie Stephen, 'have the rare interest of being interpretations by an author of his own conceptions, though interpretations in an imperfectly known language.' And it is interesting to note that in 1848 Charlotte Brontë avowed herself a warm admirer of the drawings of Thackeray —'a wizard of a draughtsman.'

Thackeray's first essay as an illustrator, in fact his

first independent publication of any sort, was *Flore et Zéphyr, Ballet Mythologique*, published in 1836. This was a small folio, representing the career of a *danseuse*, and consisted of eight designs, slightly tinted, and drawn on the stone by Mr. Edward Morton, brother of the author of *Box and Cox*. In 1838 *Damascus and Palmyra: a Journey to the East*, by C. G. Addison, was illustrated with ten drawings by Thackeray, reproduced in lithography by Madeley, and coloured by hand. Thackeray's name does not appear on the plates, nor is there any mention of him in the book, yet in booksellers' catalogues the illustrations are now invariably ascribed to him. The authority seems to be a copy of the book, sold at Sotheby's in 1891, for £27, which is said to have contained inside the cover Thackeray's receipt, when a very young man, for twenty pounds for his illustrations for this work. The two volumes of *Comic Tales and Sketches* have twelve plates etched by Thackeray, and printed in a tint of brown on a machine-ruled ground. It is interesting to note that, while in many of the illustrations the lights are left white from the surface of the plate, in several instances the high lights throughout the edition have been systematically scraped out with a knife on the print itself, as was pointed out in the case of some coloured aquatints. *Notes of a Journey from Cornhill to Cairo*, published in 1846, has an etched frontispiece, 'A Street View at Constantinople,' coloured by hand; and the story of how Thackeray was whisked off at thirty-six hours' notice, with a free passage from the Directors of the P. and O. Company, is told in the preface for the benefit of those who insisted that he wrote 'out of pure fancy in retirement at Putney.'

In 1846 Thackeray began a series of Christmas books, issued, with plates plain or coloured, in pink pictorial boards. Text and illustrations show a rich

and graphic humour combined with an intense appreciation of the virtues, the failings, and the foibles of the great middle class. All were published for the Christmas season, but bear the date of the following year on the title-page. The first, dated 1847 for Christmas 1846, was *Mrs. Perkins's Ball*, published at 7s. 6d. plain, 10s. 6d. coloured. The illustrations consist of twenty-two wood-engravings after drawings by the author, with one yellow tone printed, leaving white spaces for the high lights, and the whole finished by hand. *Our Street*, 1848, was illustrated in the same way with sixteen plates. These are excellently done, and the picture of 'The lady whom nobody knows' is almost equal to Leech at his best. This and the later books were published at 5s. plain, 7s. 6d. coloured. *Dr. Birch and his Young Friends*, 1849, has sixteen plates, executed in soft-ground etching, a method in which Thackeray was a novice, and which, apart from the humour of the pictures, gives a not very satisfactory result. *Rebecca and Rowena*, 1850, was illustrated with eight plates by Doyle, but in 1851 Thackeray again took up his pencil for *The Kickleburys on the Rhine*. The fifteen plates are engraved on wood, and finished with one colour printed and the rest added by hand, as in *Our Street* and *Dr. Birch and his Young Friends*. *The Kickleburys on the Rhine* is notable for the fierce criticism it provoked from the *Times*. It was no wonder that a suggestion of the Christmas books owing their origin to 'the vacuity of the author's exchequer,' with a further reference to 'the rinsings of a void brain,' roused Thackeray's wrath and satirical humour. The second edition of *The Kickleburys* in 1851 is as valuable as the first, for it contains the well-known 'Essay on Thunder and Small Beer,' in which Thackeray ridicules the pompous diction and affected superiority of his mighty assailant.

Another small point in connection with Thackeray

and illustrated books is that in *Sand and Canvas; a narrative of Adventures in Egypt, with a sojourn among the Artists in Rome*, by Samuel Bevan, containing hand-coloured wood-engravings after the author's drawings, there comes the first appearance in print of the famous ballad of 'The three sailors in Bristol city, who took a boat and went to sea.' This was an impromptu contribution by Thackeray to an evening's entertainment by the artists in Rome, at which he and Bevan were both present.

Another caricaturist, contemporary with Leech and Thackeray, and like them sometimes making book-illustrations in colour, is Hablot Knight Browne, better known as 'Phiz'—a sobriquet that he adopted to harmonise with Dickens's 'Boz.' He was born on July 12, 1815, and was apprenticed to Finden, the well-known line-engraver. The laborious method of engraving on steel was little to his taste, and he soon forsook this work for water-colour painting and for book-illustration, which he could produce rapidly by etching. His first real chance of distinction came with the unhappy death of Seymour, who had finished the first seven plates for the *Posthumous Papers of the Pickwick Club*. 'Phiz' and Thackeray were both candidates for the office of illustrator, and the choice fell upon 'Phiz.' In his long series of illustrations to Dickens's works he has given the supreme example of the power of an artist's pencil to realise and embody the creations of an author's imagination, making them clear to the blunter perceptions of the ordinary reader. Mr. Pickwick in his spectacles and gaiters, Sam Weller with his striped waistcoat, Mrs. Gamp propoging a toast, are all characters whose appearance in the flesh has been made real and immortal by 'Phiz,' and imitated by every later illustrator of Dickens. 'More persons are indebted to the caricaturist,' says Mr. Hollingshead, 'than to the faultless

descriptive passages of the great creative mind that called the amusing puppets into existence.'

While illustrations to Dickens are the principal work by 'Phiz,' there also exists a considerable number of his coloured illustrations for books. The plates for *Mr. Facey Romford's Hounds* have already been mentioned, and the best of his coloured work was of a similar sporting nature. *How Pippins enjoyed a Day with the Fox Hounds, A Run with the Stag Hounds,* and *Hunting Bits* (1862), are sets of twelve hand-coloured etchings, vigorous and spirited. In *Dame Perkins and her Grey Mare, or the Mount for Market,* published in 1866, Lindon Meadows's humorous verse gave an opening for eight most amusing plates reproduced in coloured lithography by Vincent Brooks. The rest of the artist's coloured work appears to assume a 'pot-boiling' character. With *Home Pictures —Sixteen domestic scenes of Childhood,* published in 1851, he inaugurated a series of moral but sickly-sentimental scenes of domesticity, and was doomed, to his sorrow, to illustrate children's books year after year. *Illustrations of the Five Senses* in 1852 was issued at 3s. 6d. plain, 5s. 6d. coloured, the five plates being etchings with a machine-ruled ground. In 1853 he made eight etchings for *A Day of Pleasure, a Simple Story for Young Children,* by Mrs. Harriet Myrtle, and in the following year for *The Water Lily,* by the same authoress, nineteen illustrations engraved on wood by T. Bolton, all of them coloured by hand.

Snowflakes, by M. Betham Edwards, published in 1862, is interesting for its illustrations by 'Phiz,' printed in colour from wood-blocks by Edmund Evans. There are twelve coloured plates, consisting of a full-page frontispiece and eleven pages of text and picture surrounded by a floral border. The other pages with a margin of plain wood-engraving are, to tell the truth, much to be preferred. Still the book was popular, and

was republished in 1883 by Messrs. Routledge, who in the same year issued *Phiz's Toy Book* with forty-four coloured plates, containing *Phiz's Merry Hours* with eight plates, *Phiz's Funny Alphabet* with sixteen, *Phiz's Funny Stories* with eight, and *Phiz's Baby Sweethearts* with twelve plates. All of these were first published separately. Throughout his children's books 'Phiz' seems to be labouring at an uncongenial task, and appears to have little sympathy with nursery life. It must be remembered, however, that those were days when children were 'seen and not heard,' were surveyed from distant Olympian heights, and spoon-fed with 'moral' literature. Since the days of 'Phiz,' thanks to Caldecott, Kate Greenaway, Lewis Carroll, Kenneth Grahame and others, there has grown a wonderful appreciation of the true inwardness of child-life, and children's literature has suffered a marvellous change. How the modern child, surrounded by scores of coloured books, would scorn the paltry morals of well-meaning Mrs. Myrtle and the insipid nursery scenes of 'Phiz'!

CHAPTER XVIII

NATURE-PRINTING

AMONG the many methods of printing that had a short and struggling existence in the middle of the nineteenth century, the process of Nature-Printing stands out as having a more permanent interest than the rest. The first publication definitely dealing with the subject was a pamphlet published at Vienna in 1853 with the title *The Discovery of the Natural Printing-Process.* This was read before the Imperial Academy of Sciences at Vienna by Alois Auer, Director of the Government Printing Office. It was evidently translated at once into different languages ; at any rate, the copy now before me is in English. With it are twelve plates illustrating the nature-printing of ferns, leaves, sea-weeds, etc.

First, however, a word as to the process itself, and its origin as stated by Auer. At the beginning of his book he explains that nature-printing is a method of obtaining an exact representation of some original, be it plant, flower, insect, material or textile, produced directly from the original itself. The object to be reproduced is passed between a copper plate and a lead plate, through two rollers closely screwed together. As a result of high pressure the original leaves its image impressed with all its peculiar delicacies on the lead plate. If colours are then applied to this stamped lead plate, a copy can be obtained in the most varying colours by means of a single impression of each plate.

221

The lead plate, on account of its softness, is not capable of furnishing a large number of impressions, but it may be stereotyped or galvanised. Such is a summary of Auer's simple prefatory remarks, but their simplicity is spoiled by the assertive arrogance which mars the rest of his book.

The origin of Auer's invention in Vienna was entirely due to an effort to rival England in the commercial field, in which she was then recognised as supreme. It is hardly necessary at the present day to point the moral of the story, which is as follows :—On August 2, 1852, the Secretary of the Viennese Chamber of Commerce drew the attention of the ministry to some lithographed samples of lace issued by a Nottingham firm, and forwarded to Vienna by the Austrian consul in London. The Ministry of Commerce at once recognised the advantage of this compared with the ordinary and expensive methods of circulating pieces of real lace, which soon became crumpled and dirty. They published accordingly a circular pointing out 'that this circumstance served as an example and as a new proof what great value the English set upon getting up in a handsome and elegant manner their sample-books, and how much they endeavour to make their goods known as much as possible and to present them to their customers in an inviting manner.'

These English designs were then submitted to Alois Auer, who was extremely jealous for the prestige of the Imperial Printing Office. Within twenty-four hours he produced fresh patterns from real lace by means of the nature-process described, the idea of using a soft lead plate instead of guttapercha being suggested by his overseer Worring. In the case of lace it is obvious that, the ground on the stereotyped plate being raised and the pattern in intaglio, it was possible by applying colour to the ground to produce the exact effect of a lace pattern pinned on blue paper. It was a proud

moment for Auer when the council 'found the resemblance so deceptive that they took them to be real lace, until, by touching and closely examining them, they convinced themselves that they were the production of the printing press.'

It was now suggested to Auer by Haidinger, of the Austrian geological institution, that the process should be used for producing facsimiles of leaves. Professor Leydolt showed great interest in this idea, and some wonderful impressions of oak leaves were taken. Auer now gave his process the name of 'the natural self-acting printing-process' (*Naturselbstdruck*), and added that he expected that in a short time the *selbst* would vanish. On October 12, 1852, he took out in Worring's name a patent with exclusive rights for Austria.

There now steps upon the scene an angry Englishman, in the person of Henry Bradbury, eldest son of William Bradbury, of the firm of Bradbury and Evans, the proprietors of *Punch*. He was born in 1831, and in 1850 entered, as a pupil, the Imperial Printing Office at Vienna. Full of intense indignation at the honours assumed by Auer, he started a crusade, stating it as his object 'by an investigation of dates and the separate pretensions of individuals to endeavour to clear away the mist that self-interest or self-flattery may have induced.' On May 11, 1855, he delivered a lecture on *Nature-Printing: its Origin and Objects*, before the Royal Institution of Great Britain. This he published in 1856, dedicating it somewhat cruelly to Alois Auer. The main object of this work was to show that the employés of the Austrian government were not justified in asserting an exclusive right to priority in the invention, simply on account of its first application in its fullest form at the Imperial Printing Office. Bradbury points triumphantly to experiments made in nature-printing on the Continent dating as far back as two hundred and fifty years before his time.

Surely, however, Auer makes sufficient acknowledgment in 'Remark 3' of his pamphlet, where he refers to these experiments; and one cannot help having something more than a suspicion that this is the source of Bradbury's own information. Moreover, in his Royal Institution lecture, Bradbury very discreetly never mentioned the fact that on June 28, 1853, a patent was granted to Messrs. W. Bradbury and F. M. Evans for 'taking Impressions and Producing Printing Surfaces.' Their declaration stated that 'this Invention consists of placing plants and other vegetable matters, insects, and other substances, between a surface of steel and a surface of polished lead, and by pressure obtaining an impression on the lead, and from such impression obtaining an electrotype surface suitable for printing.' This is essentially Auer's process, but in the description there is no mention of Auer, and only a casual remark in parenthesis that the process has been 'communicated from abroad.' Yet they claim it as an invention, and take out a patent, without mentioning Auer, and substituting the vaguest of phrases for his straightforward title 'Nature-Printing.' Then, with a flourish of trumpets, they published a set of twenty-one plates, in paper wrappers (at £1, 1s. or at 1s. 6d. for separate plates), with the title 'A few leaves from the Newly-Invented Process of *Nature-Printing*. Bradbury and Evans, Patentees, 1854.'

The early experiments to which Bradbury refers in his Royal Institution lecture are of considerable interest. In the *Book of Art* of Alexis Pedemontanus, in 1572, may be found the first recorded hint as to taking impressions of plants. In 1650 De Moncoys in his *Journal des Voyages* gave instructions as to a method employed by a Dane, Welkenstein. He dried his plants, blackened them over a lamp, and took an impression by placing them between two soft leaves of paper. Similar impressions were made in 1707 by

Hessel, says Linnæus in his *Philosophica Botanica*; and later, Professor Kniphof worked in the same manner in his printing office, established at Erfurt in conjunction with a bookseller, Funke. Kniphof produced in 1761 his *Botanica in Originali*,[1] consisting of twelve volumes with twelve hundred plates, nature-printed in black. Kniphof's only new step was to use printer's ink instead of lamp-black, and a flat press in place of the smoothing bone. Seligmann, an engraver, made similar experiments; and from 1788 to 1796 Hoppe edited his *Ectypa Plantarum Ratisbonensium* and his *Ectypa Plantarum Selectarum*, with illustrations produced in the manner of Kniphof. All this Auer knew and readily acknowledged. He was probably, however, entirely unaware of the obscure discoveries of Peter Khyl, a Danish goldsmith and engraver, whose work first raised nature-printing of leaves from a simple contrivance to an art. In a manuscript dated May 1, 1833, with the title *The Description of the Method to copy Flat Objects of Nature and Art*, Khyl gave details of his invention, and the description was accompanied by forty-six plates representing printed copies of leaves, linen, woven stuffs, laces, bird feathers, fish scales, and serpent skins. Khyl states his method with careful precision. He used a rolling-machine with two polished cylinders of steel. If the object to be reproduced was a leaf, it was dried and placed between a polished steel plate, half an inch thick, and a thoroughly heated lead plate with a fine surface. These two plates were run rapidly between the cylinders, and the leaf under the pressure yielded its form on the softer lead plate, showing the raised and sunk parts exactly as in nature. He notes that laces, figured ribbons, and

[1] D. Jo. Hieron. Kniphofii Botanica in Originali seu Herbarium Vivum, in quo Plantarum tam indigenarum quam exoticarum peculiari quadam operosaque encheiresi atramento impressorio obductarum elegantissima ectypa exhibentur. Halae Magd., 1761.

225

other textile materials, can be printed without prepara-
tion, but that a leaf must be thoroughly dried and freed
from sap.

Khyl died in the year which saw his invention
employed, and the only step still required to bring it to
perfection was the idea of electrotyping the lead mould
so that an infinity of impressions might be taken. In
England also various efforts were being made in a
similar direction. Dr. Branson of Sheffield commenced
a series of experiments in 1847, and in 1851 read a
paper embodying his results before the Society of Arts,
and suggested the application of the most essential
and most important element in Nature-Printing—the
electrotype. His first experiments were made by taking
impressions of ferns on guttapercha. He discarded
this in favour of electrotype copies, but even this
method he found too tedious and costly for practical
use. Various other experiments had been made by
Messrs. Sturges and Aitken in decorating metal objects
with nature-printed impressions. All these instances
are accumulated with gathering scorn by Bradbury, but
there is yet another early effort in nature-printing, un-
known even to Bradbury. In *The Art of Drawing,
and Painting in Water-Colours*, printed for J. Peele
in 1731, is given 'A speedy Way of Painting the Leaf
of any Tree or Herb, as exact as Nature itself,' and
also 'Another Way of Printing the Leaves of Plants so
that the Impression shall appear as black as if it had
been done in a Printing Press.' The directions given
are for taking impressions by means of linseed oil or
printer's ink. But the author goes a step further when
he adds, 'The Method of Taking-off the Leaves of
Plants in Plaister of Paris, so that they may afterwards
be cast in any Metal.' All this would have appealed to
Bradbury, especially as the author claims no patent,
and indeed appends the quaint and obliging note that
'if any Gentleman or Lady should meet with any

Difficulty in performing any Thing directed in this Treatise, and will send Word to the Publisher thereof where they may be waited upon, the Author will attend them and shew them how to perform every experiment therein mentioned, upon a reasonable Satisfaction.'

All these experiments, however, were tentative and incomplete, and there is no reason to suppose that Auer benefited to any extent by early researches. The work of Khyl and Branson, especially in view of the fact that neither published nor made practical use of his experiments, was probably quite unknown in Vienna. The idea of nature-printing was doubtless in the air at the time, but Worring seems to have arrived quite independently at his application of soft lead, and there seems to be no reason why Auer should not have the credit for the first definite and practical development of the process. Even if Auer had availed himself of the scattered experiences of different experimentalists, Bradbury's attack would be unjustifiable. Certainly he need not have written that 'it is evident that Councillor Auer, who has arrogated to himself the *sole* discovery of Nature-Printing, has given proof of a selfish and unfair desire to aggrandise himself at the expense of others : his passion for fame has led him even beyond the warrantable bounds of propriety,' and so forth. Auer may have obtained hints from prior work, but he was not a thief or a plagiarist; and as Alfred de Musset says—' C'est imiter quelqu'un que de planter des choux.'

The first application of the process to book illustration was made by Auer in the Chevalier Von Heufler's *Specimen Florae Cryptogamae Vallis Arpasch Carpatae Transylvani*, published at Vienna in 1853. With later German publications we are not concerned. Within two years Bradbury, profiting by his studies in Vienna, introduced the process into England. His description of his method of printing and of colouring is of some

interest. Where there were three, four, or more colours to be employed—as in the case of plants, with stems, roots, leaves, and flowers—the plan adopted was to apply first the darkest colour, generally that of the roots. The superfluous ink was cleaned off, and the next darkest colour, perhaps that of the stems, was then applied; and so on till every part received its right tint. In this state, before the plate was printed, the colours on the different parts of the copper looked as if the actual plant was embedded in the metal. By putting on the darkest colour at the beginning, there was less chance of smearing the lighter and more delicate tints, and the method also made it easier to blend one colour with another. It will be seen that this way of printing in colours is entirely analogous to that followed in the case of a coloured mezzotint or aquatint plate. Bradbury explains, too, that the embossed appearance of a nature-printed plate is produced by the use of four or five thicknesses of blanketing between the rollers of the printing-press. The impression on the plate itself is in deep intaglio, and it is the wonder of nature-printing that soft lead should receive an instantaneous imprint of fern or sea-weed complete in every detail, at the very moment when the object itself is squashed to a pulp.

The first English book for which the process was employed was *The Ferns of Great Britain and Ireland*, by T. Moore and J. Lindley, published by Bradbury and Evans in 1855, with illustrations nature-printed by Henry Bradbury. The book contains fifty-one plates and is in large folio. It was republished in 1857, and appeared in octavo in 1859. Nature-printing lent itself with great success to the reproduction of ferns, giving complicated forms and the tender organisation of veins with minute accuracy. As Lindley points out in the preface to this book, botanical drawings, when compared with nature-printing, are 'little more than indifferent diagrams.'

228

NATURE-PRINTING

Another work by Bradbury is *The Nature-printed British Sea-Weeds*. This was published in 1859 with text by W. G. Johnstone and A. Croall. It is in four volumes with over two hundred plates, showing with realistic precision the tangled intricacies of every species of sea-weed. 'It is by touch alone,' said the *Times* of the period, 'that the spectators can be convinced that these wonderful groups of sea-weed, spread on the sheet in all their rich variety of tints and minute structural organisation, are not actually the pressed weeds themselves.'

The only other besides Bradbury to make real use of nature-printing was an eccentric amateur named R. C. Lucas. He published some volumes of etchings that possess considerable quaintness, and his work as a nature-printer is exceedingly artistic. His book of nature-prints issued by himself at Chilworth Tower in 1858 is exceedingly rare, but a copy can be seen in the British Museum Library. It has the etched title—*Facsimiles of Nature from the Valley, the Forest, the Field, and the Garden, by R. C. Lucas, Sculptor, Chilworth Tower, Hants*. The plates are executed entirely in Bradbury's manner, but are finer in colouring. They are all on India paper, and owing to this, or to amateur printing, the colours have run together, never leaving a hard edge and giving a certain charm of accidental softness.

The inevitable costliness of the process was the only bar to its extended use. Nature-printing seems to have died with Bradbury, and a unique and valuable method of reproducing botanical specimens was lost. It is a sad fact that Bradbury died by his own hand in 1860 at the early age of twenty-nine. He had accomplished much before his death, for in addition to the work mentioned he was a recognised authority on printing, had lectured more than once at the Royal Institution, and had published two books on Bank

Note Engraving. At the time of his death he thought of producing a large work in folio on the graphic arts of the nineteenth century, but never got beyond a prospectus that was ample enough to indicate the wide scale of his design.

The nature-printing of Auer and Bradbury is not to be confused with a method of taking impressions of butterfly wings, to which the term 'nature-printing' has also been applied. Directions for this are given as far back as 1731 in the aforementioned book on *The Art of Drawing*. Under the heading, 'The manner of making the Impressions of any Butterfly in a Minute in all their Colours,' is given the following account :—

'When you have taken a Butterfly, kill it without spoiling the Wings, and contrive to spread them in a flying manner as regularly as may be; then take a piece of white Paper, and with a small Brush or Pencil wash a part of the Paper with Gum-Water; then lay your Butterfly on the Paper, and when 'tis well fixt, cut away the Body close to the Wings, then lay the Paper on a smooth Board with the Fly upwards, and on that another Paper, upon which put a smooth Trencher, and a great weight upon that; or else put your whole Preparation into a Screw-press, and screw it down very hard, letting it so remain for an Hour; then take off your Butterfly's Wings, and their perfect Impression, with all their beautiful Colours mark'd distinctly, will remain on the Paper. I have done several this Way, which answers very well; and to explain the Reason why it can be so, you must understand, that all the Fine Colours observ'd on a Butterfly's Wings, are properly Feathers, which stick to the Gum so fast, that, when the Gum is dry, they leave the Wing. When you have done this, draw between the Wings of your Impression the Body of the Butterfly, and colour your Drawing of that Body after the Life.'

It is a far cry from 1731 to 1880, but it is not till the latter year that there appears to be any further reference to this particular kind of nature-printing.

NATURE-PRINTING

In 1880 a little book was published by 'A. M. C.' with the title *A Guide to Nature-Printing Butterflies and Moths*. The author seems to have no idea of the antiquity of his process, though he says that 'the French missionaries in India had a recipe, many years ago, for transferring the wings of Butterflies.' His method is exactly that of Peele's book, though he gives other processes of using wax, varnish, or rice-water, and adds some advice as to touching up defects by hand. There is a frontispiece showing three butterfly wings reproduced by this process. Where this differs from the nature-printing of Auer and Bradbury is of course that it necessitates the destruction of a separate butterfly for each single impression, and therefore cannot be of any practical use.

This last method has been brought to absolute perfection in a book published at Boston, U.S.A., in 1900: *As Nature shows them: Moths and Butterflies of the United States east of the Rocky Mountains*, by Sherman F. Denton. Besides four hundred half-tone illustrations there are fifty-six coloured plates which the author describes as Nature Prints. He explains that they are direct transfers from the insects themselves, the scales of the wings being transferred to the paper, while the bodies are printed from engravings, and are afterwards coloured by hand. I am inclined to think that in the case of the wings there must be a slight substratum of colour either printed or hand-painted, and on this the actual wings must have been transferred under very high pressure. For this edition the author had to make over 50,000 transfers, no one else being able to do the work to his satisfaction; and more than half of the specimens used were collected by himself. The coloured illustrations are magnificent, embodying all the perfection and beauty of the actual specimens. As you look at the plates sideways, and move them in the light, the glint and

sheen of the butterfly wings show ever-changing beauties of iridescent colour. The method, of course, is one that can be applied only to butterflies; but in the history of colour-illustration I know nothing more wonderful than this book.

CHAPTER XIX

THE PROCESS OF CHROMO-LITHOGRAPHY

BETWEEN 1830 and 1840 the aquatint process was being gradually ousted from its dominion by the cheaper method of lithography. The story of the invention and rise of lithography is so well known that it may suffice to recall simply its outstanding facts and dates before passing to the development of chromo-lithography. Aloys Senefelder, the inventor of lithography, was born at Prague in 1771 or 1772. At the first he earned a precarious living as an author, and like Blake in England sought some means of becoming composer, printer, and publisher of his own productions. As the acquisition of a printing-press was beyond his means he began a series of experiments, having as their object the discovery of some cheaper and readier means of printing. It is curious that both Blake and Senefelder aimed at some method of leaving their writing *in relief*, and that both, within a period of ten years from each other, accomplished their object in essentially the same way—Blake on copper, Senefelder on stone.

In his attempt to find a stopping-out varnish for use on an etched copper-plate, Senefelder hit on a composition of three parts of wax, with one part of common soap, melted together over the fire, mixed with a small quantity of lamp-black, and dissolved in rain-water. At the same time he conceived the notion that the Kellheim stone, which he used for grinding colours, might

233

economically be substituted for metal plates, and he accordingly perfected a means of polishing and etching the stone, and printing from it. This was not genuine lithography, but it led to the discovery of the essential principle of lithography, as Senefelder himself relates in his *Complete Course of Lithography*, published by Ackermann in 1819.

He was working one day in his small laboratory, and had just finished polishing a stone plate, which he intended to cover with etching ground, when his mother entered the room and asked him to write out a bill for the washerwoman, who was waiting for the linen. There happened to be not a scrap of paper at hand, and not a drop of ink in the inkstand. His mother was in a hurry, and Senefelder, without much thought, wrote the list with his composition of wax, soap, and lamp-black, on the stone which he had just been polishing, meaning to copy it out at leisure. Some time after, he was on the point of wiping this list from the stone, when the idea suddenly struck him to leave the writing, and try the effect of biting the stone with aqua-fortis, wondering whether it might not perhaps be possible to apply printing ink and take impressions in the same way as from a wood-block. Acting on this, he found that the unprotected parts of the stone were bitten away, leaving the writing sufficiently elevated for printer's ink to be applied and impressions to be taken. This took place in 1798, but there was still a further discovery to be made, which gave entirely new shape to the art of lithography, and left it in its present form.

The whole secret lies in the chemical antagonism existing between water and grease, when applied to a surface possessing a like affinity for both. The lithographer takes a stone, and on this draws his design with an ink composed of tallow, wax, soap, shellac, and Paris black. A weak solution of acid poured over this

234

decomposes the carbonate of lime in the stone and the soap in the ink. The solution of the acid renders those parts of the stone that have not been drawn on still more averse to receiving any fatty substance such as printer's ink, and the resistance is increased by the addition of a solution of gum. Before printing, the stone is well moistened with water, and when inked with the roller will receive the ink only on the greasy parts, that is the parts drawn upon, and will reject the ink from the parts treated with acid, gum, and water. Senefelder's final discovery, therefore, is a form of printing from stone without resorting to engraving either in relief or intaglio. The original inventor, in fact, elaborated the whole art to a wonderful perfection. He devised roller, press, and tools ; he worked out the most efficient details for each stage of the process ; he gives directions for almost every method of lithography now employed ; points out that his methods are applicable to zinc, copper, and other metals ; and even anticipates the latest developments by devising a 'stone paper' to take the place of all of them.

Probably no inventor has ever so immediately and so fully realised the possibilities of his invention as Senefelder did in the case of lithography. Though he had hardly time or opportunity to put all his theories into practice, there were few of the later developments of lithography that its inventor had not foreseen. It was many years, for instance, before chromo-lithography became an accomplished fact, yet the *Complete Course* contains several allusions to the process, and at the beginning of the book is an initial letter from an early printed book, reproduced in red and blue as well as black. Senefelder was quick to notice that the drawing on the natural tint of the stone often deceived the artist as to the just gradation of his tones, and that in general the drawing on the half-tinted stone had a better effect than the print on white shining paper. This induced

him to try the effect of an impression on a yellowish paper, but here the difficulty was that paper of this kind, if of the best quality, was very expensive; while inferior kinds contained ingredients in the colour which soiled the impressions. After many fruitless experiments in printing the paper and then colouring it, he devised the method of printing a yellowish tint by means of a second stone, over the drawing already printed. This method was found to be not only the cheapest and most expeditious, but possessed the additional advantage that the margins of the print could be left white, thus contributing to heighten the effect of the drawing. A further suggestion was made to Senefelder by Piloty that he should print the lights in white colour, so as to make the impressions more like autograph drawings. Experiments, however, with white oil-colour for this purpose proved unsuccessful, and Senefelder then discovered the method of leaving out spaces for the lights in colouring the tint-plate, or by cutting them out altogether before the plate was coloured, thus producing the effect of high light by means of the white untinted paper.

The idea of printing lithographs with one or more tint plates to resemble chalk drawings thus originated with Senefelder, but one of its principal exponents was Charles Joseph Hullmandel. It is interesting to note in passing that Hullmandel for scraping out the lights on the stone used an ordinary mezzotint scraper, kept extremely sharp. Closely associated with Hullmandel is J. D. Harding, who did much to encourage him in his experiments, and who, in 1827, before his connection with Hullmandel, had published *Winter Sketches in Lapland* with twenty-four plates, printed with a single yellow tint added afterwards. Hullmandel discovered means of producing neutral and graduated tints, and in November 1840 took out a patent for his method of lithotint—'A New Effect of Light and Shadow,

236

"ARUNDEL CASTLE." BY J. D. HARDING
FROM "HARDING'S PORTFOLIO," 1837

Imitating a Brush or Stump Drawing, or both com-
bined, Produced on Paper, being an Impression from
Stone, Prepared in a Particular Manner for that Pur-
pose.' The process, put briefly, consisted first in com-
pleting a drawing on stone with lithographic ink by
means of a brush. This was covered with gum-water
and weak nitric acid to fix it, and a solution of resin,
exactly as in the case of aquatint, was poured over the
stone. This resin reticulated in the usual way, and if
strong acid was then poured over, it entered all the
fissures, leaving the drawing protected where the
resinous particles adhered, and therefore printed with
a granulated effect. Lithotint may be treated in colour,
or have a single yellow tone applied, as for example in
The Baronial Halls of England, with its lithotints
made under the superintendence of Harding from
drawings by Cattermole, Prout, and others.

It must not be supposed that all coloured lithographs
that appear in books are printed in colour. For a long
time the system was the same as that pursued in the
case of coloured aquatints. There is a substratum of
printed colour, usually the flat yellow tone, with the
high lights left in white, which has already been referred
to. The rest of the colouring is applied entirely by
hand, and for the finest result of this method one may
look at Roberts's *Holy Land*. It must be remembered
that Haghe, who executed the lithographs for this
work, was an accomplished artist, and had the cunning
to keep the lines of his lithography in a soft grey.
With a feebler or less skilled practitioner you get in
the hand-coloured lithograph an inevitable sootiness.
The set of lithographed views of Scotland by R. P.
Bonington, published in colour after his death, may be
cited as a sufficient example. Any one who has made
a finished and shaded pencil drawing, and has then
attempted to colour it, will recognise the result I mean.
The painter, too, knows how valueless and muddy a

water-colour drawing becomes when any element of black is allowed to intrude. With an aquatint, on the other hand, or with the grey broken lines of soft-ground etching, the etched lines and ground may be employed, as pencil often is in a water-colour, to help out the use of colour and give subtle suggestions of form. That soft-ground etching was ever superseded by lithography was due to the comparative ease of the latter method; but where the early soft-ground etching was soft and grey, the early lithograph was black and gritty. Herein lies the weakness of the hand-coloured lithograph as compared with the aquatint printed in two tints and finished by hand. If the lithograph is made on white paper, there is the inevitable sootiness in the colouring. If, on the other hand, a yellow tone is printed, the added colouring must always be a little flat. The lithograph finished in colour by hand—one says it with misgiving as one looks at the plates in the *Holy Land*—lacks the quality, the transparency, the play of delicate colour, the buoyant and liquid freshness of the coloured aquatint. The true possibilities of hand-coloured lithography were never so well grasped by our English artists and printers as by some of the contemporary Frenchmen, such as Lami and Monnier. Using little more than an outline of lithography, these last two artists (their 'Voyage en Angleterre' is an interesting and excellent example of their method) worked over this in subdued tints that are perfect in their quiet harmony of tone.

Colour-printing proper in lithography was a development of Senefelder's process of printing in chalk tints. Senefelder himself made various experiments, but found difficulty in printing successfully except with black, vermilion, and dark blue. However, he was working on the right lines. 'The manner of printing in different colours,' he wrote, 'is capable of such a degree of perfection that I have no doubt perfect paint-

ings will one day be produced by it. The experience which I have gained in this respect corroborates my conviction ; and if my time were not so much taken up by various occupations, I would justify it by some specimens.' When chromo-lithography was first seriously started the three-colour theory was given a trial, but was quickly abandoned. The system now is to print one colour on each stone, or rather one tone, for the chromo-lithographer often builds up what may seem simple colours by the super-position of two or more tones. A saving, however, of time and expense may occasionally be effected by the same stone carrying two distinct colours on two separate parts. The system of registration and printing differs hardly at all from that described as in use for other processes. A finished chromo-lithograph is frequently the result of twenty printings, and in exceptional cases the number is even larger. The whole process is made admirably simple in the *Art of Chromolithography*, by Mr. G. A. Audsley, published in 1883. The writer selects as an example of the process one of the plates in his *Ornamental Arts of Japan*, and in the forty-four plates of the *Art of Chromolithography* the whole process of its making is analysed, showing the twenty-two printings that made up the original, singly and in combination. The *modus operandi* is completely explained by the chromo-lithographer, M. Alfred Lemercier, of Paris. The book is interesting and easily accessible, but of even greater interest is a unique series of bound plates, of the date 1853, in the National Art Library. They bear a title written in ink :—*How a Picture is reproduced Fac Simile in Color of the Original by means of Chromo-Lithography. By Day & Son, Lithographers to the Queen. Presented to Col¹. Sir Proby Cantley by Day & Son.* The twenty-three plates show the twelve printings employed, separately and in combination. Another set of interesting ex-

amples, showing the different stages by which a chromo-lithograph is built up, appears in Dibdin's *Progressive Lessons in Water-Colour Painting* (1858).

The method, put briefly, is to prepare a key drawing, and then as many separate stones as there will be colours or tints required, each bearing a 'false transfer' of the key or outline drawing, in its reduced or correct size. It is interesting to note that to reduce a drawing it is transferred to a large sheet of indiarubber, which is then allowed to contract to the required size; this being precisely opposite to the method employed by Leech for producing his 'Sketches in Oil.' The next step is for the artist to prepare his scale of colours, which requires great skill and experience, for apart from effects of light and shade he has to consider all the results produced by the combination of several colours or over-printings. For guidance of the artist the scale of colours is reproduced in a series of small contiguous squares on the margins of the proofs. This is frequently seen in the coloured plates forming Christmas supplements, and represents the exact colours needed for successive printings, placed in the proper order. The artist then has to take each of the stones and proceed to fill in with a black fatty ink those portions which he has decided shall be printed in a particular colour. Needless to say, the printing requires the greatest care and experience. The printer must be an artist scarcely inferior to the one who places the design on the stone, for the slightest inaccuracy or want of skill on his part, in registration or in colouring, may destroy the result of the best set of drawings produced.

In most chromo-lithographs produced in this way there is something frigid and artificial, degenerating at its worst into the hideous glossiness and formality that have made the German oleograph a byword for ugliness. Easiness of imitation led the mechanical,

commercial lithographer to the cheap and vulgar re-production of the worst type of popular pictures. For the illustration of books pure chromo-lithography has almost ceased to find employment, and its main uses are for the large plates given with Christmas numbers and for posters. To the poster is due a remarkable revival in chromo-lithography. Of late years the artist has begun to object to building up his colour by super-printing several tones, has ceased his laborious imitation of nature, and his pernicious striving after realism, and in the manner of the artists of Japan has invented a colour scheme of his own. The conventional colours and designs of the modern poster are often superb in their decorative effect, and belong to the highest art in that they are not only decorative, but admirably adapted to the end for which they were made.

In book-illustration the success of lithography in the future is merged in that of process-work. Lithography must either succumb to the inroads of mechanical process, or it must maintain its utility by means of a union with process. The work of the camera can be employed as a ground for colour imparted by lithography, while the dazzling effect produced by the mesh of the mechanical screen is mellowed and softened by tints artistically applied by lithographic means. On the Continent lithography has already been employed in conjunction with photogravure and collotype with most artistic results, and similar combinations have been successfully used in our own country. In *Bibliographica* (1894-97), for instance, will be found plates that show a union of collotype and chromo-lithography ; and in Mr. Cyril Davenport's *English Embroidered Bookbindings* the colour has been applied by chromo-lithography to half-tone plates with most excellent results. It is on the development of such conjunctions as these that the future success of lithography must depend.

CHAPTER XX

BOOKS ILLUSTRATED BY COLOURED LITHOGRAPHS

BEFORE speaking of the books illustrated by the various processes described in the last chapter, it may be as well to put in their proper perspective the men whose names are most closely associated with the development of chromo-lithography in this country. The most important of them, Charles Joseph Hullmandel, was born in London in 1789, and after travelling on the Continent, published, in 1818, *Twenty-four Views of Italy*, drawn and lithographed by himself. This, it should be remembered, was a year before Senefelder's book was published in English, so that Hullmandel may be reckoned as one of the pioneers of the art. In 1827 he issued a pamphlet, *On some important Improvements in Lithographic Printing*. Amongst the artists who availed themselves of Hullmandel's processes were Clarkson Stanfield, David Roberts, Haghe, Nash, and Cattermole. With the last he was allied in his invention of lithotint, the application of liquid ink to stone by means of a brush; and among other improvements that he discovered or developed were the employment of a graduated tint, the introduction of white in the high lights, and the use of the stump on the stone.

The earliest and most important firm of lithographic printers and publishers was that of Messrs. Day and Haghe. Louis Haghe was born at Tournay, in Belgium. It is interesting to note that his work was

executed with his left hand entirely, his right hand
being deformed from his birth. He studied lithography
at Tournay, working with the Chevalier de la Barrière
and J. B. de Jonghe. Shortly after 1810 he came to
England and entered into partnership with William
Day, a publisher at Gate Street, Lincoln's Inn Fields.
The series of works produced by this firm raised litho-
graphy to perhaps the highest point it ever attained.
Their success was largely due to Haghe's own artistic
powers, and also to the fact that Day and Haghe had
the knack, like Ackermann, of gathering round them
a brilliant and resourceful staff. In 1852 Haghe pub-
lished his last work in lithography, a set of views of
Santa Sophia at Constantinople. From this date he
devoted himself entirely to water-colour painting, and
his talent raised him, in 1873, to the high office of
President of the New Society of Painters in Water-
Colours, now the Royal Institute. After Haghe's
resignation the firm was continued as Day and Sons,
and still continues in existence as 'Vincent Brooks,
Day and Son.'

Closely associated with Day and Haghe was Owen
Jones, so well known as an architect and designer, and
particularly as the author of the *Grammar of Ornament*.
Born in London in 1825, he was educated at the
Charterhouse, and then became the pupil of Vulliamy
the architect. In 1834 he travelled in Spain, and
brought back material for his book on the Alhambra,
which will be referred to later. After a further visit to
Granada in 1837 he started a complete lithographic
establishment at John Street, Adelphi, employing a
staff of artists to carry out his ideas. For the Alhambra
pictures he worked along with Day and Haghe, and
later on moved to 9 Argyll Place, where, during the
'forties and early 'fifties, he executed a great deal of
illuminated work for Messrs. Longman and Co. An
older firm, already mentioned in connection with aqua-

tint illustrations, which adopted the new process of lithography with considerable success, was that of M'Lean in the Haymarket.

Before treating of chromo-lithography proper, a few of the books may be mentioned in which the colouring was applied by hand throughout the edition.

One of the first to publish lithograph illustrations, systematically coloured by hand, was N. Whittock, who styled himself 'Lithographer and Draftsman to the University of Oxford.' The second edition of his *Microcosm of Oxford*, in 1828, has a frontispiece and five lithographed costume plates, all tinted by hand. In 1829 he produced *The Art of drawing and colouring from nature, Flowers, Fruits and Shells: to which is added correct directions for preparing the most brilliant colours for Painting on Velvet.* There is a plain and a coloured copy of each illustration, all of them lithographs, representing very naturalistic flowers and shells, highly suitable for their intended destiny. One shudders to think of the resultant black velvet cushions, painted by amiable and accomplished young ladies, for the adornment of drawing-rooms. In 1827 appeared Whittock's *Decorative Painter's and Glazier's Guide; containing the most approved methods of imitating oak, mahogany, maple, marbles, etc., in oil and distemper colour.* A third edition of this, with considerable additions, appeared in 1832, and the illustrations of the book are interesting, more from the method employed in their production than from their pictorial attractiveness. In representing various woods and marbles, the effect of colour and polish has been obtained by first painting the lithograph with bright watercolours, and then covering this with a solution of gumarabic, used as a varnish. The final result, though somewhat startling, no doubt satisfied the author's wishes in depicting a shiny, polished surface. In 1840 Whittock issued a work *On the Construction and*

244

*decoration of the Shop Fronts of London, illustrated
with coloured representations.*

From 1820 to 1835, however, hand-coloured lithographs were by no means common. One of the few
other books that call for notice is the *Scotch Sketches*
by R. P. Bonington, published by Colnaghi and Co. in
1829. These were originally published at Paris in
1826,[1] and on Bonington's death in 1828 appeared in
the present form. Badly printed and coloured, they
are a distinct libel on a great artist.

Notable among the early lithograph illustrations coloured entirely by hand is Edward Lear's *Illustrations
of the Family of Psittacidae or Parrots*, published by the
author in 1832, the plates being printed by Hullmandel.
The parrots are excellently figured, and drawing and
colouring show close observation of nature coupled
with much artistic feeling. Lear at the time drew for
the Zoological Society, and after the publication of this
book was employed by the Earl of Derby in drawing
the plates for the volume entitled *The Knowsley Menagerie*. It was for Lord Derby's grandchildren that
Lear at this time composed the famous 'nonsense
verses,' which will probably perpetuate his memory
long after his *Family of Psittacidae* is forgotten.
Practically a companion volume, published in the same
year, 1832, is J. Gould's *Century of Birds from the
Himalaya Mountains*. It contains eighty lithographs
printed by Hullmandel, and finely coloured by hand.

The next step in the history of coloured lithographs
was the discovery of Hullmandel's lithotint process,
and of the method of superimposing a yellow tint,
leaving the high lights in white. From 1837 there is an
endless succession of books illustrated in this manner,
too numerous for the mention of all. They assume a
stereotyped form ; and a glance at the pictured title-

[1] *Vues Pittoresques de l'Écosse.* Texte par Am. Pichot. Ch. Gosselin et
Lami-Denozan, éditeurs.

245

page, the dedication page in lithographic 'copper-plate'
writing, and the succession of tinted landscape views,
will fix the date of a book as 1836 to 1845. A few of
the more important may be mentioned in detail, espe-
cially as many contain the lithographic work of men
who rose to considerable fame as painters.

In Harding's *Sketches at Home and Abroad*, pub-
lished in 1836, Hullmandel's lithotint printing made
its first appearance. The preface to *Harding's Portfolio*,
published a year later, says that 'in the *Sketches at
Home and Abroad* Mr. Harding has applied a new
mode of his own for introducing the *whites* in *printing*
instead of laying them on with the pencil.[1] By this
process a lasting effect is produced ; the tints thus
obtained being permanent and free from dinginess
which has hitherto been such a fatal objection to their
production in the usual manner.' The *Sketches at
Home and Abroad* was dedicated to Louis-Philippe,
King of the French. To show his approval of the
work, Louis wished to decorate the artist with the
'Legion of Honour.' This, however, being unaccept-
able according to English etiquette concerning foreign
decorations, His Majesty ordered a breakfast service
of Sèvres china to be forwarded instead. Fate, how-
ever, was again unpropitious, for one of the principal
pieces met with an accident *en route*. His Majesty
therefore sent instead, by the hands of Count Sebastiani,
an autograph letter with a magnificent diamond ring.

Lewis's Sketches and Drawings of the Alhambra
has twenty-six plates, ten lithographed by W. Gauci,
eight by J. F. Lewis himself, seven by J. D. Harding,
and one by R. J. Lane. To the same date, 1836 or
1837, belongs *Lewis's Illustrations of Constantinople*,
the twenty-eight plates being drawn on stone by J. F.
Lewis after original sketches by Coke Smyth. The
printer is C. Hullmandel, the publisher M'Lean. In

[1] 'Pencil' in the sense of water-colour brush.

1836 was published *Lewis's Sketches of Spain and Spanish Characters*, with twenty-six plates printed by Hullmandel.

An early work in this style, published by Day and Sons without date, is *Picturesque Sketches in Spain: Taken during the Years* 1832 *and* 1833, by David Roberts. To 1837 belongs *Sketches in Italy, Switzerland, France, etc.*, by T. M. Richardson, junior, with eleven plates lithographed by himself, and fifteen by J. B. Pyne. By J. B. Pyne in the following year is *Windsor, with its Surrounding Scenery*, 'printed in Chromatic Lithography by A. Ducôté, 70 St. Martin's Lane,' and published by M'Lean. In 1838 also we have *Sketches on the Moselle, the Rhine, and the Meuse*, by Clarkson Stanfield, with sixteen lithographs by T. S. Boys, seven by W. Gauci, four by A. Picken, and three by L. Haghe. In the same year *Sketches on the Danube*, by George Hering, was published by M'Lean, with twenty-six plates lithographed for Day and Haghe, nearly all by J. B. Pyne, with a few by Catterson Smith.

Nash's *Architecture of the Middle Ages*, published in 1838, has a reference to Hullmandel's process in the preface:—'In producing the effects of the original sketches Mr. Nash begs leave to express the obligation he is under to the new Style of Lithography invented by Mr. Hullmandel, without which, indeed, Mr. Nash would never have had courage to encounter the labour necessary, by the old method, to have produced the desired effect. By the introduction of the stump in place of the point for making large tints, the Artist has an instrument placed in his hands, which for freedom and rapidity of execution, admitting at the same time both of the greatest delicacy as well as force of tint, nearly equals the pencil in colour—indeed it may almost be called painting on stone.' This work was issued also in an edition coloured by hand.

247

In 1839 T. M. Richardson, senior and junior, published together a set of seven lithographs entitled *Sketches at Shotley Bridge Spa and on the Derwent*; and an interesting work of the same year is *Groups of Cattle* by T. Sidney Cooper, published by Ackermann, with twenty-six plates printed by Hullmandel. In 1841 M'Lean published *The Park and the Forest*, with lithographs by J. D. Harding, printed by Hullmandel. From 1840 to 1850 Haghe, who was a splendid draughtsman with the knack of making his interiors interesting by the introduction of appropriate scenes and costumes, issued his *Sketches in Belgium and Germany*. The book was printed by Day and Haghe, and published by Hodgson and Graves. The first volume appeared in 1840 with twenty-six plates, the second in 1845 with twenty-six plates, and the third with twenty-seven plates in 1850. The last volume is often found with the plates coloured by hand. From 1839 to 1849 *The Mansions of England in the Olden Time*, by Joseph Nash, was published by M'Lean in four parts, each with twenty-six plates, the first in 1839, the second in 1840, and the third and fourth in 1841 and 1849 respectively. The parts could be had either plain or coloured, in the latter case the colour being applied by hand. Of a similar nature is C. J. Richardson's *Studies from Old English Mansions*, published by M'Lean in four series from 1841 to 1848, one or two plates of goldsmiths' work being coloured by hand. Among Richardson's other works may also be mentioned *Architectural Remains of the Reigns of Elizabeth and James I.* (1840), *The Workman's Guide to the Study of Old English Architecture* (1845), and *Studies of Ornamental Design* (1851).

Before 1850 the method of toned lithotint was becoming out of date, and was being superseded by work in colour. In 1847 such distinguished artists as David Roberts, Stanfield, J. D. Harding, Nash, and

"HOTEL DE CLUNY, PARIS." BY T. S. BOYS

FROM "PICTURESQUE ARCHITECTURE IN PARIS, GHENT, ANTWERP AND ROUEN," 1839

others, joined in illustrating by lithotint a book entitled
Scotland Delineated. The work was not a success,
and the reason was clearly defined in a private letter by
Cadell, the well-known publisher. 'It has two draw-
backs,' he writes; 'the first, it is rather late; the
second, too dear. Success will attend no one thing in
these scrambling, pushing, competing, bustling times,
that is not good, *new*, and cheap. I mean by *new* that
it must have a dash of originality.'

The tinted method was admirably adapted for
hand-colouring, and many of the books mentioned
were issued in colours as well as plain. By 1837,
however, Hullmandel was beginning to make more
determined advances in printing graduated colours,
and some of his publications in which the colour-
ing is of special note, must here be recalled. His
earliest book in this manner was *Harding's Port-
folio* (1837). Its twenty-four plates form a delightful
set of landscape drawings, pleasing alike in colour,
composition, and draughtsmanship. Next came a
genuine triumph in the *Picturesque Architecture in
Paris, Ghent, Antwerp, and Rouen*, published in 1839
with twenty-six plates by Thomas Shotter Boys, a
rather neglected artist who merits a far higher place
than he has ever been awarded in the annals of the
English water-colour school. Many of the lithograph
illustrations already mentioned have been the work of
no ordinary men, but in this book Boys is head and
shoulders above them all. His drawing is refined and
sensitive, and his colouring cool, simple, and direct.
The dedication is noteworthy — 'To C. Hullmandel
Esq. in acknowledgment of his great Improvements
and highly important discoveries in Lithography this
Work, forming another Epoch, and presenting entirely
new capabilities of the Art, is dedicated by his sincere
Friend, Thomas Shotter Boys.' In the Descriptive
Notice the publisher pointed out that 'the whole of

the drawings composing this volume are produced entirely by means of lithography, they are printed in oil colours and come from the press precisely as they appear. It was expressly stipulated . . . that not a touch should be added afterwards, and this injunction has been strictly adhered to. They are pictures drawn on stone and reproduced by printing in colours, every touch is the work of the artist, and every impression the product of the press. This is the first and as yet the only attempt to imitate pictorial effects of landscape architecture in chromo-lithography, and in its application to this class of subjects, it has been carried so far beyond what was required in copying polychrome architecture, hieroglyphics, arabesques, etc., that it has become almost a new art.' This last remark is evidently aimed at the work of Owen Jones in the volume on the Alhambra, then appearing; and the publisher adds an explanation of the difference between the two methods of working. 'In mere decorative subjects,' he says, 'the colours are positive and opaque, the tints flat, and the several hues of equal intensity throughout, whereas in these views the various effects of light and shade, of local colour and general tone, result from transparent and graduated tints.' The clear transparency of the artist's colouring, and in particular the sparkle of white in the blue sky, are admirably rendered. The method, however, of piling up opaque colours was the one that survived, and the *Picturesque Architecture in Paris* stands almost alone as a genuinely artistic production in chromo-lithography. There is the same strength and attractiveness of draughtsmanship in Boys's *Original Views of London*, published in 1842. The plates of this are, as a rule, printed in a yellow tone, without further colouring; but there seem to be coloured copies in existence.

Another striking book printed in one or two tints,

DAVID ROBERTS

is the *Views in the Holy Land, Syria, Idumea, Arabia, Egypt, and Nubia*, by David Roberts, R.A. There is a deep and absorbing interest in the subject, for in no other publication have the sites and buildings famous in sacred history and Eastern legend been so vividly represented. It is difficult to speak in sufficiently high terms of the beauty and interest of the varied subjects in this great work. It represents the results of Roberts's travels in the East during the years 1838 and 1839. The extraordinary merit and interest of the drawings which he exhibited on his return created a great sensation. The fidelity of his accurate pencil, his skilful adherence to truth of costume and surroundings, his attention to characteristic effect in architecture and landscape, won immediate recognition and praise. Commissions from royal and other patrons of art crowded upon him for pictures of his Eastern subjects, and a publisher, F. G. Moon, was soon found to undertake their reproduction for wider circulation. The result was the present work with about two hundred and fifty plates, accompanied by an admirable descriptive text by the Rev. Dr. Croly and W. Brockedon. The book was published in parts from 1842 to 1849, and the original cost for subscribers for a coloured copy was close on £150. For the coloured edition the plates were all executed in two tints by Louis Haghe, and were exquisitely coloured by hand in imitation of the original drawings. It should be said that Roberts himself did no drawing on the stone for this book. The lithographs were done entirely from Roberts's drawings by Harding and Haghe, the latter of whom devoted about eight years to the series. The book is really in six volumes. Three dealing with the Holy Land contain one hundred and twenty-two coloured plates, and three of Egypt and Nubia contain one hundred and twenty-three plates. In addition to the coloured plates there are maps and a

251

portrait. A small edition with fresh plates was published in six volumes by Day and Son in 1855.

So far we have dealt mainly with 'tint printing,' where one or two ground or surface tints, usually of a yellow tone, were used in conjunction with the black outlines of the picture, the whole being occasionally finished by hand-colouring. Reference has also been made to Hullmandel's success in printing in a few colours with a graduated tint. It now remains to speak of the plates produced by elaborate over-printing of colours in the fully developed process, described in Audsley's *Art of Chromo-Lithography*, and mentioned in our last chapter.

The method was particularly suited to the rendering of brilliant colours and intricate details of form. It opened up new possibilities for the illustration of objects of art, costume, textiles, heraldry, botany, zoology, and so forth. One of the earliest books illustrated in this style is Owen Jones's *Plans, Elevations, Sections, and Details of the Alhambra*, published by Day and Haghe. The book is in two volumes, the first of which appeared in 1842, the second in 1845. Victor Hugo spoke of the Alhambra as 'un palais que les Génies ont doré comme un rêve et rempli d'harmonies.' Its external glories and the mysteries of its interior, with the fretted work on dome and arch and column, pass description in colour as in words. This book, however, almost accomplishes the difficult task. The line engravings fully suggest the nobility of the architecture, while the numerous colour plates depict faithfully the ornamental decoration, consisting mainly of a scheme of blue, red, and gold. The plates are of a large size, and are produced in six or seven tints. Many of them were drawn, lithographed, printed in colours, and published by Owen Jones at his own establishment, and are dated from 1836 onwards. Some of the finest plates, however, have the

"BETHANY"

FROM "VIEWS IN THE HOLY LAND," BY DAVID ROBERTS, 1842-1849

imprint—'printed in colours by Day and Haghe.' The whole work, a magnificent production, was published at a hundred and fifty guineas a copy, but it was not a commercial success, and can now be bought for a fraction of its original value.

The Industrial Arts of the XIXth Century at the Great Exhibition, 1851, by M. Digby Wyatt, was published from 1851 to 1853 in forty parts, with one hundred and sixty plates, printed in colour. The book is interesting as a record of early Victorian art, with its few beauties and its many atrocities. It is valuable, too, for its clear account in the preface of the position of chromo-lithography at the time, and of the particular method of producing the plates. Among the principal lithographers employed were F. Bedford, J. Sleigh, and J. A. Vintner. The greatest number of printings for any one subject was fourteen, and the average number seven. The work necessitated the use of 1069 stones, weighing in all twenty-five tons. The storing of these stones, it may be added, is one of the difficulties in any lithographic establishment, and to an unaccustomed outsider the place appears at first entry like a disused graveyard. The stones, which come from Bavaria only, cost several pence a pound, and as they frequently consist of large slabs, many inches thick, their cost is no small consideration. Of course, the surface is continually being ground down, to admit of its fresh employment. Good stones are nowadays difficult to obtain, and the failure of any old firm is looked on by brother lithographers as a happy opportunity for acquiring valuable stock.

Very similar in nature to the *Industrial Arts* is *The Art Treasures of the United Kingdom*. The book was compiled by J. B. Waring, and published by Day and Sons in 1858, with eighty-two chromo-lithographs by F. Bedford. These are slightly more advanced than those of the *Industrial Arts*, but the

advance of the art is made apparent by a glance at a third similar volume, published in 1863, in which the plates are characterised by a much higher finish. This is the *Masterpieces of Industrial Art and Sculpture at the International Exhibition*, 1862. The objects illustrated were selected and described by J. B. Waring, and the whole work was issued by Day and Sons with three hundred and one chromo-lithographs made by and under the direction of W. R. Tymms, A. Warren, and G. MacCulloch.

Chromo-lithography was also applied at this time to landscape plates. *The Gardens of England*, by E. A. Brooke, is illustrated with twenty-seven chromo-lithographs in brilliant, not to say startling, colours. The book represents chromo-lithography in its naked hideousness, with its futile attempts at realism; and yet I have heard these plates described as 'lovely.' A far better result is attained in *India Ancient and Modern*, a collection of fifty plates after drawings by William Simpson, the famous war correspondent. Simpson was a keen archæologist as well as an indefatigable worker, and after the close of the Indian Mutiny had gathered a great mass of valuable sketches. It was intended to embody these in a great work published in forty-two parts at two guineas each. Owing to the failure of Messrs. Day and Son, the project had to be abandoned, and the present work was issued instead in ten parts. The text is by Sir John Kaye, and the plates attain a remarkable degree of perfection, giving a wonderfully good idea of the landscape, costume, and native industries of our Indian empire. Simpson's earlier work, published in two or three tints of lithography, is worth notice, particularly his forty illustrations to Brackenbury's *Campaign in the Crimea*, and the eighty-one plates in *The Seat of War in the East*, both published by Day in 1855. The latter work gives the names of many lithographers working for

Messrs. Day and Son, among them C. Haghe, B. Morin, E. Walker, T. Picken, J. Needham, J. A. Vintner, T. G. Dutton, R. M. Bryson, and F. Jones. Simpson himself, when he first came from Glasgow to London, found employment with Messrs. Day and Haghe, and his *Autobiography* (1903) contains many references to his work and fellow-workmen.

A series of plates after Joseph Wolf, entitled *Zoological Sketches* (1861), is another good example of chromo-lithography. The fifty plates, lithographed by Vincent Brooks, are a faithful, if not very artistic, rendering of animal life. A second series of fifty plates appeared in 1867.

During all this period, and for some twenty years later, chromo-lithography was applied to books of every kind, too numerous for mention. Much of its continued success, even in the face of modern colour processes, has been due to the admirable results produced by Mr. William Griggs. For some time Mr. Griggs was in charge of all the photo-lithographic work done for the Indian Government at Whitehall, and between 1860 and 1870 had opportunities of studying the new processes of photo-zincography discovered and used by Sir Henry James, of the Ordnance Survey Office at Southampton. Mr. Griggs has since devoted his life-study to the reproduction of art objects by means of chromo-lithography assisted by photography. His first works were produced for the Indian Government, who were eager to promote a wider knowledge of Indian art manufactures, and to appeal to those interested in India to prevent the decline or degradation of its native industries. *The Textile Fabrics of India* (1874-80) and the *Journal of Indian Art* (1886—) were admirably suited to this purpose. Textiles of Kashmir, brass and copper of the Punjab, enamels of Jeypore, pottery from Mooltan—these and kindred objects were reproduced by Mr. Griggs in chromo-lithographs of extraordinary

beauty and fidelity. Of the various other works undertaken at his art factory at Peckham, it is unnecessary to speak in detail. Under the auspices of the Board of Education he has produced his fine series of *Portfolios of Industrial Art* (1881—). For the British Museum he has facsimiled the *Papyrus of Ani*, and since 1899 has been engaged in reproducing the *Illuminated Manuscripts*. The last is a most striking piece of work, and for some of the plates no less than forty-five printings have been employed. His skill in executing richly coloured facsimiles of ancient bookbindings has been shown in the Burlington Fine Arts Club catalogue of the Exhibition of Bookbindings (1891), and in Fletcher's *Foreign Bookbindings* (1896). Unfortunately, however, Mr. Griggs at that time was unable to procure a permanent gold, with the result that the gold in the elaborate tooling is tending to become black. One of his most successful reproductions of a binding is one in illustration of a paper by Mr. Cyril Davenport in *Bibliographica* (1896), where the plate is in collotype and chromo-lithography, a yellow colour being used instead of gold.

But for the brilliant and painstaking work of Mr. Griggs, chromo-lithography as a means of illustrating books would be almost a lost art, like that of coloured aquatint. To a certain extent one may gauge his importance to the collector by the fact that the secondhand catalogue (the collector's barometer) always inserts the name of Griggs, when it omits those of Day, Haghe, or Hullmandel.

CHAPTER XXI

THE CHISWICK PRESS, AND CHILDREN'S BOOKS

A NOTABLE revival of colour-printing from woodblocks dates from the rise of the famous Chiswick Press. Charles Whittingham, nephew of the founder of the original business at Chiswick, established a separate printing-office at 21 Took's Court, and soon afterwards came to know William Pickering, one of the most remarkable and enterprising of English publishers. Pickering had started in business in 1821 as a seller of old books in a little shop at 31 Lincoln's Inn Fields. He soon found patrons with long purses, and employed his fine taste and knowledge in producing for their gratification 'elegant reprints of the best literature.' With Whittingham he formed an alliance that enriched the world of books with many beautiful editions; and even if the only achievement of the two had been the revival of the old-faced Roman type, invented by Nicolas Jenson, they would still have deserved well of all readers of books. Their names and works were so intimately associated that it was natural enough for a friend of Whittingham to ask one day which influenced the other most. 'My dear sir,' replied Charles, 'when you tell me which half of a pair of scissors is the most useful, I will answer your question.'

In his book *The Charles Whittinghams*, privately printed by the Grolier Club in 1896, Mr. A. Warren gives a pleasing picture of the introduction of these

R

two worthies, telling how the bookseller, a short, fat man, addicted to maroon waistcoats whose elaborate embroideries were not entirely concealed by the snuff which descended on them in frequent showers, greeted his new acquaintance with the courtesy demanded by the occasion, and then fell to talking of title-pages. The two cronies after this meeting would go together for their midday meal to the Crown Coffee-House in Holborn, and talk of new projects for books and of fresh fancies in paper, type, and binding. They suffered no book to drift unheeded through the stages of its manufacture. In the little summer-house in Whittingham's garden at Chiswick they would forgather on a Sunday afternoon, with side-pockets bulging with well-worn title-pages and samples of type, to settle the final form and proportion of the future work.

After his uncle's death at Chiswick in 1840, Charles Whittingham kept up the two printing-presses for about nine years, the one at Took's Court, the other at Chiswick; but wherever the books came from they bore the stamp of the 'Chiswick Press.' Some of the finest specimens of Whittingham's nephew's craftsmanship are to be found in the books of Henry Shaw, all of whose works appear to have been published by Pickering. Whittingham must have known something of Savage's work, and in some books by Shaw he continues the revival of colour-printing from woodblocks, which had been undertaken by Savage without apparent success. In Shaw's early books the illustrations are all engraved on metal and coloured by hand, and though Whittingham printed the text, he clung to wood-blocks for pictorial effects, and would have no hand in plate engraving. In 1833 he printed for Shaw a volume, published by Pickering, called *Illuminated Ornaments selected from Manuscripts and Early Printed Books from the Sixth to the Seventeenth Cen-*

258

turies. Sir Frederic Madden, of the British Museum, wrote the descriptive text, while Shaw, who was a rare artist in his way, drew, engraved, and coloured many of the illustrations. With their careful selection of pigments and their faithful colouring, Shaw's reproductions attain almost to the brilliancy of an original manuscript, and those interested in Shaw's work, and in mediæval manuscripts generally, should see a collection of this artist's original facsimiles in the National Art Library. The laborious method of illustration by means of his own hand-coloured engravings was continued by Shaw for seven years, as may be seen in *Specimens of Ancient Furniture*, with descriptions by Sir S. R. Meyrick, and *Ancient Plate and Furniture from the Colleges of Oxford and the Ashmolean Museum*, both printed at the Chiswick Press, and published by Pickering in 1836 and 1837 respectively.

Till 1840 no colour-printing was produced by the Chiswick Press with the exception of some headpieces, titles, and borders, printed in black and red. There is, however, one doubtful instance in a volume of the year 1820, an edition of *Puckle's Club*,[1] one of the many books that the Chiswick Press helped to revive and make popular. *Puckle's Club* made its first appearance in 1711, and in 1817 it was reprinted with twenty-five wood-engravings by Branston, Thompson, and others, after Thurston. These engravings by themselves were issued with a title-page in 1820, and a new edition of the whole book, with text and illustrations, was published by Charles Whittingham, nephew, in 1834. It is the 1820 edition that now claims our attention, for it was ' printed (for the proprietor) in colours, from the original blocks, and limited to one hundred impressions.' The method of colouring is that of the old chiaroscuros and of the first attempts at chromo-litho-

[1] A full account of Puckle and his book appears in Mr. Austin Dobson's *Eighteenth Century Vignettes* (ser. iii.).

graphy, a single tint with the high lights omitted being printed over the black-and-white print. The tints in this case were conveyed from wood-blocks, and different colours were used to suit the different subjects. Mr. Warren is inclined to think that the 1817, and presumably also the 1820, edition of the Puckle book is not a Whittingham production, but it is claimed as such by Mr. W. J. Linton in his work on wood-engraving, and in favour of his claim is the decorative W on the 1817 and 1820 title-pages. It is, however, equally possible that the W stands for Mr. Edward Walmsley, 'a gentleman whose taste led him to the love of embellished books,' and who selected this old-world book as a medium for Thurston's illustrations. It is, therefore, just possible that the two earlier editions were printed by or for Whittingham senior, and that to the Pickering influence was due the reproduction of text and illustrations in their new and dainty form of 1834. The wood-engraving is good enough to win Mr. Linton's praise, and the chiaroscuro style of the 1820 edition is so unusual, that it makes this edition rare and valuable, especially when it is remembered that only a hundred impressions were taken for it from the blocks, which were used years later for the new edition.

Setting aside this book, we find the first definite colour-printing of the Chiswick Press in 1840, when Whittingham began to set up Shaw's *Encyclopædia of Ornament*, which appeared two years later. For this book he made his first experiments in real colour-printing from wood-blocks, and the result was some reproductions of book-bindings at the beginning of the *Encyclopædia*, and one later plate depicting needle-work. The rest of the plates are all engraved on copper, and coloured by Shaw as before. The best piece by Whittingham is the title-page, reproducing 'an old binding in the possession of George Lucy, Esq.

of Charlecote, Warwickshire.'[1] It is printed in black, red, green, blue, and yellow. Shaw was so pleased with the success of this experiment that he resolved to employ the method in future for all his books. In 1843 he produced his *Dresses and Decorations of the Middle Ages*, issued originally in parts, and then in a single large paper volume. Here Whittingham's colour-printing was much more extensively employed to supplement the engraved work, and to reproduce initial letters and manuscript ornaments. Two years later came the *Alphabets, Numerals, and Devices of the Middle Ages*, again with a portion of the illustrations worked in colour at the Chiswick Press.

Shaw's books were too costly in their production to be a financial success. His old-fashioned style of work, produced with most loving care and with infinite pains by artist and printer alike, was being ousted by the newer method of chromo-lithography, by this time well advanced. The bitterest epigram contains a modicum of truth, and if we are not altogether a 'nation of shopkeepers,' we must nevertheless acknowledge as our fitting motto the old saying, φιλοκαλοῦμεν μετ᾽ εὐτελείας. Chromo-lithography offered a cheaper market, and Whittingham's coloured woodcuts had to go to the wall.

Whittingham seems to have stood almost alone in this revival of colour-printing from wood between 1840 and 1850. In the *Memorials of the Antiquity and Architecture of the County of Essex* by the Rev. A. Suckling, published by J. Weale in 1845, besides lithographs, there are two or three wood-engravings 'printed in colors by Gregory, Collins and Reynolds,' to whom I shall have occasion to refer in a succeeding chapter.

[1] Mr. Warren is surely mistaken in giving this as the title-page of Shaw's *Elizabethan Architecture*, which he says appeared in 1842 with Whittingham's first specimens of block colour-printing. The *Elizabethan Architecture* was published in 1839, and contains no colour plates.

ENGLISH COLOURED BOOKS

Though colour-printing from wood-blocks for such works as those of Shaw proved unremunerative, Whittingham found another use for wood-blocks, which was to be fruitful of results. This was in the illustration of children's books. The close of the eighteenth century saw the publication of an endless number of 'books for the young,' mostly of the 'penny plain and twopence coloured' order. Many of them come really under the category of chap-books, illustrated by rude woodcuts, and hawked by country pedlars. Among prominent publishers who issued such books during the first few decades of last century were J. Lumsden and Sons, of Glasgow; J. G. Rusher, Bridge Street, Banbury; and J. Kendrew, of Colliergate, York. Among London publishers, whose scale rises to 'one shilling plain, two shillings coloured,' were J. Newbery, of St. Paul's Churchyard (who was succeeded by T. Carnan, and his son E. Newbery, and later by J. Harris); Darton and Harvey; Tilt and Bogue; J. Marshall, and others. Mr. Tuer in his *Forgotten Children's Books* tells how the colouring of the pictures was done by children in their teens, who worked with astonishing celerity and precision. They sat round a table, each with a little pan of water-colour, a brush, a partly coloured copy as a guide, and a pile of printed sheets. One child would paint the red, another the yellow, and so on till the colouring was complete.

To the John Newbery mentioned above, we must always be grateful for having inspired Mr. Austin Dobson with the subject of one of his delightful *Eighteenth Century Vignettes*, under the title of 'An Old London Bookseller.' He was patron and publisher to Johnson and Goldsmith and Christopher Smart, but his claim to the gratitude of posterity lies, to quote his biographer Mr. Welsh, in his being 'the first bookseller who made the issue of books, specially intended for

262

children, a business of any importance.' He was the publisher of *The Renowned History of Giles Ginger-bread*, of *Mrs. Margery Two-Shoes*, of the redoubtable *Tommy Trip and his dog Jouler*, all of which Dr. Johnson thought too childish, but which Charles Lamb preferred to the Barbaulds and Trimmers, 'those blights and blasts of all that is human in man and child.'

Perhaps Goldsmith was the author of some of Newbery's 'classics of the nursery'; at any rate, Newbery's publications are an oasis in the desert. The 'blights and blasts' are all too common. The note of early children's books is a priggish piety, born of the solemn ignorance of human nature under which their writers seem to have laboured. The precocious child of the period was burdened with depressing moralities and melancholy instruction, all conveyed in stilted and affected phrasing. Among typical titles are *The Child's Spiritual Treasury*, *The First Principles of Religion and the Existence of a Deity explained in a series of dialogues adapted to the Capacity of the Infant Mind*, *Geography and Astronomy familiarized for the Youth of Both Sexes*, *A Child's Thoughts on Death*! Most of us have *Sandford and Merton* (1858), one of the more enlightened survivals of this style, among the recollections of our early childhood.

English-speaking children, the wide world over, owe much to a trio of men who strove to regenerate juvenile literature, to protect children from over-doses of Mrs. Markham and 'useful knowledge' in general, and to revive old tales sung or said from time immemorial, with all the elements of fancy, imagination, sympathy, and affection, that appeal to the child mind. These three regenerators were Sir Henry Cole, who wrote under the *nom de plume* of 'Felix Summerly,' Joseph Cundall, the publisher, and Charles Whittingham, the printer. The outcome of this union was the series known as 'The Home Treasury.' We are apt to flatter

ourselves that modern children's books possess artistic qualities peculiarly their own, but a glance at 'The Home Treasury' of sixty years ago shows how much we are indebted to these three pioneers. Their books were attractively printed in fine old-faced type, with choicely designed borders, and with illustrations by the best artists of the day. In 1843 appeared *Sir Hornbook, Little Red Riding-Hood, Beauty and the Beast*, and *Jack and the Bean-Stalk*; in 1844, *Puck's Report to Oberon* and *An Alphabet of Quadrupeds*; in 1845, *Jack the Giant Killer* and *Cinderella*; in 1846, *Tales from Spenser's Faerie Queene*—and this is only a selection. Among the artists employed were J. C. Horsley, T. Webster, C. W. Cope, R. Redgrave, J. H. Townsend, and J. Absolon. The usual price of the books was 2s. or 2s. 6d. plain, 3s. 6d. or 4s. 6d. coloured—the colouring here being almost always done by hand, and not printed as in Shaw's books. *The Most Delectable History of Reynard the Fox* (1846) with its twenty-four pictures after Albert van Everdingen, was more expensive, costing 6s. 6d. In *Fraser's Magazine* for April 1846 Thackeray writes with ecstasy of these Cundall volumes, the mere sight of which, he says, is 'as good as a nosegay.'

There is another volume printed by Whittingham, which appears to be unique of its kind. Though published by Longman, it contains a preface written from 'Camden Cottages' and signed 'J. C.'—*i.e.* Joseph Cundall. The book appeared in 1849, and bears the title *Songs, Madrigals and Sonnets: A gathering of some of the most pleasant flowers of old English Poetry*. Each page is enclosed in double lines of different colours, and has a border of coloured ornament, with arabesques often enclosing vignettes. The whole is designed in an old Italian style to suit the supposed origin of the sonnet and the madrigal; and on the flyleaf, above Whittingham's imprint, is a special note

that 'the ornamental borders in this book have been printed by means of wood-blocks.' There are sixty-three coloured borders in addition to the title-page. The least number of printings employed is three, and some pages show the use of considerably more. The colouring is rich, the designs elegant, and the whole book is a worthy record of one of our greatest English printers. It is well worth a pound or two to the happy finder, and surely it was with prophetic instinct that Shakespeare wrote in the *Merry Wives of Windsor*, ' I had rather than forty shillings I had my book of Songs and Sonnets.'

CHAPTER XXII

EDMUND EVANS
CRANE, GREENAWAY, AND CALDECOTT

THE modern revival of colour-printing from wood-blocks, inaugurated by Whittingham, Leighton, and others, owes its full success to the energy, enterprise, and artistic skill of Edmund Evans. It is this printer that we have to thank for the delightful coloured plates by Caldecott, Greenaway, and Crane, that during the last thirty years have won the affection of old and young. Most of all, perhaps, are those of us indebted, who are young enough to remember the joys of our childish days, when *Under the Window, The Three Jovial Huntsmen,* and *The Great Panjandrum Himself,* delightful beyond all books that we had ever seen or imagined, were gift-books new and fresh. Where are they now, all those dear companions of our nursery days? Perhaps they were too dear, too well-thumbed to live. One looks back across the years, and thinks of them with sorrow and regret, as of friends departed. Did they survive, they should hold a place of honour in the bookcase that we cherish most.

Edmund Evans was born at Southwark in February 1826, and at the age of fourteen found employment in the composing-room of Samuel Bentley's printing establishment at Bangor House, Shoe Lane. When sweeping out the press-room before the arrival of the workmen in the morning, he would scratch

266

designs on some thick piece of slate, and try his hand at taking impressions. His interference with the presses brought him into trouble, but it also taught his employers that the boy was capable of something beyond the drudgery of his present occupation. Through the influence of the two overseers at Bangor House he was introduced to Ebenezer Landells, and joined him in May 1840 for a seven years' apprenticeship. Birket Foster, one year senior to Evans, was articled to Landells at the same time. The two pupils had many tastes in common, particularly a love of the picturesque, and would often join in sketching excursions.

At the expiration of the seven years, in May 1847, Edmund Evans launched out as a wood-engraver on his own account, first at his private residence at Camberwell, then (in 1851) at Racquet Court, Fleet Street. He secured his first orders from the firm of Ingram, Cooke and Co., whose manager was E. Ward, afterwards a partner in the firm of Ward and Lock. In 1852 Birket Foster was preparing for Ingram, Cooke and Co. a set of illustrations to Madame Ida Pfeiffer's *Travels in the Holy Land*. These were handed over to Edmund Evans, who engraved them for three printings. A key-block, giving the outlines, was worked in a dark brown tint, the second block in buff, and the third in a greyish blue. A similar method was pursued with the illustrations for *Fern Leaves from Fanny's Portfolio*, *Little Ferns*, etc., written about 1853 by Miss G. P. Willis under the pseudonym of ' Fanny Fern.'

Mr. Evans's next work for this firm was the preparation of an illustrated cover, then quite a novelty, for Mayhew's *Letters Left at the Pastrycook's*. It was printed in a bright red and a dark blue on white paper, the blue printed over the red producing a black shade. A similar cover was engraved from a design by Birket Foster for *The Log of the Water Lily*, and also for the

Lamplighter, published by G. Routledge and F. Warne. It was found, however, that the white paper used for these covers was easily soiled. This caused Mr. Evans to substitute a yellow paper with an enamel surface, which had an immediate popularity, and was greatly in request for railway novels—whence our modern term 'yellow-back.' In some cases publishers commissioned Mr. Evans to supply these yellow covers for 'remainders' left in stock, with the result that they not only sold the remnant, but a reprint as well. An enormous number of these covers was printed for all the leading publishers of the day, and among the artists who made the illustrations were Birket Foster, Sir John Gilbert, George Cruikshank, 'Phiz,' Charles Keene, and others.

Edmund Evans's first colour-printing of real importance as book illustration was for *The Poems of Oliver Goldsmith*, an edition published in 1858 with pictures by Birket Foster and ornaments by F. Noël Humphreys. It is my privilege to quote the story of this in Mr. Evans's own words:[1] 'Birket Foster made his first drawings on wood. After I engraved each, I sent him a pull on drawing-paper, which he coloured as he wished it to appear. I followed this as faithfully as I could, buying the dry colours from the artist colourman, and grinding them by hand. Birket Foster never liked this book, though it sold very well indeed.' The colours that the printer bought were those used by Foster himself—cobalt blue, raw sienna, burnt sienna, etc., among them—and every care was taken to reproduce as accurately as possible the texture of the original. The printing, it should be mentioned, was all done on a hand-press. The first edition was soon sold out, and a second edition with a number of fresh pictures appeared in 1859.

[1] I quote from a very kind letter written to me by Mr. Evans about a year before his death. He was then living in retirement at Ventnor, and though close on eighty could still enjoy his daily amusement of painting in water-colour.

EDMUND EVANS

From 1858 to 1860 Evans engraved and printed the wood-blocks to illustrate the *Common Objects of the Sea Shore* and the *Common Objects of the Country*, by the Rev. J. G. Wood ; also *Our Woodlands, Heaths, and Hedges*, and *British Butterflies*. All of these books were illustrated by W. S. Coleman, and the printing was done in six to twelve colours on a hand-press. In 1860 appeared *Common Wayside Flowers*, by Thomas Miller, some of the colour reproductions of Birket Foster's drawings being most delicate and effective. Other books of this period that had a large sale were Foster's *Bible Emblem Anniversary Book*, Lieut.-Col. Seccombe's *Army and Navy Birthday Book*, and *Little Bird Red and Little Bird Blue*, by M. Betham Edwards, with illustrations by T. R. Macquoid.

In *The Art Album*, published for Joseph Cundall by W. Kent and Co. in 1861, an attempt was made to reproduce water-colour drawings by some of the best-known artists of the day. The sixteen plates illustrate the uncertainty, the power as well as the inherent weakness, of colour-printing from wood. 'Winter,' by T. Sidney Cooper, or 'Fruit,' by W. Hunt, could not have been better translated in any other process employed for book-illustration. Of the fourteen other plates a few are fair, but most are feeble.

Evans's next work of importance was *A Chronicle of England*, written and illustrated by James E. Doyle, brother of Dicky Doyle, the well-known *Punch* artist, and son of 'H. B.' the caricaturist. The artist drew the designs on wood himself, and coloured a proof of each subject as he received it from the printer. For each of the eighty-one illustrations nine or ten colour-blocks were engraved, and the whole work was done on a hand-press, employed on this book for the last time. The work was published in 1864 at two guineas, and the entire edition sold out within a year

269

of its publication. Colour illustrations are almost invariably on separate plates, and it is a striking feature of this book that all the illustrations are in the text. Mr. Evans told me that he considered this the most carefully executed book he had ever printed.

It should be noted in passing that the first two coloured plates presented by the *Graphic* to its readers were executed by Edmund Evans. One of these, a large double-page picture of the Albert Memorial in gold and colours, appeared in 1872. The other is 'The Old Soldier,' a picture of a veteran war-horse in a field, stirred by the sound of a trumpet as some soldiers pass. This was after a water-colour drawing by Basil Bradley, and appeared in July 1873.

It is, however, in the colour-printing of children's books by Walter Crane, Randolph Caldecott, and Kate Greenaway that Edmund Evans has built his most enduring monument. Reference was made in our last chapter to the crudity and worthlessness of children's books in the early years of the nineteenth century. The appearance of the Whittingham books banished the old order of things, and led the way to the complete revolution in children's books culminating in the work of the three artists mentioned above. All three have been grouped under the title of 'Academicians of the Nursery,' and their names have long been household words. As contemporary illustrators of children's books they must always be linked together, though all have gifts peculiarly their own, with a style as distinct and individual as possible. A glance at a pictured page by any one of them reveals the artist; no need, like Alfred on his jewel, to say Greenaway, Crane, Caldecott 'had me made.'

Kate Greenaway and Randolph Caldecott both died at a comparatively young age; Mr. Walter Crane is the only one of the trio now alive. For the sake of convenience, however, one must use the present tense

270

throughout in speaking of these three artists and their work together. All three of them, distinct though their styles are, work to a large extent on common ground. They grasp the fact that the child's book need neither be childish nor priggishly instructive; that the child mind is essentially receptive, and that designs inherently beautiful will find ready appreciation from young as well as old. In consequence, they have made the ideal books for children; not books ostensibly intended for the young, while coquetting with grown-ups under their false disguise; but books full of real fascination for the child mind, and at the same time instinct with charm for the 'Olympian,' who still is fortunate enough to retain something of childhood's happy spirit. The child, it must be remembered, 'moves about in worlds not realised'; he still has eyes for wonderment, a mind receptive and impressionable, overflowing with fancy and imagination, with a literal preference in his play for symbolism rather than reality: make-believe is the essence of his being. The child, too, is serious in his fun, and all three artists have adopted just that right attitude of playful gravity which is the key to childhood's heart.

The work of these three artists, moreover, owes much of its success to an air of convincing sincerity. They work as if they could not help it, for the sheer joy of working; and they laugh, and make others laugh, with a humour that is irrepressible. Every picture shows that the painter's heart and soul was in it, and reveals the fact that it was made for his own satisfaction no less than for the delight of youthful spectators. In technique also there is this point of similarity, that all of them take into consideration the method by which their drawings are to be reproduced, and study its obvious advantages as well as its obvious deficiencies. The result is that in their individual way all display consummate skill in working with pure

colours and flat tones, with a simple and direct treatment that adapts itself to the scope of the wood-engraver and the colour-printer from wood-blocks.

Like all other firms of wood-engravers, that of E. Evans and Sons has been driven to adopt the modern three-colour process. Knowing this, I asked the late Mr. Edmund Evans to say frankly whether he thought colour-printing from wood must yield to the three-colour process. He wrote in reply :—' I must say I do think the three-colour process will utterly drive out this now old method of colour-printing. I do think the Walter Crane toy-books or the Caldecott drawings could *not* have been better reproduced by any process, but Birket Foster *could*.' In reproducing Birket Foster the printer had to superimpose block upon block, struggling to express a finished water-colour drawing, with its full scheme of graduated colour, and the result was that not only was the transparency of water-colour lost, but the artist's drawing was completely misinterpreted. The three artists now in question worked with an eye to the possibilities of reproduction, with the result that the work of Edmund Evans will bear placing beside the original for comparison. The National Art Library is rich in the possession of a large number of original drawings by Crane, Caldecott, and Greenaway; and, when possible, these are mounted along with the reproduction, making the excellence of the printer's work readily apparent.

It is difficult to realise that Mr. Walter Crane published his first toy-books fifteen years before Kate Greenaway and Caldecott entered the field. One of his boyhood efforts as an artist was a set of coloured page designs to Tennyson's ' Lady of Shalott,' made about 1858, when the artist was only fourteen. These were shown to Ruskin and to W. J. Linton, the famous wood-engraver. The former praised them, and the latter took Crane for three years as his apprentice. It

272

was for a sixpenny series of toy-books, published partly by Ward and partly by Routledge, that Crane first appeared as an illustrator in colour. The artist was amused one day by a request sent by the publishers through Mr. Evans that some children designed for his next book 'should not be unnecessarily covered with hair,' this being considered a dangerous innovation of Pre-Raphaelite tendency.

Two or three of these toy-books were issued every year; and to the period between 1864 and 1869 belong *The Railroad Alphabet*, *The Farmyard A B C*, *Cock Robin*, *The House that Jack Built*, *Dame Trot and her Comical Cat*, *The Waddling Frog*, *Chattering Jack*, *Annie and Jack in London*, *How Jessie was Lost*, *One—two—Buckle my Shoe*, *Multiplication Table in Verse*, *Grammar in Rhyme*, and, best of all in decorative aim and quaint humour, the *Song of Sixpence*. In these books the artist was limited in his scale of colour to red and blue, with black for the key block, so that a certain crudity was unavoidable. With *King Luckieboy's Party*, *The Fairy Ship*, and *The Little Pig*, in 1869 and 1870, there was a marked advance. The range of tints was extended; black was employed as a colour as well as for outline, its use in broad masses becoming one of the decorative features of the books; yellow was added, and with it the tints produced by superimposing yellow upon red and blue. The colouring therefore became as harmonious as the limited range of printing ink could effect. The printer did all he could to express the life and the superb decoration of the originals, and Mr. Crane is the first to acknowledge it. 'Mr. Edmund Evans,' he writes,[1] 'was known for the skill with which he had developed colour-printing, and I was fortunate in being thus associated with so competent a craftsman and so resourceful a workshop as his.' Mr. Crane confesses

[1] *Art Journal: Easter Art Annual*, 1898.

also to being strongly influenced by some Japanese prints given to him in 1865 by a naval officer; and in *The Fairy Ship* and *King Luckieboy's Party* his study of Japanese methods is strikingly apparent. A second influence came with a long visit to Italy between 1871 and 1873, and the forms of later Renaissance art are to be traced in the treatment and accessories of designs for later books, notably *Princess Belle Étoile*, *The Hind in the Wood*, *The Sleeping Beauty*, *Beauty and the Beast*, *Goody Two Shoes*, and others of the 'Shilling Toy-Books.' The whole series, comprising forty volumes in all, came to a close in 1876.

In 1877 Edmund Evans ventured on an enterprise of his own by arranging with Walter Crane a book to be published by Routledge under the title of *The Baby's Opera*. Every page contains a rendering in verse of some old nursery tale, with accompanying tunes and illustrated borders. The price was five shillings, and Routledge laughed at the notion of ten thousand copies being printed, especially with no gold on the cover! The public, however, thought differently, and a second edition was soon in demand. The range of colour in this book was much wider. Light blues, yellows, and brick reds, delicately blended, take the place of the more direct and vivid colours of the earlier toy-books. It is particularly noticeable in this book that certain of the illustrations—'Here we go round the mulberry bush,' 'How does my lady's garden grow?' and 'Lavender blue,' to take a few instances—stand out as unmistakable influences upon Kate Greenaway, whose first work appeared two years later. The success of the *Baby's Opera* caused it to be followed by a second book containing French and German, as well as English, nursery songs. This was the *Baby's Bouquet*; and to complete the triplets, as the artist himself has named them, there appeared some seven years later, in 1886, *The Baby's Own Aesop*, wonderful for

274

its realistic rendering of animal forms decoratively adapted.

With *Slateandpencilvania, Little Queen Anne*, and *Pothooks and Perseverance*, a new series of nursery books began in 1885, but the illustrations for these were drawn on zinc lithographic plates, a method that was also adopted for *Echoes of Hellas* (1887), *Flora's Feast* (1889), and *Queen Summer* (1891). In these and the later books illustrated in colour by this process the difference of technique can be felt, purity of line and simplicity of flat tints being abandoned for more elaborate colour effects. In *Flora's Feast* and *Queen Summer*, the colouring, although fuller, is marked by extreme delicacy, the tints being kept to a subdued scale. It is unnecessary to dwell on the charm of poetical imagination that has given life and movement to all the flowers as they rise from sleep to Flora's call, or gather round the banners of the Lily and the Rose.

In *A Floral Fantasy* (1899) the same ideas are repeated, but the artist returns to Edmund Evans for his wood-blocks, which give flatness to the tints, but are able to convey a softer and richer effect of colouring. It strikes one, however, that the use of a key-block would have strengthened the outlines, and pulled together the whole design. This book completes the list of the principal colour-printed books of Walter Crane, and Evans might justly have added, without boasting, his '*quorum pars magna fui*.' Mr. Crane gladly acknowledges that he owed much in the beginning to the printer's suggestions, and that no small amount of his later success was due to the loving care bestowed by the printer on every detail of the work. Colour-printing with Edmund Evans was always a labour of love.

Looking through all these books by Walter Crane, it is at once realised that the important element, the alpha and the omega of his work, is decoration. The artist's mind is steeped in the study of mediæval books.

275

He seems to have had a prior existence in the days when books glowed with gold and colour, when artist and scribe worked lovingly and piously together to make a thing of beauty, undismayed by the fears of a publisher or the demands of the world-market. Supreme though his work is in graphic skill, originality, and inventive variety, all of these qualities are dominated by the decorative sense. Purity of line and beauty of colour are always present, but always as part and parcel of an ornamental design. Picture and printed type must blend in harmonious unison. Plan, balance, proportion, relation to type, are all essential in the artist's mind to a beautiful book illustration. Everywhere you see signs of the creed, expressed and developed in his *Decorative Illustration of Books*, that book illustration means something more than a collection of pictorial sketches; that each picture is an organic element, forming an integral and constructive part of the book as a unified whole.

So in these books mentioned above you may note this perfect union of type and picture in relation to the page, and for many of them the artist has even designed end-papers and cover as well. These end-papers are printed in colour like the rest of the book, and their maker's idea was to produce ' something delicately suggestive of the character and contents of the book, but nothing that competes with the illustrations proper. It may be considered as a kind of quadrangle, forecourt, or even a garden or grass plot before the door.'

To pass from the work of Crane to that of Kate Greenaway is like passing from the poetry of one country to that of another. Each language has special beauties and peculiar charms that make comparison difficult and choice impossible, particularly when one could be happy with either. The principal elements in the work of Walter Crane are decoration and symbolism. Kate Greenaway, too, had an instinctive sense of deco-

ration, but in her case ornament, spacing, and proportion were secondary objects. Her work is more purely pictorial, with a grace, beauty, and tenderness peculiarly its own ; and perhaps it is the directness of the pictorial motives that makes the Greenaway pictures of one's childhood linger so clearly outlined in the memory. With womanly winsomeness she made herself a queen in a little kingdom of her own, a kingdom like the island-valley of Avilion, 'deep-meadowed, happy, fair with orchard lawns,' a land of flowers and gardens, of red-brick houses with dormer windows, peopled with charming children clad in long, high-waisted gowns, muffs, pelisses, and sun-bonnets. In all her work there is a 'sweet reasonableness,' an atmosphere of old-world peace and simple piety that recalls Izaak Walton's *Compleat Angler* and 'fresh sheets that smell of lavender.' The curtains and frocks of dainty chintz and dimity, the houses with the reddest of red bricks, the gardens green as green can be, the little lads and lasses 'with rosy cheeks and flaxen curls,' tumbling, toddling, dancing, singing—all make for happiness, all are 'for the best in the best of all possible worlds.'

Born in 1846, a year later than Crane, it was not till 1879 that Kate Greenaway won any real success. Before that date she designed a large number of Christmas cards and valentines as well as casual book illustrations. About 1871 she did some unsigned work for some children's books, *Aunt Louisa's Toy-Books*, published by Warne, and *Nursery Toy-Books*, published by Gall and Inglis. It is interesting to note that in 1876 she collaborated with Crane, a fact that one would not recognise but for the title, *The Quiver of Love, a Collection of Valentines, Ancient and Modern, with Illustrations in Colours from Drawings by Walter Crane and K. Greenaway*. At the end of 1879 appeared *Under the Window*, a book which was entirely a venture on the part of Edmund Evans. It was both

written and illustrated by Kate Greenaway, pictorial and literary inspiration working harmoniously together as they did in the case of Blake. The book achieved an instant and wonderful triumph, being printed and reprinted till 100,000 copies were issued, without taking into account the French and German editions. The original drawings were exhibited at the Fine Art Society in 1879, on which occasion Ruskin saw them, and exhausted the resources of his vocabulary in praise of their unaffected beauty, their sweetness and naïveté, their delicacy of sentiment, their subtlety of humour, and their exquisiteness of simple technique. It was the last-named quality that enabled Evans to reproduce these and all the artist's illustrations with so large a measure of success.

To 1881 belongs *Mother Goose, or the Old Nursery Rhymes*, always one of Kate Greenaway's own favourites. *Mother Goose* was followed, in 1881, by *A Day in a Child's Life*, containing various songs set to music by Mr. M. B. Foster, and in 1882 by *Little Ann and other Poems*, a selection of verses by Jane and Ann Taylor. In *Marigold Garden* (1885) Kate Greenaway was again her own poet, writing verses that make one wish for more. In 1882 appeared the *Language of Flowers*, a delightful book, for Kate Greenaway loved flowers and drew them exquisitely. *Kate Greenaway's Painting-Book* of 1884 consisted of illustrations collected from the various books which have been already mentioned.

These are the best and most typical of her picture-books. In her other coloured work illustrating Bret Harte's *Queen of the Pirate Isle* (1886), Browning's *Pied Piper of Hamelin* (1888), and *The April Baby's Book of Tunes* (1900), she was not so happy as when pencil and brush followed her own fancies. The series of dainty little *Almanacks*, published yearly from 1883 to 1897, must not be forgotten, for every volume is full of the perennial charm that characterises all the artist's

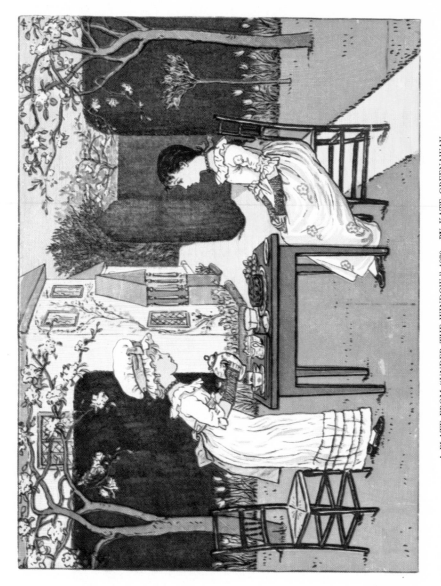

A PLATE FROM "UNDER THE WINDOW," 1879. BY KATE GREENAWAY
PRINTED FROM THE ORIGINAL WOOD-BLOCKS

colour work. Kate Greenaway lived to fulfil Ruskin's early words of encouragement :—' Holbein lives for all times with his grim and ugly " Dance of Death " ; a not dissimilar and more beautiful immortality may be in store for you if you worthily apply yourself to produce a Dance of Life.'

Caldecott was born in 1846, the same year as Kate Greenaway, but for a long time he missed his true vocation. It was not till 1872 that he settled in London, and the clink of sovereigns and rustle of bank-notes in a Manchester bank became sounds of the past. Even in Manchester, however, he was draughtsman first and bank-clerk second, and in these early days developed a style peculiarly his own, obtaining wonderful effects by sheer power of line. He studied the ' art of leaving out as a science,' believing, to use his own words, that ' the fewer the lines, the less error committed.' Phil May has been credited with the invention of drawing in terse, dramatic outline that is never strictly outline at all, and it has been stated that his style was caused by the exigencies of the cheap Australian printing presses. There is, in my opinion, little in his actual technique that you do not find already fully developed by Caldecott. In both cases the economy of means and apparent simplicity suggested by the final drawing were only achieved by endless studies. Nobody knows the true inwardness of Phil May's work till he has seen his carefully finished pencil studies. The same statement is equally true of Caldecott ; and, to give a single instance, among the original drawings by him at South Kensington are no less than nine careful studies for the small and insignificant fox that adorns the Aesop fable of the Fox and the Stork. Another striking example of apparent simplicity is the famous sketch of the mad dog dancing. At first sight it is in outline, broken perhaps, but outline for all that—a rapid and effective

sketch. Now analyse it, and you will find that it is composed of over two hundred and fifty separate strokes of the pen, not one of which is meaningless or unnecessary.

In 1875 and 1876 Caldecott was making black-and-white illustrations for Washington Irving's *Old Christmas* and *Bracebridge Hall*. It was here that he found his true *milieu*. He is a caricaturist, but his caricatures are always poetical and romantic. His world lies in the past, among the old manners and customs of eighteenth-century England, not the eighteenth century of Pope and Sheridan, amid the elegant and dissipated beau-monde of the town ; but rather that of Oliver Goldsmith, amid simple country life with its 'homely joys and destiny obscure.' He excelled in expressing fresh and breezy scenes of the English squirearchy in manor-house and hunting-field. His work is full of eloquent design, an abundance of kindly humour, an inexhaustible store of fancy—all expressed in attractive colour. In 1876 he became one of the foremost draughtsmen of the *Graphic*, the editor of which was the first to reveal to the public Caldecott's delicate colouring and astonishing freshness of invention. *Christmas Visitors*, which appeared in the *Graphic* in 1876, was followed by other coloured reproductions every summer and winter till 1886. *Mr. Chumley's Holidays, Flirtations in France, The Rivals, Mr. Carlyon's Christmas*, and *The Strange Adventures of a Dog-Cart*, are among those that will always be gratefully remembered by *Graphic* readers. The complete collection, printed by Edmund Evans, was published in one volume in 1888, and also in three oblong folios from 1887 to 1889. With these may be mentioned *A Sketch-Book of R. Caldecott's*, also reproduced by Evans, and published by Routledge in 1883.

It is again to the credit of Edmund Evans that he

first suggested to the artist that he should make coloured illustrations for children's books. Caldecott himself was doubtful as to this venture, and wrote to a friend, 'I get a small, small royalty.' The smallness of the royalty, however, was amply balanced by the immediate success of his first two picture-books, *The House that Jack Built* and *John Gilpin*, published in 1878. It was the year of Kate Greenaway's *Under the Window*, and two such 'discoveries' as Greenaway and Caldecott in one year should count for ever to Edmund Evans's honour. There were sixteen of these Caldecott picture-books in all, issued at a shilling each in coloured paper covers, and appearing two a year towards Christmas time with unfailing regularity till the artist's death. Ostensibly picture-books for children, they were in reality works of art full of subtle charm and rare originality. Every variety of talent the artist possessed finds its full display in his ingenious adaptation of nursery rhymes, old ballads, and the comic poems of the eighteenth century. In his colouring he employed flat tints of great variety, sometimes making finished water-colour drawings, but more often making a pen-drawing first, and then colouring a proof of the wood-engraving sent by the printer. Examples of these coloured proofs may be seen at South Kensington.

With *The House that Jack Built* and *John Gilpin* Caldecott set himself a very high standard, which he nevertheless managed to sustain with only an occasional falling off, due partly to want of complete sympathy with his subject, partly to failing health. *John Gilpin* seemed inimitable, yet it was followed in 1879 by the fascinating *Elegy on the Death of a Mad Dog*, and by *The Babes in the Wood*. The complete list continues as follows :—*Three Jovial Huntsmen* and *Sing a Song of Sixpence* (1880); *The Queen of Hearts* and *The Farmer's Boy* (1881); *The Milkmaid, Hey-diddle-*

diddle the Cat and the Fiddle, and *Baby Bunting* (the last two in one volume, 1882); *The Fox jumps over the Parson's Gate*, and *A Frog he would a-wooing go* (1883); *Come Lasses and Lads*, *Ride a Cock Horse to Banbury Cross*, and *A Farmer went trotting upon his Grey Mare* (the last two in one volume, 1884); *Mrs. Mary Blaize* and *The Great Panjandrum Himself* (1885). Since the original issue of these books in separate parts more than one collected edition has been printed by Edmund Evans and published by Routledge.

We have dwelt at such length on the work of these three artists in association with Edmund Evans, partly because of its importance in the history of colour - printing, partly also because collectors are offered here a fresh field and an interesting opportunity. The work of these 'academicians of the nursery' is well worth treasuring, and the number of volumes that have passed unscathed through years of nursery life must be comparatively small. Yet even Kate Greenaway's books, which are the rarest of all, can now be purchased for a 'mere song.' Before many years have passed they should be worth their weight in gold.

CHAPTER XXIII

LEIGHTON, VIZETELLY, KNIGHT, AND FAWCETT

IT must not be supposed that Edmund Evans and the Chiswick Press were the only firms associated with the revival of colour-printing from wood-blocks, or that the process was employed solely for the illustration of children's books. A notable landmark in the history of English illustration was the appearance of a special Christmas supplement to the *Illustrated London News* in 1855, containing the first examples of colour illustration in an English newspaper. The four plates—two after Sir John Gilbert, and one after 'Phiz' and G. Thomas respectively—were printed from wood-blocks by George Leighton, of Red Lion Square.

George Leighton was born about 1826, and began his career as an apprentice to Baxter. In 1849 Baxter made application to the Judicial Committee of the Privy Council for an extension of his patent. George Leighton opposed this application on the ground that he had served his time with Baxter in the hope of practising the art himself, and that, if the extension were granted, he would be without employment, five years of his apprenticeship having been devoted solely to his study of Baxter's methods. Leighton, however, lost his case, and Lord Brougham, in delivering judgment on behalf of the court, remarked on the great merit and utility of the patent, concluding by the statement that the court would recommend the extension

of the patent for five years without any conditions. Leighton was therefore left to his own resources, and accordingly took over the business of Messrs. Gregory, Collins and Reynolds. This firm, founded in 1843, had been producing colour-printing work on Savage's lines, contributing illustrations to some of the children's books published by Cundall. In the *Art Union* (the forerunner of the *Art Journal*) for April 1846 is a specimen of their printing in seven colours on an ordinary hand-press. The work, though it shows an advance on that of Savage, is still hard and mechanical. In 1849 Reynolds left London in order to work for Messrs. Winton, the pottery firm, and his departure gave Leighton the opportunity of acquiring the business.

Leighton at once set himself to improve on the Baxter tradition. For the *Art Journal* of 1851 he printed a reproduction of Landseer's 'Hawking Party,' in sixteen transparent tints. In this picture he departed from Baxter's method, by printing entirely from wood ; but in his later work he used metal plates freely for conveying the colours. The 'Hawking Party' was accompanied by an appreciative notice from the editorial pen, and Baxter, still smarting perhaps from a sense of injury, seems to have felt aggrieved at his rebellious pupil being honoured with such prominence. He accordingly protested to the editor, with the result that a description of his own process appeared three months later, with a full acknowledgment of its value, but without any disparagement of Leighton's rival work.

A good example of the early work of Leighton Brothers—for George Leighton took into partnership his brother Blair—is to be found in Miller's *Village Queen*, published by Cundall and Addey in 1852, with five facsimiles of water-colour drawings. Not long after this date George Leighton found a patron in Mr. Herbert Ingram, founder and proprietor of the

Illustrated London News. The association bore fruit in the plate of 1855, already mentioned ; and from 1858 Leighton was printer and publisher of the paper. Colour-printing from wood-blocks, or wood-blocks combined with metal, held its own in this paper till the eighties, when it was driven from the field by the chromo-lithograph.

A large amount of the work of Leighton Brothers appears in the children's books published by Routledge, often in crude and glaring colours, a typical example being *The Coloured Scrap-Book*. It was probably one of this set, 'things got up cheap to catch the eyes of mothers at bookstalls,' that roused Ruskin's wrath when in 1872 he was delivering the lectures published later in *Ariadne Florentina*. *Puss in Boots* particularly irritated him—'a most definite work of the colour school, red jackets and white paws and yellow coaches as distinct as Giotto or Raphael would have kept them. But the thing is done by fools for money, and becomes entirely monstrous and abominable.' Much better examples of the firm's work appear in *The Fields and the Woodlands* and *The Pictorial Beauties of Nature*, published at one guinea each in 1873, each with twenty-four plates 'in the highest style of chromographic art.' Even finer work are some of the delightful coloured plates printed by Leighton Brothers from drawings by ' E.V.B.,' notably those for *Beauty and the Beast*, published in 1875. For some of these over a dozen printings were employed, and the soft tints in the drapery are extremely delicate. In spite of the excellent results thus obtained, Leighton Brothers were unable to make a financial success of printing in oil-colours from wood-blocks, and the firm disappears in 1885.

Mention must be made too of George Leighton's cousin, Mr. John Leighton, F.S.A., who was born in 1822, and lives to tell the tale of how he rode daily from his house at Regent's Park, where he still resides,

to assist Owen Jones in arranging the art exhibits of the 1862 Exhibition. Kindly, genial, and humorous, Mr. Leighton can make time pass very quickly amid anecdotes of these old days, but their place is not here. Probably no man has ever designed so much book ornament, so many title-pages, frontispieces, borders, head and tail pieces, as Mr. Leighton, and much of his admirable work was printed in coloured inks. A noteworthy example is *The Life of Man Symbolised*, of the year 1866, a book that cost £1100 for the actual printing, the borders being executed in single colours of red, yellow, and blue.

Probably owing to the influence of Owen Jones this style of coloured border became exceedingly popular at this period, the firm of Murray being among the foremost of its supporters. One of the colour-printers who worked for Murray was Henry R. Vizetelly, afterwards so well known as the Paris correspondent of the *Illustrated London News*, and the publisher of Zola's novels. The connection of the firm of Vizetelly Brothers with Murray came about through a breakdown in Owen Jones's establishment during the printing of an illustrated edition of *Ancient Spanish Ballads* by J. G. Lockhart, in 1841. The printing was finished by Vizetelly, who contributed the titles, borders, and a number of decorative designs, though the whole of the ornament was designed by Owen Jones. Red, blue, and yellow were all freely employed, either singly or in combination. The same style of border decoration appears in the *Book of Common Prayer*, printed for Murray by Vizetelly in 1845, and again in 1850. It is decorated with a great variety of vignettes, initials, borders, and ornaments by Owen Jones, who probably executed the chromo-lithography of the eight title-pages. The rest of the decorative ornament is printed in red and blue, apparently from wood-blocks. Milman's *Horace*, printed by Vizetelly in 1849 for John Murray,

is another remarkable example of the use of decorative borders, in this case classical in style, printed in different colours. A typical example of the colour-printing of ordinary illustrations by Vizetelly is *Christmas with the Poets*, published by Bogue in 1851. The fifty illustrations, engraved by Vizetelly himself from designs by Birket Foster, were printed in tints of grey, brown, and a brownish pink,[1] with a gold line border, and with ornamental initials in black and gold. This book was selected by the trustees of the British Museum to be shown at the great Exhibition of 1851, as representative of the best in English printing and illustration.

Another colour-printer who employed wood-blocks was Charles Knight, the great pioneer of cheap illus-trated literature. In 1838 he patented a process for printing four colours on the sheet in one passage through the press, but it is doubtful whether his pro-cess, like others directed to the same end, ever had any commercial value. Knight's outstanding work was his *Old England*, issued in parts during 1844 and 1845. It forms two folio volumes, and is a unique and wonderful publication, considering that it contains nearly two thousand five hundred wood-engravings, with a page of illustrations following almost every page of text, and with a dozen full-page coloured plates to each volume. The only reference in the book to the method of the colour-printing is a brief note in regard to a picture of the Coronation Chair, stating that it was reproduced by means of twelve plates, from a drawing specially prepared. The word 'plates' is pro-bably used in a wide sense, for the embossing at the back of each print shows that the colouring was applied by means of surface printing from wood-blocks. *Old England's Worthies*, published in 1847, is illustrated

[1] In the National Art Library is a set of proofs printed in ordinary ink on India paper.

by twenty similar coloured plates, in addition to numerous wood-engravings. The colour, however, in all Knight's work, seems rather dead and oily, and is frequently put on in dense, heavy masses, making it lack sparkle and expression.

Another noteworthy contemporary of Leighton and Evans was Benjamin Fawcett, born at Bridlington in the East Riding of Yorkshire in 1808. Fawcett produced some remarkable examples ot colour-printing from wood-blocks on the ordinary hand-press, and seems to have arrived at his results independently of all tradition. He was, however, specially fortunate in having as his literary assistant the Rev. F. Orpen Morris, Vicar of Napperton, two miles from where he started work as a jobbing printer and stationer. Morris was a prolific writer on subjects of natural history as well as religion, and with his co-operation Fawcett produced the series of subscription works, all of them illustrated with plates printed in colours from wood-blocks, of which the *History of British Birds* was the first. This book appeared originally in monthly parts from 1851 to 1857. It was reissued in a new and enlarged form in 1862, and by 1895 some eight editions had appeared. *A Natural History of British Butterflies* made its first appearance in 1853 in a single volume, while *A Natural History of the Nests and Eggs of British Birds* was issued in monthly parts from 1853 to 1856. Both of these books, as well as *The County Seats of Great Britain and Ireland*, for which Morris also supplied the text, have appeared in several editions. The same applies to the *Ruined Abbeys of Britain* by F. Ross, Couch's *History of the Fishes of the British Islands*, and Lowe's *Beautiful Leaved Plants*, all of them with plates printed by Fawcett. It should be said that there is a good deal of hand-colouring in some of these books. The whole of Fawcett's work—designing, engraving, and printing

—was carried out by locally trained workers at the little town of Driffield, in East Yorkshire, with a population of under six thousand. The *County Seats* is said to have brought in, from first to last, some £30,000, but in spite of this apparent prosperity Fawcett, like George Leighton, was unable to make his colour-printing a commercial success. For some years before his death in 1894 he was in failing health, and the business gradually declined. His successors were unable to continue it, and in 1895 the stock was sold.

CHAPTER XXIV

THE THREE-COLOUR PROCESS AND ITS APPLICATION

SO far we have been dealing with artistic processes, in which the personal element is always present. Copper-plate, wood-block, and stone convey the creation of an artist's fancy as the result of actual manual labour, and yield their pictures only to individual and patient craftsmanship. The end of last century, however, witnessed the attempt to displace all manual labour in book illustration by purely mechanical processes. The natural agency of photography took the place of the artist's brain and hand, and of the millions of pictures that appear in books and magazines throughout Europe and America, all but an infinitesimal fraction are photo-mechanical productions. The impetus given by process to illustrated journalism can only be realised after an examination of the illustrated periodicals of the last twenty years. In 1883 there were only four sixpenny weekly papers, using about eighty blocks, nearly all wood-engravings. Now there are about fifteen sixpenny papers published weekly, employing over a thousand process-blocks. In 1888 a number of the *Illustrated London News* contained twenty-six pictures, made up of seventeen wood-engravings, seven line process-blocks, and two half-tone process-blocks, whereas one of the present numbers contains more than fifty process-blocks and not a single wood-engraving.

The first achievement in photo-mechanical repro-

290

duction was the perfection by M. Gillot, of Paris, of the art of zincography. The earliest public recognition of the value of this process was at the Paris Exhibition of 1855, when it won the distinction of Honourable Mention. Though it was used extensively by M. Gillot, who died in 1872, at his establishment in Paris, it was not till about 1876 that the process was employed in England. Zincography is a means of reproducing drawings executed in clear black lines or masses, without any half-tones, the drawing being transferred by photography to zinc, and all the white spaces being then bitten away by acid. It is, in effect, a woodcut produced by mechanical means, without the artistic work of drawing on the block and the manual trouble of carving away the superfluous wood from the design.

Zincography, however, will only produce line drawings, and the next step was the discovery of a method of representing gradations of tone, and so making possible the reproduction of oil-paintings, water-colours, wash drawings, or photographs from nature. This was achieved by the half-tone process, of which Meisenbach, who patented it in 1882, may claim to be the inventor and pioneer.[1] This process killed wood-engraving all over the world, and has done more to revolutionise book illustration than all other methods put together. Its important feature is the use of a glass screen, finely ruled with lines, which is interposed in the camera between the lens and the negative. The negative is broken up by the screen into a large number of minute squares or dots, which are strong or weak in proportion as the corresponding parts of the original are light or dark. The picture produced is thus built up of an infinity of dots, shadows being represented by the

[1] For a full and valuable account of the rise and development of process work, see the paper by Carl Hentschel on 'Process Engraving' in the *Journal of the Society of Arts* for 1900 ; and the Cantor Lectures, by J. D. Geddes, on 'Photography as applied to Illustration and Printing,' in the same publication for 1902.

grouping of dots close together. The negative is then transferred to a sensitised piece of copper, and the spaces round the dots forming the picture are etched away. To the half-tone print single tints of colour may be applied, a method that has been adopted with considerable success in the American monthly magazines, and in the illustration of a certain number of English books.

Trichromatic photography is based on the half-tone process. The 'three-colour' process is by far the most important development in the whole range of photographic illustration invented or evolved during the past half century. In so far as it is a mechanical, as opposed to an artistic, process, we need not go into the formidable theories of colour analysis, of molecular swings, of the undulation of light. The general principle on which it is based is the accepted theory that any colour can be resolved into the three primary colours of red, yellow, and blue-violet, which form its component parts. It was on this theory that Le Blon, as has been seen in chapter vi., based his system of colour-printing. Le Blon's work seems to have attracted some popular interest, for in the early part of the nineteenth century several books by Moses Harris and others treated of the three-colour theory in relation to painting. Few, however, had such faith in their theories as G. Field, the author of *An Essay on the Analogy and Harmony of Colours*. He works himself into a state of devotional ecstasy and mysticism, culminating in his final paragraph :—' If all reason be allied to the Universal, then must the development of reason in a sensible object indicate the universal reason or intelligence to which it belongs. Dull of consciousness therefore will be the mind that in contemplating a system so simple, various, and harmonious as that of colours, should not discover therein a type of that Triune Essence who could not but construct all things after the pattern of His own

perfection'! All these books show that the theory was well to the fore, and it is not surprising to note that the early chromo-lithographers attempted its application. An example is to be found in Aresti's *Lithozographia* (1857), one of the plates in which reproduces a fresco by Michelangelo, showing the 'effect of the three primary colours printed over each other.'

The phenomena connected with the three-colour theory in its relation to photographic processes have been the subject of various investigations by well-known scientists, from Duhauron and Cross in the 'forties to Sir William Abney in modern days. Once the principle is accepted that any combination of colours, say in a painting, can be resolved into its primary elements, it remains only for the photographer to obtain three negatives, which, as it were, automatically dissect the original, making three distinct photographic records of the reds, yellows, and blues which enter into the composition. This result is obtained by the use of transparent screens of coloured pigment or liquid, 'light filters,' as they are technically termed, placed in front of the lens. These filters admit any two of the primary colours and absorb the other one. Three separate screens are employed, each with the lines ruled at a different angle, and when the negative records of the colour analysis are obtained, the three photographs are converted into printing surfaces, exactly as in the ordinary half-tone process described above. On the metal printing surface the separate colours are impressed in ink and transferred to paper. The block representing the yellow tones of the original is printed first with yellow ink; over this picture the block representing red is accurately registered and printed in red; while the final block representing blue is printed over the combination of the first two, with blue ink. The result is a complete picture containing all the shades of the original, no matter whether the original is a natural

object, an oil-painting, or a water-colour, an object of art or of commerce.

Theoretically the three-colour process is all-sufficient for the correct reproduction of a coloured original, but it must not be forgotten that the printer can ink the plates with colour which differs materially from what it ought to be, so that there is, after all, no necessarily true reproduction. To neutralise previous incorrectness of printing, and to secure more perfect harmony, a fourth plate, inked with grey or black, is occasionally used, just as it was by Le Blon. This, however, should only be necessary where the difficulties of ascertaining the true colours in ink have led the printer astray. The fourth colour, however chosen, will always tend to decrease considerably the luminosity of a three-colour print, and by the really good colour-printer the fourth plate is only employed where the original, as for instance a portrait by Rembrandt or Velasquez, is altogether deep in tone, with rich browns, almost approaching black, in the background; or where a modern artist has worked with a wash of colour over a drawing in black or grey chalk.

One of the main objections to the process is its mechanical nature. It can be understood that a collector may treasure an aquatint, a chromo-lithograph, a coloured wood-engraving—but a process plate, never. Moreover, it is extremely unlikely that the clay-surfaced paper, essential to the finest printing from half-tone blocks, will survive for a hundred years. Certainly it will never remain sound and unfaded like the rag papers of olden days. Another objection is the dazzling nature of the mesh; and though modern science has not yet succeeded in finding a substitute for the screen, yet it is fair to say that the reticulation of the screen has been made so fine, and the methods of its application have become so ingenious, that the mesh in the best work is hardly apparent. It may be noted that

294

under certain conditions of lines an effect as of shot silk is accidentally produced. It is a remarkable result, and often not unpleasing, but it is absolutely untrue as far as the original is concerned. Last of all, there is the tendency of the colours to overlap in the printing. It is impossible to rely on a printer to secure always an absolutely exact registration. The difficulty will never be overcome till some means is discovered of printing the three colours at once, and though several inventors have professed to accomplish this, their machines have never proved an entire success. What is most wanted is an ink that will dry with great rapidity. Two damp inks superimposed one on the other produce a muddy effect, and under present conditions the best result is procured by allowing each ink several hours to dry, and by keeping the paper in an absolutely even temperature, so as to avoid all risk of its shrinking before the next printing. By these means a complete three-colour print can be easily produced from a drawing or from nature within two days. The weekly paper, with half of its illustrations in colour, already an accomplished fact in America, is one of the immediate possibilities of the future for our own country as well. Under pressure, the print can be completed in far less time, for, in connection with a recent law-suit, Mr. Carl Hentschel, to show before some barristers his process at Norwood, executed colour-prints from a water-colour drawing of Lincoln's Inn within four hours from start to finish.

The great value of the three-colour process lies in the speed and cheapness with which the prints can be produced. As an artistic method of reproducing water-colours, or natural objects such as butterflies or leaves, it is sometimes wonderfully successful, but the results are very uneven. At its best the three-colour process produces excellent results; at its worst it is a positive conflagration of crude blues and greens and oranges that coalesce without harmony. Such as it is, however,

the process has come to stay. It is winning increasing importance in every kind of pictorial, scientific, educational, and industrial application. The comparative ease and cheapness of production have stimulated the output to a remarkable degree, and the last few years have seen the use of the three-colour process for the wide illustration of general literature, from classical reissues to children's books.

While the printing processes are still imperfect, and while fuller researches into theory and practice may be expected to bring about constant improvements, it is unnecessary to enter into any detailed account of the many books to which the process has been applied. At the same time, attention may be drawn to a few facts and dates that mark the rise and development of this method of colour-work in relation to book illustration. In March 1897 the editor of the *Magazine of Art* published a full-page three-colour plate of 'Hadrian's Villa,' after the well-known picture by Richard Wilson in the National Gallery. The blocks were made under exceptional difficulties, for the picture had to be photographed where it hung, without the aid of the electric lamps which play so important a part in the three-colour studio. Yet the reproduction is eminently satisfactory, suggesting with success the fat, oily nature of the paint itself, and the grey-green tones that the painter loved. The reproduction was the work of Messrs. André and Sleigh, of Bushey, and I have laid special stress upon it, not only because to my mind it has not since been surpassed, but also because it is one of the earliest instances of the process being used for a plate in a book.

Though it found occasional use for frontispieces and illustrations of natural history specimens, ceramic objects, and so forth, it was not till about 1900 that the three-colour process became firmly established as a method of book illustration. Messrs. Adam and Charles

Black were the first to appreciate its wide scope, and to publish a whole series of books illustrated throughout in colour. The first of these were *War Impressions* and *Japan*, with illustrations by Mortimer Menpes. The drawings of the same artist serve also to illustrate *World Pictures* (1902), *World's Children* (1903), and the *Durbar* (1903). Mr. Menpes has always been a wanderer over the face of the earth, and these books are delightful reproductions of the treasures of his sketch-books. *The Holy Land* (1902) and *Egypt* (1902), with illustrations by John Fulleylove and R. Talbot Kelly respectively, *Holland* (1904) and *Norway* (1905), both by Nico Jungmann, are among several books showing how fascinating an addition may be lent by coloured plates to books of foreign travel.

It may be noted that in most modern coloured books the text is frankly subservient to the illustrations. The three-colour process has produced the paradoxical result that the plates make the book, while the text merely illustrates. Further examples of the successful reproduction of water-colours in facsimile are *Cruikshank's Water-Colours* (1903), *Happy England* (1903), with its illustrations of Mrs. Allingham's charming drawings—both of these being published by Black— and *British Water-Colour Art* (1904), published by *The Studio*. It is only fair to add that nearly all the colour-plates for Messrs. A. and C. Black have been executed by Mr. Carl Hentschel. For some, however, Mr. Mortimer Menpes, who has established a press of his own, is responsible; and he has produced some particularly good results in the reproduction of his own drawings.

One of the best and earliest examples of the three-colour process as a means of reproducing ceramic objects is Cosmo Monkhouse's *History and Description of Chinese Porcelain*, published by Cassell in 1901, with thirty-one colour-plates by André and Sleigh.

Another book worthy of special mention is the *Pintoricchio*, by C. Ricci, translated by Florence Simmonds, and published by Heinemann in 1902. It was one of the first books to show the use of the three-colour process in the reproduction of paintings by an old master. The fifteen plates are admirable for the fine effects of their colouring, and this in spite of the fact that the plates, which measure ten by eight inches in colour surface, are far beyond the ordinary limits of size to which the process is supposed to be subject.

Having spoken of the use for colour-printing in modern days of lithography, wood-blocks, and process, separately and in conjunction, it is right to add a reference to the rarer and more expensive method of colour photogravure. This is a way of printing photo-engravings in colours at one impression after the manner of the old mezzotints and stipple. Messrs. Boussod, Valadon et Cie. have been particularly successful in their reproduction of water-colours by this method; and for its application to books one may mention the magnificent Goupil series of 'English Historical Memoirs' (1893—), Skelton's *Charles I.*, Holmes's *Queen Victoria*, etc.

Finally, one must call attention to the numerous editions, with illustrations in the three-colour process, which Messrs. Methuen began to produce in 1903, of the famous books which delighted our grandfathers and ancestors. Their 'Burlington Library of Coloured Books' ranges from the splendid folio edition of Alken's *National Sports*, for which the collector must pay five guineas, to the reproductions in a reduced quarto of Pugin and Rowlandson's *Microcosm of London*, and of numerous other volumes mentioned in the preceding pages. For the poorer man their 'Illustrated Pocket Library' provides reprints in miniature of Alken's sporting books, the *Tours of Dr. Syntax*, and the other volumes of prose and verse which the

grotesque fancy of Rowlandson has enriched. The extraordinary increase in the value of old books which has marked the book-sales of the last three years is a clear proof that the collector is discovering that rare books grow rarer. It is impossible to reproduce the atmosphere and aroma or all the grace and dignity of the past; but, with care and piety, Messrs. Methuen have been able to present in facsimile or miniature to the modern book-buyer some of the volumes which in their original form are becoming impossible of acquisition by the owner of a slender purse.

One never knows to what unforeseen and unexpected ends the unknown forces of science are secretly working. What seems an impossibility to-day may become accomplished fact to-morrow. A successful means of direct photography from nature may bring a sudden revolution in pictures and in the illustration of books. But in the scientific and mechanical there must always be lacking the element of human sympathy and human interpretation. 'All art,' says Walter Pater, 'which is in any way imitative or reproductive of fact—form, colour, or incident, is the representation of such fact as connected with soul, of a specific personality, in its preferences, its volition, and power.' Photography can see only the surface, never the spirit; it can never penetrate the mystery that underlies the surface of the commonest things. This is where all process-work fails, and always will fail, when compared with the older methods of artistic engraving. To take one modern instance, the finest photogravure of Mr. Watts's *Love and Death* or of his *Orpheus and Eurydice* will not for a moment bear comparison with the mezzotint rendering of the same picture by Mr. Frank Short. In process you will always miss the human element, 'the heart to resolve, the head to contrive, the hand to execute.'

CHAPTER XXV

THE COLLECTING OF COLOURED BOOKS: A NOTE
ON CATALOGUES AND PRICES

'IT is naught, it is naught, saith the buyer; but when he has gone on his way, then he boasteth.' Old as the days of Solomon and his proverbs are the joy of collecting, the delight of snapping up unconsidered trifles, the keen excitement of 'chop, swop, barter, or exchange,' the pride in a bargain fairly won. It is a fit subject for the philosopher, this obsessing instinct that makes men gather things old and rare, often for the mere pride of their possession. There is a story, possibly apocryphal, of a secretary of the Society of Antiquaries, who was heard to utter the pious aspiration, 'Would to God there was nothing in this world older than a new-laid egg!' Even then, it may be affirmed, without much ulterior quibbling as to the age of new-laid eggs, that men would still collect. The passion is inherent in human nature, born in the blood.

'In tea-cup times' people collected in a quiet and sober way. Wrote Dean Swift to his Stella in 1711:—'I was at Bateman's, the bookseller's, to see a fine old library he has bought; and my fingers itched, as yours would do at a china shop; but I resisted, and found everything too dear, and I have fooled away too much money that way already.' Walpole and the great connoisseurs of Swift's time paid their pounds, where hundreds to-day would be of no avail. Walpole writes from Strawberry Hill in 1770:—'Another rage is for

300

"CHRISTIE'S AUCTION ROOMS." BY J. BLUCK, AFTER ROWLANDSON AND PUGIN
FROM "THE MICROCOSM OF LONDON," 1810

prints of English portraits. I have been collecting them for above thirty years, and originally never gave for a mezzotint above one or two shillings. The lowest are now a crown, most from half-a-guinea to a guinea.' Now that art-collecting is a fashionable mania, it is fenced in on every side with the barriers of modern commercialism. There are corners in pictures and prints no less than in wheat and steel. 'Bulls' and 'bears' make a zoological garden of Christie's and Sotheby's, as well as the Stock Exchange.

The itch for collecting is almost as widespread and fatal a disease as the *cacoethes scribendi*, and at the same time it is infinitely more expensive as an amusement. The big game—pictures, china, jewellery, and what not—seems to have become the preserve of the millionaire. But those whose aspirations are limited by the length of their purse may still find solace in the collecting of books. The coloured books of which we write, though not to be found in the fourpenny-box, can still be had for a moderate price. 'With Coloured Plates' is now one of the finger-posts of booksellers' catalogues; and Ackermann, Rowlandson, Alken, Baxter, and other names that have figured in our past chapters, are writ large among the prominent catchwords. If these coloured books are rising in price, the rise is natural and legitimate. It is due not only to their intrinsic merits, but also to their increasing rarity, and the reason for this is not far to seek.

Any second-hand bookseller's catalogue of to-day contains a delightful quantity of varied entertainment for the lover of books. Most irritating, as a rule, the catalogue entries are, with their haphazard headings and their unscientific arrangement. My personal interest, however, lies less in these than in the brevier notes that come at intervals to enliven the page. So long as these notes content themselves with saying of a book—and it must be understood that I quote from

301

catalogues before me—that 'this is a beautiful work for the drawing-room table,' or 'a prize for collectors,' or that 'the female figures are particularly charming,' or that it is 'a scurrilous publication,' then their comments may be pardoned. So also when they contain a touch of unconscious humour. *The Dictionary of English Authors*, offered for the ridiculous sum of two and sixpence, is unblushingly claimed to be 'Allibone, Lowndes, and the Dictionary of National Biography condensed into a handy volume.' Of the *Illustrations of British Mycology*, by Mrs. T. J. Hussey, we are told that 'the figures are so faithful that there can be no difficulty in at once determining with certainty the objects they are intended to represent.' These notes may even be forgiven for occasional ventures in literary criticism. Of Fairburn's *Everlasting Songster*, for instance, with its Cruikshank illustrations, we read :—' This is a RIPPING collection, including a large number of the famous " patter songs," full of witty hits and funny passages. The music-hall singers of to-day should reintroduce this feature. I have heard some of them *try*,—but——'

Such remarks as the above are harmless, and often edifying, not to say amusing. They have a way, however, these brevier notes, of recommending ruthless destruction with a persuasiveness that is all the more dangerous because there is something seductive and innocent and insinuating in the very nature of brevier type. They sing in various keys a siren's song that has lured to destruction many a stout-bound volume, shattered its sturdy back, and made flotsam and jetsam of pages of fair and valuable text. Alken's *National Sports of Great Britain*, we are told, is 'a unique set for framing purposes.' Of Orme's *Oriental Field Sports* it is said—' These famous plates measure 22 × 18 inches, and framed would make a fascinating series to adorn a smoking-room.' Frequent remarks are made

to the effect that 'every plate is worthy of framing,' or
'to cut up for the fine plates, copy is worth more than
the price now asked.'

Then there are those higher flights, perhaps less
dangerous because they amuse the more. 'These
lovely plates,' says the note on Fénelon's *Adventures
of Telemachus*, 'disposed in groups of twelves and
eights in frames, would make a notable addition to the
mural ornamentation of a home of taste, where art was
not only respected, but represented.' Next comes one
that surely by its style and solemn aposiopesis he that
runs may mark as the work of our literary frequenter
of the halls of music. Bartolozzi's *L'Amico dei Fan-
ciulli* is the book in question, and—says the note—'the
book itself is such a pretty one, and so nice an example
of a superior child's book of last century, that it would
be a pity to—but, *really*, those Bartolozzis *in black and
gold frames!*' With the ethics of bookselling we are
not concerned, and, after all, these notes are but the
modern translation of the more outspoken, 'What d'ye
lack, noble sir?' 'What d'ye lack, beauteous madam?'
with which passing squire and dame in olden days
were wheedled and cajoled. 'But yet, the pity of
it!'

These notes, none the less, are signs of the times,
and the very fact that booksellers think it worth while
to print such cruel suggestions shows that there is a
constant demand for coloured plates for the purpose of
framing. If further proof be wanted, it will be found
in the fact that the plates are often offered singly for
sale. I note, for instance, in a 1902 catalogue, a list of
several plates from Orme's *Oriental Field Sports*, sold
separately at 6s. and 7s. 6d. apiece, and from Rowland-
son's *Loyal Volunteers* at 5s. each, and must myself
plead guilty to having purchased plates by Daniell at
an even smaller price. But there is yet another source
of destruction to coloured books, one fortunately less

frequent than it used to be—I mean 'the pernicious vice of cutting plates and title-pages out of many books to illustrate one book' that has made the name of Granger immortal. Books of portraits, of topography, and of costume, are among the first to suffer, and Ackermann's *Microcosm of London* and Daniell's *Voyage round Great Britain* are prominent examples. Lysons's *Magna Britannia* was recently offered for sale at £60, extra illustrated with the fine series of plates by Byrne for Hearne's *Antiquities of Great Britain*, the set of Thames views by Farington, and several plates from Pyne's *Royal Residences*—thus involving the ruin of three superb books. The catalogues, you will find, speak politely of these inserted excerpts as 'extra illustrations,' and charge extra accordingly—but alas for the poor victims whose glory is departed, no longer to be proudly described as 'a unique copy, uncut, in the original covers, complete'!

All these adversities make the scarcity and the consequent high prices of coloured books easy to understand—indeed, it is to be wondered that the prices have risen no higher. The difficulties of colour printing and of colouring by hand have always caused coloured books to appear in a limited and comparatively expensive edition. Of most of Ackermann's books, for instance, only a thousand copies were printed, so that allowing for shrinkage by wear and tear, the ravages of time, and the mutilation for purposes of framing or 'extra-illustration,' it will be seen that a sound copy, in good condition, of the *Oxford* or *Cambridge*, the *Westminster Abbey* or the *Microcosm of London*, is a distinct rarity, and therefore has a reasonable claim to an enhanced price.

Any one whose work connects him with a library is constantly besieged by well-meaning friends and relations anxious to learn the value of books of which they wish to dispose. Now, unless you happen to have

304

been making a study of recent market prices of the particular class of book in question, it is difficult, and well-nigh impossible, to state a price. Personally, if I have reason to think the book of value, I advise the owner to send it to Sotheby's, and obtain what will be the fair market price, minus of course the commission. This chapter, however, may meet the eye of some owners of books to whom it may not be untimely to utter a word of warning. The ignorant book-owner is very apt to be attracted by an advertisement to this effect—'Books wanted, all First Editions, Original Bindings, unless otherwise stated,' or '£4 offered for the following . . .' With the ethics of bookselling, as was said before, I am not concerned, and the vendor may in this way get a fair price without trouble. Mr. Andrew Lang, however, recently drew attention to the enormous discrepancy existing in many cases between the amounts offered by these advertisers and the actual prices of the auction-room, which can readily be found in Slater's *Book Prices Current*. In a recent weekly paper I noted an offer of twenty-five shillings for *Jorrocks' Jaunts and Jollities*, whereas in booksellers' catalogues the *third* edition is priced at three to five guineas, and a good copy of the first edition is worth considerably more. Another offer of twenty-five shillings was made for *Hawbuck Grange*, a book worth two or three pounds in good condition. In another place £3 is offered for Ireland's *Life of Napoleon*, but in the current catalogues the price runs from £20 to £30. A still more startling example, though not relating to a coloured book, has just come to my notice. Among 'Books wanted, 25s. each offered,' comes Shelley's *Victore and Cazire*, 1810, a book of which four copies at the most are known ; and for the last one sold Mr. T. J. Wise had to pay the heavy ransom of £600 ! The advertiser seems to realise the absurdity, for a few weeks later he names no amount, but says simply 'a

U

high price paid.' Advertisers, indeed, are rapidly becoming more shy in offering cash prices in black and white, but this makes it the more necessary that the unwary book-collector should be forewarned and forearmed.

APPENDIX I

COLOURED BOOKS WITH PLATES PRINTED
BY BAXTER

MUDIE, R. Feathered Tribes of the British Isles. Two vols., with vignette title in each. 1834.

Fisher's Drawing-Room Scrap Book. Frontispiece. 1835.

GANDEE, B. F. The Artist, or Instructor in Painting, Drawing, etc. Frontispiece and bordered title. 1835.

MUDIE, R. The Seasons : Spring, Summer, Autumn, and Winter. Four vols., with frontispieces and vignette titles. 1835-37.

MUDIE, R. The Firmaments : The Earth, the Air, the Heavens, the Sea. Four vols., with frontispieces and vignette titles. 1835-38.

Peter Parley's Annual. With folding plate. 1835.

BAXTER, J. Agricultural and Horticultural Gleaner. Frontispiece and title-page. 1836.

Garland of Love. Frontispiece. 1836.

Germany and the Germans in 1834, 1835, and 1836. Two vols. Frontispieces. 1836.

BAXTER'S PICTORIAL ALBUM, or Cabinet of Paintings for the year 1837. Ten plates and vignette title. 1837.

SAUNDERS, E. Advice on the Teeth. Frontispiece. 1837.

WILLIAMS, J. Narrative of Missionary Enterprise with South Sea Islanders. Frontispiece to first edition, and in later editions another portrait. 1837-39.

M'INTOSH, C. The Greenhouse. The first edition (1837) has one plate by Baxter, the second (1838) has about half a dozen. 1837-38.

MUDIE, R. Man in his physical structure; Man in his intellectual faculties; Man as a moral and account-able being; Man in his relations to society. Four vols., with frontispieces and vignette titles. 1838-40.

MEDHURST, W. H. China, its state and prospects. Engravings on wood by Baxter, and coloured frontispiece. 1838.

COOK, E. Melaia and other Poems. Frontispiece and vignette on title. 1838.

ELLIS, Rev. W. History of Madagascar. Frontis-piece. 1838.

CAMPBELL, J. British India, etc. Frontispiece. 1839.

WILSON, Rev. S. S. A Narrative of Greek Missions. Frontispiece. 1839.

CAMPBELL, J. Maritime Discovery and Christian Missions. Frontispiece. 1840.

FREEMAN AND JONES. Persecutions of the Christians in Madagascar. One plate. 1840.

Shells and their Inmates. Frontispiece. 1841.

NICOLAS, Sir N. H. History of the Order of Knight-hood. Fully illustrated by Baxter. Four vols. 1842.

MOFFAT, R. Missionary Labours and Scenes in Southern Africa. Wood-engravings by Baxter, and coloured frontispiece. 1842.

CAMPBELL, J. The Martyr of Erromanga. Frontis-piece. 1842.

MILNER, Rev. T. Astronomy and the Scripture. Frontispiece. 1843.

Transactions of the British and Foreign Institute. One plate. 1845.

Child's Companion for 1846. Frontispiece. 1846.

Child's Companion for 1847. Frontispiece. 1847.

SHERWOOD, Mrs. Social Tales for the Young. Frontispiece. 1847.

Le Souvenir, or Pocket Tablet for 1847. Several illustrations. 1847.

MALLET, P. H. Northern Antiquities. Frontispiece. 1847.

Child's Companion for 1848. Frontispiece. 1848.

Child's Companion for 1849. Frontispiece. 1849.

Child's Companion for 1850. Frontispiece. 1850.

HUMBOLDT, F. H. A. Views of Nature. Frontispiece. 1850.

Female Agency among the Heathen. Folding plate. 1850.

Child's Companion for 1851. Frontispiece. 1851.

Baxter's Pictorial Key to the Great Exhibition. Two plates. 1851.

WATERHOUSE, Rev. J. Vah-ta-ah, the Feejeean Princess. 1857.

Not dated

ELLIOT, M. Tales for Boys. Frontispiece.

Loiterings among the Lakes. Frontispiece.

Perennial, The. Frontispiece.

Sights in all Seasons. Frontispiece.

SHERWOOD, Mrs. Caroline Mordaunt. Frontispiece.

WILSON, H. C. England's Queen and Prince Albert. Two portraits.

WILSON, Rev. S. S. Sixteen years in Malta and Greece. Frontispiece. (184—).

APPENDIX II

COLOURED BOOKS PUBLISHED BY R. ACKERMANN

* The Loyal Volunteers of London and Environs.
87 pl. by Rowlandson. 1799.

Costume of the Russian Army. 8 pl. 1807.

Costume of the Swedish Army. 24 pl. 1808.

The Repository of Arts, Literature, Commerce, Manu-
facture, and Politics. Issued monthly. 1809-
1828.

* The Poetical Magazine. (Issued monthly.) 1809-
1811.

* The Microcosm of London; or London in Miniature.
Text to vols. 1 and 2 by W. H. Pyne; to vol. 3
by W. Combe. 104 pl. by Pugin and Rowland-
son. 1810.

New ed. 'Burlington Library of Coloured
Books.' Methuen, 1904.

The History of the Abbey Church of St. Peter's, West-
minster. Text by W. Combe. 83 pl. 1812.

* The Tour of Dr. Syntax in Search of the Picturesque.
Text by W. Combe. (This is the first Tour only;
published originally in the Poetical Magazine.)
31 pl. 1812.

New ed. Methuen, 1904.

Historical Sketch of Moscow. 12 pl. 1813.

* See also Appendix III.

* Poetical Sketches of Scarborough. Text by J. B. Papworth, Rev. F. Wrangham, and W. Combe. 21 pl. by Rowlandson. 1813.

History of the University of Oxford. 81 pl. (including 17 of costume), and 32 supplementary portraits of Founders. 1814.

History of the University of Cambridge. 79 pl. (including 15 of costume), and 15 supplementary portraits of Founders. 1814.

Sketches of Russia. 15 pl. 1814.

* The Military Adventures of Johnny Newcome. 12 pl. by Rowlandson. 1815.

A Series of Portraits of the Emperors of Turkey. 31 pl. by J. Young. 1815.

* Naples and the Campagna Felice. By Lewis Engelbach. (Published originally in the ' Repository,' 1809-15, with the title, ' Letters from Italy.') 18 pl. by Rowlandson. 1815.

* The English Dance of Death. By W. Combe. 74 pl. (including frontispiece and title-page) by Rowlandson. 1816.

　　New edition. Methuen, 1904.

* The Grand Master; or, Adventures of Qui Hi in Hindostan. 28 pl. 1816.

History of the Colleges of Winchester, Eton, and Westminster; with the Charterhouse and the Schools of St. Paul's, Merchant Taylors', Harrow, Rugby, and Christ's Hospital. Text by W. Combe and W. H. Pyne. 48 pl. 1816.

Hints for Improving the Condition of the Peasantry. By R. Elsam. 10 pl. 1816.

　　　　* See also Appendix III.

Select Views of London. Text by J. B. Papworth. (Published originally in the 'Repository,' 1810-15.) 76 pl. 1816.

* The Dance of Life. By W. Combe. 26 pl. by Rowlandson. 1817.

New edition. Methuen, 1904.

Costume of the Netherlands. 30 pl. 1817.

* The Vicar of Wakefield. By Oliver Goldsmith. 24 pl. by Rowlandson. 1817.

New edition. Methuen, 1903.

Rural Residences. Text by J. B. Papworth. (Published originally in the 'Repository,' 1816-17, with the title 'Architectural Hints.') 27 pl. 1818.

* The Tour of Dr. Syntax in Search of Consolation. By W. Combe. 24 pl. by Rowlandson. 1820.

New edition. Methuen, 1904.

Picturesque Illustrations of Buenos Ayres and Monte Video. By E. E. Vidal. 24 pl. 1820.

A Picturesque Tour of the Rhine from Metz to Cologne. By Baron von Gerning. 24 pl. 1820.

A Picturesque Tour from Geneva to Milan. By F. Shoberl. (Published originally in the 'Repository,' 1818-20.) 36 pl. 1820.

A Picturesque Tour of the Seine. By M. Sauvan. 24 pl. 1821.

A Picturesque Tour of the English Lakes. 48 pl. 1821.

* The Tour of Dr. Syntax in Search of a Wife. 24 pl. by Rowlandson. 1821.

* See also Appendix III.

PUBLISHED BY R. ACKERMANN

* Sentimental Travels in the Southern Provinces of France. (Published originally in the 'Repository,' 1817-20.) 18 pl. by Rowlandson. 1821.

History of Madeira. By W. Combe. 27 pl. 1821.

The World in Miniature. 42 vols. Edited by F. Shoberl. 1821-1827.

> Illyria and Dalmatia. 2 vols. 1821.
> Africa. 4 vols. 1821.
> Turkey. 6 vols. 1821.
> Hindostan. 6 vols. 1822.
> Persia. 3 vols. 1822.
> Russia. 4 vols. 1822-23.
> Austria. 2 vols. 1823.
> China. 2 vols. 1823.
> Japan. 1 vol. 1823.
> The Netherlands. 1 vol. 1823.
> The South Sea Islands. 2 vols. 1824.
> The Asiatic Islands. 2 vols. 1824.
> Tibet. 1 vol. 1824.
> Spain and Portugal. 2 vols. 1825.
> England, Scotland, and Ireland. 4 vols. 1827.

Illustrations of Japan. By M. Titsingh. 11 pl. 1822.

* The History of Johnny Quae Genus. By W. Combe. 24 pl. by Rowlandson. 1822.

> New edition. Methuen, 1904.

Hints on Ornamental Gardening. By J. B. Papworth. (Published originally in the 'Repository.') 34 pl. 1823.

A Picturesque Tour through the Oberland in the Canton of Berne. (Published originally in the 'Repository,' 1821-22.) 17 pl. 1823.

Visit to the Monastery of La Trappe. By W. D. Fellowes. 1823.

A Picturesque Tour along the rivers Ganges and Jumna. 26 pl. 1824.

* See also Appendix III.

313

Academy for Grown Horsemen. By G. Gambado. 27 pl. 1825.

A Picturesque Tour of the Thames. 24 pl. 1828.

Characters in the Grand Fancy Ball given by the British Ambassador, Sir Henry Wellesley, at Vienna, 1826. 1828.

The History and Doctrine of Buddhism. By E. Upham. 43 pl. 1829.

Scenery, Costumes, and Architecture, chiefly on the western side of India. By Captain R. M. Grindlay. 36 pl. (Two parts issued by Ackermann in 1826; but published finally by Smith, Elder.) 1830.

APPENDIX III

COLOURED BOOKS WITH PLATES BY ROWLANDSON

JONES, E. Musical Bouquet, or Popular Songs and Ballads, etc. Frontispiece. Sm. obl. 4to. 1799.

The Loyal Volunteers of London and Environs. 87 pl. 4to. Ackermann, 1799.

Hungarian and Highland Broadsword Exercise. 24 pl. Obl. fol. H. Angelo, 1799.

JONES, E. The Bardic Museum; or Primitive British Literature, etc. Frontispiece. Fol. 1802.

JONES, E. Selection of the most Admired and Original German Waltzes. Frontispiece. Sm. obl. 4to. 1806.

BERESFORD, T. Pleasures of Human Life, Investigated in a Dozen Dissertations. 5 pl. Cr. 8vo. 1807.

Chesterfield Travestie, or School for Modern Manners. Folding front, etc. Post 8vo. Tegg, 1808.

BROWN, T. Beauties, consisting of Humorous Pieces in Prose and Verse. Folding frontispiece. 1808.

The Microcosm of London, or London in Miniature. 104 pl. by Rowlandson and Pugin. 3 vols. Roy. 4to. Ackermann, 1808-10.

New ed. 'Burlington Library of Coloured Books.' Methuen, 1904.

The Miseries of Human Life. 50 pl. 1808.

STEVENS, G. A. A Lecture on Heads. Folding frontispiece. Sm. 8vo. 1808.

An Essay on the Art of Ingeniously Tormenting. 5 pl. by Rowlandson after G. M. Woodward. Sm. 8vo. Tegg, 1809.

The Poetical Magazine. Pl. by Rowlandson, etc. (including original series for 'Dr. Syntax in Search of the Picturesque'). 4 vols. 8vo. Ackermann, 1809-11.

Surprising Adventures of the renowned Baron Munchausen. 8 pl. 8vo. 1809.

STERNE, L. Sentimental Journey through France and Italy. 2 pl. 12mo. Tegg, 1809.

The Beauties of Sterne. 2 pl. 12 mo. Tegg, 1809.

DR. SYNTAX—FIRST TOUR

COMBE, W. The Tour of Dr. Syntax in Search of the Picturesque. 31 pl. Roy. 8vo. Ackermann, 1812.

Four editions were published in 1812, the fifth in 1813, sixth in 1815, seventh in 1817, eighth in 1819. New ed. Methuen, 1904.

French edition. 'Le Don Quichotte Romantique, ou Voyage du Docteur Syntaxe, à la Recherche du Pittoresque.' 26 pl. Paris, 1821.

German edition. 'Die Reise des Doktors Syntax um das Malerische aufzusuchen.' 31 pl. Berlin, 1822.

DR. SYNTAX—SECOND TOUR

COMBE, W. The Tour of Dr. Syntax in Search of Consolation. 24 pl. Roy. 8vo. Ackermann, 1820.

New ed. Methuen, 1904.

DR. SYNTAX—THIRD TOUR

COMBE, W. The Tour of Dr. Syntax in Search of a Wife. 25 pl. Roy. 8vo. Ackermann, 1821.

New ed. Methuen, 1904.

PLATES BY ROWLANDSON

COMBE, W. The Three Tours of Dr. Syntax. A miniature ed. 80 pl. 16mo. Ackermann, 1823.

Later reprints by Nattali and Bond, and by J. Camden Hotten.

New ed. in 3 vols. Methuen, 1904.

DR. SYNTAX—IMITATIONS, ETC.

(The plates not by Rowlandson.)

The Tour of Dr. Syntax through London. 20 pl. Roy. 8vo. 1820.

Syntax in Paris, or a Tour in search of the Grotesque. 17 pl. Roy. 8vo. 1820.

The Tour of Dr. Prosody, in search of the Antique and Picturesque. 20 pl. 8vo. 1821.

Adventures of Dr. Comicus, a comic satirical poem for the Squeamish and the Queer. 8vo. Blake, *n.d.*

Dr. Comicus, or the Frolics of Fortune. 15 pl. 8vo. Jacques and Wright, *n.d.*

Poetical Sketches of Scarborough. 21 pl. by Rowlandson after T. Green. 8vo. Ackermann, 1813.

Military Adventures of Johnny Newcome. 15 pl. 8vo. Ackermann, 1815.

New ed. Methuen, 1904.

Naples and the Campagna Felice. 18 pl. Roy. 8vo. Ackermann, 1815.

The Grand Master: or, Adventures of Qui Hi in Hindostan. 28 pl. Roy. 8vo. Ackermann, 1816.

COMBE, W. The English Dance of Death. 72 pl.
(Originally in 24 monthly parts, 1815-16.) 2 vols.
Roy. 8vo. Ackermann, 1816.

New ed. Methuen, 1904.

COMBE, W. The Dance of Life. 26 pl. (Originally
in 8 monthly parts, 1817.) Roy. 8vo. Ackermann,
1817.

New ed. Methuen, 1904.

GOLDSMITH, O. The Vicar of Wakefield. 24 pl.
Ackermann, 1817.

BURTON, A. Adventures of Johnny Newcome in the
Navy. 16 pl. 8vo. 1818.

New ed. Methuen, 1904.

The Characteristic Sketches of the Lower Orders. 54
pl. 12mo. Leigh, 1820.

Journal of Sentimental Travels in the Southern Pro-
vinces of France. 18 pl. Roy. 8vo. Ackermann,
1821.

Real Life in London, Rambles and Adventures of Bob
Tallyho, Esq., etc. (Pl. by Rowlandson and
others.) 2 vols. 8vo. 1822.

New ed. Methuen, 1904.

COMBE, W. The History of Johnny Quae Genus.
24 pl. Roy. 8vo. Ackermann, 1822.

New ed. Methuen, 1904.

WESTMACOTT, R. The English Spy. (2 pl. by Row-
landson, the rest by R. Cruikshank.) 8vo. 1827.

APPENDIX IV

COLOURED BOOKS WITH PLATES BY ALKEN

The Beauties and Defects in the Figure of the Horse, comparatively delineated. 18 pl. Imp. 8vo. S. and J. Fuller, 1816.

 Reprint, 1881.

Specimens of Riding near London. 14 pl. Ob. fol. M'Lean, 1821.

* The National Sports of Great Britain. 50 pl. Fol. M'Lean, 1821.

 New ed. 'Burlington Library of Coloured Books.' Methuen, 1903.

Real Life in Ireland. (Contains 19 pl. by H. A. and others.) 8vo. 1821.

 4th ed. Evans [1822].

Real Life in London. (Contains 32 pl. by H. A. and others.) 2 vols. 8vo. 1821–24.

Symptoms of Being Amused. 42 pl. Ob. fol. M'Lean, 1822.

Illustrations to Popular Songs. 42 pl. Ob. fol. M'Lean, 1823.

A Touch at the Fine Arts. 12 pl. Imp. 8vo. M'Lean, 1824.

Alken's Sporting Scrap Book. 50 pl. Sm. ob. fol. M'Lean, 1824.

Shakespeare's Seven Ages of Man. 7 pl. Ob. fol. M'Lean, 1824.

 * See also p. 320.

British Proverbs. 6 pl. Ob. fol. Ackermann, 1824.

* The National Sports of Great Britain. 50 pl. M'Lean, 1825.

EGAN, P. Sporting Anecdotes. (1 pl. only by H. Alken.) Sherwood, 1825.

'NIMROD' (C. J. APPERLEY). The Chace, the Turf, and the Road. (1st ed. 1837.) 1st ed. with the 14 pl. by H. Alken coloured. 8vo. Murray, 1870.

VYNER, R. T. Notitia Venatica. 8 pl. 8vo. Ackermann, 1841.

'NIMROD' (C. J. APPERLEY). Memoirs of the Life of John Mytton, Esq. 1st ed. 12 pl. 8vo. Ackermann, 1837.
> 2nd ed. 18 pl. Ackermann, 1837.
> 3rd ed. Ackermann, 1851.
> 4th ed. 1869.
> 5th ed. 1870.
> 6th ed. 1877.
> 7th ed. 1899.
> New ed. Methuen, 1904.

'NIMROD' (C. J. APPERLEY). The Life of a Sportsman. 36 pl. Roy. 8vo. Ackermann, 1842.
> Another ed. 1873.
> Another ed. 1874.
> Another ed. 1901.
> New ed. Methuen, 1904.

Analysis of the Hunting Field. 7 pl. 8vo. 1846.
> New ed. Methuen, 1904.

Alken's Hunting Accomplishments. 6 pl. Ob. fol. Fores, 1850.

* The plates are different from those of *The National Sports*, 1821.

SURTEES, R. Jorrocks' Jaunts and Jollities. 1st ed.
(Pl. by 'Phiz.') 1838.
 2nd ed. 16 pl. by H. Alken. 1843.
 A reprint of the 2nd ed. Methuen, 1904.
 3rd ed. Routledge, 1869.
 4th ed. 1874.
 5th ed. 1893.
 6th ed. (Pl. by H. Alken and 'Phiz.') 1900.
 7th ed. ,, ,, 1901.

REYNARDSON, C. T. S. Birch. Down the Road, or
Reminiscences of a Gentleman Coachman. 12 pl.
Roy. 8vo. Longmans, 1875.

BLEW, W. C. A. The Quorn Hunt and its Masters.
24 pl. (12 coloured). Roy. 8vo. 1889.
 New ed. 1899.

BLEW, W. C. A. A History of Steeplechasing. 28 pl.
(chiefly after H. Alken). Roy. 8vo. 1891.
 New ed. 1901.

GENERAL INDEX

(Titles of books are printed in italics.)

323

INDEX

INDEX

329

INDEX

INDEX

INDEX